Early Medieval Art

Oxford History of Art

Lawrence Nees is the author of *From Justinian to Charlemagne, European Art 565–787: An Annotated Bibliography* (Boston, 1985), *The Gundohinus Gospels* (Cambridge, Mass., 1987), *A Tainted Mantle: Hercules and the Classical Tradition at the Carolingian Court* (Philadelphia, 1991), and editor of *Approaches to Early-Medieval Art* (Cambridge, Mass., 1998). He is currently completing a book on Frankish manuscript illumination. Since 1978 he has taught at the University of Delaware, where he is Professor in the Department of Art History.

Oxford History of Art

Titles in the Oxford History of Art series are up-to-date, fully illustrated introductions to a wide variety of subjects written by leading experts in their field. They will appear regularly, building into an interlocking and comprehensive series. In the list below, published titles appear in bold.

WESTERN ART

Archaic and Classical Greek Art
Robin Osborne

Classical Art From Greece to Rome
Mary Beard & John Henderson

Imperial Rome and Christian Triumph
Jas Elsner

Early Medieval Art
Lawrence Nees

Medieval Art
Veronica Sekules

Art in Renaissance Italy
Evelyn Welch

Northern European Art
Susie Nash

Early Modern Art
Nigel Llewellyn

Art in Europe 1700–1830
Matthew Craske

Modern Art 1851–1929
Richard Brettell

After Modern Art 1945–2000
David Hopkins

Contemporary Art

WESTERN ARCHITECTURE

Greek Architecture
David Small

Roman Architecture
Janet Delaine

Early Medieval Architecture
Roger Stalley

Medieval Architecture
Nicola Coldstream

Renaissance Architecture
Christy Anderson

Baroque and Rococo Architecture
Hilary Ballon

European Architecture 1750–1890
Barry Bergdoll

Modern Architecture
Alan Colquhoun

Contemporary Architecture
Anthony Vidler

Architecture in the United States
Dell Upton

WORLD ART

Aegean Art and Architecture
Donald Preziosi & Louise Hitchcock

Early Art and Architecture of Africa
Peter Garlake

African Art
John Picton

Contemporary African Art
Olu Oguibe

African-American Art
Sharon F. Patton

Nineteenth-Century American Art
Barbara Groseclose

Twentieth-Century American Art
Erika Doss

Australian Art
Andrew Sayers

Byzantine Art
Robin Cormack

Art in China
Craig Clunas

East European Art
Jeremy Howard

Ancient Egyptian Art
Marianne Eaton-Krauss

Indian Art
Partha Mitter

Islamic Art
Irene Bierman

Japanese Art
Karen Brock

Melanesian Art
Michael O'Hanlon

Mesoamerican Art
Cecelia Klein

Native North American Art
Janet Berlo & Ruth Phillips

Polynesian and Micronesian Art
Adrienne Kaeppler

South-East Asian Art
John Guy

Latin American Art

WESTERN DESIGN

Twentieth-Century Design
Jonathan Woodham

American Design
Jeffrey Meikle

Nineteenth-Century Design
Gillian Naylor

Fashion
Christopher Breward

PHOTOGRAPHY

The Photograph
Graham Clarke

American Photography
Miles Orvell

Contemporary Photography

WESTERN SCULPTURE

Sculpture 1900–1945
Penelope Curtis

Sculpture Since 1945
Andrew Causey

THEMES AND GENRES

Landscape and Western Art
Malcolm Andrews

Portraiture
Shearer West

Eroticism and Art
Alyce Mahon

Beauty and Art
Elizabeth Prettejohn

Women in Art

REFERENCE BOOKS

The Art of Art History: A Critical Anthology
Donald Preziosi (ed.)

Oxford History of Art

Early Medieval Art

Lawrence Nees

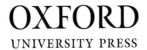

OXFORD
UNIVERSITY PRESS

OXFORD
UNIVERSITY PRESS

Great Clarendon Street, Oxford OX2 6DP

Oxford New York

Athens Auckland Bangkok Bogotá Buenos Aires Cape Town
Chennai Dar es Salaam Delhi Florence Hong Kong Istanbul Karachi
Kolkata Kuala Lumpur Madrid Melbourne Mexico City Mumbai
Nairobi Paris São Paulo Shanghai Singapore Taipei Tokyo Toronto Warsaw
and associated companies in Berlin Ibadan

Oxford is a registered trade mark of Oxford University Press
in the UK and in certain other countries

© Lawrence Nees 2002
First published 2002 by Oxford University Press

0-19-284243-9

10 9 8 7 6 5 4 3 2 1

British Library Cataloguing in Publication Data
Data available

Library of Congress Cataloguing in Publication Data
Data available

ISBN 0-19-284243-9

Picture research by Elisabeth Agate
Typesetting and production management by
The Running Head Limited, Cambridge, www.therunninghead.com
Printed in Hong Kong on acid-free paper by C&C Offset Printing Co. Ltd

*The websites referred to in the list on pages 261 and 262 of this book are in the public domain
and the addresses are provided by Oxford University Press in good faith and for information
only. Oxford University Press disclaims any responsibility for their content.*

Contents

	Acknowledgements	7
	Introduction	9
Chapter 1	The Roman Language of Art	17
Chapter 2	Earliest Christian Art	31
Chapter 3	Conversion	47
Chapter 4	Art for Aristocrats	63
Chapter 5	Endings and Beginnings	81
Chapter 6	Craftsmanship and Artistry	99
Chapter 7	Saints and Holy Places	117
Chapter 8	Holy Images	137
Chapter 9	Word and Image	153
Chapter 10	Art at Court	173
Chapter 11	Expressive and Didactic Images	195
Chapter 12	Towards a New Age	213

Conclusion	237
Notes	245
Further Reading	250
Timeline	254
Museums and Websites	261
List of Illustrations	263
Index	268

Acknowledgements

I would like to thank Simon Mason, formerly editor of the Oxford History of Art, for inviting me to contribute a volume to this series, and for being throughout the writing of the first version the kind of supportive and engaged editor of whom authors dream. This book would never have been possible without the generous support of research and travel grants over several decades that permitted me to see and study the art of the early medieval period. These supporters include the National Endowment for the Humanities, the American Philosophical Society, the John Simon Guggenheim Memorial Foundation, the Institute for Advanced Study (Princeton), the Center for Advanced Study in the Visual Arts of the National Gallery of Art (Washington), and the General University Research Fund of the University of Delaware. I am deeply grateful to these organizations and institutions and to their staffs, as I am to all the museums and libraries, far too numerous to list here, which have generously permitted me to study the precious objects in their collections.

Many colleagues have inspired, corrected, and taught me, for which I am deeply indebted, and countless students have contributed in ways they will never know through their questions, doubts, confusion, scepticism, and insights as I presented early medieval art to them. Teresa Nevins and Stephen Wagner deserve special mention for having read versions of the text and for many acts of kindness during its writing.

My greatest debt is to the support and inspiration of my wife Vicky and son Alexander, indefatigable fellow travellers through the real and imagined landscapes of the early medieval world.

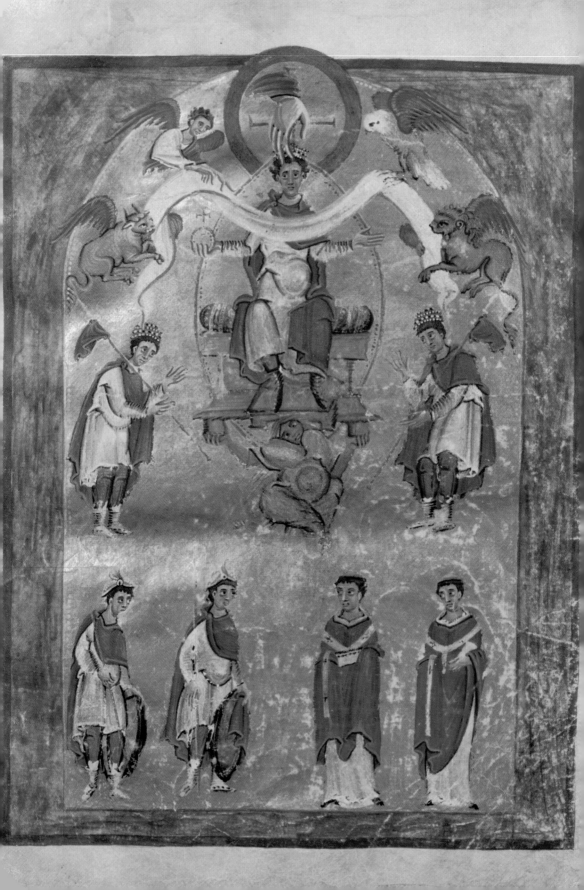

Introduction

Emperor Otto III sits on his throne, flanked by two soldiers bending to offer banners of victory while making gestures of humility and acclamation [1]. Grasping the opened book-scroll that floats before the emperor are a lion, ox, eagle, and human figure symbolizing the four Evangelists, authors of the four Gospels. Below him are four more figures, two soldiers, perhaps best interpreted as members of the nobility, and two high-ranking ecclesiastical officers, probably bishops. Supporting the emperor's throne is a personification of Earth, heightening the impression that he is literally above the earth, ascended almost to heaven, whence descends the Hand of God as if either crowning him or touching his forehead in blessing. The emperor stretches his arms as if to receive homage, opening himself to the viewer's gaze, which he returns with a fixed and seemingly eternal stare. This majestic image is arresting in its directness. The composition is simplified, centralized, symmetrical, drawing the beholder's attention to the imperial visage through its strong colours, gesturing subsidiary figures, and framing arch. The nearly ocular almond shape around the emperor separates him from the other figures and serves as a visual bull's-eye.

Created at the turn of the first millennium, this remarkable image embodies many characteristics of the early medieval artistic tradition. Although its central subject is political rather than Christian, it is pervasively a Christian work of art, displaying the emperor flanked by Christian symbols, through whose mediation he receives his authority from God. Moreover, it was made in a monastery, albeit one supported by imperial patronage, a fitting example of the interweaving of sacred and secular that was a hallmark of the period. Its style makes little use of or reference to the natural world, indicating no specific place or time for the event depicted. Indeed natural space is not just ignored but denied, the image disposed upon two superimposed strips in a manner corresponding to no conceivable real earthly setting, and set forth against a background of glittering gold. Its unnatural appearance is fitting, however, for what is depicted here is not an event but an idea. Otto is presented as if in heaven, although when the manuscript was executed he was still alive on earth. There is truly no space

Detail of 1

The figure of Otto III enthroned

1
Aachen Gospels of Otto III, Otto III enthroned in majesty, probably from Reichenau on Lake Constance, on the border between Germany and Switzerland, late tenth century
The inscription on the facing page, showing the chief scribe of the manuscript and likely painter of this image, the monk Liuthar, reads *Hoc Auguste Libro tibi cor Deus induat Otto quem de Liuthario te suscepisse memento*, translated by Henry Mayr-Harting 'May God clothe your heart with this book, august Otto, and remember that you received it from Liuthar'.

or time to be illusionistically represented, for the image records a desire in which heaven and earth are linked, and past, present, and future are intermingled. Therefore the imperial visage conveys no sense of presenting an accurate likeness of Otto's physical features, for such trivial details of the emperor's individuality are subsumed in the majesty of his office.

When Ingres represented Napoleon in a strikingly similar composition [2], the effect is so incongruous as to seem bizarre, with Napoleon inserted into his pompous regalia as if a hole had been cut for his (or someone else's) head. Of course reactions to such an image can vary. Whereas an early nineteenth-century French critic objected to its anachronistic sterility, observing that 'had Ingres attempted to paint Dagobert or another king of the earliest dynasty he could not have chosen more Gothic ornaments or given the figure a more coldly symmetrical pose',[1] in the late twentieth century Robert Rosenblum found an uncanny intensity, noting that 'the oppressive frontality of a medieval icon contributes, too, in transforming a flesh-and-blood figure of modern history into a haunting and ageless image of unquestioned, unapproachable power'.[2] Within the modern tradition Ingres's painting was an anomaly, an anachronism, more a metaphor and reference to a glorious ancient tradition than something to be taken literally. Such an image can be criticized for what it fails to attempt, or praised for its discomforting yet riveting aura.

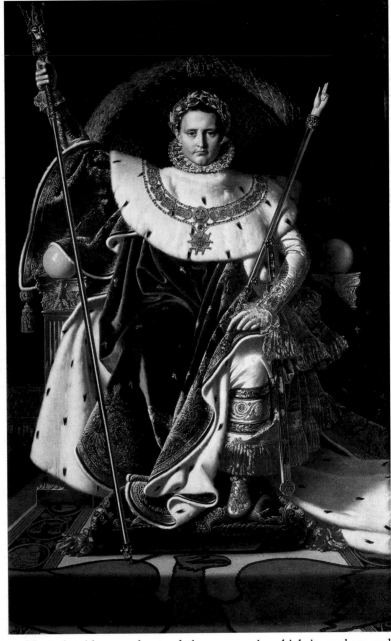

2 Jean-Auguste Dominique Ingres

Napoleon Enthroned in Majesty, 1806

Ingres used essentially the same arrangement for his mythological image of Zeus receiving the petition of Achilles' mother Thetis, painted five years later. Napoleon carries distinctively French staffs and insignia, including the startling Hand of Justice dating from the fourteenth century, while the golden insects on his cloak are based upon objects found in the fifth-century tomb of a Frankish king. He sits above an eagle with outstretched wings.

How should we understand the manner in which its makers and original medieval viewers took Otto's image? Representing something that never occurred in a place no living human had seen unless in a dream or vision might be thought to open a path promoting individual fantasy, producing images incomprehensible to all but the artist. Yet although unique, this image of Emperor Otto III is not so arbitrary or fantastic that a contemporary viewer would have had difficulty reading or decoding it. Indeed it stands within a tradition of visual culture

stretching back through much of the first millennium to Roman antiquity, exemplified by a gemstone depicting Augustus enthroned in heaven [3]. Although encoding a deeply Christian world-view, Otto III's image in its essential visual form is ultimately derived as surely from the pre-Christian period of the Roman empire as is the imperial title itself.

The Roman heritage is essential for early medieval art, but by no means adequate to account for its character. The portrait of Emperor Otto III in the Aachen Gospels, for all its Roman features, is in other respects totally unlike the Roman artistic tradition. One of its most remarkable features is its location, painted not on a wall or a panel but on the page of a book. The book is a copy of the four Gospels, the first books of the Christian New Testament, the story and words of Jesus, the essential Christian book, found on every Christian altar. Passages from the Gospel book were read in every performance of the central Christian liturgical service, the Mass. Graeco-Roman antiquity knew books, of course, but they were different in form, material, value, production, and artistic status. Indeed, in the Graeco-Roman world, books were not works of art, and only very late and in association with Christianity were some works of classical culture produced in luxuriously artistic editions. In contrast, Christianity inherited from Judaism the centrality of a book in its religion and culture, and developed new artistic means of signalling the book's importance. The presence of the

3

The Gemma Augustea, onyx cameo, *c.*10 BC? (190 × 230 mm)

Like the image of Otto III the figures appear on two separate registers. In the upper Augustus sits on the throne of Jupiter, with Roma (personification of the city) beside him, while his successor Tiberius descends from a chariot. Below is the erection of a trophy by Roman soldiers, amid pathetic defeated barbarians. Instead of Jupiter's thunderbolt, Augustus has the long staff of a Roman augur, suggesting that he has arranged the victory of his adopted son and representative.

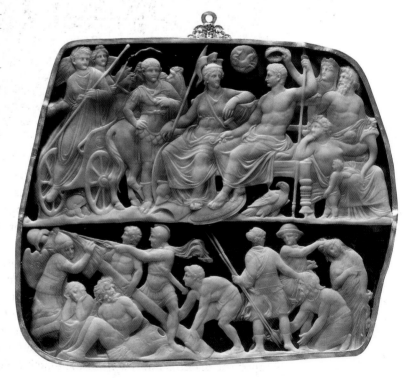

Aachen (or Liuthar) Gospels of Otto III, Crucifixion, probably from Reichenau, late tenth century

Christ is shown between the two thieves, Stephaton at Christ's left offering a vinegar-soaked sponge at the moment of Christ's death. At Christ's right are the Virgin Mary and the apostle John, while at the bottom are soldiers casting lots for possession of Christ's garments.

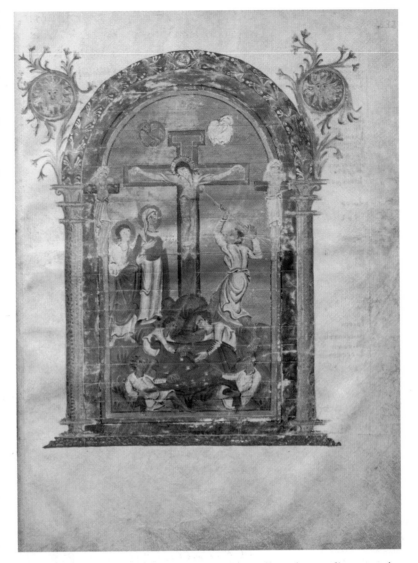

imperial image in the Aachen Gospels is really only an adjunct to the magnificently written words of the sacred text, and anyone who holds and looks through or reads this manuscript cannot but recognize that the most numerous and significant and striking images are those based upon the Gospel text, including images of Christ's birth, his miracles, his death on the cross [4].

Like the imperial portrait, the narrative images are presented under arched frames that force compression and selectivity, creating a field taller than wide. This reflects the shape of the page in a medieval or for that matter a modern book, and is very different from the wider-than-tall format of most modern paintings hung in museums, or paintings on walls from antiquity through the Middle Ages. The format is based upon the material limitations of the functional object with which the

work of art is associated, but the 'limitation' is also a spur, encouraging a development of the image not as a discursive narrative read across time and space but as a hierarchy read from the top down. Although the treatment of space is unnatural, with the setting reduced to a series of brown lumps floating on a golden background, it allows and indeed compels the viewer to concentrate upon the most important figure, Christ, surrounded by and centred under the arch. The two thieves crucified with him are included, yet the artist has removed those less significant figures from Christ's space, literally tying them to the encircling frame. The interest in vivid narrative details such as the four soldiers casting lots for the possession of Christ's seamless robe is visually and spatially subordinated, moved to the bottom of the page and merging with the green ground instead of standing isolated against the gleaming gold. It is a staggering image, intimate yet dignified, passionate yet remote, full of telling natural detail yet artificial, nearly abstract. How did the artists and viewers of the early medieval period come to establish such a strongly determined field in which images could be read?

This book is devoted to the visual arts, excluding architecture, of the early Middle Ages, during the years AD 300–1000, with primary focus on western Europe. Recent years have seen extensive research on early medieval institutions, people, texts, and magic, among other issues, yet consideration of early medieval art in dramatically new ways has largely been confined to specialist literature and has not been part of the broader interdisciplinary discourse. Some art historical studies still in use tell an old story of barbarian tribes descending from the misty north with their brains full of demons and monsters, and of abstract ornament. Although no one questions the ferment around and within the late Roman world, recent scholars have destroyed the myth that everyone was in motion, and have shown that the Goths and Franks and the other 'Wandering Tribes' were not ancient ethnic groupings but shifting political associations of diverse people that eventually define themselves in ethnic terms. The early Middle Ages was a time of ethnogenesis, the cultural creation of new 'peoples', not of the migration of stable populations. In artistic terms this has the greatest importance, questioning in principle the traditional designation of 'barbarian' or 'northern' art as an inheritance from some prehistoric past. Recent research has shown the origin of many allegedly 'barbarian' traditions and art forms within the Roman world itself. One formulation holds that 'the Germanic world was perhaps the greatest and most enduring creation of Roman political and military genius, and owed its very existence to Roman initiative'.[3] Early medieval art often employs Roman forms and compositions and symbols because they constituted the most widespread and effective language for visual communication.

The history of the Middle Ages in general and the early medieval period in western Europe in particular is often presented as a story that may be interesting in its own terms as an escape into mist and mystery, but might also be described as a hiatus or byway, the road not taken, interrupting the achievements of Graeco-Roman antiquity and an imagined inexorable march towards our modern world. This picture now seems increasingly unsatisfactory, in many ways most informative about the culture of the nineteenth and earlier twentieth centuries when it was developed, for the early medieval period is not a Romantic interlude but a formative period in which many current political and cultural patterns began. As the imperial portrait in the Aachen Gospels shows, the early medieval period ultimately preserved aspects of the Roman tradition and passed those on, sometimes in radically altered guise, to subsequent European culture. Study of its artistic production offers insights into the relationship between cultural change and ethnicity, and between aristocratic and popular cultures and audiences, the effects of the rise of new élite social groups, and many other issues of great interest today. Many wonderful works of art, not just superlative examples of craftsmanship, which even its harshest critics have never denied, but original and profoundly expressive visual images represent the culture of the people by and for whom they were made, and still seize the spirit of many beholders today.

This book avoids a Hegelian presentation of the contest between classical thesis and barbarian antithesis, as if their interplay determined the course of early medieval art and culture. Instead it focuses on a range of topics that seem to me important and revealing. I offer a different story of early medieval art in place of the more traditional tale of the decline of Rome and triumph of Christianity and barbarism that has long dominated the historical treatment of the early Middle Ages. One over-arching theme reappearing at many points will be the role of tradition in early medieval western art. The early medieval artistic tradition not only receives and transforms, it literally invents a tradition upon which it founds itself. Unlike today, when the most hackneyed images and conceptions are commonly presented as novel or 'original', in the early Middle Ages, the most novel and original images and conceptions were often presented as if continuing an ancient tradition.

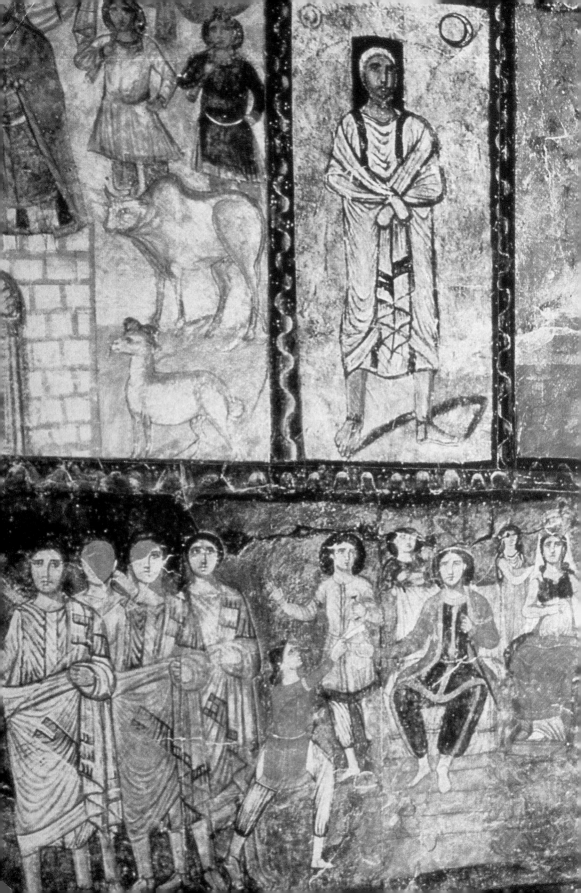

The Roman Language of Art

1

Rising over the ruins of ancient Rome is the triumphal column celebrating Trajan's victorious wars. Originally it stood surrounded by the basilica, temple, and libraries of that emperor's enormous new forum, constructed in the early second century [5]. In many respects the pre-eminent monument of the 'golden age' of Rome, its rich and varied depictions of active life represent a climax of the ancient world's artistic tradition. Yet in other ways it announces a new world. Erecting memorial columns was a venerable tradition of the Greeks, but previous victory monuments in Rome and elsewhere in its empire had normally been arches through which triumphal processions could actually move. In form and decoration alike triumphal arches captured an idealized version of that elaborate ritual celebration, with depictions of sacrifices and piles of booty recalling the actual sacrifices and displays of the great event. Trajan's Column did not span an avenue of movement, but marked a fixed axis in a kind of courtyard, an implicit interior. It raised the imperial portrait statue that crowned it almost to heaven, anticipating or at least reflecting the Senate's posthumous decree that Trajan was divine, and made room at its base for his mortal remains, breaking the long-standing Roman law prohibiting burial within the city. Its remarkable decoration was also novel: it was no fluted Corinthian or other traditional column form, but was wrapped by hundreds of yards of upward-spiralling helical bands of figural reliefs. These reliefs depicted not the triumphal procession, but rather the wars that preceded it, a vast historical narrative culminating in the imperial (now divine) victory, an intensely focused image of the past projected into the future as if it were a living present.

Trajan's image appears innumerable times on his column, offering advice to a war council, offering sacrifice to the gods, directing affairs. Several times he addresses his soldiers, and several times receives the submission of ambassadors or defeated prisoners. These scenes are depicted in a manner that may plausibly be thought to reflect the historical event, and to have been accepted as such by the original Roman viewers, yet analogous events tend to be depicted in closely analogous formalized compositions. For example, when the emperor addresses his troops he stands on a raised platform so that they can see and hear him,

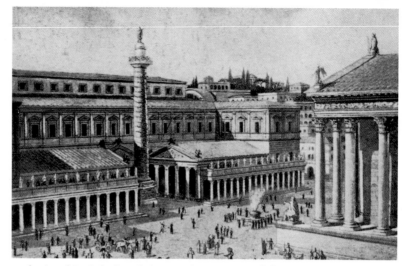

5

Reconstruction of Trajan's Column rising in the centre of Trajan's Forum, with the Basilica Ulpia the huge building behind it (after H. L. Pinner). The complex, including the Column, was dedicated in AD 112, celebrating victories of the previous decade, and possibly only completed after Trajan's death in AD 117

Not reliable in details, this view does give a sense of the work's scale (40 metres high) and surroundings. Whatever may have been the events of the wars, portrayed in 155 scenes with some 2,500 figures, they were here represented with a single dominant starring actor, the emperor himself.

and raises his right hand in a speaking gesture [**6**]. When receiving submission, he is often seated on a horse presented in profile with one front leg raised, while the submitters press forward to implore his mercy [**7**]. One imagines that if a raised position could be found, anyone addressing thousands of troops would have spoken from it, while a victor might be expected to assume a dominating position on horseback, the vanquished expressing their humility and submission through their posture and action. Yet it is clear after viewing different events repeating the same essential arrangements that these plausible images are in fact formulaic, not so much recording what transpired as seeking to

6

Trajan's Column, *c.*AD 120

Emperor Trajan addressing his soldiers, his hand raised in a gesture of speech, the military standards just before him, and the crowd of soldiers beneath, many of them seen from behind (a type commonly designated as an *adlocutio* image).

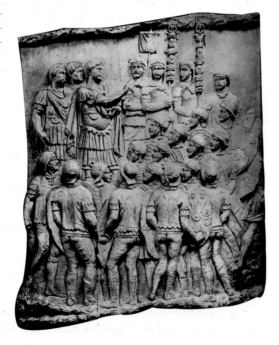

7

Trajan's Column

Trajan riding forward on his horse, a crowd of barbarian men and children before him making gestures of speech (hands raised or pointing) and submission (hands outstretched with palms turned up). Such an image is commonly designated with the term *adventus*.

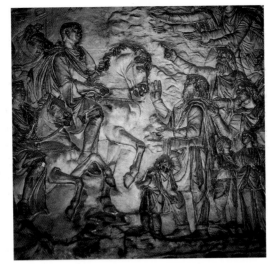

communicate to the viewers a clear understanding of what happened. These pictorial formulae are reminiscent of the verbal commonplaces, *topoi*, in ancient rhetorical literature, designed to characterize and transmit effectively rather than to describe literally.

Trajan's Column creates the visual memory of events by casting them in forms familiar from representation of other events. Artists selected and emphasized elements deemed essential and diminished others deemed unimportant. Such practices were scarcely new phenomena in the history of art with the Column of Trajan; for all its startling naturalism, the great frieze on the Parthenon in Athens cannot be regarded as an accurate or innocent transcription of external reality. Yet what is new within the Graeco-Roman tradition is the Trajan Column's still hesitant but increasingly overt acceptance of art as a construction meant to communicate, its willingness to be repetitive and evidently artificial in the hopes of being more clear to its audience. The almost grudging use of repetitive formulae in the Trajan Column becomes commonplace in many subsequent works of Roman art, and artists learned how to exploit the new manner in expressive ways. Two generations after Trajan's Column was erected, Marcus Aurelius constructed a monument startlingly analogous, with the same dimensions and distinctive spiralling narrative reliefs, clearly referring to the Trajan Column as a means of claiming that Marcus should be regarded as somehow like the great and successful Trajan. The designer of Marcus' column reduced the number of bands and the number of figures inhabiting them, and used higher relief carving as a means to enhance visibility and clarity, implicitly criticizing the Trajan Column in these respects, and also altered the structure of individual scenes with a similar effect.

The narrative images of the Marcus Aurelius Column employ the same formulae used on Trajan's Column for the imperial address, the

Emperor Marcus Aurelius
addressing his soldiers
(*adlocutio* image), surrounded
by his officers. The emperor is
in the centre, the full length of
his body visible, raised as if on
a projecting ledge.

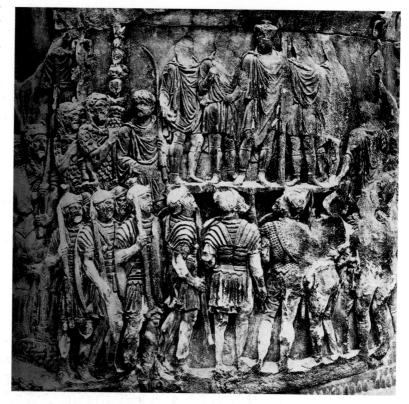

adlocutio [**8**], and the *adventus*, tending further to simplify those scenes, emphasizing centralized and increasingly symmetrical compositions. Noteworthy also is a shift in pictorial strategy. In a Trajan Column *adlocutio* [**6**] the image is constructed in a profile view that encourages the viewer to read the image from left to right as if it were a text, casting the viewer as an outside observer watching an interchange among the people represented within the image. In a Marcus Aurelius Column *adlocutio* [**8**], the image is constructed in a frontal view, stopping the flow of the narrative, and casting the viewer as if a member of the crowd of listeners over whose shoulders he or she sees and almost hears the emperor. The designer of the Marcus Aurelius Column also finds new means to convey dramatic expression. The horror of one image [**9**] is underscored through an obviously arbitrary arrangement of all the executioners' swords into descending parallel lines, an artificial evocation of implacable and pitiless power lent further emphasis by the parallel Roman spears behind them. The swords are carved in high relief and jump to the front of the picture plane. No longer is there any illusionistic receding depth behind the figures as in the two reliefs from Trajan's Column.

In an imperial work from the middle of the third century [**10**], the entire surface is alive with a maelstrom of struggling bodies. Before and behind do not exist, only above and below, the former occupied

by the vanquishing Roman soldiers and the latter by their vanquished enemy. At the top and centre is the victorious general, perhaps the emperor, not hurling a spear but raising his hand in a gesture that implies victory by decree. The artist is not transcribing a vision of the event as much as inventing a new compositional type that combines elements of the formal arrangements and of the ideological significance of the established *adlocutio* and *adventus* formulae. Yet it is clear that showing and seeing are both operating in a manner notably different from the apparent naturalism and illusionism of the Trajan Column.

By the end of the fourth century, important imperial works of art unabashedly adopted even more obviously unnatural means that effectively conveyed the intended message. In 285 Emperor Diocletian established a new system of governing the Roman world, known as the Tetrarchy because it effectively divided authority among four rulers. These were arranged in two pairs, a senior Augustus in both the eastern and western halves of the empire, each assisted by a Caesar, who had his own region of direct rule, and was envisaged as the eventual successor to his Augustus. The system was intended to provide an impersonal and abstract structure for imperial rule, but was in fact so much Diocletian's personal vision and creation that it never

9
Marcus Aurelius Column, execution scene
Barbarian prisoners, hands tied behind their backs, are pushed forward to the point where other barbarians use swords to cut off their heads. Along the bottom of the scene are severed heads and bodies. In the background are mounted Roman soldiers carrying spears.

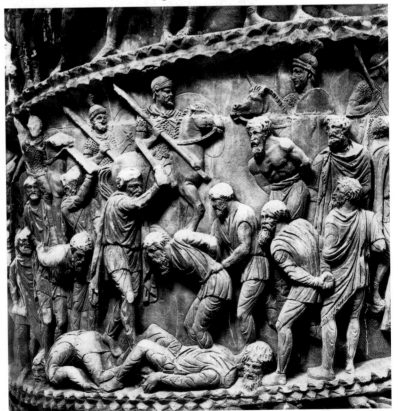

10

Commonly known as the Ludovisi Battle Sarcophagus, the work is often associated with Trajan Decius' son Hostilian and dated to *c.*251, but it may have been made for another member of an imperial family, and could date a decade or more later (marble, 1.52 m H)

On the lid the central place is reserved for an inscription, probably originally painted, with huge masks at the corners, defeated barbarians beneath the plaque, a victorious general granting clemency at the left, and a portrait of the wife or mother of the deceased at the right, set off by a cloth of honour held by servants. The main battle scene relief shows the victorious general at the centre surrounded by Roman troops, the defeated barbarians pushed to the bottom.

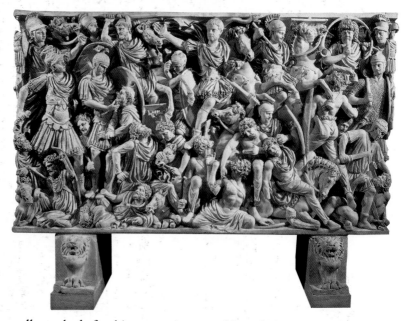

11

Four Tetrarchs, from Constantinople although perhaps carved in Egypt, porphyry, *c.*300 (1.3 m H). (Venice, San Marco, south-west corner pier)

Each pair of embracing rulers has identical attributes, for example the eagle-head grips on their swords, but it seems likely that in each the senior Augustus is distinguished from the junior Caesar whom he embraces by being bearded rather than clean-shaven, as if to suggest a paternal relationship. The group probably stood on top of a triumphal column, probably in or near the imperial palace in Constantinople, before it was removed to Venice after 1204.

really worked after his own retirement. Nonetheless it was represented in works datable to Diocletian's period, such as a group portrait of the four Tetrarchs [**11**]. The work is obviously not a portrait in the usually understood sense, for all four of the figures appear virtually identical, lacking any individual physiognomic features. They are linked into two pairs through an embrace, advertising their collegial unity and mutual support. The unnatural colour heightens their distance from the every-day world, for they are entirely in purple, carved in the immensely hard porphyry stone reserved for imperial commissions. Such a work should not be dismissed as a failure of naturalism, but recognized as a triumph of expressing through visual form an idea or, if taken literally, a vision of a supernatural reality.

Coins

The monuments discussed so far all depict emperors, and constitute official statements. Such monuments were by no means limited to the city of Rome, but appeared throughout the empire in important cities. Even without such grand monumental works of art, the imperial

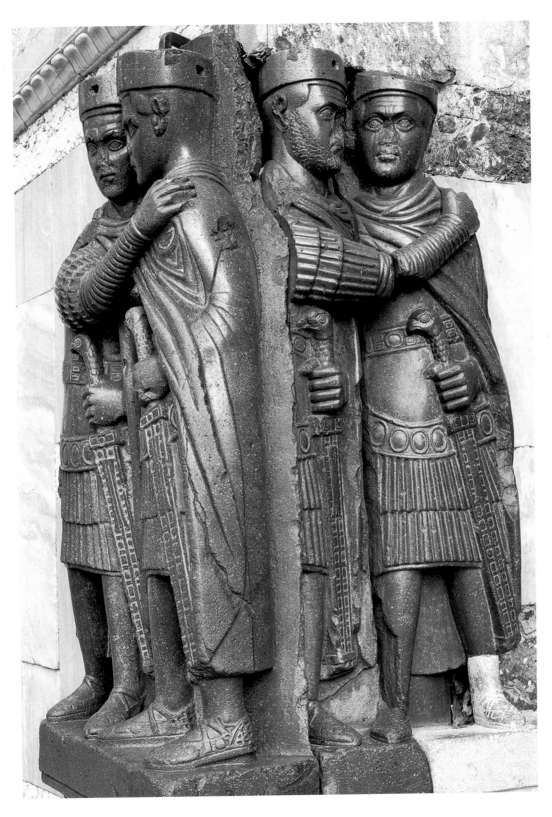

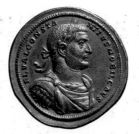
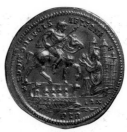

ideology was expressed through a language that might be thought coarse relative to earlier traditions, but whose widespread use testifies to its effectiveness. Coins issued by each new emperor employed such images [12]. Drained of the occasional specificity we may be accustomed to expect, this could be any emperor and any city of the late Roman empire, and only the inscriptions can identify them for us, as they alone could have identified them to the contemporary beholder. The image's magnificent economy offers another kind of specificity, conveying the elaborate ceremony of the imperial *adventus* in which the people of the Roman world acknowledged the supremacy and petitioned the benevolent protection of their leader, expressed also through surviving panegyric orations, which used similarly repetitive formulae.

Given the centuries-old tradition of coinage featuring the ruler's portrait in a profile view, the appearance of coins in which the ruler is portrayed frontally, gazing at the spectator, must have been arresting. With rare exceptions, frontal portraits appear first during the Tetrarchic period, a particularly intriguing example being issued by the last Tetrarch [13]. The father–son relationship implied by the Tetrarchic portrait group is here literalized, stressing the family continuity on the imperial throne. Possession of that throne with the support and protection of the gods is emphasized by the reverse of the coin, where Jupiter the king of the gods sits in the pose and with many of the attributes of the imperial tradition [1–3]. Here the surrounding legend renders explicit what the image effectively conveys: Jupiter is the protector, as it were the sponsor, of the two mortals, and like them gazes directly at the beholder to whom that truth is communicated.

In a world where few inhabitants of the Roman world would ever

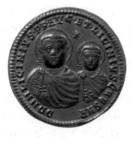
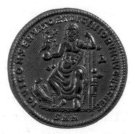

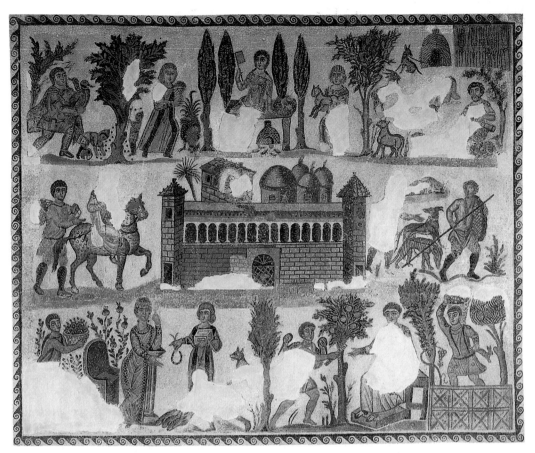

Floor mosaic, from the House of Dominus Iulius in Carthage, probably from the middle or second half of the fourth century

The composition is laid out in three registers, here manifestly conceived as neither a spatial nor temporal unity. Surrounded by images of rural life, with hunting, shepherding, and harvesting, both the landowner and his wife appear twice, she at top centre and lower left, he at centre left and lower right.

see their emperor in the flesh, such clear communication was much more important than presenting an accurate likeness or setting a particular scene: the virtual identity between the two rulers, save for disparity of size, conveys not their merely incidental family resemblance but their essential unity in office. In a vast and extraordinarily disparate world of many languages and cultures where few were literate, such images could be understood, 'read' as it were, and served as an effective universal means of communication. Later Roman art's genius in creating an effective pictorial language, although forged in the imperial service, was adaptable enough to be applied to other contexts. If a wealthy landowner had himself portrayed returning to his estate [14], the composition gained clarity in meaning from its similarity to an imperial *adventus*, with the lord of the manor approaching on horseback from the side. Below in the right corner, he is seated to receive a document from a servant, who bends in an attitude of subservience. This arrangement closely recalls a common imperial formula used for conveyance of documents, later adopted by Christian art for other actions [60]. The use of such formulae does not mean that the landowner is claiming to be like or to rival the emperor,

which would be not only ludicrous but dangerous. Rather he, or the artist in his employ, borrows a mode of representation that maps a social hierarchy. The reference and impact of such a work is local, but the language is not, for a similar work might be found in Britain as well as in northern Africa, or for that matter in the east, where the mosaics of Antioch offer many comparanda. In spite of many local variants there was also a broader Roman visual culture that was in a sense imperial even without reference to the emperor. Similarly, if the imagery of the imperial *adventus* on Trajan's Column [7] or on a coin from London [12] connect not so much to an 'event' as to a staged ceremony, a kind of liturgy, the same may well be imagined at the local level, the equivalent of the scene in films set in great British or French houses of the eighteenth to early twentieth centuries where all the servants come out to greet the lord of the manor ritually upon his arrival. In the late Roman world, if art was less and less concerned to imitate life, life came increasingly to imitate art. When the emperor arrived in

15

Funerary stele of a centurion in the pretorian guard in Rome, third century (1.25 m H)

The eagle in the lunette above him alludes to his military career, as more explicitly do the eagle standards attached to the columns at either side. The directness of the fixed frontal posture and gaze and the outstretched arms beautifully parallel the frontal eagle above, whose wings seem extended as if in protection, and at the same time surely allude to a hope that his spirit may ascend to a higher realm.

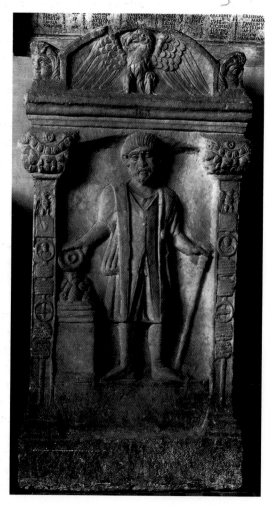

a city, it would be in everyone's interest to structure the ceremonial events in a manner corresponding to the familiar images, indeed to do otherwise would cast doubt on the validity and authenticity of both art and life.

By the third century, the cult of the divine emperor had become a religion in the Roman world, albeit one that shows few signs of ever having satisfied anyone's spiritual needs. Imperial cult imagery drew upon the more ancient traditions of art in the service of the many religions of the Roman world. The portrait image of Trajan that originally crowned his column, or the image of Augustus on a gem [3] reflect the cult images standing in temples throughout the Greek and Roman world, whose characteristics were advertised through such means as coin issues [13]. Immobile figures either standing or seated, such images embodied what their artists and audiences took to be the character of the deity represented, with few probably ever having believed that the images housed or were in any sense identical with the deity. The long narrative cycle of events displayed on the Trajan Column comprised another genre with deep roots in ancient religious art, corresponding to the representations of historical and what we term mythological events, as on the pediments or friezes of temples. Representations of cult actions like Trajan offering sacrifice to the gods relate to religious types like the sacrificial images frequently left as votive offerings or decorating funerary monuments, as on a third-century gravestone depicting a Roman centurion pouring a libation onto an altar [15]. Lines between sacred and imperial and secular were increasingly difficult to define, for later Roman art constructs a flexible new language susceptible to surprising permutations.

Religious art

One of the most fascinating surviving works of religious art of the late Roman period is the synagogue of Dura (the Greek Europos) on the Euphrates River in modern Syria. Discovered in the 1930s, the frescos in the assembly hall were buried during the course of Dura's unsuccessful defence against a Persian attack in AD 256. The focal element in the room [16] was the Torah shrine, a niche in the centre of one wall in which the sacred Jewish scripture, the books of Moses (the first five books of the Christian Bible) were preserved and displayed. Here were the images that were the smallest, apparently the first to have been painted, and in many respects the most sacred. The Jerusalem Temple is at the centre and some of its liturgical implements at the left. At the right is a tiny image of Abraham preparing to offer in sacrifice his son Isaac, for whom the large sheep was substituted at the last moment. All the images refer to a sacred time and sacred place and sacred action, absent in reality but passionately alive in memory and

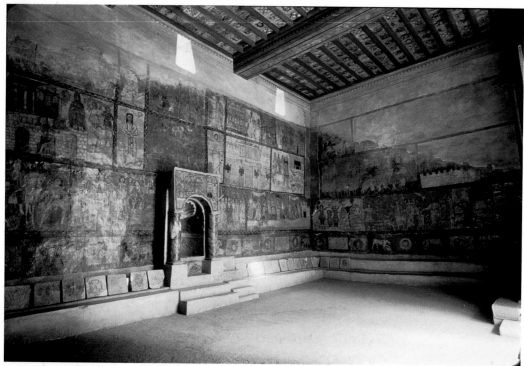

16

Dura (Europos), Synagogue,
view of paintings on the west
wall, before AD 256

At the centre is the Torah
shrine with its shell-niche.
Immediately above the Torah
shrine are David enthroned
amid the 12 tribes, and
flanking it are four large
standing figures (Abraham and
an uncertain figure at the left,
Moses and Ezra at the right).
At the left of the Torah shrine is
the enthroned King Ahasuerus
of Persia, from the Esther
story, and at the right the
prophet Samuel anoints David
as king.

desire. The sacrifice image implies an important historical narrative,
for this event established God's covenant with Abraham and his
descendants. It was also an important ritual or liturgical scene, for the
sacrifice of the sheep took place on the site of the later Temple, and
inaugurated the animal sacrifice that was performed there for a thou-
sand years, until the destruction of the third Temple by Roman armies
in the first and second centuries.

Datable probably to the early third century, the paintings on the
Torah shrine were originally the only figural imagery in the great hall,
which could accommodate several dozen worshippers. Above the
shrine was a large tree-like image alluding symbolically to the garden
of paradise (lost and desired), flanked by a table for offerings to God
and by an empty throne. The central image of a lion related to the once
and promised ruler of the descendants of Abraham, the lion of Judah.
At some point not very long before the destruction of Dura, the
imagery was enormously enriched through a cycle of large painted
images on all the walls [**16**]. The paintings showed important events of
Jewish history, including the birth of Moses, the destruction of the
Philistines' temple by the Ark of the Covenant, and the anointing of
David as king. Other scenes such as the prophet Elijah bringing a dead
child back to life are by no means great historical events, but rather
suggest a more personal reference, the hopes of the community that
God would use his power on their behalf. Some of the images are less
historical than ritual in focus, notably one which shows the Jerusalem

Temple and its liturgical furnishings in the absence of any historical figure or event.

The new decoration's central images, above the Torah shrine, show all the people of Israel gathering under the leadership of David, enthroned at the top of the wall and facing the audience. The Israelites are divided into two groups in a composition analogous to Otto III enthroned in the much later Aachen Gospels [1]; both use the familiar language of Roman iconography. That word 'iconography' is entirely appropriate here, and also contains a warning. The term is common art-historical jargon for the subject-matter represented in works of art, derived from the Greek for 'writing in images'. Here the subject might have been conveyed in any number of ways, but the adoption of the Roman artistic language makes it immediately clear that we see more than a recording of a past event. David is a paradigmatic ruler, past and future, the historical figure and the future Messiah, the one who rules by the authority and with the support of divinity, and deserves the loyalty of all his people, who are dependent upon him for their prosperity and salvation. In this context we can be confident that the intended audience, mature Jewish men, were uniformly literate, so the imagery cannot have been intended as a 'book for the illiterate', conveying messages to those who were unable to read the textual book in which the various images were described. The imagery is a kind of hyper-text, a commentary upon the sacred text, selecting certain elements for special attention by placing them always before the audience's eyes, while performing the by no means insignificant function of expressing the community's commitment to their god through richly decorating the place of worship.

Noteworthy also is the representation of four standing figures in pairs at either side above the Torah shrine. They probably represent Abraham, Moses, Ezra, and a fourth now almost entirely destroyed. These four standing figures occupy the same positions as the four Symbols of the Evangelists flanking the Christian ruler Otto III, and also in formal terms recall the portrait images that must have been the common cult images in the temples of other religions.[1] Although their visual form evoked the cult-image genre, everyone in the prayer hall will have known that they worshipped a god who rejected any representation in physical form.

Earliest Christian Art

2

According to Luke's Gospel (20: 25), when asked whether it was lawful to pay tribute to Caesar (that is, to the Roman Emperor Tiberius), Jesus said: 'Shew me a penny. Whose image and inscription hath it? They answering said to him, Caesar's. And he said to them, Render therefore to Caesar the things that are Caesar's: and to God the things that are God's.' Roman coins showed the imperial portrait on one side and some other image or inscription on the other, as on a late first-century coin of Domitian [17]. Jesus did not indicate that such an object offended him, did not turn away in horror from its figural imagery. Indeed the text presents him as aware of the nature of that imagery even before the coin was shown to him; the imagery stuck in his memory. He also understood its social function, but understood that function in the secular world to be different from, and largely irrelevant to, his sacred mission and message. He saw it simply as money, not as iconography, certainly not as a religious idol that must perforce be shunned.

Jesus was a Jew, and Christianity began within Judaism. Drawing upon Jewish traditions enshrined in the Old Testament, the earliest Christians made no significant place for visual art in their religious practice. In this respect both Jews and Christians were highly unusual among the many peoples inhabiting the vast Roman world, for whom visual images were a normal part of both secular and religious life. By abjuring such art, whether speaking in a temperate and reasonable manner about the impossibility of capturing any likeness of an invisible spiritual divinity or vociferously condemning ancient religious images as idols and demons, the earliest Christians set themselves apart from the culture that surrounded them. For some Christians, this distinctive practice may have been largely a habit and preference taken almost for granted. For some others it must have been a significant and deliberately provocative part of the early Christians' self-characterization as Other, not concerned with or really part of the secular, which is to say the Roman, world.

Among the scant surviving evidence from the first two centuries of Christianity, very little bears upon the visual arts. The Christians' lack of any religious art was not an important or defining feature of the religion noted by others, and there is not much more evidence from

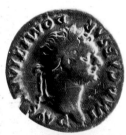

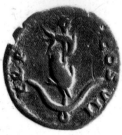

Christian writers. Following in the tradition associated with Jesus's words about giving Caesar his due, Christians were aware of the existence of art all around them, but paid art little attention. Prior to the end of the second century there is nothing at all that can really be termed 'Christian art'.

Christian signs and symbols

For the earliest Christians the making of religious art, if not quite taboo, aroused an aversion that became a habit and commitment, whose gradual erosion during the course of the third century must have been traumatic to some. Yet Christian art begins not as a great storm but rather as the tide turning, in an undramatic way, and its beginnings are little noted either by Christian or non-Christian contemporary observers. The pervasiveness of the Roman visual culture surrounding the Christians surely played the largest role in this process. Christianity spread through different areas of the Roman empire and through different social classes, no longer a tiny Jewish cult but a large society numbering many thousands in the larger Roman cities, spread as a result of its proselytizing impulse. Many new Christians probably saw little reason to depart from what they regarded as normal, the expression of all areas of life, including religion, in visual terms. The demographic explosion of Christianity seems to be datable to the early third century, and Christian visual art suddenly appears and rapidly develops at the same moment.

Clement, bishop of Alexandria, probably the largest Christian community of the early third century, told his followers that although Christians were forbidden to make idols as did pagans, if they needed a seal in order to conduct public business it would be permissible to mark that seal with some kind of image, as did most people in the Roman world. He indicated that certain types of images should be avoided, and encouraged the use of others:

Our seals should be a dove or a fish or a ship running in a fair wind or a musical lyre such as the one Polycrates used or a ship's anchor such as the one Seleucus had engraved on his sealstone. And if someone is fishing he will call to mind the apostle and the children [newly baptized Christians?] drawn up out of the water. We who are forbidden to attach ourselves to idols must not engrave the face of idols, or the sword or the bow, since we follow the path of peace, or drinking cups, since we are sober.[1]

Clement says nothing about the form or material of permissible Christian imagery, or about its style, being concerned only with its subject-matter and function. He regards images as embodying ideas, virtually as pictograms, signs pointing to events and concepts, for which it is conventional to apply the term 'symbols'.

As Clement says, a fish or fisherman would make a Christian think of 'the apostle', presumably Peter and Andrew, or James and John, fishermen before being called to follow Jesus (Matthew 4: 18–22). That Clement is speaking of practical needs and real images is clear from the occurrence of the imagery he discusses, such as a fish or fisherman, on the class of objects to which he specifically refers, seals. The fish in this sense could seem almost an attribute of certain apostles, but this was clearly not the most important meaning signified by the image. In Matthew's Gospel (4: 19) Jesus calls Peter and Andrew, saying 'Follow me, and I will make you fishers of men.' Seen in reference to this well-known text, the fish symbolizes the souls to be pursued by Jesus's mission, particularly those that will be 'caught', brought to salvation among the blessed in heaven after their death. Moreover, one of the miracles of Jesus is the provision of sustenance for multitudes, sometimes wine (John 2: 1–11), sometimes bread and fish, as when five thousand people were fed with five loaves of bread and two fish (Mark 7: 33–44). Christian believers would know this story, and the fish would remind them of Christ's power to work miracles, to save from hunger as well as other dangers. Yet the manner in which the story was told in the Gospel and interpreted by later Christian preachers also presented such miracles as prefiguring the central Christian liturgical rite of the Mass, in which bread and wine are consumed by the faithful after being transformed through prayers of consecration into the body and blood of Christ. In this last sense the image of the fish symbolizes the Mass, and can represent the miraculous food, Jesus's body, offered in the eucharistic sacrifice. The symbolism of Christ the Saviour as a fish is still conveyed by the emblem today often seen on bumper stickers and used in other contexts by contemporary Christians, the fish with the inscription IXΘYC [*ichthys*], the common Greek word for fish, but also representing an anagram comprised of the first letters of the Greek words spelling Jesus Christ, Son of God, Saviour. The first appearance of this symbolism cannot be exactly dated, but certainly falls in the earliest Christian period [**18**].

According to Clement, a dove is also permissible, but he seems to assume that he need not explain why. He has just spoken of Christians following peace rather than war, and the dove is still today used as a symbol of peace. This is a kind of 'natural symbolism' based upon the generally peaceful (if often lascivious) behaviour of doves, and would be recognizable to anyone, indeed was used in pagan Roman iconography in a manner indistinguishable from Christian usage. As in the case of the fisherman, however, Clement very likely imagines a Christian significance. A reader of Genesis would know that the dove bearing an olive branch is associated with the end of the great flood, the preservation of Noah's family, and the readiness of the earth to receive them

18

Early Christian seal impression, with anchor, fish, and IXΘYC inscription, pressed from a red jasper seal ring, probably third century. Franz Dölger read the letters at the left as an invocation to the Archangels Michael and Gabriel, seeking their protection.

again (Genesis 8: 8–12) [19]. As such, it is associated with God's first covenant with man, and symbolizes God's power to punish and preserve. In Matthew's Gospel (10: 16) Jesus sends forth his disciples to spread the word of God and to work healing miracles, telling them: 'I send you forth as sheep in the midst of wolves: be ye therefore wise as serpents, and harmless as doves.' With this text in mind the dove could be seen as a symbol of the Christian in the world. Elsewhere Matthew (3: 16) describes the baptism of Christ, saying that when he came out of the water 'the heavens were opened unto him, and he saw the Spirit of God descending like a dove and lighting upon him'. With this text in mind, the dove might also symbolize the spirit of God, the third person of the Christian divine trinity.

Precisely which meaning of the dove was foremost in Clement's mind we cannot say—very likely more than one; and we cannot say which meanings would have been perceived by a Christian who saw this image-sign: peace, salvation, the Christian preacher among pagans, the holy spirit. Presumably different people would see different meanings. The context, whether on a seal, or associated with a tomb, in a place of baptism, or in proximity with an altar, would be an interpretive clue. The ideographic character of the image is essential, however, and the most popular early Christian images were those which, like a dove or fish, were richest in range of meaning. The choice of such polyvalent images probably also reflected the currents of natural symbolism, and the traditions of the secular world. Jesus tells his disciples to be 'wise as serpents and harmless as doves' (Matthew 10: 6), but although doves were commonly adopted by Christian art, in spite of this authoritative text and commentaries upon it by so influential a Father of the Church as Augustine, to the best of my knowledge the serpent never in early Christian art symbolizes a wise Christian. The negative connotations of the loathsome worm, compounded by its strong association with some leading pagan deities, were simply too strong.[2]

All the images cited by Clement as appropriate for Christian use were common in the Roman world, so he is seeking to dictate not how

Christians should have images specially created for their use, but rather how they should choose among the images readily available in the Roman world, and how they should interpret those chosen. The interpretation could be almost a reversal of the common Roman significance. Clement refers to an anchor, as on a coin of Domitian [17], and indeed Clement specifically acknowledges that the anchor was used as a device by a pagan, pre-Christian ruler. In Hellenistic and Roman iconography the anchor represented victory in a battle at sea, but in this passage Clement excludes military imagery as inappropriate for Christian use. Manifestly the newly applied Christian precedents might not only supplement but altogether replace explicit traditional meanings. The deeper generic meaning of victory is retained, but reapplied, so that the anchor with fish upon it that represented a naval victory in pagan iconography could become Christ's victory over death on the cross [18].

Image-signs that made reference to a belief in salvation could be multiplied and combined in the manner of early prayers such as the funerary *commendatio animae* (blessing of the soul), scattered in a seemingly random manner [19]. Yet Christian art was able to link ideographic signs to convey various and increasingly complex messages. A tomb slab from the catacomb of Domitilla [20] shows a pair of fish, each touching the hook-like fluke of an anchor. The beholder is reminded of Clement's image of the fisherman who captures men, so the fish may represent Christian souls brought to a safe harbour, the anchor then becoming a symbol of hope and indeed of paradise. In his Epistle to the Hebrews (6: 18–19), Paul wrote that 'we may have the strongest comfort, who have fled for refuge to hold fast the hope set right before us, which we have as an anchor of the soul, sure and firm'. Such a meaning again accords with its natural symbolism, but the form of this particular anchor evokes the cross, pre-eminent Christian emblem. The cross sign made on the body of the newly baptized

20

Tomb closure slab with anchor and two fish, Rome, third century, from the Domitilla catacomb

Such objects were used to close the burial chamber carved into the walls of these underground cemeteries. They roughly correspond to modern tomb markers, decorated with an established genre of signs from which individual customers might choose.

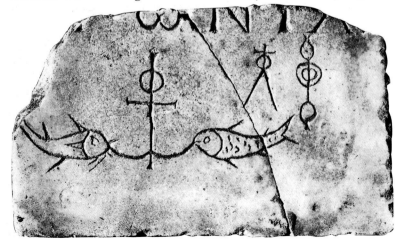

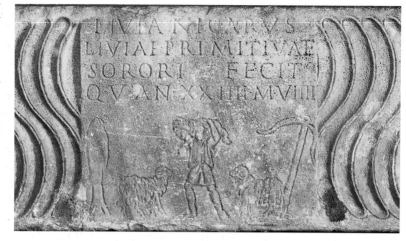

21

Sarcophagus for Livia Primitiva, detail of central section, with good shepherd, fish, and anchor, marble, third century

Most of the surface of the sarcophagus was decorated with repeated curves, known as strigillation, a common form much less expensive than figural carving over the entire surface.

Christian was the mark by which he or she would be recognized by God as a believer and taken to paradise; the cross was for Christians the sign of divine power, of victory over sin and death. Here the Christian souls, represented by the fish, are 'caught' to salvation through their belief in the power of the cross, sanctified by Jesus Christ's sacrificial death. The same complex of images was presented in a slightly different manner on a sarcophagus [**21**]. On the central panel beneath the inscription identifying the deceased are three images set in a row. Reading them left to right, like words in a book, one reads fish, shepherd, anchor, or as the contemporary viewer might expand and understand the sequence, God loves each human being so much that he pursues him or her and, if only they will believe in him, brings them to heaven.

Story-telling

The earliest Christian art was not exclusively a system of symbolic signs, for the Christian Bible was a treasure trove of gripping stories that lent themselves to expanded narrative pictures. The Old Testament conveyed the essential Christian message of hope for the achievement of eternal happiness through the saving power of a loving

22

Sarcophagus from Santa Maria Antiqua, Rome, marble, mid-third century

The story of Jonah is at the left, and at the right end are figures of the good shepherd and the Baptism of Christ. The two large central figures are a woman praying and a man reading. These are common types, the seated reading figure often associated in Graeco-Roman traditions with an author or philosopher.

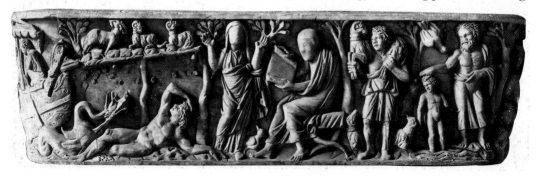

and forgiving God by means of vivid narratives, and artists early seized on these. A favourite was the story of Jonah, who disobeyed God's commission to go to Nineveh to preach against its wickedness, instead taking ship to flee from God's anger. During a storm Jonah was thrown overboard (the sailors thought he was bad luck, 'a Jonah') and swallowed by a great fish. After three days in its belly, Jonah, who had prayed to God and had been preserved from death, was thrown up onto the shore (Jonah 1–2), and then went on to Nineveh. After warning the Ninevites that God would destroy them, he retired to a place from which he could see Nineveh, and waited under an ivy vine, which protected him from the hot sun (Jonah 4). Sometimes only one of these episodes was shown, the most important being Jonah's rest under the vine, which may suggest the expectation of the destruction of the sinning secular world, as well as conveying God's protection and forgiveness of sinners. A sarcophagus made in Rome [22] emphasizes this part of the story, showing a handsome nude Jonah resting. This is more than a luxuriously rendered personified version of the anchor ideogram considered before, for above Jonah is visible a small image of the ship from which he was thrown.

The sequence of episodes that together tell the essential story in sufficient detail to convey the gist of the textual narrative is carried beyond this incipient step in a number of works. The ceiling of a tomb chamber [23] shows the Jonah story in four episodes, in nearly semi-

23
Ceiling painting in a large chamber from the catacomb of SS Pietro e Marcellino, Rome, late third or early fourth century
In the medallion at the centre is the good shepherd, while arranged in the expanded semicircles at the ends of the cross-design are four Jonah scenes, the Prophet resting as if in paradise immediately beneath the shepherd. Between the Jonah scenes are individual figures shown in prayer.

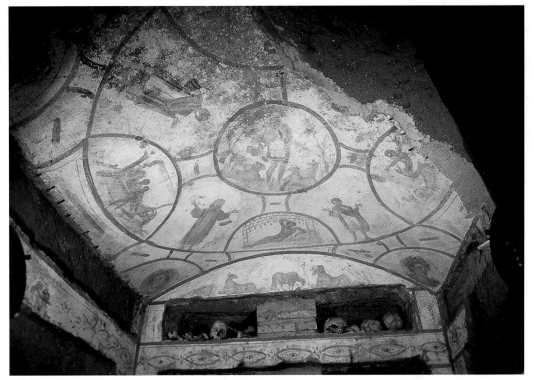

circular compartments arranged as if comprising the expanded terminals of a cross at whose centre appears the Good Shepherd. The Jonah story, albeit a ripping yarn on its own terms, is based on a minor book of the Old Testament, and is portrayed not for entertainment or decorative value. It owes its prominence in the earliest Christian art to the symbolic value of its content. That Jonah seemed to die but was brought back from the dead after three days rendered him an obvious parallel to, a 'type' for, Christ's death on the cross and resurrection on Easter morning, three days later. Indeed, in the Gospels (Matthew 12: 39–41) Jesus himself makes the typological connection, saying that like Jonah the Son of Man would be as if dead for three days. The association of the Jonah image here with the cross, and with the Good Shepherd, strongly suggests that such a meaning was intended in the painting. At the same time, Jonah's 'death' in water and rebirth springing from water relates him to the symbolic death and rebirth through the liturgical rite of baptism that constituted ritual entrance into the Christian community, and not coincidentally took place in this earliest period during the night before the Easter celebration.

This complex visual composition [23] was not unique, for related images occurred also in catacombs on the other side of the city. How such programmes were transmitted remains mysterious. The formal similarities are striking enough to suggest some overlap of painters if not necessarily a 'workshop', but the arrangement of familiar elements of early Christian iconography in a special form may have been produced through visual memory, the desire to emulate a meaningful decorative programme. The interest in narrative drove some of the interest in increasing detail, but the style of the paintings is simply that of contemporary Roman art, whether pagan or secular. No distinctive Christian style exists at this period, whether at the level of simple pictograms or more sophisticated and expensive objects that involved some attempt at achieving beauty and conveying aesthetic pleasure. The youthful, nude, athletic figure of Jonah scarcely evokes the image of an ascetic prophet [22], and although this sarcophagus was certainly made for a Christian's use, there is no reason to think that it was made by a Christian artist. It was not even made for a particular client, for the heads of the two central figures, the seated man and standing woman at the centre, were never carved in detail but (unlike all the other figures) were only roughed out. This is a common practice of Roman sculptors of the second and third century: they developed stocks of nearly complete sarcophagi with the currently popular imagery, which could be purchased and 'customized' for those who would be buried in them by turning the central heads into portraits. This sarcophagus was intended for someone of substantial wealth who wanted to be buried in a tomb that not only conveyed his and/or her membership of the Christian community through its choice of images, but conveyed

through their elegant style a cultivated taste. Although originally introduced into and justified within the Christian community in reference to its meaning alone, meaning that might be conveyed through crudely incised image-signs, meaning that continued as the bedrock of early medieval art, the desire for beauty and the expression of social status quickly became significant factors as well.

Art in the Christian sanctuary

Most surviving Christian art of the third century stems from a funerary context, notably the many sarcophagi and paintings in the catacombs of Rome. In part this reflects accidents of survival, in part the importance for Christians of the belief that their religion offered a unique avenue towards bodily resurrection and victory over death. We are fortunate to have had preserved one large-scale non-funerary work of earliest Christian art, from the Christian meeting-house at Dura. The decoration of the larger room in the small converted house, which served as the assembly room for the eucharistic service or Mass, did not survive, but a smaller room in an opposite corner is remarkably well preserved. It served for baptism, the marking of the body with water and the sign of the cross that enrolled a person in the Christian community and claimed to wash away all his or her prior sins. This critical rite was performed but once in a lifetime, following an extended period of training and education in the Christian faith. The room's elaborate decoration both underscores the significance of baptism in a Christian's life and provides a pictorial commentary upon its meaning.

Like the Torah shrine in the nearby synagogue [16], the most sacred spot in the room, here the font of water, is marked by an arch on columns [24]. The vault of the arch, above the water, was painted to resemble a starry sky and represented the heaven from which divine grace descended upon the newly baptized. On the wall behind the font is the Good Shepherd, here at the left side rather than on the central axis, represented as if driving a large herd of sheep before him. This illustrates a parable told by Jesus (Matthew 18: 12–14), in which the shepherd's love for even the single lost sheep represents God's love for each human soul, even those that have wandered and been lost. Tiny figures at the lower left represent Adam and Eve, whose disobedience to God introduced sin and death into the world (Genesis 3). The message to the newly baptized is clear: sin and death entered the world through Adam's disobedience, but forgiveness of sin and eternal life are possible through baptism and a subsequent life as a Christian.

On the wall beside the baptismal font are figural paintings. In the lower register large female figures advance towards a coffin-like structure crowned by two stars. Dressed in white and holding lighted candles, they represent the women visiting the tomb of Jesus on Easter

24

Baptistery of the Christian meeting-house (*domus ecclesiae*) at Dura, a Roman frontier city on the Euphrates River in Syria, from the first half of the third century (before AD 256)

The building was located not far from the Synagogue discussed in Chapter 1, and preserved in the course of the same unsuccessful defence of the city.

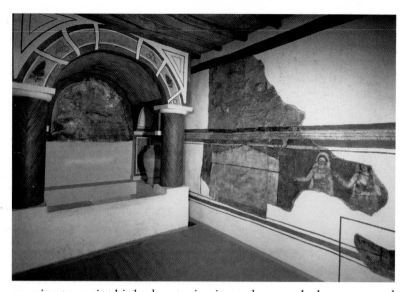

morning to anoint his body, meeting instead an angel who announced his resurrection from the tomb, his victory over death (Matthew 28: 1–6). The stars represent heavenly light, and most likely the immaterial angel. Arranged at the corner of the room beside the coffin-like baptismal font, the iconographic connection between Christ's victory over death and the victory over sin and death accomplished through baptism for each Christian could scarcely be more clear. Underscoring the theme of God's miraculous powers to save human beings who believe in him are the small scenes in the upper register, Christ and Peter walking on water, and a paralysed man healed by Jesus. Peter and the paralytic owe their miraculous triumphs to their faith in the divine powers of Christ, and are models for the Christians undergoing the baptismal rite. Indeed, the women dressed in white advancing towards the tomb are also advancing towards the font, along with the white-robed and surely candle-bearing living people of Dura. This small and relatively crudely painted decoration is not only rich in symbolic meanings, as had been the funerary art of the early Christians, but links its imagery with Christian liturgical performances.

Religious art of non-Christian cults in late antiquity

It should not be inferred from the coincidence of the expanding Christian community with the appearance of Christian art that the influx of new and either ignorant or half-hearted Christians explains the birth of Christian art. The third century saw a social, political, spiritual, and artistic revolution in the Roman world. Christianity was only one of the rapidly spreading new religions expressing their beliefs through art, and visual art played an increasingly distinctive and dramatic role in conveying imperial ideology during the same period.

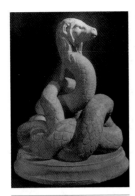

Detail of 25

Christians, including the leaders of the Church, wanted to spread their message, and in the Roman world images were an overwhelmingly attractive and effective means of communication. When a charlatan named Alexander declared himself to be the prophet of a new divinity named Glycon, as a means of persuading people to pay him for healing miracles worked by the 'god', he presented the 'god' in visual form, putting a female mask over the head of a tame serpent. Seen from a suitable distance, and accompanied by appropriate smoke and sound effects, the performance must have been a vividly sensual experience, and is described as such in the lengthy diatribe against the new (and short-lived) cult by the contemporary satirist Lucian. Glycon survives still, in a cult image of the god [**25**].[3] It may seem ludicrous to us, but such an image's evident power in the third century bespeaks the spiritual hunger that drove many people, a hunger that sought satisfaction in visual form through images and processions, often the stranger the better: the transformation of a man into an ass through the power of a god was a popular story.[4]

The citizen of the Roman world in late antiquity responded to images, which undergirded a sense of personal and communal identity. Another new religion rapidly spreading within the Roman world of the third century, the cult of the Persian god Mithras, developed elaborate and extensive iconography, as in the Mithraeum at Dura, which contained images of Mithras hunting and enthroned.[5] Mithraic sanctuaries from Syria to Scotland had a painting or relief of Mithras killing the cosmic bull, bringing life to the universe through a

25

Glycon, cult statue of a 'deity' in the form of a serpent, marble, probably third century
Found in 1962 with a hoard of third-century marbles dedicated to saviour gods such as Hecate, Isis, Cybele, and the Thracian Rider God, seen here as excavated. Glycon's cult began at Abonoteichus on the north coast of Asia Minor in the early third century. That the statue was found at Tomis near the mouth of the Danube shows the wide distribution of this strange cult.

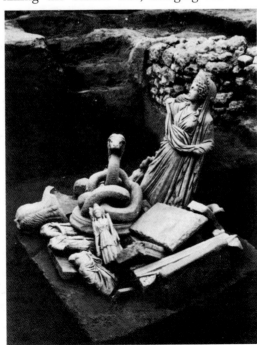

sacrificial death. Larger than any other image in the sanctuary, often framed by an arch with the signs of the zodiac indicating its cosmic significance, this image varied little in appearance, being immediately recognizable, at least to all believers. The image represented no local god, but one everywhere the same, represented not a static divine presence, but a symbolically charged divine activity having only an indirect relationship to the ritual carried out in his worship. Without great detail, without background or setting, these reliefs displayed the vigorous power of the heroic divinity overcoming the great beast by placing one knee upon its back to press it down, an image which well expressed the essential concept of Mithras' power to assist and protect his adherents in this world and in the next. A bronze brooch shows this central religious image taken out of the context of the sacred cult room and worn as a personal ornament and talisman [26], probably by a devotee who was a soldier and sought his god's protection in battle.

The Mithraic image seems an apt expression of the conflict between life and death, but the conflict could have been displayed in many other ways. That it was always presented according to the same visual formula accords with the pictorial syntax of the late Roman visual language, in which compositions express meaning, and variety of expression is replaced by repetition and clarity. After all, the Mithraic

26

Mithras slaying the cosmic bull, on a small (7 cm) bronze medallion found in Ostia, near Rome, third century

The rays around the god's head show his close identification with the sun. The dog, snake, cock, and raven are symbolic creatures.

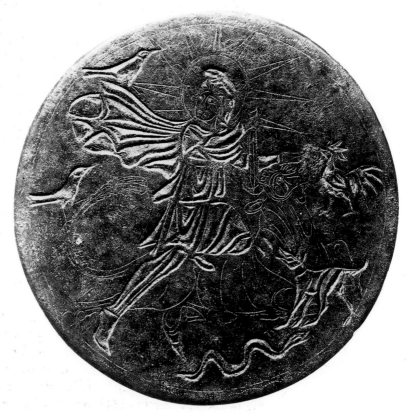

cult image, whether in a cult room or on a personal object, is not primarily an aesthetic object, to be appreciated for its artist's skills, but a functional religious statement. The particular form of the depiction is similar to a well-known Roman image, and whether or not it was derived from that Roman image, the formal analogy would have assisted a Roman viewer to understand it. The greatest Roman hero was Hercules (the Greek Herakles), best known for his many Labours ridding the world of lions, hydras, and other monsters. From early Greek art, his triumph had often been represented by having him press down from behind, kneeling with one leg on the back of the beast, whether a bull or a gigantic stag [27].

The vast and highly developed world of Roman iconography provided many formulae not only ready-made for adaptation to new contexts, but formulae with an already established significance that would make the meaning of the new image more readily recognizable. In this example, borrowing the form of one of Hercules' deeds for the Mithraic episode also conveyed the notion that Mithras was a beneficent hero, like Hercules. In another example of not just convenient but appropriately meaningful adaptation of Roman iconography, the figure of Jonah resting, seen in Christian sculpture and painting [22, 23], was borrowed from the sleeping Endymion, a youth about to be visited by the pagan goddess Diana, who would carry him to heaven and give him immortality.

During the third century Christian art began, and rapidly became part of the Roman art world, adapting many of its techniques and its images. At the same time the Roman world was in many respects becoming more like that of the Christians. The emphasis on personal immortality that could be won with the assistance of a caring beneficent god was shared not only with Mithraism, but also with new developments within Roman religion itself. During the course of the second century, Roman burial practices shifted from cremation to inhumation, and the sudden upsurge in production of large stone sarcophagi evinces the increasing desire to preserve the body, implying some sense that it might be needed again.[6] Even traditional Graeco-Roman religion shifted, Hercules being a leading example. In many texts from late antiquity he is addressed as 'Saviour' and 'Averter of Evil', and invoked for personal protection. His exploits, the most common subject on Roman sarcophagi, on one example [27] prominently feature an episode rare in earlier ancient art and literature, the episode with Alcestis [shown on page 30]. Owing a favour to her husband Admetus, after Alcestis' premature death Hercules descended to the underworld and led her back to life on earth, here represented by the open door. This scene of personal resurrection occurs again as part of a cycle of Hercules scenes in a catacomb painting of the next century [34], whose origin remains much debated.

Whether Christians could there have used a pagan figure to represent the Christian hope for eternal life, or pagans used their own hero to express their similar interest, Christian and Roman artistic traditions manifestly developed many points of contact, expressing what was increasingly a unified and coherent new culture.

Visual formulae

27

Sarcophagus from Velletri, near Rome, second century (1.45 m H)

An incredibly elaborate work, with architectural frame of alternating arches and pediments borne on female caryatid-columns, with kneeling Atlas figures below. In the main figural register at the centre are the Labours of Hercules. The image of Hercules' conquest of the Cyreneian Stag, in which he presses its back down with his knee in the manner later used for Mithras, is at the left end.

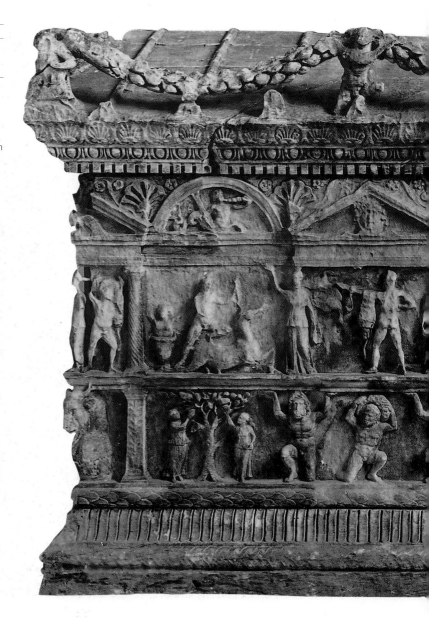

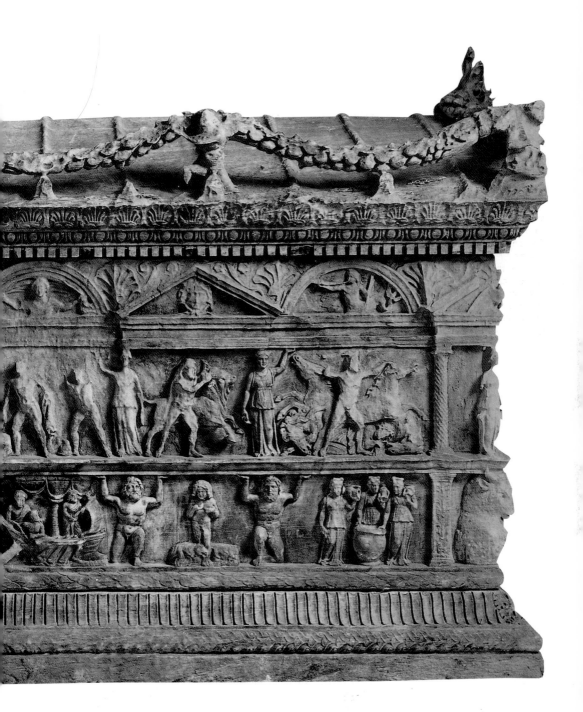

Conversion

By the early fourth century the Christian and imperial cultures and communities were in effect at war with one another, both numerous, powerful, well entrenched, and convinced that it held the unique answer to the growing political, social, and spiritual troubles of the time. The leading role in the alliance eventually established between Christians and the Roman empire was played by Emperor Constantine (**Map 1**). Apologists such as Eusebius hastened to present Constantine's conversion to Christianity as a stroke of divine providence, but it is clear that the result was surprising to nearly everyone and dismaying to many on both sides. The aftershocks reverberated for centuries. In artistic terms the *rapprochement* was unusually well prepared, and although the early fourth century saw radical new departures in some spheres, most saw a surprising degree of continuity.

Radical new departures were most evident in the area of architecture. Prior to the fourth century, there was no established identifiably Christian architecture. If you walked past a Christian place of worship you would very likely not be aware of it, not because Christians were hiding but simply because they had no distinctive building type that signalled their sacred space. Greek and Roman temples were recognizable by such features as pediments and colonnades, but Christians used any convenient structure, which they termed the *domus ecclesiae*, literally the house of or for the church, with 'church' meaning not a building but the community of the Christian faithful. The Christians at Dura, fewer in number and less wealthy that their Jewish neighbours, worshipped in an ordinary domestic dwelling, whose conversion to Christian cult use entailed few structural alterations beyond the provision of an altar and a baptismal pool. Christian communities in Alexandria and Rome must have had many 'houses', some very large. At Rome we have evidence for a large plain hall at San Crisogono, and a variety of simple structures near the cemetery and associated catacombs of San Sebastiano.

Only after Constantine's decision to legalize and support Christianity did Christianity receive a special form of large building, the basilica, which rapidly became its established type. A common

Map 1 The Roman Empire at the death of Emperor Constantine, *c.*337

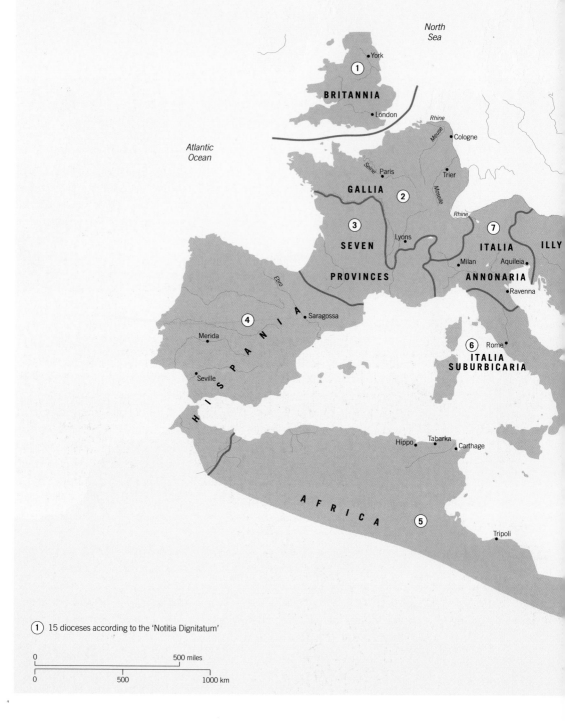

North
Sea

•York

①

BRITANNIA

•London

Atlantic
Ocean

Rhine

Meuse

•Cologne

Seine •Paris

•Trier

GALLIA

②

Moselle

③

Lyons

Rhine

⑦

SEVEN

ITALIA

ILLY

•Milan

Aquileia•

PROVINCES

ANNONARIA

Ebro

•Ravenna

•Saragossa

④

H
I
S
P
A
N
I
A

•Merida

⑥ •Rome•

ITALIA

SUBURBICARIA

•Seville

Tabarka

Hippo• • •Carthage

A F R I C A

⑤

•Tripoli

① 15 dioceses according to the 'Notitia Dignitatum'

0 500 miles
|————————————————————|
0 500 1000 km

48 CONVERSION

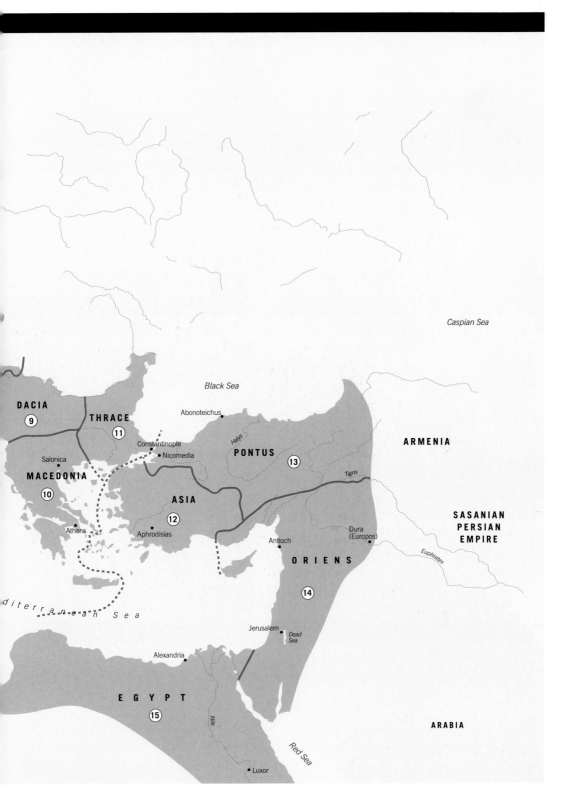

Caspian Sea

Black Sea

DACIA
(9)

THRACE
(11)

Abonoteichus

ARMENIA

Constantinople

Salonica

Nicomedia

PONTUS

Halys

(13)

Tigris

MACEDONIA

(10)

ASIA

(12)

Athens

Aphrodisias

Antioch

Dura
(Europos)

SASANIAN
PERSIAN
EMPIRE

Euphrates

O R I E N S

(14)

diterranean Sea

Jerusalem

Dead
Sea

Alexandria

E G Y P T

(15)

Nile

ARABIA

Red Sea

Luxor

Roman type since the early empire, in form a basilica was a large rectangular hall with rows of columns on the interior supporting a raised central space, known today as the nave, with one or more lower and darker aisles at either side. The Forum of Trajan had as its central building the Basilica Ulpia, immediately adjacent to Trajan's Column [5], and indeed Roman basilicas had strong imperial overtones. Constantine decided to support the Christian Church by building large basilicas for Christian use in various parts of the empire, including eventually Constantinople and Jerusalem. The earliest of the Constantinian basilicas was built for the bishop of Constantine's capital city, Rome, in the area of the imperial palace known as the Lateran, from which it takes one of its names. Today it is the basilica of St John, having been dedicated to John the Baptist since the seventh century; prior to that time it was dedicated to the Saviour, Christ, but was most commonly known after its founder as the Constantinian Basilica. It housed the chair or *cathedra* used by the bishop, and has since the beginning of the fourth century been the cathedral of Rome. Its original decoration is now entirely gone, and known only from images made prior to its seventeenth-century restoration, and from textual sources. The interior of Santa Maria Maggiore [52] gives a general idea of the immense scale and lavish effect of Constantine's Lateran Basilica. Texts report that it contained thousands of pounds of golden and silver candelabra and other furnishings,[1] and the adjacent baptistery included a golden lamb that functioned as a spouting fountain, flanked by life-size silver figures of Christ and John the Baptist. Perhaps the most extraordinary feature of the Constantinian Basilica was the *fastigium*, a kind of screen, almost like a triumphal arch, standing between the altar and the

28

Arch of Constantine, Rome, reliefs above the western arch

Hurriedly erected after Constantine's victory in 312, the large horizontal strip at the centre shows Constantine (now headless) distributing gifts. Above are two medallions taken from an earlier monument of Hadrian, showing a lion hunt and sacrifice at an altar. Their presence is not only a sign of the haste of construction, but along with other reliefs on the arch taken from monuments of Trajan and Marcus Aurelius, connects Constantine with the 'golden age' of the second century.

congregation gathered in the nave.[2] Its top was crowned with 18 nearly life-size silver figures, facing the congregation Christ enthroned surrounded by his 12 apostles, and facing the altar Christ enthroned surrounded by four angels, the whole complex of figures and *fastigium* totalling 3,125 pounds (1,420 kg) of silver. We may gain some idea of the appearance of these hierarchically arranged figures from the contemporary reliefs of the Arch hastily erected by the Roman Senate to celebrate Constantine's triumphal entry into the city. For example, the scene of Constantine's address to the citizens of Rome employs the *adlocutio* formula in a strictly symmetrical and almost schematic fashion, and his distribution of largesse to the Roman people adapted the same composition to show him enthroned at the centre of the crowd [**28**]. The style of the Lateran figures may have been more elegant, to be sure, in part because of the use of luxurious metal and thus different artists, but some sense of the close relationship may be achieved by looking at a later fourth-century image of Christ enthroned and surrounded by the apostles [**29**].

29

Mosaic in the apse of the Chapel of San Aquillino, at San Lorenzo in Milan, from the second half of the fourth century

At the centre is Christ, hand raised as if teaching, the lecturing theme emphasized by the *capsa* containing book-rolls at his feet.

No such hierarchically displayed image of Christ and his apostolic court survives from the pre-Constantinian period, and at least in iconographic terms it is tempting to speak of a 'conversion of Christianity' to a wholesale embrace of Roman and specifically imperial conceptions.[3] Such a view has much validity, no doubt, but should not be drawn too starkly, not only because Christian art's increasingly close relationship with the Roman visual language pre-dates the conversion of Constantine. Certainly there was an 'imperialist' party among leaders of the fourth-century Church, who very quickly came to identify the newly Christianizing Roman empire as the embodiment of a divine plan, a 'holy empire'. One must also assume not only that the bishop of Rome was agreeable to such a gift as the Lateran Basilica, but also that the non-Christian artists who fashioned the silver figures on the Lateran *fastigium* were in some manner guided by Christians, who alone could have dictated even such basics as the number of the apostles. Simply because the fundamental pictorial framework depends upon an imperial formula, and the direct patron of the project was the imperial purse, it need not follow that the fundamental meaning was imperial, or in any sense un-Christian.

Majesty

After the early fourth century, the enthroned image of the Christian God suddenly becomes a central element of Christian iconography, and scholars have long advanced hypotheses seeking to account for this important phenomenon. In a controversial recent book, Thomas Mathews has argued that the early Christian image of divine majesty is not seeking to state that Christ was like the Roman emperor, but was modelled upon that of the Christian bishop enthroned in the apse of his basilica, teaching the faithful.[4] Yet it is revealingly characteristic of the art of late antiquity that one cannot neatly separate Christian and

secular realms, for they are inextricably linked in complex and changing ways. The bishop's seat or *cathedra* was located by the later fourth century in a basilica, a building type with powerful imperial associations of long standing, located where the emperor's seat stood when the basilica was used as an audience hall. The bishop was an important official in a unit of the Roman government, the city, and increasingly comes to be its leading representative in many places. The bishop had teaching functions, to be sure, but also important judicial functions, taking what had been imperial prerogatives. For that matter, Christ is both a ruler, 'king of kings', and the greatest of teachers. The mosaic of San Aquillino in Milan [**29**] shows him in both roles, as does a beautiful ivory produced early in the fifth century [**30**].

On this small carving, Christ is presented as a teacher, a philosopher, as if lecturing from a text, surrounded by gesturing listeners, the figure to his right also holding a roll and posed almost as if a secretary. Yet Christ is enthroned, and presented under an arch, both features redolent of imperial iconography. Is he teacher or emperor? He is both, but also neither. Rather the image draws upon a range of pictorial motifs and traditions, including in this case a highly sophisticated classicizing style, being remarkably similar in conception to the portrayal of a Roman official on a contemporary secular ivory [**31**]. The poses of the enthroned figures are virtually identical, both include

30

Ivory pyxis, early fifth century, of uncertain origin (Italy? Syria? Trier?) (120 mm H, 146 mm diameter)

Christ sits as if lecturing, with Paul to his right holding a roll and Peter at his left with a staff, other apostles standing and gesturing behind. A pyxis is a small round box made by carving the outside of a complete section of an elephant's tusk.

smaller flanking figures holding books, the standing and gesturing figures here below rather than behind, and use elaborate architectural frames to highlight the central figure. Both works use the same language to inscribe the same projection of hierarchy, recording not an event but a relationship. Their essential meaning is the majesty of the enthroned figure, whose centrality and frontality stop all action, forcing all the other figures inside the image and the beholder outside it to face the imposing revelation of power. The fact that on one panel [31] the urban official writes upon a scroll the acclamation being delivered to him is absurd as representation of an event, but accurate as a

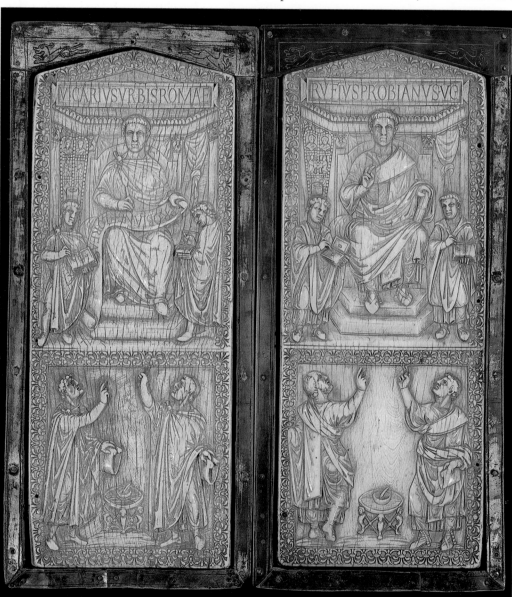

statement of this ivory panel's honorific function and significance. Yet the Christian work [30] adds new elements of Christian meaning to the pictorial armature offered by such a Roman formula, and to be fully 'read' it must first be seen as a complete object. Its other side depicts Abraham's sacrifice of his son Isaac on an altar. That image represents God's covenant with his chosen people, fulfilled in the new covenant of Christ with which it is paired. Moreover, as Abraham offered his son Isaac, so God offers his son Jesus. The ivory thus links throne and altar as aspects of a single revelation, links them ideologically as they were linked visually and spatially in a basilica, where the episcopal throne would be seen rising above and behind the altar. The powerful liturgical reference of the ivory's imagery is connected with its function as a container for the eucharistic bread, and a pyxis like this would probably have stood upon an altar when in use. Most important, perhaps, both sides represent the eruption of divinity upon human affairs, a divinity represented only by the hand descending from heaven on the Old Testament side, but by the human portrayal of Christ on the other.

This richly layered ivory carving defines not a single meaning but a range of meanings, in a manner analogous to the earliest Christian symbolic images. Such continuity of attitude accompanies even some essentially new subjects. The sarcophagus of Junius Bassus, the prefect of the city of Rome [32] presents a group of subjects familiar from the earliest Christian art, similarly scattered on the surface of the composite work not as narrative but as ideographically linked units of meaning, virtual pictographs albeit now rendered in sophisticated sculptural form. The powerful drive to multiply image-signs is apparent in the strange device adopted for the string of traditional early Christian subjects stretched across the middle of the sarcophagus front, salvation and miracle scenes acted out by symbolic lambs; above and to the left of Daniel a lamb-John baptizes a lamb-Christ, perhaps recalling the previously mentioned baptismal group flanking a lamb from the Lateran baptistery. Yet there is also a strong focus upon images of judgement, not only Christ led before Pilate stretched across the two upper right panels, but the arrest of Peter beside Abraham, and the martyrdom of Paul at lower right. Very likely the presence of the two great Roman saints upon a sarcophagus for the city prefect is deliberate. The central images show Christ enthroned, literally resting his feet upon a personification of the vault of heaven, and Christ entering Jerusalem. Both images relate to and are plausibly derived from Roman majesty and *adlocutio* formulae, and the rich framing motifs of rows of columns clearly derive from such earlier Roman sarcophagi as that from Velletri [27]. The unprecedented richness of the decoration is surely related to the wealth and high social position of Junius Bassus, and its personal reference is

32

Junius Bassus sarcophagus, AD 359 (1.18 × 44 m)

An unusually rich sarcophagus, one of only two two-tiered columned sarcophagi known. The episodes on the upper frieze of the front are Abraham's sacrifice of Isaac, Peter's arrest, Christ enthroned, Christ's arrest and Pilate's judgement, and on the lower frieze Job on the dunghill, Adam and Eve, Christ's entry into Jerusalem, Daniel in the lion's den, and the arrest of Paul. On both narrow sides, not visible here, are images of naked winged children ('putti') harvesting.

underscored by the inscription immediately above the central figure of Christ: NEOFITUS IIT AD DEUM ('newly baptized, he has gone to God').

Christian and non-Christian

Junius Bassus was by no means the first of the old Roman senatorial aristocrats to convert to Christianity, and hindsight should not make us believe that such conversions were inevitable. Indeed, only two years after Junius Bassus' death, Constantine's nephew Julian came to the imperial throne. Although raised within a Christian family, Julian rejected Christianity in favour of a personal version of pagan religion, hence the sobriquet 'the Apostate' by which he is commonly known. Recognizing that Christianity could not be suppressed, he sought to contain it by promoting a kind of cultural apartheid that ironically evokes the earliest Christian view of the Church as Other. He barred Christians from teaching the Graeco-Roman literary heritage, saying 'they have Luke and Mark: let them go back to their churches and expound them'.[5] This statement reveals that like Christians, Julian was a man of the book, linking literature and religion in a manner foreign to the Graeco-Roman tradition, and thereby inventing a new tradition presented as an appeal to the past. Himself highly educated in the Hellenistic cultural tradition, he sought to give paganism something like the coherent administrative organization that strengthened

Christianity. His efforts failed, but provide a telling insight into the new world of the fourth century.

The close links between Christian and non-Christian communities visible in such works as the Junius Bassus sarcophagus may also be seen in funerary painting. In the fourth-century Via Latina catacomb, the tenacity of early Christian iconographic tradition is evident, for most of the subjects are chosen and arranged in a manner that reveals little impact of the conversion of Constantine. The large chamber at the end of one arm, Cubiculum C, has such familiar images as the sacrifice of Isaac, the good shepherd, and two Jonah scenes; only the image of Christ enthroned surrounded by books at the top of the ceiling picks up a distinctively post-Constantinian theme. Remarkably, the chamber at the end of a different arm of the same catacomb, produced perhaps as much as a generation later, Cubiculum O, obviously depends upon the earlier chamber. Its image of Moses Crossing the Red Sea is virtually identical, and its large image of the Raising of Lazarus [33] almost exactly repeats the earlier image's formal arrangement and location, although its subject-matter may have been reinterpreted.[6] The iconographic banality, almost casualness, of such later fourth-century works of art as these catacomb paintings, or the beautiful ivory casket in Brescia, might be due to the use of professional artists with a primarily commercial motivation, or perhaps to the less intense experience demanded by the increasingly secular orientation of the post-Constantinian Christian community. The most controversial paintings in the Via Latina catacomb pose a different problem of historical interpretation. Cubiculum N presents, within a

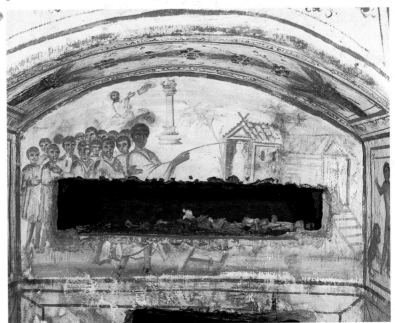

33

Via Latina catacomb, Cubiculum O, mid-fourth century

After the grave was dug into the wall for a wealthy member of the Christian community, it was covered with a large painting representing Christ raising Lazarus from the dead. Lazarus stands wrapped like a mummy at the entrance to his tomb, which appears like a temple set in a landscape. The image is obviously an expression of the deceased's own hopes, realized or frustrated when the tomb was opened and the bones removed, most likely for use as relics.

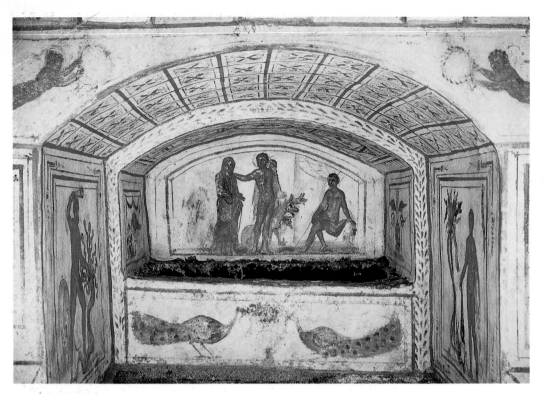

painted architectural system indistinguishable from the predomi-
nantly Christian chambers, a remarkable series of images of the pagan
hero Hercules. The cycle has very ancient roots as a whole and in its
individual elements; a series of Labours combined with more unusual
scenes such as the recovery of Alcestis from the underworld already
occur on the Velletri sarcophagus [27 and also on page 30]. Yet the
arrangement of the figures in the Via Latina image [34] emphasizes
the central heroic figure of Hercules and his right hand's power in a
manner recalling the Moses of the adjacent Christian chamber [33] as
much as or more than the pagan sarcophagus. In contrast to some who
have seen here a 'Christianized Hercules' being put to use by a
Christian patron, it seems more likely that the chamber was used for
burials of a contemporary pagan family, or conceivably a still pagan
branch of the same family, itself a striking illustration of the intimate
association of the two communities. The two chambers show literally
side by side the similar formal means employed by artists and patrons
of the mid-fourth century to express their focus upon the hope for
corporal resurrection after death. The confessional differences,
Christian and pagan, seem less important, as if dialects of the same
language. The relationship underscores the fluidity of 'borders' at this
period.

The generic, almost unfocused, quality of the decoration of the Via
Latina catacomb paintings and of the Junius Bassus sarcophagus have

35

Ambulatory vault of Santa
Costanza, Rome, mid-fourth
century

Built as a mausoleum for
Constantine's daughter, and
originally centred on her
porphyry sarcophagus, the
building was later converted to
a church. The two ambulatory
vault panels seen here present
very different types of
ornament, the nearer with lush
and naturalistic vegetation and
birds as if scattered loosely,
the further a rigid system of
linked circles arranged in
straight lines on both vertical
and horizontal axes,
alternating between frontal
human figures or faces and
geometric star-like patterns.

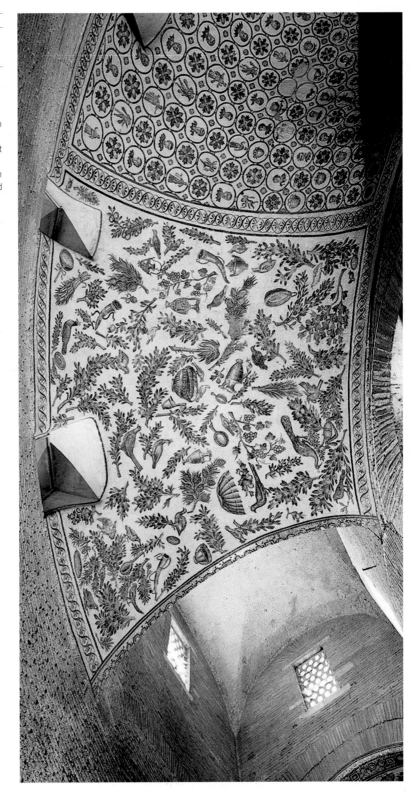

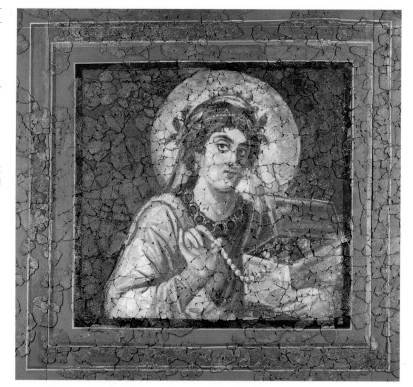

Reconstructed panel from the restored ceiling of a chamber from the Constantinian imperial palace in Trier, early fourth century

The interpretation of this figure is uncertain, as is also the case for the others on the reconstructed ceiling [page 46]. The four females are very richly dressed, holding a cup, a lyre, a mirror, and a jewel-box respectively, while the bearded male figures suggest learned men of some sort. Some scholars have identified the central figure as Constantine's mother Helena, and the other women as his wife, sister, and daughter. The aureoles of light behind their heads (the forerunners of later Christian haloes) suggest some high status or importance.

been discussed here primarily in terms of subject-matter, but should be assessed also in terms of pictorial style. The importance of compartmentalization and repetition of relatively small units also characterize tendencies in mural decoration with painting and mosaic. Beautiful ornamental fields spread over vaults without any strong focal element [35]. No single orientation unites all the figures in the pictorial fields, which are here arranged so as to be seen right-side-up by the viewer standing below. It is a sensible principle across such a complex curving space, to be sure, a carpet-like quality also appropriately found in many floor mosaics of the same period, where illusionistic pictures (*emblemata*) set into a surrounding frame are replaced by an overall pattern entirely without coherent spatial structure capturing any illusion of the physical world. This multi-directional quality coincides with a predilection for decorating floors and ceilings as richly as walls, and is often true not just of primarily 'ornamental' images but also of the disposition of large figures. An elaborate painted ceiling [36 and also on page 46] is made up of 15 figural panels, seven half-length portrait-like busts and eight pairs of flying 'putti' (to use the non-committal Italian term for such figures, related to the ancient cupid). The arrangement is radial around the central figure, which despite its location is smaller rather than larger than the four at its diagonals. The figures have no evident Christian content, and could be allegorical personifications rather than portraits. In such images the

issue of meaning seems to recede behind that of style and status: whether imperial princesses or goddesses or even simply decorative, these ladies are aristocrats.

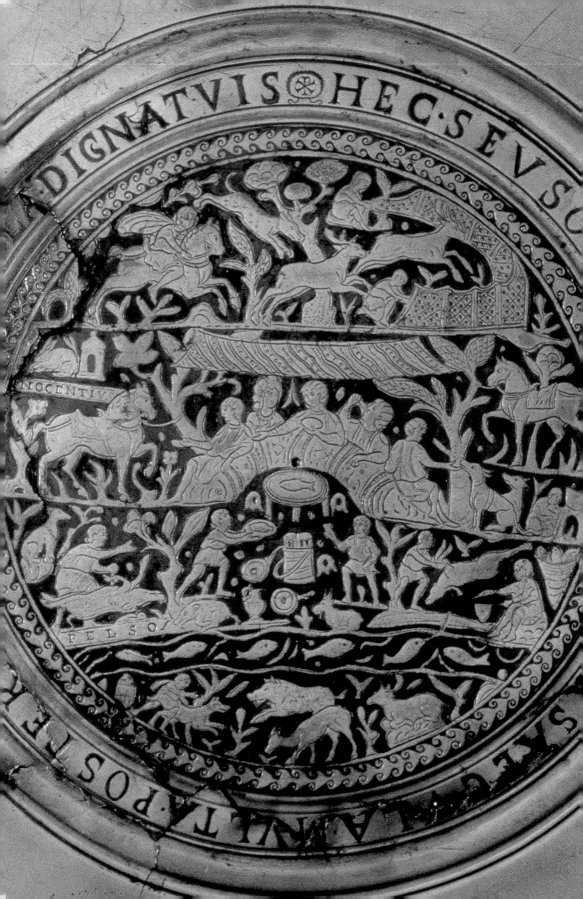

Art for Aristocrats

4

The late Roman world was increasingly decentralized, and the visual formulae in the mosaic of Dominus Iulius' villa [14] suggest that each aristocrat's home was coming to be his castle. The phrase is not only a metaphor, for indeed this country estate is presented as not only self-sufficient but fortified, a strong rallying point for local authority in a troubled time. There had always been wealthy men (and occasionally independent women) in the Roman world, commonly employed by the imperial government as its local or regional representatives, aristocrats with great country estates to which they might retire. Cicero loved his gardens at Tusculum, to be sure, but was like most of his contemporaries of the late Republic and early empire a man of the city, where his intellectual and political interests lay. In late antiquity, as cities began a long decline that became precipitate in the fifth and sixth centuries, many aristocrats established primary residence in the countryside, becoming increasingly isolated and independent. Some were from ancient senatorial families, while other country gentlemen were 'new men' risen through imperial and military service. Although his mother was aristocratic, the father of Ausonius of Bordeaux came from a humble, possibly servile background, but after receiving a fine education Ausonius eventually became the tutor of the future Emperor Gratian, and acquired great wealth. Late Roman aristocrats like Ausonius and his wide circle of acquaintances, who knew each other and exchanged letters and poems, had much in common, not least their great wealth. In the later fourth century, as in the later twentieth, a larger and larger portion of society's wealth was concentrated in a smaller and smaller segment of the populace. While a wealthy Senator might have an annual income of 120,000 gold coins, a merchant would probably have only 200, and a peasant would have to survive somehow on five.[1]

Some aristocrats continued to play important political roles in the imperial administration, as did Rufius Probianus and Junius Bassus [31 and 32] in Rome, while the later fourth century sees not only an increasing growth of aristocratic power, but also its diffusion through the provinces. Rome is joined as a capital city and imperial residence first by Trier [36], then by Milan [29] and in the early fifth century by

Map 2 Aristocratic wealth in the late Roman Empire

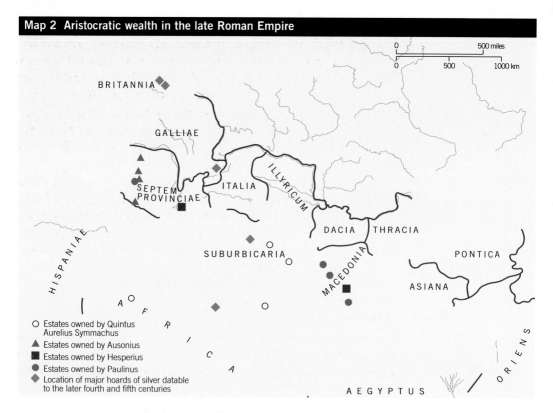

○ Estates owned by Quintus
Aurelius Symmachus
▲ Estates owned by Ausonius
■ Estates owned by Hesperius
● Estates owned by Paulinus
◆ Location of major hoards of silver datable
to the later fourth and fifth centuries

Ravenna; the court itself begins to wander, foreshadowing itinerant medieval courts. Ausonius became consul in 379, but although he travelled between his Gallic estates and Trier, he appears never even to have visited Rome. Men and women of senatorial rank like Ausonius could have estates throughout western and eastern parts of the Roman world [**Map 2**]. Aristocratic villas were represented in art and literature as places of civilized rustic peace and prosperity, where pleasures of the table and the chase (or at least of riding) could be pursued along with reading and study of traditional classical literary texts as well as, for some, newer Christian theological writing. Sidonius Apollinaris portrays such a life, writing c.460 about the villa inherited from his father, where little had changed since the time of Ausonius nearly a century earlier.[2] Scenes of rural life enjoyed by the aristocracy, displayed on the floors of country villas and on luxury objects that may be imagined to have been displayed in villas, may or may not have accurately recorded their daily activities but surely denoted their social status.

Artistic production reflects the interests and patronage of the wealthy class, who used imperial formulae for the representation of such activities long associated with the imperial court as feasting and hunting [**14, 28**]. In this regard visual culture tells a rather different story from contemporary literature, in which hunting becomes an important literary theme only from the sixth century.[3] A third-

century glass plate [37] shows a horseman with spear about to confront a great wild boar, while the small dog and servant beneath him are pursuing two stags arranged to suggest that the mounted hunter is heroically, if implausibly, attacking them as well. Space and time are suspended in favour of a heroically signitive image. An inscription makes clear the emblematic force of the hunt as victory and prosperity: 'Alexander, fortunate man, may you live long with your family and friends.'[4] Both object and wish were domestic, used in the home rather than in public, but a new kind of home that increasingly functioned as a political centre, where the estate owner was lord over dependent clients of all sorts, and where his family entertained their social equals. Obvious expense and luxury of material as well as workmanship conveyed status and power. In this example, not only the gold is expensive, so is the glass, a luxury material in the Roman world.

Silver

The pre-eminent luxury material of the late Roman world was silver. The fourth and fifth centuries are a great age of silver hoards, in part reflecting the growing insecurity of the times, but in part the social

37

Gold-glass plate ('the Alexander Plate'), mid-third century (257 mm diameter)

The decoration is in gold leaf, with painted details. The technique was common at the period, and many glass objects of the same technique have been found in Christian and Jewish catacombs, often mortared to the wall adjacent to tombs.

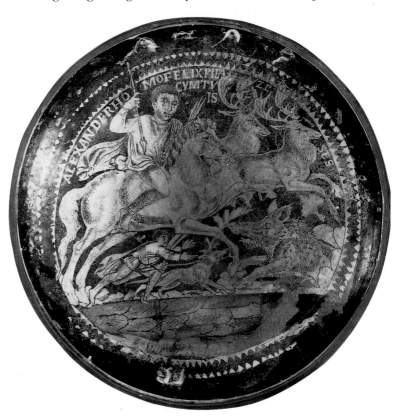

prestige attached to silver objects, such as Constantine's gift of silver statues for the Lateran Basilica. Large collections of silver objects are found in fourth-century sites in England (Mildenhall and Water Newton), Germany (Kaiseraugst), north Africa (Carthage) and throughout the empire. From a still-unknown site, part of a collection of 14 silver plates, ewers, and other vessels [40], is a large silver platter whose central medallion displays scenes of hunting, fishing, and banqueting, arranged in registers [also shown on page 62], as on the mosaic from Carthage [14]. The imagery's generic quality suggests production in specialized workshops that adapted stock designs and themes for particular patrons, and thereby gives us a strong index of such imagery's popularity. The frequent occurrence of inscriptions and monograms certifies that the pieces were customized for important recipients (as already seen in regard to sarcophagi [22]), very possibly as part of a pattern of gift exchange; stylistic and functional parallels with silver services from eighteenth- and nineteenth-century country houses are striking.

The grandest item in one hoard was a lidded box commonly known as the Projecta casket [38, 39]. Half-length figures of a man and woman at the centre of its top represent the couple to whom the box was probably presented as a wedding gift; the large inscription along the bottom edge of the hinged top's front reads: 'Secundus and Projecta, live in Christ.' Projecta holds a scroll, the marriage contract, while Secundus is identified as an important office-holder by the large pin, called a bow- or crossbow-fibula by archaeologists, with which his cloak is held on one shoulder. On the main axis beneath them is Venus, goddess of love and beauty, arranging her hair, flanked by sea-centaurs

38
Projecta casket, oblique overall view of the front, second half of fourth century, Rome (549 × 431 × 279 mm H)
Part of the so-called Esquiline Treasure, after the hill in Rome where it was found in 1793. Comprising approximately 60 pieces, the treasure has been divided among several museums, and most scholars agree that these pieces were a collection including objects of different date and origin.

and putti holding her mirror and make-up box. Beneath the Venus figure on the front of the lower section is a wealthy Roman lady, surely Projecta herself, arranging her hair. She is flanked by 11 attendants, represented within the colonnade that runs entirely around the box, who offer her a mirror, other boxes like this casket itself, and the paraphernalia of a lady's making-up ritual. The parallel between Projecta and Venus apparently has no religious implication, but is merely an elaborate way of complimenting Projecta's beauty. Her pre-eminence on her own casket is conveyed by her axial position, by the fact that on the bottom she sits while others stand, by her larger scale, by her frontal pose, even by the folding seat she uses, a type often associated with the emperor and other high officials [**137**]. It would be dangerous to see here an accurate portrayal of a single or indeed of a customary event, even if marriage alliances among aristocratic clans were immensely important, and weddings memorialized in an important poetic genre.[5] Rather the event's importance is represented through a ritual of hierarchy, very much in the manner of imperial iconographic formulae. We see here a high degree of slippage among the many signs presented to us, the luxuriousness of the object and its workmanship being more significant than the jumbled specific messages.

The considerable importance of women in late fourth-century society is well exemplified by this luxurious object. Wealthy women were patrons and associates of Jerome, the widow Paula following him from Rome to Palestine in order to lead a more perfect Christian life. Indeed, the same lady Projecta who received the casket on her wedding was probably memorialized on her death in 385 in a lengthy inscription

Horse trappings, silver with gilding, from the Esquiline Treasure, probably Rome, second half of fourth century (each 635 mm L)

Each of the two chains comprises linked alternating ornamented and figural plates, the former shaped rather like a shield or doubled pelta ornaments, the latter showing three frontal lions' heads and, as the central and most important piece, emphasized by the suspended crescent, an eagle with outstretched wings.

set up by Pope Damasus in Rome.[6] The domestic character of the toilet-casket, and the accompanying container linking its female owner with the (also female) nine Muses, does not mean that the collection as a whole is exclusively characterized by gendered female themes; in some respects, at least, differences of gender are marked less strongly at this period than differences of class. Other objects included silver crossbow-fibulae of the sort worn by Secundus on the Projecta casket, personifications of the four great cities of the late Roman empire, and two unparalleled large hollow arms holding a flowering sceptre-like object, perhaps ornaments decorating the arms of an official chair or throne. There was also a silver chain-like horse-trapping bearing imperial military iconography [41], for use on special occasions when a senatorial aristocrat rode through the city with his horde of retainers, recalling imperial ceremonies like an *adventus* [7 and 12]. The eagle with outstretched wings is the same motif as the eagle above a centurion's portrait on his gravestone [15], both recalling the eagles on top of the military standards (called 'eagles' by the Romans) that flank him.

The Projecta casket is one of some 20 objects, most likely not a single 'wedding hoard' but a collection accumulated by a family that patronized one among a number of active silversmithing workshops. The workshops' location is uncertain, but given that the patrons were located in Rome, and the hoard was found there, Rome seems the most likely origin. Workshops specializing in the manufacture of silver objects were known in the capital city for centuries, and their activity into the early fifth century is witnessed by a fascinating passage in Augustine's *City of God*. He uses the apparently well-

known practice of producing silver vessels through the hands of many different craftsmen as an analogy to the proliferation within pagan religion of minor divinities with specific but trivial responsibilities.[7] Indeed, Kathleen Shelton argued that four different craftsmen were responsible for the Projecta casket, and that some features such as the swinging handles were stock items acquired ready-made from a different specialized source. Inscriptions on extant vessels testify to the existence of silversmithing workshops not only in Rome but in Trier, Mainz, Cologne, and Aquileia, as well as an equal number of eastern centres. The list is strikingly associated with imperial mints, and also with Roman state factories producing weapons and cloth, likely because these are places associated with the imperial court and with the unsettled Rhine and Danube frontiers. That the extant silver vessels share not only form and imagery but are made of almost exactly the same silver alloy suggests a high degree of control, leading Kenneth Painter to emphasize the likelihood that major silver collections were instruments of imperial political largesse. He suggests that although for us today the imagery is the most significant aspect, in the fourth century the weight of silver might have been the pre-eminent sign of its owner's importance.[8] The fourth-century inventory of Constantine's gifts of gold and silver to the Lateran Basilica describes the iconography and placement of figures on the *fastigium* [see above, Chapter 3], but for the long list of patens, candelabra, and other items given at the same time imagery is never mentioned, and weight never left out.

The strongly commercial impression conveyed by the Esquiline Treasure is underscored by the wide distribution of closely related objects. Among the 30 silver plates and other serving pieces found at Mildenhall, totalling 85 pounds in all (39 kg), was a fluted bowl closely recalling one of the Esquiline pieces, showing the rapid spread of such fashionable luxury objects across the whole of the empire. A fragmentary fluted silver dish found in the Traprain Law hoard in Scotland is nearly identical to a fluted dish from the Esquiline Treasure in both motifs and workmanship, and probably originated in the same workshop, eventually ending with a large collection of hacked silver pieces in what looks most like pirate's loot.[9] This example shows the passage of fashionable Roman aristocratic art beyond the empire's northern border, and the presence of a closely related fourth-century fluted silver bowl among the treasures buried at Sutton Hoo in the early seventh century shows that such objects could circulate for long periods of time, passed hand-to-hand as heirlooms, virtually as antiques, rather than simply being melted down for their metal content. The Sevso hoard [40] is one striking example of conspicuous consumption and display, an important means of attaining and describing social status on the part of an individual most likely a 'new

man', very probably not from an old Roman family but from a 'barbarian' background.

Ivory carvings

Like silver, ivory had been used in earlier Greek and Roman art, but becomes a major art form only in the fourth century, remaining so for roughly the same period, through to the end of the fifth and the early sixth century. It is no accident that a large portion of surviving ivories are either diptychs issued by consuls and other imperial officials, or were intended for Christian altars. The majestic enthroned images of consul or of Christ [**30** and **31**] carried their message not only through their iconography but through their material. Indeed, the underlying message of power seems to have outweighed any sense of the arena in

42

Ivory diptych of Consul Boethius, front, 487, probably from Rome (each panel 350 × 126 mm)

In his hand Boethius holds the *mappa*, a kind of sack which he throws to begin the games in the circus. At his feet are bags of money to be distributed among the people as a gift, and palm leaves to be awarded to the victors in the games. The inscription gives the consul's names and many titles, while within the wreath is his monogram, the same kind of device for personalizing generic imagery commonly used on silver plates.

which that power was exercised, and secular consular ivories often survived in use on Christian altars for long periods of time, having been as it were converted. The diptych of Consul Boethius, father of the famous philosopher [**42**], shows him standing on one leaf and seated on the other, bearing in both a sceptre topped by a eagle, alluding like the wreaths in the pediments to Boethius' triumph. The image's power is heightened by the massiveness of the square-headed figures, who fill the pictorial space to overflowing, and push forward into the space of the viewer. Paintings were added to the back in the seventh or eighth century [**43**], and for the message of greetings and self-congratulation originally written there were substituted names to be remembered in a litany during the Mass.

The art of the Roman aristocracy was part of a broad tendency extending beyond the borders of the empire. The artistic medium most

43

Ivory diptych of Consul Boethius, back, 487, probably from Rome

The paintings and inscription, probably added in the seventh or eighth century, are in scale, materials, and style similar to book paintings. The right wing has portraits of important Christian authors, Saints Jerome, Augustine, and Gregory, while the raising of Lazarus on the left is obviously in the same pictorial tradition already used in the Via Latina catacomb painting of the subject [**33**].

strongly associated with Rome's great rival in the east, Sasanian Persia, is silver plate, most commonly decorated with royal iconography, images of monarchs often portrayed in hunting scenes.[10] Indeed, on some occasions obviously Roman silver was collected, treasured, buried, and eventually found together with Sasanian plate, as in the Klimova Treasure from southern Russia. The borders of the Roman empire were sometimes marked by walls and other fortifications, as famously Hadrian's surviving wall across northernmost England, but also by towns and cities that were not only garrisons but also commercial centres, attracting settlers and merchants from afar, from both sides of the border. The frontier fortress at Dura on the Persian frontier has already been noted for its unique preservation of early Christian and Jewish sacred buildings and paintings, but the frontier along the Rhine was from the end of the third century equally important, busy, indeed cosmopolitan. Trier, Cologne, and Mainz were imperial mints, sites of the production of silver, the second famous for its production of glass vessels, the first of them also in the early fourth century an imperial capital. Indeed, the late empire was becoming much like a living cell, having not only a nucleus but also an enclosing membrane that was essential, active, and highly permeable. The development of what has long been termed 'barbarian art' needs to be seen in relation to Rome, not in the Romantic historiographical tradition in which the 'barbarians' (especially Germans) were entirely Other, and in some almost mystical way pure, untouched by Rome.

Men from beyond the frontier had been serving in the Roman army since the early days of the empire, with increasing prominence from the third century. Many 'barbarian' (essentially meaning not having either Latin or Greek as their mother tongue) soldiers rose to high office, especially as the army became increasingly the avenue towards political power. Stilicho, the *magister militum* (in effect army chief of staff and commander) of the Roman forces in the west from the 380s until his fall and execution in 407, had himself portrayed as consul on a beautiful ivory diptych [44], wearing military dress fastened at one shoulder with the same distinctive, official, and emphatically rendered crossbow-fibula worn by Turcius Secundus on the Projecta Casket [39].[11] That the barbarian soldier could be represented exactly as if a member of an ancient senatorial family is underscored by the elegant classicizing style of the figure, his easy stance and beautifully rendered garments which create, along with the architectural background, a powerful sense of pictorial space. Moreover, his status within the senatorial aristocracy is clear from his appearance beside his wife, niece of Emperor Theodosius I, and their son. Indeed, this man, who was by birth a member of the Vandal group, was the subject of notoriously elaborate Latin panegyric poems, and may have hoped that his son could eventually become emperor.[12]

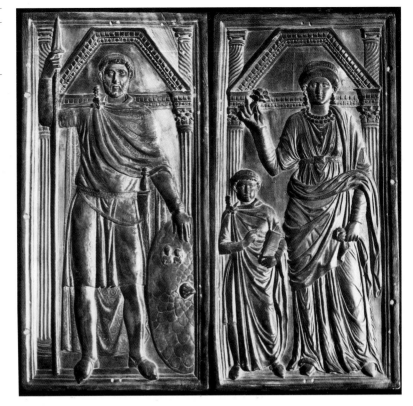

Ivory diptych of Stilicho and
Serena, c.400, from Rome or
northern Italy (each panel 322
× 162 mm)
Stilicho is dressed as a military
man in a military cloak
(*chlamys*) covered with small
medallions. On the shield is a
small medallion with the
double portraits of the young
joint emperors Arcadius and
Honorius. Stilicho's wife
Serena, Emperor Theodosius'
daughter, wears a pearl
necklace, an ornate belt, and
holds a rose. Their son wears
the *chlamys* and fibula like his
father, and holds a notebook,
indicating that he is pursuing
the studies appropriate for a
Roman aristocrat.

Roman and barbarian metalwork

The type of fibula worn by Stilicho and his son, and by Turcius Secundus, occurs also among metal works of art commonly termed barbarian, as new Germanic figures usurped the symbols of imperial authority.[13] It is likely that the type originated among Celtic groups, and came to be adopted as an exotic fashion by Roman aristocrats, becoming 'naturalized' as an important Roman emblem, and then exported. A pair of roughly the same period of the early fifth century, with essentially the same shape and mechanism, has sharply different decoration [45]. Their surface is covered with small bits of coloured glass and semiprecious stones, most commonly bright red garnets, with gold filigree ornament around the edges and filling the space between the stones. The brilliant colouristic effect led archaeologists to term this new style of decoration, which appears in the fifth century across the enormous area from modern France to Ukraine, the 'polychrome style'. Beyond the direct linkage with Roman fibulae of the same type, these fibulae compare closely with aristocratic Roman arts of the same period in several ways. They present even more clearly a preference for costly materials, for here the materials are displayed with very little design at all. Although the style and technique are obviously,

Pair of bow-fibulae, early fifth century, found at Untersiebenbrunn (Austria) (each 159 mm L)

The place of manufacture is unknown, and although some have suggested an origin near the Black Sea, they may have originated much nearer to the find-spot. The stones and glass are set in golden cabochon mounts, that is, are raised above the surface and held in place by a golden framing border wall.

indeed emphatically non-Roman, the overall pattern, disposed upon a surface lacking any meaningful depth, is consistent with a major trend of Roman art of the period.

These fibulae are part of a very widespread object-class, and neither the point of origin of the class nor of such individual examples can be determined. Like the silver treasures, part of the essential quality of the barbarian jewellery was precisely its wide distribution across and beyond the Roman empire. These fibulae likewise obviously belong to a high social class, to people of wealth and power for whom display, and very likely also exchange of gifts, was both an indication and a means to achieve status, indicating a high level of competition and social fluidity within the ruling social strata and confirming the sense of significant social and cultural changes known from so many other sources.[14] The major differences between Roman silver plate and barbarian jewellery are twofold. First, although both were produced for

and displayed by an aristocratic class, they were classes within different populations, the former within the ancient aristocracy (even if individual owners were parvenus like Sevso), the latter within an essentially new class formed around military leaders. The second major difference is that although both groups of objects have mostly been found buried in the ground, the silver has typically come from treasure hoards, but the jewellery from undisturbed burials. In this sense the barbarian jewellery offers a better analogy with early Christian funerary arts than with domestic display objects like the Projecta casket. Even this distinction masks an important similarity, however, for it has been argued recently that there is a strong correlation between production of silver coinage, including unauthorized usurpations of the imperial prerogative, and rich burials.[15]

'Barbarian' metalwork has an intimate albeit complex relationship with the Roman tradition. An elaborately decorated belt buckle found in a grave in Saxony [46] was probably made in a Roman workshop along the Rhine, and was issued to or bought by a barbarian soldier in the Roman army. He eventually moved outside the empire's borders, perhaps to his home area, and the buckle was there buried with him. Its survival is probably due to the rite of burial with weapons, predominantly Germanic during this period, but it is likely that soldiers and even non-military personnel were issued similar official equipment irrespective of Roman or Germanic language or ethnic background. The decoration of the buckle features two small free-standing beasts, looking behind themselves, and close beside them two large biting beast heads, detached from any body. Originating in Roman iconography, such monstrous beasts and part-beasts stand at the beginning of a development in northern European art generally known as 'Style I' animal art. The silver and niello-decorated frieze of spirals linking the beast heads is dependent upon Mediterranean vegetal ornament, while most of the surface is given over to abstract and geometric ornament.

46

Belt buckle, found in Herbergen (Lower Saxony), bronze, *c.*fourth century (113 mm w)

The double-pronged buckle would have held a massive military belt, its rich decoration suggesting an officer. The great loop is decorated with two biting animal heads, linked by a C-shape with spirals in niello. The outside of the loop and the buckle to which it is attached, and also the rectangular belt-plaque, are decorated with chip-carved patterns of meanders, swastikas, spindles, and crosses.

The faceted appearance results from the sharply pointed tool used to carve the matrix (mould) from which such objects were cast, the technique being known as chip-carving. Although such a taste for abstraction has often been linked with barbarian traditions, the ornamental patterns are based upon Mediterranean sources, and in fact this object should be considered Roman art, the only barbarian feature being its find spot. It is as Roman as Stilicho's fibula, or the Projecta casket, except for one important aspect. This object is part of an enormous class found in 'barbarian' graves, attesting to the popularity of such objects among Rome's neighbours and soldiers, and it is surely the taste, the preference for this type of object that led to it being imitated, and its stylistic features developed, in metalwork produced by and for the barbarians.

Dependence upon, and yet difference from Roman objects and traditions is seen with particular clarity in a large class of objects known as bracteates, golden medallions designed to be hung around the neck. Decorated on one side only, die-impressed rather than cast, they are based upon the imagery of Roman commemorative medallions and imperial coins with which barbarian soldiers were paid, and which for centuries they had been taking back to their homes across the frontier. These pendants appear in north Germanic, especially Scandinavian, contexts, in large numbers during the fifth and sixth centuries. Their imagery is dominated by the imperial profile portrait head, and to a lesser extent by the image of the imperial figure on horseback either in the *adventus* ceremony [**12**] or triumphing over an enemy. Bracteates were potent images, designed to play an amuletic function, and thereby bear witness to the reception of the underlying theme of the late Roman imperial iconography of power. Indeed, on some examples [**47**] the two themes are represented simultaneously, for the rider's

47

Gold bracteate found in Gotland (Sweden), fifth century

An unusually elaborate bracteate, this one has six major ornamental borders around the central image of a mounted horseman. The special potency of the human head is underscored here by the six disembodied heads stacked in V-shape on the mounting piece over the rider.

head has been enormously enlarged, entirely replacing the body. Although scarcely likely to be confused with its Roman prototype, even details like the fillet and trailing beads can be traced to Roman sources [12]. Eventually the religious and magical content of the imagery is underlined with runic inscriptions and added imagery that complete the translation from Roman to Scandinavian iconography: a bracteate from Funen includes an eagle-like bird with curved beak, and beneath the horse's head the runes signifying 'the high One', most likely Odin, chief of the Germanic pantheon.[16]

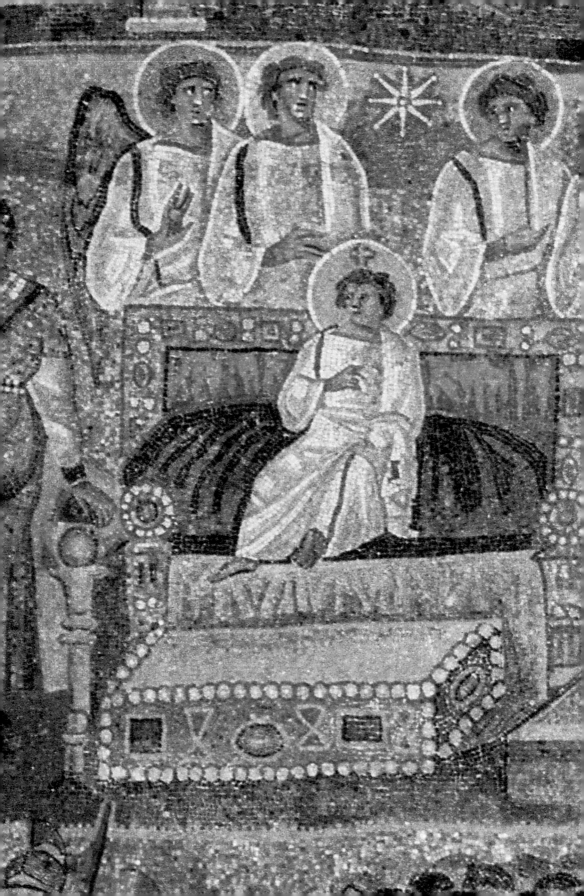

Endings and Beginnings

5

After the death of Emperor Theodosius I in 395, his two young sons Arcadius and Honorius divided theoretical authority in eastern and western parts of the empire between them, while actual power was exercised by Stilicho [**44**] and other military leaders, often of barbarian origin. During the next decades Roman imperial authority was hammered by a series of disasters from which, at least in the west, it never recovered. In 406, large groups of barbarians (organized in confederacies known to the Romans as Vandals, Suevi, and Alans) crossed the Rhine, looting their way across Gaul towards Spain, which they entered in 409. Twenty years later some of these barbarians crossed into Africa, and rapidly established a Vandal kingdom centred on the great city of Carthage, which they captured in 439. Into the power vacuum left by their passing, the emperor known as Constantine III, raised to the imperial throne by the army in Britain in 407, led the Roman army of Britain into Gaul, hoping to repeat the triumphal progress of his namesake (but not relative) a century earlier. Instead he was defeated by Honorius' army and executed, but the legions never returned to Britain, which henceforth followed its own course independent of central Roman authority. In 410 Alaric the Visigothic king and his followers sacked Rome, subsequently leaving Italy to establish a Visigothic kingdom in Spain and southern Gaul, to which the imperial government delegated *de facto* independent status from 418. Italy retained its direct connection with imperial government longer, after the 420s for several decades under the rule of Honorius' sister Galla Placidia, once married to a Visigothic ruler, and now acting for her infant son Valentinian III in the new capital of Ravenna. Invaded again by the Huns in the 450s, and Rome sacked again by the Vandals in 455, by the end of the fifth century Italy was no longer an imperial seat but was ruled by Theoderic, king of the Ostrogoths, to whom its government had been entrusted by the Roman emperor, resident in Constantinople.

Detail of 53

Christ child enthroned between angels and beneath the star at Bethlehem.

The 'barbarians'

It used to be presented as historical 'fact' that the Roman empire 'fell' in 476, when the boy-emperor Romulus Augustulus was deposed by

the Germanic Odovacer. Odovacer did take the title king of Italy, but continued to recognize the ultimate authority of the Roman emperor in Constantinople. That the latter recognized Odovacer's title did not prevent him from encouraging Theoderic the Ostrogoth to lead an army into Italy in 493, replacing one barbarian king with another who was thought, disastrously wrongly as it turned out, to be a less dangerous subject. Theoderic's real authority stemmed from being the only credible leader of an important army gathered together in the aftermath of the Hunnic invasions of the mid-fifth century, as was recognized by the Roman imperial office of *magister militum* (master of the soldiers), which Theoderic twice held. Indeed, he was thoroughly Romanized, having spent ten years (461–71) at Constantinople. The Ostrogoths were not an ancient ethnic 'tribe', even though the Roman historian Cassiodorus, who eventually served as Theoderic's minister, tried to create an ancient history for the Ostrogoths, as Virgil had done for the Romans.[1] In Italy, as in Gaul and elsewhere with the possible exception of Britain, the barbarian invasions are better understood as a political revolution led by a military class than as the wholesale 'wandering of peoples' that was once represented in maps tracing the 'roots of the barbarians'. The nature and extent of the undeniably increasing barbarian presence and role in late antiquity is a huge and controversial topic, and one must reckon with a considerable diversity in different regions, but I must confess to being among those who would prefer to emphasize continuity rather than catastrophe.

The establishment of barbarian overlordship in many areas left remarkably few obvious marks on artistic production during the fifth century, but this artistic stability is not the whole picture. From the later fifth century there was a decline in the amount of artistic production, not precipitate, but obvious, as for example the production of stone sarcophagi in south-western France.[2] Some changes are more dramatic, as exemplified by material associated with Childeric, king of a relatively small group known as the Franks. As early as 469 he co-operated with a Roman count to recapture Angers from Odovacer, helping drive the latter to his historiographic star-turn in Italy a few years later. Childeric's connection with the empire is clear from his seal ring, showing a frontal portrait and bearing a Latin inscription, indicating that he lived in a world where literacy was important. His grave included brooches like those worn by Secundus on the Projecta casket, and by Stilicho, representing his high office in the Roman imperial system. Yet Childeric was very different from his Roman contemporaries like Sidonius Apollinaris. He was probably illiterate, and still a pagan, and his burial near Tournai in 482 also included the skeletons of several dozen horses.

Discovered in 1683, this grave created a sensation, and exerted immense influence upon scholars and even rulers; the little golden

insects adorning Napoleon's imperial robe [2] are derived from similar jewels buried with Childeric, 'first king of the Franks'. The burial remains one of the most important monuments of early medieval art, not only because it is unusual in being relatively firmly dated. The grave goods included many examples of a new version of the polychrome style, called cloisonné, in which the jewels, now generally restricted to red garnets, were set within narrow walls, creating an effect reminiscent of much later medieval stained glass windows. The fittings for Childeric's ceremonial sword [48] exhibit the stunning visual richness of this style, which clearly derives from the older polychrome style with cabochon jewels [45], but most likely was also inspired by late Roman chip-carving metalwork, with its complex overall patterns defined by narrow linear networks [46]. Whatever its roots, the distinctively novel style was closely identified with the newly emerging international barbarian aristocracy and royalty, with 'cocked-hat' shaped sword mounts apparently produced in the same workshop as Childeric's appearing also in graves in Sweden, where they probably travelled as gifts.

The Ostrogoths and Ravenna

Childeric himself married not a Frank but a Thuringian princess, and married his daughter not to a Frank but to Theoderic the Ostrogoth. Theoderic offers the richest case of the interaction between Roman traditions and the new barbarian rulers. Judging both from texts and surviving works of art, Theoderic presented himself not as an invader but as a restorer, a common enough rhetorical pose for conquerors, yet in this case having some truth. Cassiodorus wrote a series of letters on his behalf to the Roman Senate about preserving Roman buildings and artworks.[3] Theoderic provided circus games in Rome, and it was he who was the last to be accorded the honour of a ceremonial *adventus* in the ancient capital, in 500, a medallion being issued to mark the event.[4]

Theoderic was a builder, the moving force behind not only his own domical tomb in Ravenna, but a series of churches. Because he and the other Ostrogoths, like most of the Germanic groups within the empire, were adherents of the Arian version of Christianity, branded a heresy by the eventually triumphant Catholic and Orthodox Church, some of these new Ostrogothic religious constructions were twinned with earlier churches. The surviving Arian Baptistery, for example, is manifestly an early sixth-century reduced version of the mid-fifth-century Orthodox Baptistery, and its surviving dome mosaic likewise follows the precedent of the Orthodox building. Theoderic's greatest undertaking was the construction of a new basilica that would serve as the Arian cathedral, standing beside his palace. Although this is not

48

Sword and scabbard mounts from the tomb of King Childeric, before *c*.482. Silver-gilt and cloisonné garnets. Probably made by an itinerant craftsman working for the king at his 'court' in Tournai, or in a workshop in the Trier-Cologne area, but possibly imported from elsewhere

The luminosity of the jewels is intensified by the use of thin sheets of hammered silver or silver-gilt to reflect light through the translucent gems, set in complex and densely packed geometric patterns.

Ravenna, San Apollinare
Nuovo, detail of mosaics on
the south wall, first half of sixth
century

The four narrative images
visible in the photograph are
the Last Supper, Christ in the
Garden of Gethsemane, the
betrayal of Judas, and Christ
led to his trial. Note that the
cycle reads in the opposite
direction from the procession,
clearly arranged so that the
Last Supper, instituting the
eucharist, is placed closest to
the altar where it is liturgically
re-enacted.

the church for whose decoration Theoderic specifically asked the Pope to send trained mosaicists,[5] the style and iconography of San Apollinare Nuovo have strong links with Rome. Each wall has three registers. The lowest shows a majestic procession of figures marching towards the altar, on one side female saints advancing behind the three Magi towards the enthroned Virgin and Child, celebrating their *adventus* (the name given to the feast of the wise men), and on the other side male saints advancing towards the enthroned Christ [49]. The second level includes standing prophets and patriarchs and perhaps also apostles, recalling in their form the four standing patriarchs above the Torah shrine in the Dura synagogue [16]. The uppermost level is much the smallest, but in certain respects the most extraordinary, alternating illusionistic niches crowned by doves flanking a cross with the most extensive surviving early narrative cycle of the life of Christ.

Such magnificent decoration proclaimed the Ostrogothic king as successor to the Roman emperor. Other contemporary barbarian rulers adopted a similar strategy. Before it was destroyed in 1764, Toulouse had a church known as 'La Daurade' from its profusion of gold mosaics on the interior. Its plan was most unusual, a nave leading to a sanctuary comprising seven sides of a regular decagon, the entire surface having three storeys with rows of niches in which individual figures were represented. The iconography, as far as it can be judged from the seventeenth-century description, included some narrative scenes, such as the Massacre of the Innocents, along with a rather bewildering array of single figures, including Old Testament figures, saints, and angels. The date of the church is uncertain, and may be connected with the Visigothic court centred at Toulouse until 507, although it might be after the Frankish conquest of that year.[6] Whether or not either of these two probably Gothic royal churches displayed heretical Arian features is debatable, but in any event Arianism is no barbarian tradition, for Arius was a priest from sophisticated Alexandria. Moreover, a distinctive or at least separate Arian church is already found in late fourth-century Milan; the religion favoured by most barbarian ruling groups was one of the choices available in the Roman world. It is probably a coincidence that only the Franks made what eventually proved the right choice when they became orthodox Christians, a lucky chance entailing important consequences.

That such apparently Romanized artistic productions as these great churches could be patronized by barbarian kings holding court in Toulouse (and later Toledo) and Ravenna is not inconsistent with their patronage also of luxurious metalwork in the distinctive new style associated with barbarian courts. Best known are large fibulae in the form of an eagle from Visigothic Spain, where several sets have been found, and from Ostrogothic Italy [50]. They employ the new cloisonné technique already described in connection with the burial equipment of the Frankish king Childeric [48], and have many stylistic and iconographic as well as technical connections. Their place of manufacture cannot be established, and gift-exchange among royal families who intermarried cannot be ruled out. The differences are sufficiently great, however, to suggest that this splendid style was rapidly disseminated and quickly imitated in new workshops, rather than being distributed from a single place of origin.

The eagle is a familiar military and imperial symbol [2, 11, 13, 15, 41], and it is easy to identify its underlying iconography, conveying status and power [51]. The fibula from Ostrogothic Italy [50] is perhaps most remarkable for the highly abstract form that nonetheless so effectively characterizes the great bird of prey. The enlargement of the hooked beak and round eye are a feature of this entire class, but here the way in which the wings seem drawn in almost as if the bird

Eagle fibula, cloisonné garnets and gold on bronze, c.500 (121 mm L). Found at Domagnano (San Marino), near Ravenna, its place of manufacture is uncertain, and may have been at or for the Ostrogothic court at Ravenna

From the grave of a queen or princess, it is one of a matched pair of fibulae, buried along with earrings, a long pin, a ring, insects like those from Childeric's tomb, and other personal jewellery. The central disk contains an equal-armed cross, raised from the surrounding ground, and almost certainly a Christian and not merely a geometric motif.

were diving upon its prey, and the manner in which the *cloisons* form chevron patterns pointing forward, effectively accelerating the sense of movement, are masterly and unique. It is important to note that this great fibula is from a collection of jewellery worn not by a man but a woman, and that the motif of the eagle head became common in female-associated jewellery and even pottery.[7] The Ostrogoths were prepared to give large roles to women, perhaps because of the importance of heredity in establishing a right to the royal succession and other property; indeed Theoderic was succeeded by his daughter Amalasuntha. This is a major difference from traditions of Roman law, but not so different from traditions of contemporary Roman aristocratic families. Already mentioned have been Projecta and her casket, and Galla Placidia in Ravenna, while a series of empresses and imperial

princesses wielded great influence in Constantinople, and acted as patrons of major artistic projects.

The expansion of Christian narrative art

With the disappearance of effective Roman imperial authority, many responsibilities fell upon local leaders, the aristocratic scions of old senatorial families, still pagan in some cases, or the new barbarian leaders with whom they alternately competed and cooperated, or a new class of rapidly increasing importance, the bishops, leaders of the Christian community. The categories often intersected, as barbarians married into senatorial or even imperial families, while many bishops were chosen from powerful senatorial families, for example Ambrose in Milan, or Sidonius Apollinaris in Clermont. Sometimes the choice for a city's bishop fell upon men of humbler backgrounds such as Augustine of Hippo in north Africa, or the great Martin of Tours, men known as outstanding for learning or holiness.

Bishops inherited the imperial and aristocratic responsibility for construction and maintenance of public works, and of course especially for churches. Rome and Italy were not alone in receiving large new churches. Although few early churches in Gaul survive, literary testimony shows that many new churches were built, often richly decorated,

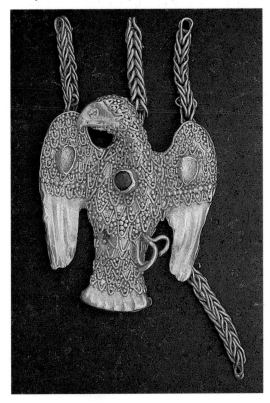

51

Eagle pendant, gold foil and granulation with jewels, found in Sweden, probably sixth century (23 mm H, 21 mm w). Byzantine (or at least eastern Europe or Mediterranean)

The similar position of semi-folded wings and profile head as on the Ostrogothic fibula testifies to the currency of such charged symbolic emblems in the late Roman world, and also to the rapid diffusion of such grand jewels.

52

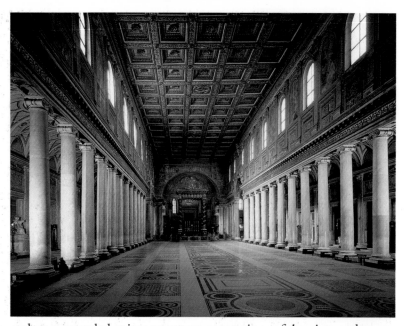

and were regarded as important representations of the piety and power
of their builders.[8] The new basilica housing the tomb of his predecessor
St Martin was constructed by Bishop Perpetuus of Tours after 461, and
incorporated a large stone for Martin's tomb given by one of Perpetuus's
episcopal colleagues, Euphronius of Autun.[9] Such cooperation with
neighbouring bishops is not unusual, and is a telling indication of the
rise of an important social class. For example, Sidonius Apollinaris,
who had been Prefect of Rome, returned to his home region of central
Gaul and was soon thereafter appointed bishop of Clermont, in about
468. He did not need to build a church, for that had been accomplished
by his immediate predecessor, but he did provide an elaborate inscrip-
tion for the new church built by the bishop of nearby Lyons. Sidonius
emphasizes the brilliant light of its interior, its splendour: 'marble
diversified by various shining tints [that] pervades the vaulting, the
floor, the windows; forming designs of diverse colour, a verdant grass-
green encrustation brings winding lines of sapphire-hued stones over
the leek-green glass.'[10]

 In the ancient capital city of Rome, the bishop (to whom we are
accustomed to refer, as I shall henceforth, as the pope, 'father') played
an increasingly independent political role. In 452 Pope Leo I met with
Attila, leader of the Huns, when he invaded Italy, persuading Attila to
withdraw without attacking Rome. A few years earlier his pre-
decessor, Sixtus III, had assumed another traditionally imperial
responsibility and prerogative by erecting a huge basilica, Santa Maria
Maggiore [52]. At the centre of its great triumphal arch over the altar
he proclaimed his role as builder and also political leader with the
dedicatory inscription XYSTUS EPISCOPUS PLEBI DEI (Xystus [usually

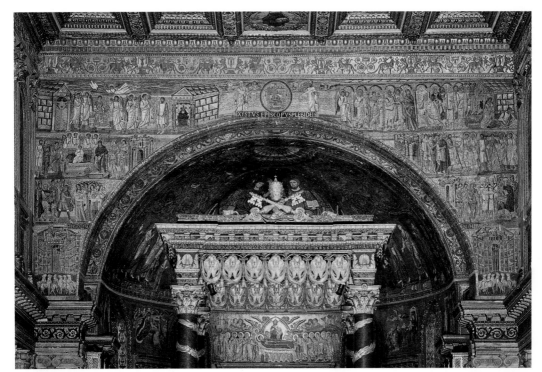

53

Rome, Santa Maria Maggiore, 432–40, mosaic on the so-called triumphal arch above the altar

On the left side in the top register is the Annunciation of the birth of Christ to the Virgin Mary, seated in the centre, while at the right an angel speaks to Joseph. In the next register is the Adoration of the Magi. Below that is King Herod ordering his soldiers to kill the young male children of Jerusalem, the so-called Massacre of the Innocents, while at the bottom symbolic lambs are represented gathering at the gates of Jerusalem. On the right side is the Christ child's flight to and reception in Egypt.

Detail of 53

The *hetoimasia*, or empty throne, directly above the altar. On the throne are two tiny portraits of Saints Peter and Paul, two special patrons of the pope, also shown standing.

Anglicized as Sixtus] Bishop of the People of God) [**53**].[11] This enormous church, accommodating some two thousand worshippers, competed in scale and lavish decoration with the imperial basilicas of the fourth century.[12] Dedicated to the Virgin Mary, her enthroned figure surely occupied the centre of the enormous apse, before its destruction and replacement in the thirteenth century, following the pattern of earlier imperial and Christian portrayals of Majesty [**28–31**].

Fortunately, the story of the infancy of Christ survives almost intact in the narrative images on the arch preceding the lost apse [**53**]. Dominated by golden colours, the effect of the series of six episodes is rich and imposing. At the centre left, the infant Christ sits upon a magnificently jewelled throne, with a celestial guard of angels behind him [page 80]. The symmetry associated with majesty is so powerful in moulding the composition that the three Magi come to adore him are divided at either side, with Joseph at the far left making a balancing

fourth male figure. Also creating majestic symmetry are the images of two women flanking the central figure of the child. The woman at Christ's left wears the imperial Roman costume that the Virgin wore in the Annunciation scene (and which also evokes the costume worn by the contemporary Empress Galla Placidia), and has the place of honour at Christ's right hand, while the woman at the other side has the blue mantle almost always used to identify the Virgin. Which is the Virgin Mary? The question remains difficult and controversial,[13] but however the individual figures are interpreted it seems to have been thought essential to distinguish in visual terms the frontal majestic divine all-ruler against the unbalanced scene immediately below, which portrays the unjust secular ruler King Herod.

The theme of rulership is central to the entire programme of images in the basilica. The walls are decorated with scenes drawn from the Old Testament, not a consecutive narrative from the creation, however, but scenes from the lives of four leaders of the chosen people of God, namely Abraham, Jacob, Moses, and Joshua. They are the forerunners of the building's patron, the pope, who claims precisely this role for himself, according to the dedicatory inscription. Like the pope, they win victories over their enemies by invoking the power of God, here expressed with the aid of traditional Roman pictorial syntax. Joshua stopping the sun in order to complete his victory against five kings at Gabaon (Joshua 10: 12–13), and Moses holding his arms aloft to gain victory over the Amalekites (Exodus 17: 11–13) are formed like the imperial *adlocutio* [**6** and **8**] scenes, and Abraham encountering

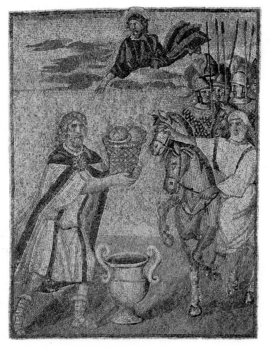

54

Santa Maria Maggiore, 432–40, mosaic in the nave, Abraham and Melchisedek

In the Bible this episode is apparently minor, contrasting the four evil Canaanite kings defeated by Abraham with the respectful conduct of Melchisedek, the king of Salem, who was also a priest, and came to offer bread and wine to Abraham, invoking the protection and blessing of God upon him. The half-length figure of Christ appears in the sky, with right hand outstretched to receive the offering made through Abraham to him.

Melchisedek (Genesis 14: 18–20) like the imperial *adventus* [12]. This latter scene is the climax of the Old Testament cycle, ending the series on the north nave wall, where it joins the triumphal arch [54]. Melchisedek's bread and wine were taken by Christians as prefiguring the eucharistic sacrifice, which helps explain the location of this scene beside or rather above the altar, but its clear portrayal of the king making offering to the leader of God's chosen people suggests the deference that the pope claimed from secular authority, rather than his dependence upon it.

Encapsulating the subtle and pervasive iconographic programme of the church decoration is the axial image on the triumphal arch, directly above the altar. Above Pope Sixtus's dedicatory inscription [53 detail] are standing figures of his apostolic forerunners and patrons, Saints Peter and Paul. They flank the image of a throne, emblem of authority, manifestly Christ's throne in heaven, for it bears a cross of victory and a crown of eternal life. On the footstool is the seven-sealed book of the Apocalypse (Rev. 5: 1–10), and based upon the same texts are the lion heads in profile on each upper corner of the throne's back, referring to the lion of Judah and his royal descendants David and Solomon, whose throne was decorated with lions (1 Kings 10: 18–20). Also based on a biblical text (Rev. 4: 6–8) are the four winged creatures carrying books, probably here identified as symbols of the four Evangelists. This is a heavenly and a future throne, but it probably corresponded closely to the jewelled throne of the Virgin in the lost apse mosaic, and to the papal throne on the axis beneath it in the apse of the church, a connection emphasized by its medallion portraits of Peter and Paul flanking the central crown.

Although the empty throne is the focus, most of the church's decoration is given over to narratives based on both Old and New Testaments. From its beginnings Christian art drew upon this immensely rich source, so unlike the pagan religious tradition in being contained within a single authoritative text. New in the fifth century are lengthy connected series of narrative scenes, arranged in chronological rather than thematic order. The walls of the great Constantinian basilicas provided a splendid setting for such long cycles, but it seems that during the fourth century no such cycles were deployed, lengthy Old Testament cycles and illustrated lives of the apostles appearing most likely only from the early fifth century. Whether the early fifth-century cycle of poems by Prudentius was inspired by or intended to inspire such a programme of narrative paintings cannot be known, but certainly indicates that by this period such a programme was thought plausible.[14]

Connected narratives also appear at this time in ivory sculptures. One beautiful panel [55] depicts the visit of the three women to the tomb of Christ on Easter morning, where they find sleeping Roman

soldiers and an angel telling them that Christ has risen from the dead (Matthew 28). The artist has attempted to illustrate the Resurrection by showing Christ powerfully striding up a mountain to heaven as the hand of God reaches down, while two terrified witnesses cower below him. The motif of the fruitful tree, here incongruously seeming to grow out of the top of the tomb, seems an obvious symbol of paradise, whose gates are now opened. Probably the awkwardness reflects an artist struggling to adapt and transform stock workshop motifs and compositions,[15] but the unique arrangement to suggest that Christ is literally climbing out of his tomb is an effective, original, and seldom repeated invention.

Cramming multiple moments together within a single framed space reflects the late Roman and early Christian suspension of the illusion of a single space-time captured in an image. During this period ivories also begin to adopt the same procedure of separating units of narrative in discrete units of space that was employed in the nave mosaics of Santa Maria Maggiore. A fifth-century ivory diptych now in Milan [56] shows the deployment of what might be termed the metope style, after the small nearly square panels of ancient Doric architecture. Seeking to cover an area too large for any single ivory

55

Ivory panel with Three Women at the Tomb and the Resurrection of Christ, probably Rome, first half of fifth century (187 × 116 mm)

The tomb is represented as an elaborate two-storey structure with statues in niches and portrait medallions above the arcaded drum for the dome. Closely related ivories show the door opened, employing a motif used for the victory over death in works like the Velletri sarcophagus [27].

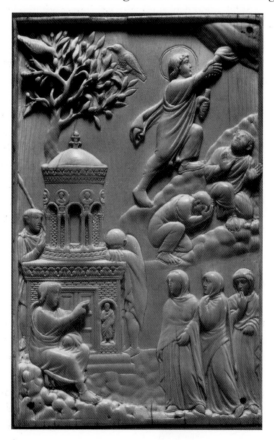

panel, limited by the size of the largest elephants' tusks, these have surrounded a central panel with four other strips, creating an early example of a new 'five-part ivory' class. The imagery is rich and dense, arranged not in strict narrative order, but highlighting the Nativity and Adoration scenes at the top of the respective panels. Links with earlier imagery are apparent in many scenes, such as the Baptism, Entry into Jerusalem, and Last Supper, the latter using the same pictorial formula employed in the slightly later mosaics of San Apollinare Nuovo [**49**] and ultimately Roman banqueting formulae [shown on page 62]. One image, the Annunciation at the upper left of the Lamb panel, is markedly outside the growing iconographic tradition, for it shows the Virgin kneeling to draw water from a stream when the angel appears to her, a motif drawn not from the canonical Gospels but from the 'Protevangelion of St James' (Prot. 9: 7).

Luxury painting in manuscripts

The use of an apocryphal textual source for this image is ironic, for the panels may have been designed to serve as the cover for a book of the four canonical Gospels. The central Christian text, whose place upon the altar, ceremonial procession to the altar, and reading from the altar constituted an essential element of the eucharistic service, was for the first time becoming not only a source for Christian iconography, but an artistically decorated object. From this period and slightly later we have not only rich covers like these in ivory, but others in luxurious

Christianity was to an extraordinary degree a religion of the book, and it seems clear that the fundamental shift from the papyrus roll that had been the standard book form used in the Greek and Roman period to the parchment codex, the bound book with many leaves, written on both sides, is associated with Christianity. The shift from roll to codex had profound impact in many spheres, clearly affecting the development of the Christian scriptural canon and notion of the Bible as a single corpus of writings. The enhanced compactness and portability of the codex may have been associated with and may have supported missionary activity, while encouraging a style of referring to authority in a written canon. The shift also seems to have created a book form both more expensive and more durable, with important effects upon literacy. The codex also made elaborate pictorial decoration of books a reasonable activity.

metalwork set with carved gems and inset cameos with cloisonné polychrome frames [**64**]. At the same time, the text itself for the first time becomes a site for elaborate pictorial decoration, the earliest appearance of a new artistic medium destined to play an immensely significant role for the next millennium.

The earliest extant illustrated biblical manuscript, known as the Quedlinburg Itala, is a severely damaged fragment of the Old Testament Book of Samuel. It was most likely produced in Rome in the first half of the fifth century, perhaps for a wealthy Christian like the Gallic Senator Paulinus of Nola, who retired to a church in southern Italy and there served, and lavishly decorated with images, a church dedicated to the martyr Felix.[16] Jerome, translator in the late fourth century of the Latin version of the Bible that, known as the Vulgate, gradually replaced the older Itala and other early versions to become standard throughout western Europe, sharply criticized the production of luxuriously decorated books, which suggests that this was a new phenomenon.[17] The Quedlinburg Itala had a dense sequence of illustration, arranged in what I previously termed the metope style, small square panels for each episode. The effect is strikingly like the roughly contemporary nave mosaics of Santa Maria Maggiore, as is the style, having such illusionistic features as cast shadows upon the ground, and loosely painted atmospheric backgrounds. Even the iconography of the four surviving fragments (the introduction of Saul, first king of the Israelites [**57**], his fall from favour with God, and Solomon's construction of the temple) is analogous to the Santa Maria Maggiore programme's special concern with the relationship between religious and political authority. Visible now where the original paint layer has fallen away are instructions to the painter of the scene: 'You make the prophet speaking facing King Saul sacrificing, and attendants.'[18] The instructions are cursory, but an important indication that the painters were most likely literate. They dictate only the matter, not the manner, of the depiction, the formal arrangement understandably being left to the judgement of the artist,

The Quedlinburg Itala,
probably Rome, first half of
fifth century

The events of 1 Samuel 13–34
are given four pictures,
reading from top left in 'lines'
analogous to the reading of the
text: King Saul pouring a
libation at an altar while
Samuel approaches in a
chariot; Saul grasping
Samuel's cloak; Agag praying
for mercy before Saul and
Samuel, who then pray to god;
Samuel killing Agag.

who created the figure of Saul and his sacrificial action by analogy with
established Roman iconography. Noteworthy, however, is the segrega-
tion of the illustrations from the text itself, which is found on different
pages, and the absence of any artistic feature specific to the new book
context. The book must have been magnificent in its original condi-
tion, although we cannot be certain that the entire text was so richly
illustrated.

One important school of thought, especially associated with Kurt
Weitzmann, has seen long consecutive narrative cycles like those at
Santa Maria Maggiore and San Apollinare Nuovo as images derived
from, transferred from, illustrations in books, for which the imagery
was created, perhaps centuries before the appearance of such cycles in
monumental form. In my own view, there is little evidence to support
such a view and much to contradict it, especially the relative novelty of
the parchment codex form, which alone could have provided a format
for such elaborately painted (as opposed to summarily sketched)
images. John Lowden has recently suggested that the absence of any

established format for illustrations among the rare extant books makes it more likely that each is better seen as an *ad hoc* production for some special circumstance than a survivor of a well-established class.[19] However, one underlying support for the theory seems to me clear, namely that such narrative cycles depend upon a narrative text such as the Bible being given a central place in society. Classical antiquity offers no book with anything like the sacred status of the Jewish and Christian Bible, the closest approximation being the great epic poems of Homer and Virgil, whose appearance in luxuriously illustrated editions is limited to parchment codices such as a Homer said to have been written for Emperor Maximinus in golden ink on purple-dyed support,[20] and the Vatican Virgil [**58**], and probably represent an attempt to create a pagan analogy for the illustrated Bible. Classical antiquity also offers no real parallel in any medium for such cycles of dozens and even hundreds of scenes arranged in chronological order. The closest parallel might be the triumphal columns of Trajan and others, but those are perhaps the exception that proves the rule, for those long cycles are not tied to any literary source, and are unique examples, not examples of a class. The Trajan Column inspired the

58

The Vatican Virgil, Rome, early fifth century

Aeneas and Achates before the sibyl, in front of the Temple of Apollo. The style of the manuscript's paintings is remarkably closely akin to the Quedlinburg Itala, using the same square frames, similar figures, and illusionistic backgrounds.

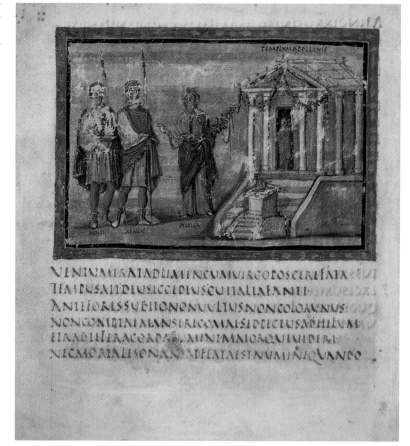

form and some of the formulae on the later examples of the genre, but there is only one Trajan Column. In contrast, there are many illustrated biblical manuscripts, with varying ways of illustrating the text, but the text itself remains constant. Succeeding centuries show a wide range of experiments in providing illustrations for these books, eventually resulting in one of the most distinctive of early medieval inventions, the illuminated book, in which the very script itself becomes part of a complex system of decoration in which pictures form only a part, a system unique to books and appearing only in them.

Craftsmanship and Artistry

6

6

During the second quarter of the sixth century, the Roman Emperor Justinian, directing affairs from Constantinople, attempted to re-establish effective imperial authority over territories in western Europe which had come under the rule of various barbarian kings. He largely succeeded in his campaigns, and his success was disastrous for nearly everyone. High taxes to fund his wars damaged the economy, contributing to attempted rebellions in the capital and deeply divisive religious dissension in the rich provinces of Syria and Egypt. The revived kingdom of Sasanian Persia took advantage of the situation to invade, sacking the great city of Antioch in 540. Justinian's general Belisarius did successfully reconquer the Vandal kingdom of North Africa in a quick campaign in 533, but the war in Italy against the Ostrogothic followers of Theoderic dragged on for decades until the final imperial victory of 553. Italy was left devastated and depopulated by the war and by the plague that struck the Mediterranean world after 542, and much of the peninsula was lost again to imperial authority with the Lombard invasion of 568. The imperial outposts were thenceforth reduced to the area around Ravenna in the north-east, around Rome in the centre, and around the coastline in the south [**Map 3**]. In many respects it is easy to see why some historians and archaeologists have made a strong case for placing the most dramatic decline, and the real border between antiquity and the Middle Ages, in the sixth century.

Artistic evidence seems at first not to coincide with other historical evidence, for the sixth century was a time of masterpieces. Justinian's many great buildings, of which Hagia Sophia in the capital is best known, exercised immense influence not only for the remainder of the medieval period but beyond. In important respects 'the great church' (as it was usually termed) embodies the art of the period in its Janus-like character. As a basilica it followed a venerable tradition of Christian architecture established by Constantine, and as a central-plan structure crowned by a dome it followed a venerable tradition of spectacular buildings reaching back to Hadrian's Pantheon. In combining the two traditions it was unprecedented, unique, original, spectacular, and both conceptually and materially unstable (the dome collapsed entirely in 558, and partially in the tenth and fourteenth

59

Ivory throne of Archbishop Maximian of Ravenna, mid-sixth century (1.50 m H, 605 mm w)

Constructed upon a wooden frame, it is entirely covered with ivory panels. Wonderfully rich strips of vine scrolls frame the many figural panels. On the front, beneath Maximian's monogram, the four Evangelists flank John the Baptist. Under each armrest are episodes from the story of Joseph (Genesis 37–50), while the entire back, both inside and outside, represents the early life of Christ and his miracles.

Map 3 The world of late antiquity, *c.*600

PICTS

IRISH

North
Sea

Jutes

Danes

Oder

Elbe

Briton s

Angles & Saxon

•York

ENGLAND

Canterbury

Rhine

S a x o n s

Cologne•

Atlantic
Ocean

BRITTANY

Thuringians

Meuse

NEUSTRIA

Soissons
Paris
Reims

AUSTRASIA

•Metz

•Worms

Seine

Rhine

FRANKISH KINGDOMS

Orleans

Loire

Langres

Moselle

Alemans

Autun

Poitiers

Basle•

Bavarians

Lyons•

Geneva•

Bordeaux•

AQUITAINE

Garonne

Toulouse

Monza

Milan•

Aquileia•

•Trieste

Suevi

CANTABRIA

VASCONIA

Rhône

BURGUNDY

Pavia•

Venice

Genoa•

LIGURIA

•Ravenna

Lombards

Douro

Palencia•

Pyrenees

Carcassonne

SEPTIMANIA

•Arles

EXARCHATE

•Ancona

VISIGOTHIC

Saragossa

Ebro

KINGDOM

Tagus

Toledo•

•Barcelona

Tarragona

Perugia•

D. OF
SPOLETO

OF

Rome•

Corsica

ITALY

Guadiana

Cordova•

Valencia•

Balearic Is

D. OF
BENEVENT

Naples•

Otran

Seville•

Cadiz•

Malaga•

Cartagena•

Sardinia

Palermo•

Ceuta•

Caesarea
•

EXARCHATE OF AFRICA

NUMIDIA

Carthage•

M

e

d

i

Sicily

•Messina

t

e

Malta
•

r

r

a

n

e

a

R O M A

TRIPOLITANA

| 0 | 100 | 200 | 300 | 400 miles |
| 0 | 100 | | 200 km | |

Vistula

Carpathians

Caspian Sea

Slavs

mium

Black Sea

Danube

Nicopolis

•Odessus

Sinope

MOESIA

•Traperus

Sardion

Skoplie

THRACE

Sebastea•

Constantinople •Chalcedon
•Nicomedia

Tigris

Salonica

•Nicaea

Daras
•

•Caesarea

RICUM

Smyrna

Iconium

•Edessa

Athens

•Miletus

Taurus

Seleucia•

Antioch
•Chalcis

Circesium
•

E M P I R E

•Apamea

Euphrates

Crete

Cyprus

Tyre•

•Damascus

S e a

Jerusalem•

Dead
Sea

Alexandria
•

E G Y P T

Ravenna, San Vitale, interior of chancel looking over the altar into the apse, constructed in the 520s and decorated c.546–8

In the apse is Christ flanked by angels, and in the panel below and to his right is the mosaic showing Emperor Justinian offering a golden bowl, while below and to Christ's left Empress Theodora is shown offering a golden chalice (not visible here). Below Christ, at ground level, is the bishop's throne, visible above and directly behind the altar.

centuries). In western Europe, the sixth century sees a declining amount of artistic production, but also an emerging pattern of spectacularly original works, often patronized by rulers.

San Vitale at Ravenna

The church of San Vitale was unusual, being not a basilica but an octagon with projecting altar area (chancel). Constructed near the beginning of Justinian's reign in the late 520s, this plan may represent an interest in emulating the latest fashion in the imperial capital, where Justinian's Hagia Sophia was only the most spectacular of a number of domed churches, and probably also indicates a special importance of the martyr-saint over whose grave the church was constructed. Just before the end of Justinian's war of reconquest, in the 540s, the chancel was redecorated with mosaics, which like the architecture of Hagia Sophia both reflect venerable traditions and embody striking novelties [60]. The emphasis in Sidonius' description of the new church built in the later fifth century in Lyons [page 88 above] foreshadows the brilliant peacock palette of blue, green, and gold colours dominating the San Vitale mosaics. In aesthetic terms they are a triumph of excess, arranged in complex interlocking fields upon irregular curving surfaces, carpets of intense colour alive with figures, too much to be taken in all at once. Hagia Sophia itself provides the greatest example of such visual intensity, whose virtually miraculous effect was noted by contemporaries. Procopius' awe-struck description of Hagia Sophia acutely notes how

vision constantly shifts round, and the beholders are quite unable to elect any particular element which they might admire more than all the others. No matter how much they concentrate their attention on this side and that, and examine everything with contracted eyebrows, they are unable to understand the craftsmanship and always depart from there amazed by the perplexing spectacle.[1]

In the lunettes flanking the altar at San Vitale are Old Testament representations of sacrifice, including Melchisedek offering bread and wine, as in Santa Maria Maggiore [54]. Here, however, the neat compilation of a narrative cycle achieved during the fifth century is abandoned for a signitive linkage reminiscent of earliest Christian art. Melchisedek does not appear with Abraham, as the biblical narrative indicates and as Santa Maria Maggiore represents, but instead with Abel offering a lamb (Genesis 4: 4), the first sacrifice acceptable to God, another reference to the eucharist. Abel and Melchisedek occupy the same visually signitive space, flanking the image of a single altar, despite being quite separated by geography and history, linked only by the theme of offering. That theme is carried through much of the decorative programme.

61

Gold bracteate from Akershus (Norway), c.600.

The border is made up of two highly stylized serpents, their open jaws meeting together at the top, with round head and eye behind. In the central medallion is a scene ultimately abstracted from Roman coin types with the triumphant mounted emperor [**12**]. Here the great curve at the centre evokes the horse's powerful neck, leading to a round head with eye, the lower jaw extended as interlace entwined with the extended legs.

At each side of the apse are images of Justinian and his empress Theodora, as if making processions to present gifts to the church's altar, arranged so that the gifts are directed to Christ himself. He sits above them in the apse, on the blue globe of the world as his throne, flanked by his angelic guard. At his left is Bishop Ecclesius of Ravenna offering a model of the church whose construction he oversaw, and at his right the martyr Vitalis receives the crown of eternal life.

Christ wears the purple robes associated with the emperor, and indeed worn here by Justinian (and Melchisedek) below and before him, but although the composition depends upon formulae of Majesty and Liberality [**28–32**], the entire setting is transfigured into something new. The decoration is active, seeming to move forward towards the real centre of the programme, the altar where the liturgical services were performed. Directly above the altar appears the heavenly Lamb, in a medallion borne by angels. On the upper side walls are the four Evangelists with the beast-Symbols, who represent the sacred Gospels both as the words and story of Christ on earth and as the sacred book upon the altar. The arch marking the entrance to the sacred space depicts Christ and the twelve apostles who represent the Church in the world.

Made for the same Archbishop Maximian who is depicted standing next to Justinian in the mosaics of San Vitale was a remarkable episcopal throne [**59**]. As in the case of the San Vitale mosaics, the style and iconography have many links with art of the eastern Mediterranean, and its manufacture has been assigned to virtually every conceivable centre, including Ravenna. The artist was clearly a master, and very likely would have needed to travel, or certainly to seek commissions from a wide area, for work of this sort can never have been commonplace. The style was a court style, the material court material, and the artist essentially a court artist, whether working for the imperial court in Constantinople or the archbishop's closely connected court in Ravenna.

Style II metalwork

The preceding chapter touched upon the emergence of a court style in precious metalwork using the cloisonné technique, appearing in luxury objects from Spain, northern Italy, and northern France. During the sixth century this style became even more complex and ambitious, enriched by mixture with other materials and techniques. A distinctive new manner of highly abstracted animal ornament, relying upon complex interweaving patterns of ribbon interlace for its rich and turbulent effects, called Style II animal art by archaeologists, emerged suddenly in the second half of the sixth century and spread rapidly across western Europe. It appeared early in Scandinavia, on gold bracteates and other pieces of luxury jewellery [**61**], and the apparently

un- or anti-classical character of this highly abstract style tempted early scholars to see its origin in the barbarian far north, allegedly untouched by Roman culture. More recently, strong cases have been made for the style's origin in Anglo-Saxon England, Merovingian Francia, or Lombard Italy, and indeed the last seems very probable, for the best precedents for the ribbon-interlace are not northern works of any sort but Mediterranean floor mosaics and textiles, a 'woven' style seeming especially natural in the latter.

In mature examples of Style II metalwork, from the period around the turn of the seventh century [**62**], abstracted animal motifs such as the great hooked beaks and sharply bent eye-ridge and powerful curving neck of the eagles that were a common theme in earlier aristocratic jewellery [**50**] appear with another creature, a serpent or even dragon, laid over the first beast, with its raised head at the narrow end and its spine running down the spine of the fibula. The difficulty of seeing the interlocking patterns is here embraced as an aesthetic, and conceivably iconographic, goal,[2] while the serpent motif is unambiguously repeated on the underside of the pin. The brooch's maker signed his work, in Latin script and words: 'May Uffila [the woman for whom

62

Bow-fibula from a wealthy female grave at Wittislingen (south-west Germany), back [left] and front, late sixth or early seventh century (160 mm L)

Here the cloisonné setting of garnets occurs with such other techniques as green glass, gold filigree, silver, and niello (silver oxidized to black).

63

The Mass of St Gilles, a fifteenth-century painting by the Master of St Gilles

The priest is elevating the eucharistic host at the moment of its consecration and transformation. Standing on the back of the altar, used as a late medieval retable, is the altar frontal given to St Denis by King Charles the Bald in the ninth century. Above it is one of the abbey's most prominently displayed treasures, the cloisonné jewelled cross made by St Eloi of Noyon.

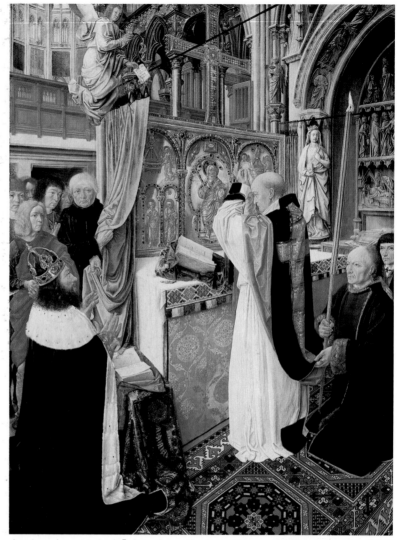

the jewel was made] live happily in god . . . Wigerig made this.' Although the evidence of pride in superlative craftsmanship may represent a broader phenomenon, the inscription itself like the design of this stunning jewel is without close parallel.[3]

The jewelled golden *sellae* (thrones, or perhaps saddles) made for King Chlotair II, which brought Eligius royal attention and patronage, have been lost. Yet works attributable to his hand survive in the settings of an ancient sardonyx cup, at Saint-Maurice d'Agaune, and of an ancient plate, from the royal monastery at Saint-Denis. Early modern engravings record the beautiful cloisonné chalice made for the royal nunnery at Chelles, and a fifteenth-century painting includes the great cross made for St Denis [63], still exhibited on the high altar nearly 1,000 years after its manufacture, but now surviving only in fragments. The luxurious royal cloisonné style was widespread across western

64

Book covers of Theodelinda, late sixth or early seventh century. Given by Queen Theodelinda to the church of John the Baptist at Monza, which she herself founded

The book contained within this glorious cover is lost. It must have been magnificently produced, possibly with gold or silver letters, but the theory that it was a Gospel book given to the queen by Pope Gregory the Great is unlikely.

Europe in the late sixth and early seventh centuries. Indeed, some of the best comparisons for the lost St Denis cross by Eligius are found on the jewelled book covers presented by the Bavarian princess Theodelinda, queen to two successive Lombard kings in Italy, to the cathedral at Monza [**64**], near Milan. Combining the cloisonné technique with gems set on the surface, and with lengthy inscription giving the queen's name, the covers (like Eligius's work for St Maurice) included ancient cameos, set in the four quadrants, suggesting that this novel artistic technique was ancient, traditional. The themes of originality, antiquity, luxury, and royalty come together again in the richest burial yet discovered from the early medieval period, from Sutton Hoo on the East Anglian coast of England [**Map 4**].

The Sutton Hoo ship-burial

Fifty-six burials have hitherto been identified at Sutton Hoo, dating from the later sixth to early seventh centuries, and varying widely in the internment ritual. Twenty are associated with mounds and many of those with significant grave goods, the balance without, and generally either lacking grave goods or having less numerous and elaborate deposits. Of the 20 with mounds, six seem to have been inhumation burials, six cremations. One of the mound burials included a horse, recalling the burial of Childeric the Frankish king, and two included large ships. The larger of these, Mound 1, which miraculously escaped

Map 4 The British Isles, *c.*700

0 50 100 miles
0 50 100 150 km

St Ninian's Isle●

Birsay●

KINGDOM OF THE PICTS

Nectansmere
●

Dunkeld●
Iona● FORTRIU St Andrews
Clatchard Craig● ●Norrie's Law
Dunadd● Edinburgh
DAL RIADA Dumbarton● ●
STRATHCLYDE B E R N I C I A
Melrose● Lindisfarne (Holy Island)
N
O
R
Moylarg T
Derry● Crannog● H
DAL RIADA U RHEGED Hadrian's Jarrow
ULSTER Bangor M Wall ●
B ●Monkwearmouth
Clogher● Lough ● Whithorn R Carlisle●
Neagh Whithorn I Durham
Armagh● Nendrum A
●Whitby
Isle of
Ardagh● Man DEIRA

CONNACHT ●York
●Kells Humber
Clonmacnoise● Durrow● ●Tara
Clonfert● Lagore LINDSEY
Kildare● Liffey Dublin Anglesey ●Lincoln
LEINSTER GWYNEDD ●Bangor ●Chester
Killaloe● WELSH MIDDLE
Derrynaflan Glendalough Peterborough● EAST
Ardagh● ●Cashel POWYS ANGLES ANGLES
EOGANACHT St Mullins K Worcester
MUNSTER ●Lismore I Offa's MERCIA
N Dyke ●
Cork● G Sutton Hoo
D Hertford Ipswich
CEREDIGION O ● ESSEX
St David's● DYFED M Llandaff● London Island of
S Thanet
Dinas Powys● Thames ●Canterbury
Glastonbury KENT
● Winchester
W E S S E X ●Hamwic SUSSEX
Exeter●
CORNWALL Isle of Wight

Remarkable testimony to the social importance of superlative artistic craftsmanship is provided by the career of Eligius (Eloi in French). Born about 588 and apprenticed to the moneyer Abbo in Limoges, in south-western Francia, he eventually rose to be named bishop of Noyon in 641, and played an important political role in the Frankish kingdom while continuing his metalworking until his death in 660. Eligius came to be venerated as a saint, patron of goldsmiths, whose Life was written by his contemporary Audoin. Although Eligius is exceptional rather than typical, renowned as a saint who was also a goldsmith rather than as a goldsmith who was also a saint, his achievement of high social position in the first place depended upon his skill. It is noteworthy that this young man apprenticed to a craftsman in the late sixth century was manifestly literate, or he never could have held office as a bishop. Noteworthy also are the wide circle of his fame and activities across the Merovingian kingdom, and his association exclusively with monasteries having intimate connections with the Merovingian royal court.

plundering, was the source of the remarkable grave goods so strongly associated with the site from the time of the initial investigation hurriedly undertaken in the summer of 1939, as war clouds gathered over Europe. The individual buried in Mound 1 was manifestly of great wealth and prestige, if not altogether demonstrably a king. The most likely candidate is Redwald, at least in Bede's opinion greatest of the East Anglian kings, who died probably between 616 and 628. The diversity of burial rites suggests that this was a moment of cultural crisis, and indeed the Anglo-Saxon rulers of England remained pagan until gradually converted to Christianity over three generations, with many crises and lapses, during the seventh century. As may be argued in many other cases, the artistic culture at such moments of great change is often associated with accelerating demand for luxury materials that could assert the status of those at the top of a highly unstable social hierarchy.[4]

The Sutton Hoo cemetery was a product of special circumstances, a fundamentally unique complex rather than a chance survivor of a 'typical' Germanic royal burial. 'The signals which emanate from Sutton Hoo are specific, the cry of a people at once pagan, autonomous, maritime and concerned to conserve an ancestral allegiance with the Scandinavian heartlands'[5] at a time of serious threat, namely from Christianity and the linked issue of subjection to Frankish quasi-imperial authority. Both the allegiance to the past and the connections with Christian and Frankish traditions are seen in the artistic contents of the burial, especially the great jewellery, which perhaps suggests a stronger Christian element than other evidence. In his *Ecclesiastical History of the English Church and People*, written a century later, Bede remembers that Redwald 'tried to serve both Christ and the ancient gods, and he had in the same temple an altar for the holy Sacrifice of Christ side by side with an altar on which victims were offered to devils'.[6]

Gathered around the body of the great man was a rich horde of treasures. He had a silver helmet, and a great shield with metal fittings of eagle and dragon, and other military equipment. Ten large silver bowls nested one inside another, all decorated with medallions and crosses, all produced in the eastern Mediterranean in the late sixth century,[7] and thus relatively rapidly translated to the other end of the Christian world through some process of trade or diplomatic exchange. Other silver objects included a fluted silver bowl with female head, close to the Esquiline Treasure [39–41], a silver ladle, and two spoons, a type of object widely used in the late Roman world that was commonly buried in 'barbarian' graves as an exotic curiosity. A very large stamped dish produced in Constantinople during the time of Emperor Anastasius (AD 491–518) appears to have been chosen to carry the ashes from a cremation. There was something that may have been a kind of royal standard, and a strange fine-grained stone object decorated with eight human heads, perhaps a ceremonial object of authority like a sceptre. There was gold, 37 gold coins from late sixth- and early seventh-century Francia, all but two showing a profile head in the tradition of Roman numismatics, here presumably representing a Frankish king even though only one carries a royal name. As well as providing the best evidence for dating the burial, not much before 620 and probably but not certainly relatively soon thereafter, the coins provide strong evidence of the centrality of connections with Merovingian Francia for the Sutton Hoo burial in particular and for seventh-century Britain in general.[8] Some of the great cloisonné jewellery may have originated in the Frankish territories, and even that made locally draws upon Frankish imported materials, techniques, and styles.

Also in the burial was the finest Celtic-style bronze hanging-bowl yet discovered, one of a class of some 70 survivors, associated with areas of Britain not settled by Germanic people, but found in a number of Germanic graves as either loot or treasure. Already old enough to have needed repair prior to its burial, the cauldron-like bowl was decorated with a series of eight wonderful escutcheons using various glass-enamel techniques. Although ultimately a heritage from the highly developed Roman glass industry, there is scant evidence for production of glass enamel in western Europe outside Celtic Ireland and Britain.[9] Some glass-enamel work was imported from eastern Mediterranean sites, in the form of rings and brooches, and notably a wonderful reliquary with a fragment of the true cross acquired from Constantinople by Queen Radegonde for her monastery at Poitiers, but that work provides no real precedent either in style or technique for the Sutton Hoo escutcheons [65].[10]

Joining the rich collection of ancient and imported material buried at Sutton Hoo were the extraordinary objects most likely produced

66

Gold buckle from Sutton Hoo, first half of seventh century, gold, probably south-eastern England (or Sweden?) (132 mm L)

Almost a pound of solid gold, with raised bosses as part of an elaborate latch system that allows the hollow buckle to be opened, perhaps to contain a relic, like a small group of carved bone buckles from Burgundy and one other slightly later piece from England. Around the bosses seethes a remarkable asymmetrical composition of biting Style II animals, their bodies stretched to interlocking ribbons enlivened by long series of dots set off by niello.

Sutton Hoo ship-burial, escutcheon from the hanging-bowl, fifth or sixth century

Around the rectangular border in reserved bronze is a beautiful pattern of linked whirling spirals associated with a style of Celtic works across western Europe, the so-called La Tène style. Most remarkable are the tiny repeat-patterns arranged as chequerboards or rosettes, created by assembling coloured glass rods, fusing, stretching to reduce, and then slicing them, producing the aptly named millefiori (thousand flowers) enamel.

locally, either in Anglo-Saxon England or in Francia, probably for the wealthy and powerful man interred there. Despite some parallels with other objects, the common characteristic among these great jewels is their uniqueness. The sword fittings recall those from Childeric's tomb, but include amazing cloisonné round bosses and square pyramidal ornaments with staggering design and technique for which there are no real parallels. On the great buckle [66] two serpents occupy the circle where the tongue is attached, and from which or behind which emerge the largest motifs, eagles' heads with pronounced brow ridge and curved beak, recalling the Wittislingen brooch [62], while the large plate is covered with crouching quadrupeds entwined with more serpents. Most remarkable are the slightly unmatched pair of hinged shoulder-clasps [67]. Their function cannot be established by comparisons, for no comparable objects exist. Their size and shape seem best

Hinged clasps from Sutton
Hoo, first half of seventh
century, probably south-
eastern England (each
127 mm L)

The decoration is on each of
the component wings divided
into three sections, a large
rectangular field, a border for
that field, and a curved
terminal, all created (in spite of
appearance to the contrary)
using the cloisonné technique.

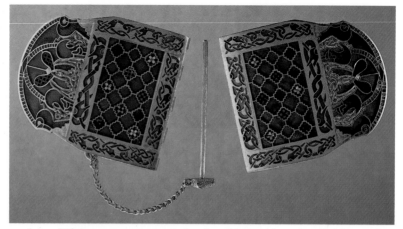

explained if the were worn over the shoulders and used to hold together
the front and back of a heavy garment. The best, the only, real compar-
isons for such objects are found in ancient Roman imperial contexts,
for example on cuirass statues like the famous Augustus from
Primaporta, leading some scholars to see a deliberate assumption of a
Roman heritage as well as a concerted and sophisticated search for
visual prototypes.[11]

The rectangular fields have a continuous all-over pattern that may
be seen as interlocking addorsed step-pyramids in two different sizes.
The larger pyramids are all filled with cut red garnets, as are the half-
pyramids and quarter-pyramids around the edge, with which they
constitute a 'background'. The smaller pyramids make the pattern or
figure, and alternating between cut garnets are eight more elaborate
patterns of blue, red, and white millefiori glass arranged in chequer-
board patterns. Set within the addorsed step-pyramids, however, they
create cross-patterns strongly suggestive of Christian symbolism. The
occurrence of similar cross-patterns on the pyramidal scabbard-
mounts and round bosses makes coincidence unlikely, especially in
light of the crosses on the imported silver bowls. The millefiori glass
appears here for the first time outside the Celto-British context, but is
used in a thoroughly different manner. First, the glass includes,
uniquely, a transparent red, evidently emulating the effect of garnet,
the red of earlier Celtic enamels being opaque. Second, the millefiori
panels are not set in a glass-enamel field to which they are joined by
firing, but are cut and set within cells, as if they were garnets or other
cut stones. The unprecedented technical invention continues in other
aspects of the design. The borders around the field comprise biting
Style II animals in series, but appear as if carved into solid gold back-
grounds. They are in fact built up within cell walls, but many of the
cells are covered with thin gold sheets creating the appearance of a solid
ground. These 'lidded cloisons' are unprecedented, and evidently con-
stitute another technique for achieving one of the effects sought and

achieved in the adjacent rectangular field of the clasp, and in such Style II objects as the Wittislingen brooch, an ambiguous visual play between figure and ground.

The ultimate achievement in this aesthetic game is represented by the curved end-pieces of these clasps. These first appear chaotic, then perhaps seem to suggest the crown of a helmet seen head on. The unprecedented use of huge individually shaped plate-garnets helps the viewer begin to read, really to decipher, the pattern, two great charging boars locked in combat. The straight line where the curved end meets the rectangular frame represents the ground. The two long irregular garnets that touch the ground, identical but in mirror-reversal, are rear legs of the two boars, short but with powerful hams leading to tiny hooves. Behind each leg is the small curved tail, from which begins the arching back. The two backs meet at the top in a diamond pattern, then continue downward towards the boars' heads. Each back is created through tiny rectangular garnets set as if on end, brilliantly evoking the raised hairs on the back of an enraged boar, a masterful use of an abstract language to convey naturalistic content. Each spine ends at the head, just behind the pointed ear. Except for the almond-shaped eye and the lower jaw, stretching to the ground, the entire head is made from one large plate-garnet, ending in the flat snout, just touched by a pointed blue tusk springing from the lower jaw. The muscular upper section of each foreleg is a pear-shape made to stand out from its surroundings by being executed in chequerboard blue-and-red millefiori wafers. The lower legs stretch down towards but fail to reach the ground, the raised forelegs suggesting either the beasts pawing the ground or, more likely here, the legs raised as the boars smash together, driving into and through each other. To help clarify the patterns, the artist uses lidded cloisons at the lower corners, and fills the areas of the 'ground' with patterns of twisted gold wire filigree, making little serpents.

One possible explanation for the invention of the shaped plate-garnet technique used here is the desire to clarify a natural form, so that it could carry an implicitly narrative and potentially symbolic content. Yet when actually worn on the shoulders, the pieces would necessarily have been seen upside-down (except from the vantage point of the wearer). Only when admired out of context, as works of artistic craft rather than part of an elaborate ritual dress, could their details be seen and appreciated. In the official context, their effect could only be more generic, gleaming and flashing, rich, golden, exotic, and strange. The master artist who planned these works may have worked with several assistants, and may have imported some of the raw materials such as cut garnets more or less ready-made. Counting all the Sutton Hoo jewellery there are some 4,000 garnets. Estimating on the basis of modern practice that (given the complex shapes) it might have taken

1½ days to shape each garnet, yielding 6,000 man-days total, it would take a team of 17 craftsmen a full year to produce the garnets alone.[12] Even if this figure is too high, these great objects manifestly represent a complex social effort, involving many craftsmen and extensive trade relations. However, Rupert Bruce-Mitford hypothesized a single master in charge of the work, and in my view the coherent style of the great pieces makes this seem likely. To state the ethnicity of this master is not only impossible but meaningless. The master knew and drew upon Frankish, Celtic, and Scandinavian as well as Anglo-Saxon materials, techniques, and styles, very likely moved within these linked cultural spheres in search of training and employment. Even if we knew his mother tongue or his father's name it would not really change or enhance our understanding of his art, which is the product of his own genius taking advantage of a rich patron and an exciting opportunity at a moment of great cultural ferment.

The Sutton Hoo master's strongly marked personal style is related to the specific context, and to the broader trends of the period, but remains individual, and original. To be sure, the 'originality' is not identical to the concept in modern art theory and historiography, but that his work was valued in part for its distinctiveness, for the fact that no one had ever seen the like, seems undeniable and essential. Of course it is important to note that early medieval works, like those of other periods and culture, can always be seen as belonging to a series, here Style II cloisonné. Still I see little to be gained by proposing the neologism 'inventivity' as a way of diminishing the intention by the artist and understanding by the viewer that something essentially new was being produced,[13] in the Sutton Hoo jewels as much as in Justinian's Hagia Sophia. Obviously good craftsmanship and fine materials are always valued, but during this period the concentration upon small numbers of extremely elaborate items, often created by novel techniques and in novel styles, seems especially prominent.

Later chapters consider this aesthetic attitude favouring extraordinary and varied craftsmanship in textiles and especially in the field of book decoration, in the latter marking a really decisive new phenomenon. In closing this discussion of luxury craftsmanship and prestigious metalwork, it is important to note the direct transference of styles and techniques to Christian ritual objects. An altar service found at Derrynaflan in southern Ireland in 1980 included a chalice, a paten, a stand for the paten, and a strainer [68]. The primary material of the major objects was silver, in a sense continuing the traditional favour of that material for high-prestige objects going back to the later Roman period. Here the silver was enriched through many additions, including amber studs, enamelled glass studs in a pseudo-cloisonné technique, elaborate panels of stamped gold foil, and extraordinary panels of gold filigree. The use of a code of letters to guide the assembly

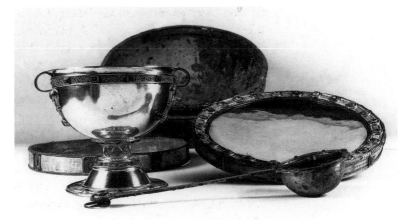

Derrynaflan (Co. Tipperary) Hoard, view of strainer, chalice, paten stand, and paten with covering bronze basin under which they were buried, Ireland, eighth–ninth century (paten diameter *c.*360 mm, chalice height 192 mm)

Derrynaflan was the site of an important early Irish monastery, and the liturgical objects were deliberately buried, probably between the ninth and twelfth centuries, probably to protect them from Viking or Irish raiders. The objects were not made as a set, the paten dating probably from the eighth and the chalice from the ninth century, but were assembled for display in an important monastic church.

of the paten from its many separately manufactured constituent parts suggests that if the artist was not necessarily literate, as is likely, he was working closely with someone who was. Although drawing extensively upon local craft traditions, and employing current distinctively Insular styles of interlace and animal ornament, it seems likely that the Derrynaflan silver was also seeking to emulate and even rival the liturgical silver used in the great basilicas of Rome. It should be noted, however, that the function of the objects was almost certainly primarily or even exclusively display, for the paten in particular is so delicately constructed that it is unlikely ever to have been regularly used in liturgical rites.

Saints and Holy Places

7

Over the tomb of St Martin of Tours the visitor could have read: 'Here lies Martin the bishop, of holy memory, whose soul is in the hand of God: but he is fully here, present and made plain in miracles of every kind.'[1] The inscription encapsulates many of the fundamental themes of the cult of saints: the physical body, remembrance, intimate connection to God, miracles, and living presence among the faithful who come to his tomb.

When Pindar announced that the 'happiness sweeter than honey' of a famous victory in the horse race at Olympia, celebrated in his poem, is 'best that can come to a man', he articulated an ideal central to early classical society but passing from the late antique and early medieval world.[2] Saints were the 'spiritual athletes' of the late antique and early Christian world, the heroes of a new quest, a new society intensely pursuing the honeyed sweetness of heaven, a foretaste of which might be experienced even on earth. Their number included the apostles and leaders of the early church, and then the martyrs, far more numerous, who suffered death for their faith. Christians believed that the souls of the martyrs went directly to heaven, and already in the New Testament their bodies are linked with the altar upon which the lamb of God was sacrificed: 'I saw under the altar the souls of them that were slain for the word of God' (Rev. 6: 9). Martyrs were conceived by St Augustine and others as mystically merged with Christ himself, as the members of his own body.[3] After Constantine's conversion, however, the path to martyrdom closed for most citizens of the Roman world. The drive for salvation, for spiritual purity, and for closer union with God perforce took other forms, notably a search for closeness to a holy man or woman, the compelling exemplar of the best that a person could be, or the pursuit of heaven-centred life in a monastery.

Like the first great Christian holy man of late antiquity, the miracle-working Antony, whose *Life* by Bishop Athanasius of Alexandria quickly circulated throughout the Christian world as a model for the new ideal,[4] Martin of Tours sought God through asceticism and simplicity. Himself stemming from a family of ordinary soldiers, his *Life*, the first classic of the genre from western Europe, was written by his close associate Sulpicius Severus, a member of the same Gallic

aristocracy as Ausonius and Sidonius [see Chapter 4]. Sulpicius tells us that he had seen some other bishops 'sitting upon a lofty throne raised high upon a kind of royal dais [cf. **59, 60**], but Martin would be seen sitting on a rough stool, such as is provided for slaves'. Martin was so notably humble that he was happy to exchange his own tunic with the filthy garment of a beggar.[5] During his life he 'had the gift of healing in such a degree that a sick man hardly ever came to him without at once being cured', and he even restored the dead to life.[6] After his death, many Christians believed that, like the martyrs, such a great saint ascended directly to heaven, where he might continue to aid his devotees. Martin's successor as bishop of Tours in the late sixth century, Gregory of Tours, wrote that when at the Last Judgement he would be condemned by Christ for his sins, Martin would take him by the hand and cover him with his sacred cloak, and thus win his salvation.[7]

Death and dead bodies were thought repugnant in Graeco-Roman antiquity, burial being always outside the city. The Christian cult of the holy dead and cultivation of their bodies thus marks a dramatic change in the actual as well as the spiritual landscape. The first great exception in the capital was made for Trajan, who after being declared a god by the Senate was buried at the base of his triumphal column [**5**].[8] The form of this monument captures an essential motif of later saints' cults, a vertical axis linking earth to heaven, the soul raised to heaven while the body remained on earth. Usually the motif is conceived metaphorically, but two of the most famous holy men of late antiquity, Symeon the Stylite the Elder (d. 459) and the Younger (d. 592), received their sobriquet (stylite=columned) because they literally spent decades alone on top of a column. Both were represented in this distinctive context, in the latter case in a large class of stamped clay tokens [**69**], almost like holy souvenirs, made from the clay at the base of the column, and thus linking an image with a material (if secondary) relic.

Inscriptions on such tokens presented them as *eulogia*, 'blessings'. Like so many of the great early saints, these holy objects originated in the eastern Mediterranean area, but many were brought back to

69

Pilgrim token, St Symeon the Younger, clay, Syria, sixth or seventh century (38 mm diameter)

The bust of the saint is represented on top of the column, while an angel brings a crown from above. The fragmentary condition may be due to the breaking-off of pieces to be consumed as medicine in hopes that the saint would mediate a cure, as contemporary collections of miracle stories attest.

Ampulla from Jerusalem,
silver repoussé,
*c.*sixth–seventh century,
*c.*5 cm diameter

The Crucifixion occupies the upper half of the image, with a bust of Christ rather than a full figure, although full figures of the crucified thieves are at either side. Stephaton and Longinus offer a vinegar-soaked sponge and stab with a lance, respectively. At the bottom the tomb is represented as a domed building with lamps, with the angel at the right and women at the left.

western Europe by the pious pilgrims who had been visiting the Holy Land in large numbers since the fourth century.[9] Several dozen small metal ampullae (appearing like silver but largely base metal) dating from the sixth and seventh centuries are preserved in the treasuries of Monza and Bobbio in northern Italy, perhaps a collection associated with Queen Theodelinda [see also **64**].[10] Their imagery relates to the holy sanctuary where the ampulla was received by a pilgrim, and where it was originally filled with holy oil, images of the Adoration of the Magi decorating ampullae from Bethlehem, and images of the Crucifixion and the empty tomb of Christ those stemming from Jerusalem [**70**]. In this example the figures at the foot of the cross could be understood as Roman soldiers gambling for Christ's garments (Matthew 27: 35), depicted in many later images [**4**], but it seems more likely that they here represent the Christian pilgrims kneeling in prayer before the jewelled cross on Golgotha that marked the site of the Crucifixion. This imagery is not exclusively, perhaps not even primarily, historical, external to the viewer and located in the past, but contemporary, 'present', and virtually including the viewer through the presentation of figures engaged in the same ritual actions.

Holy tombs

Writing to Rome from the Holy Land in 403, St Jerome exulted that 'the City has moved its seat', that the ancient pagan shrines of Rome, even on the Capitoline itself, were falling into silent dilapidation, while crowds left the city to gather at the tombs of the martyrs.[11] An important example of the kind of shrine to which Jerome refers is a

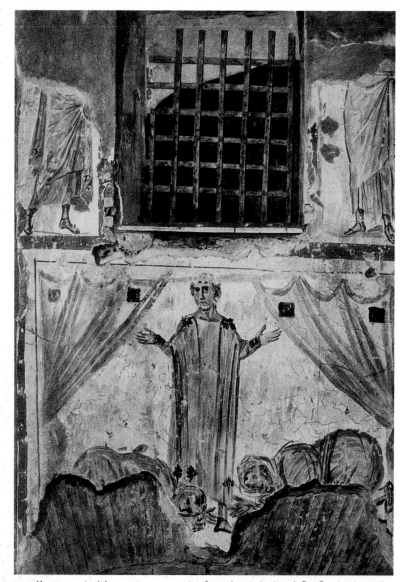

On the lateral walls are images of a man and a woman making offerings, perhaps a specific man and woman who arranged for the decoration of the shrine but clearly also mirroring all subsequent pious visitors. Above them are images of the trial and martyrdom of the saint, the earliest preserved hagiographic narrative.

small *memoria* (the common term for a burial place) [71] which is the earliest surviving example of bodies translated into Rome for reburial there. The visual focus is the standing saint, probably Cyprian, martyred bishop of Antioch, arms outstretched in prayer. Two figures kneel humbly at his feet like the two figures at the foot of the cross on the Bobbio ampulla, as he lifts hands and head and spirit towards God, interceding on behalf of his devotees. The motif of curtains drawn aside, as if to reveal a vision or apparition upon a stage, suggesting a different kind of reality, is one that will reappear in images of inspired Evangelists. The visual and ritual focus is not, however, upon the images, but upon the opening covered by a grill, through which the corporeal remains of the saint could be seen, contained in his tomb.[12]

The chapel of San Vittore in Ciel d'Oro [72] shows the increasing tendency to associate the saints with the large congregational church, collapsing the distinction between sacred temples of the gods and sacred tombs of heroes that had been so fundamental in antiquity. San Vittore is still a separate structure, but rises immediately adjacent to the new basilica erected by Ambrose, bishop of Milan (d. 397), in one of the major suburban cemeteries. A small central-planned building, it is covered with a dome of pure gold mosaic, from the centre of which the half-length figure of the martyr Victor stares down as if from his soul's place in heaven upon his body's place in the ground . The image appears within a floral wreath suggesting victory (over death) and immortality, while the saint holds elaborate staff-crosses. The link between body and image makes a virtual axis like Trajan's or Symeon's column, as if opening a way towards heaven. Ambrose arranged for his own brother Satyrus to have priority along this sacred highway, having him buried immediately beside Victor, burial *ad sanctos*, near the saints, being widely conceived as increasing the chance of salvation with them. At the corners beneath the dome are images of the four Evangelists and their symbolic Beasts (of later date), while on the side

72

Chapel of San Vittore in Ciel d'Oro, at San Ambrogio, Milan, view into dome, fifth century

On one side stands Bishop Maternus of Milan between Sts Nabor and Felix, North African martyrs brought to a place of honour in Milan by Maternus in the earlier fourth century. On the other side stands Ambrose between Sts Gervasius and Protasius, whose relics he had himself brought to Milan, and whose bodies would flank his own in the adjacent basilica as they flanked his image in this chapel.

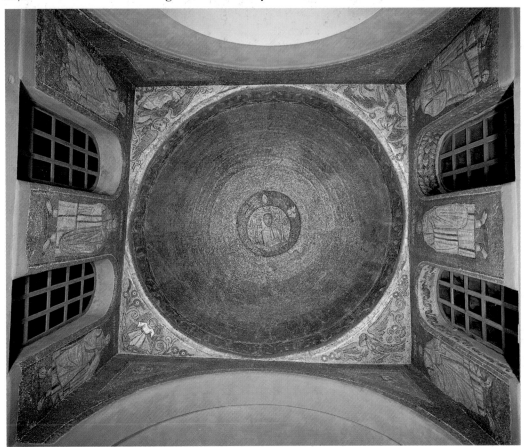

walls are six standing holy figures, guardians of the place and potent intermediaries for those who might come there.

San Apollinare in Classe, just outside Ravenna, provides a magnificent setting for the burial of the city's first bishop, not in a separate chapel but in a large basilica dedicated to him [73]. Apollinaris stands in the apse, directly facing the congregation and praying on their behalf to God. Above Apollinaris, floating miraculously in the sky, is the triumphant jewelled cross, emblem of victory over sin and death, here uniquely merged with a narrative image, the Transfiguration of Christ (Matthew 17: 1–6), cast in the symbolic language of lambs, as on the Junius Bassus sarcophagus [32]. The two lambs flanking the cross represent the prophets Moses and Elijah, and the three beneath represent the three apostolic witnesses of the moment when Jesus was 'transfigured [so that] his face did shine as the sun', while a voice from

73

San Apollinare in Classe, Ravenna, apse and mosaic decoration, c.550

Beneath the apse mosaic, between the windows, are images of other early bishops of Ravenna, successors of Apollinaris, while at the two extreme ends are large panels added in the seventh century, and based upon mosaics at nearby San Vitale, at the left a dedication scene and at the right Abel and Melchisedek at an altar, here joined by Abraham.

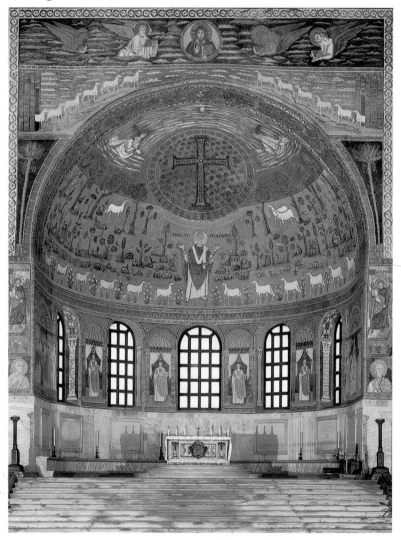

a bright cloud said 'this is my beloved Son, in whom I am well pleased'. It is difficult to imagine a more compelling assertion of the local saint as intermediary between the beholder and the incarnate divinity. Apollinaris was regarded as the first bishop of Ravenna, and also a martyr. When the church was completed and consecrated and the mosaic completed, in 550, it is likely that Archbishop Maximian was promoting Apollinaris' status as virtually apostolic, being a disciple of Peter stemming from Antioch. By promoting its founding bishop to apostolic rank, Maximian could hope to assert Ravenna's claim to be a worthy companion of Rome, Antioch, Constantinople, Alexandria, and Jerusalem as the seat of a patriarch.[13]

Apollinaris was a great local saint, but the most important holy figures could attract not only the local people to their cult, but pilgrims from afar. Local church leaders, bishops and abbots, embraced and encouraged, indeed helped create this new devotion. From the early fourth century, if not before, pilgrims travelled to the holy sites of Palestine and the surrounding region, but pilgrimages also developed in western Europe. The greatest early pilgrimage shrine in what would become France was built around the tomb of Martin at Tours. The first *memoria* for Martin's body was built (by his immediate successor) in the early fifth century, but two generations later it was grossly inadequate either to accommodate the crowds of pilgrims or properly to honour so great a saint. Bishop Perpetuus then built a new large church, into whose apse the saint's tomb was translated around 470. Placed behind the altar, sufficient room was allowed between it and the altar for the many pilgrims. Day-long and night-long access to the shrine was provided by a fenestella (a little window) much like that in SS Giovanni and Paolo, which linked the apse with the spacious atrium outside, where pilgrims could literally camp, sleeping beside the saint and hearing the services performed in his honour.[14] The arrangement is similar to that recently proposed for Santa Maria Maggiore in Rome [52], where an external chamber surrounded and gave visual access to the richly decorated holy shrine within the apse. Access to the holy body, so increasingly valuable, was also afforded by the construction of underground crypts, like that leading to Peter's tomb added to the Vatican basilica at the end of the sixth century by Pope Gregory the Great, which was subsequently imitated in northern Europe.[15]

New underground chambers were constructed as *memoriae*, as at Jouarre, east of Paris, founded by Abbess Theodechilde in the early seventh century [74], one of many important monasteries established by royal women. The importance of women in the late Roman artistic world, previously discussed [Chapter 4] in terms of jewellery and architectural patronage, continued and if anything increased in the sixth and seventh centuries. Holy women include Radegonde at Poitiers, who played a major role in disseminating the relics and cult of the holy cross, as

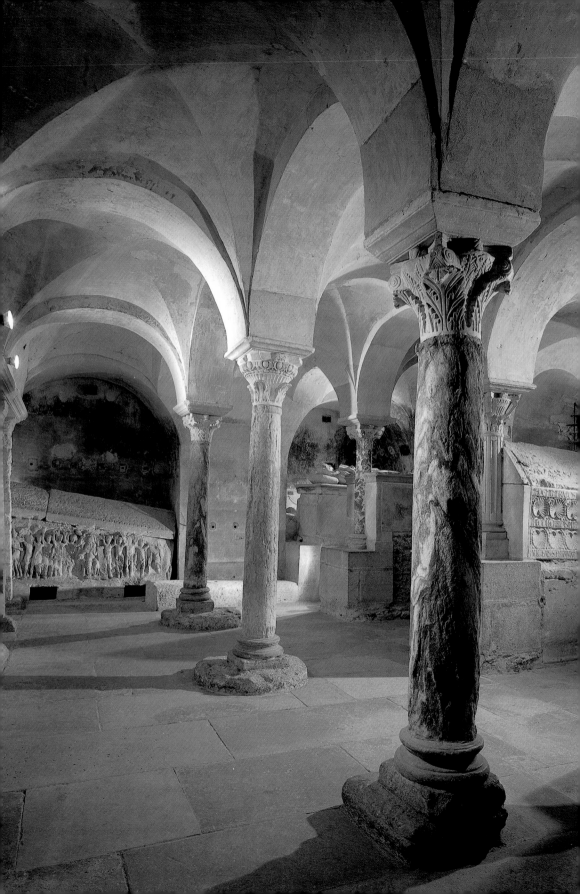

74

Jouarre, underground burial chamber, seventh century

The founding abbess was buried in a magnificent stone sarcophagus covered with carved shells, visible at the right, and St Agilbert, an Anglo-Saxon missionary who became bishop of Paris, was buried in a sarcophagus visible at the far end, with images of the saved souls rejoicing at the Last Judgement. Their arms, raised in prayer and celebration, recall the posture of Apollinaris and other saints, but now suggest the communion and identification of the faithful with their saintly patrons.

well as being the patron of the greatest poet of the age, Venantius Fortunatus. The great ladies of the court who entered monastic convents often became important patrons of artistic works, and in some cases actively engaged in their manufacture. The nuns of Chelles, near Jouarre, not only received a splendid chalice made by Eligius of Noyon, but developed a highly accomplished tradition of writing and decorating manuscripts during the eighth and ninth centuries. Founded *c*.664 by Balthilde, an Anglo-Saxon girl taken captive by slavers (at least according to her *Life*) who rose to be queen of the Neustrian Franks, the monastery preserved a linen tunic as a relic of their founder [75]. As the Christian

75

Chemise of Ste Balthilde, silk embroidery on linen, seventh century, produced at the monastery at Chelles for the founding abbess, and still preserved there

The embroidery presents an imitation of a great set of enamelled and jewelled pins and necklace, the latter featuring a pendant cross as its major element.

prohibition against burial with expensive grave goods was beginning to be observed more strictly, especially in the monastic centres where pursuit of a reformed and purified Christian life was the very reason for being, the embroidered images manage to conform to the new rules while maintaining the venerable tradition of richly furnished burials through what may be thought of as 'virtual jewels'.[16] These images, no longer real things but representations of them, nonetheless carry their devotional meaning, their social status, even perhaps something of their apotropaic function, protecting the holy body from attack by malignant forces. In this case the relationship between form, material, and content almost seem to have in effect returned to the Early Christian imagery of signs, virtually immaterial yet carrying complex and deep meanings. Yet the differences are ultimately more important. No longer is the relation between image and meaning primarily linguistic or symbolic, for the embroidered jewels capture in frozen flattened form the likeness of actual jewels, their brilliant colours, their scale and arrangement. Rather, they are almost like icons of jewellery, the central image like an icon of the cross. Moreover, the workmanship is beautiful, the silk material rare and costly.

The fragility of textiles has meant that remarkably few fabrics survive from the early medieval period, enhancing their rarity today. Luxurious textiles were always costly, in the descriptions of major gifts often taking pride of place even before gold and silver vessels,[17] and it is no coincidence that they survive for the most part wrapped around relics, or inserted in splendid altar books. Special vestments were an essential aspect of all liturgical service, and commonly exchanged as gifts, thus forming an attractive means of transmitting new visual ideas of form and ornament. Their loss also skews our understanding of artistic production in terms of gender, for the manufacture of cloth, especially richly embroidered cloth, was an important aspect of the lives of women within monasteries as well as in the secular world. A recently rediscovered group of textiles from the treasury of the church of Maaseik in Belgium may not entirely fill the lacuna, but at least indicates something of the nature and quality of what has been lost.

Brought from the nearby monastery of Aldeneik at the time of the Protestant Reformation were textiles long known as the *velamen* (veil) of St Harlindis and the *casula* (chasuble, a garment worn by a priest for the liturgy) of St Relindis. According to the *Lives* composed in the later ninth century, these two holy sisters founded the monastery in the early eighth century. Their education included 'work which is accustomed to be done by female hands in various ways and varied adornment, namely sewing and weaving, designing and working, and arranging gold and pearls on silk',[18] and a variety of richly worked fabrics were preserved at the abbey as relics of the founders. It is likely that these fabrics were actually made in England in the early ninth

century, for they include flat embroidery of threads wrapped with gold, being the earliest preserved examples of a technique later known specifically as *opus anglicanum* (English work).

Brilliantly coloured still, the embroidery on the *casula* originally comprised different items subsequently joined together, including rows of small medallions containing beasts, and rows of arches on columns framing intricately interlaced patterns of vines and animals [**76** and page 116]. In their original condition, the inner and outer borders of the arches were lined with pearls, now all lost, but creating an effect known from other textiles, ivories, and a range of illuminated manuscripts that contain painted versions of this feature. Perhaps most surprising is the woven silk fabric occupying the upper section of the *casula*. Against a red background appear interlaced medallions in a yellow-green colour, each having at its centre an enthroned figure seen from the side but turning to face the viewer, while holding aloft a staff, perhaps a sceptre [see page 116]. The inscription DAVID leaves no doubt concerning the figure's identity. Although it has generally been thought that silk-weaving was a jealously guarded preserve of imperial Byzantine workshops through the early Middle Ages, the forms of the Latin letters suggest, along with the design of figure and ornament, that this work might have been woven in western Europe (presumably from imported threads) long before silk-weaving was believed to occur there. A similar fabric was given by Pope Leo III to the Lateran Basilica:

Round St. Peter his mentor's altar, this God-protected, venerable and distinguished pontiff provided a red crimson all-silk veil to cover all four sides, with gold-studded panels and disks painted with various representations, with gold-studded stars and in the centre gold-studded crosses adorned with pearls, beautifully decorated on a wondrous scale, and put in place on feast days for adornment.[19]

76

Details from the *casula* of Sts Harlindis and Relindis, silk and linen, probably England, early ninth century. Already by the middle of the ninth century the textile was at the monastery of Aldeneik in the low countries, whence it passed to the Treasury of the parish church of St Catherine's, Maaseik

The upper central section shows a section of the woven red-silk cloth with repeated figures of King David enthroned [p. 116]. Shown here is one of several narrow strips, originally portions of different textiles, perhaps altar fittings, woven together much later.

The description is so like the composite 'veil' from Maaseik, including attached pearls as well as red silk cloth with golden medallions containing figural representations, that the traditional supposition that Leo's gift must have been produced in the east might be reconsidered.

Monasteries

Throughout this chapter mention has been made of monks and monasteries, which grew around the places where the saints lived and where their bodies were preserved, and where artistic works related to their cult were produced and exhibited. Monks truly come to the fore in the sixth and seventh centuries, especially in transalpine territories, and especially in connection with the great wave of missionary activity that converted to Christianity many of the remaining pagan groups, such as the Picts, Anglo-Saxons, and Frisians, and sought to reform and purify religious life in the already Christianized regions of Gaul and Italy. In Ireland this is the 'age of the saints', many of whom were founders of monasteries. Here I think of St Columba of Iona [**77**] among many others, especially Columbanus of Luxeuil, to whose monastic legacy I shall return in a subsequent chapter. Also from the British Isles is St Cuthbert, for whom we have two early *Lives* along with abundant sources related to the community of Lindisfarne, founded by the Irish missionary Aidan sent from Iona in 635.[20]

For Cuthbert we also have early relics, including his pectoral cross in cloisonné garnet work, and possibly his personal copy of the Gospel of

77

Iona (Scotland), monastery of St Columba. Founded in the later sixth century, the monastic buildings are from the late medieval rebuilding on the early site, but the tall stone cross, known as the Cross of St Martin, probably dates to the eighth century.

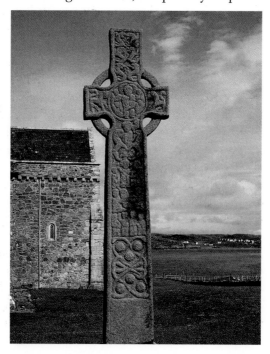

John, both probably buried with him, along with some other probably later items that came to be associated him, such as an episcopal stola with *opus anglicanum* embroidery.[21] Most remarkable in some respects is the coffin in which his body was placed at the time of the translation of 698, only 11 years after his death, for it is one of the rare survivors of what must have been a large class, carvings in wood. In this case carving is probably too grand a word, for the figures are simply rendered by engraved lines in the bare wood. They may not have been intended to be seen at all, the coffin having been wrapped in cloth and placed above the altar. The imagery is not decorative, then, indeed includes no ornament of any kind, but it does have an elaborate figural programme. On the lid is Christ surrounded by the beast-Symbols of the four Evangelists, at the head is the Virgin with the Christ child in her lap, and on the sides and foot of the coffin are eight archangels and the twelve apostles. Although probably related to a series of icons imported from Rome to northern Britain a few decades before, these images cannot have played a role as devotional or instructive images, and seem to have been primarily apotropaic, potent images bringing supernatural power to protect the holy body of the saint.[22] The saints, living and dead, became magnets attracting pilgrims and prompting luxurious artistic endeavours. On both grounds there was a potential conflict with the essential monastic vocation of poverty and separation from the world.

Monasteries were constructed as holy places, deliberately 'other' rather than normal, where those seeking a life most fully devoted to the pursuit of salvation could gather together in mutually supporting communities. Monasteries were often located by a holy place, as at Mt. Sinai, the monastery built by Justinian over the place venerated as the location of the Burning Bush, a site visited by Egeria in the fifth century, who found already a group of cells and a small church.[23] Others were located at a place sanctified by a holy person who either lived or died there, as Martin at Tours. Escape from the world may be literal, as in the island monasteries of Skellig Michael in Ireland, or Mont-Saint-Michel in northern France, or Iona and Lindisfarne in northern Britain. Mountain-top mainland locations like Benedict's Monte Cassino are joined by cliff-side locations like Benedict's first hermitage and later monastery at Subiaco, or Saint-Maurice d'Agaune, the latter powerfully associated with royal patronage, here not only with a royal founder but a saintly royal burial and healing cult.[24] Although monasteries could be and were founded in Rome itself and in other surviving urban centres, the examples just cited were much more usual in being located in the countryside. By the eighth century these new spiritual centres had spread across the Christian world, constituting a fundamentally new topographic as well as cultural system radically different from the urban-based civilization of the ancient world [Map 5].

Map 5 Some major monasteries in western Europe, *c.*550–800

Iona

Derry

Armagh

Whithorn

Durrow

Lindisfarne

Jarrow

Monkwearmouth

Ripon

Whitby

Crowland

Briadon

Malmesbury

Canterbury

Wimborne Nursling

Nor
Se

Gand

Nivelles

Fontenelle Corbie

Jumièges Laon

Chelles Echter

St Denis Jouarre

Faremoutiers Gor:

Loire Fleury

Auxerre Remi

Poitiers Luxeu

Flavigny

Longoretus Besançon

Charenton Autun

Vienne Agau

Atlantic
Ocean

Seine

Oviedo

Dumio Liebana

Uzès

Novaliciens

Ebro

Duero

Narbonne

Saragossa Ripoll

Toledo Vich

Merida Agali

Tarragona

Rhône

Mediterranean Sea

0 250 500 miles
0 500 1000 km

Fritzlar

Elbe

Lorsch

Danube

ach

eichenau Tegernsee Mondsee
 Kochel Salzburg
St. Gall Benedictbeuren
ntis
 Malles
ünstair

io
Nonantola

Black Sea

Danube

Ferentillo
Farfa
Subiaco
Rome
 Monte Cassino
 San Vincenzo
 al Volturno

Vivarium

San Vincenzo al Volturno, crypt
of Epiphanius, 824–42

Visible are the martyrdom of St
Lawrence and the martyrdom
of St Stephen. Elsewhere the
abbot is depicted kneeling at
the feet of the crucified Christ,
while in the main apse is a
figure enthroned in glory,
perhaps the Virgin as Maria
Regina (Mary the Queen of
Heaven), above a row of
archangels.

Whether or not in inaccessible (and coincidentally or not uncommonly beautiful) sites, monasteries were marked architecturally as places set apart, as with the High Crosses associated with monasteries in Ireland and in what is now western Scotland [77], or in Northumbria. Ironically, however, the special sanctity of monasteries attracted pilgrims, and the increasing role of monasteries as economic centres, often the direct forerunners of towns, and as producers and consumers of luxury arts, undercut their isolation. The nuns of Chelles, or those who produced the Maaseik textiles, were probably joined also by secular workers. Excavations carried out over the last decades at San Vincenzo al Volturno in southern Italy have revealed an early medieval monastery with an enormous building campaign of the early ninth century carried out by its abbot Joshua, testifying to its importance as a cultural and artistic centre. The architecture, sculpture, and monumental painting [78] were obviously carried on at the

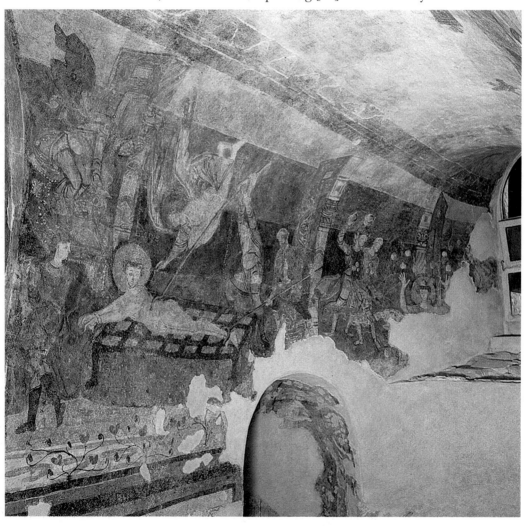

site itself, whether by members of the community or by skilled crafts-men brought in for the task. Excavations have also revealed workshops in which glass was if not made from scratch then at least refashioned, where plaques were decorated with glass-enamel and bronze bells cast using the lost-wax technique, and where the rare and highly special-ized art of ivory carving was practised. The monastery included notable wall-paintings, with the surviving fragments of the main church dedicated to the monastery's patron saint, the martyr Vincent of Saragossa, suggesting rich ornament and extensive figural iconogra-phy. Better preserved, and perhaps hinting at the nature and quality of what has been lost, are the paintings in the crypt of the smaller church on the site, carried out during the subsequent period of Abbot Epiphanius (824–42) [78]. Presumably an image of the climax of Vincent's life was represented in the crypt of the great church of Abbot Joshua, and indeed images of martyrdom and also other scenes of the saint's life were included some decades later in the crypt of the monastery of Saint-Germain in Auxerre, in France.[25]

The so-called Plan of St Gall [79] is a window opening onto early medieval thinking about the early medieval monastic site. It is impor-tant to emphasize that it is a written document, never actually built in anything close to the form 'planned', even the arrangement of the reli-quary altar of the patron saint handled entirely differently.[26] Although transmitted in a manner that remains unknown, essential elements of the plan, notably the arrangement of buildings around the cloister, did become common from the later tenth century in western monasteries. Similarly the provision for many altars within the main church, each marked with a square crowned by a cross, and located in both aisles as well as in the nave and both apses, is characteristic of monasteries built during the Carolingian period and later. Many altars where masses could be said simultaneously suggests that the community included a significant number of priests, and permitted the monastery to receive many properties in exchange for private liturgical memorialization.

Although commonly studied in relationship to built architecture, the plan has the character of an intellectual, almost a spiritual exercise, and is very much an example of monastic art, linked to manuscript dec-oration. The composition of the Plan of St Gall is two-dimensional, using the cross-shape of the transepted basilica in a manner that recalls the cross-pages decorating many books [90, 91], but here arranged with the central idea informing the plan, the cloister, placed at the very centre of the page composition. Written by scribes trained in the nearby monastery of Reichenau, probably at the command of their abbot Haito, in its literary form the Plan of St Gall is a letter with accompanying illustration, written from Haito to Abbot Gozbert of St Gall, responding to his request for thoughts about rebuilding his monastery: 'For thee, my sweetest son Gozbertus, have I drawn this

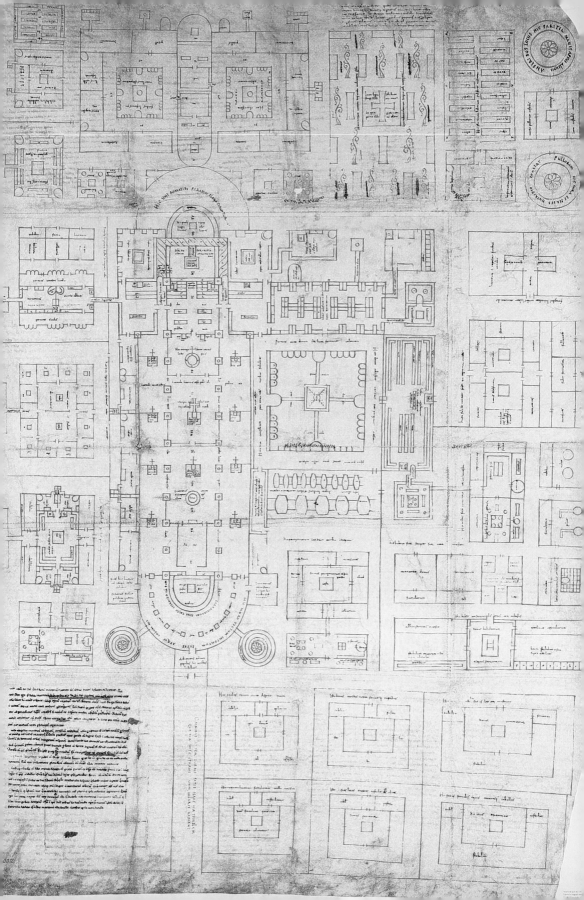

briefly annotated copy of the monastic buildings, with which you may exercise your ingenuity and recognize my devotion, whereby I trust you do not find me slow to satisfy your wishes.'[27] The affectionate and intimate tone is central to monastic life, and says much about the expected audience for works of art produced and presented in monasteries. Designed for a small and highly sophisticated audience of convinced and enthusiastic Christians, these works show a veneration for tradition mixed with the search for ever better responses to the needs and demands of a changing world.

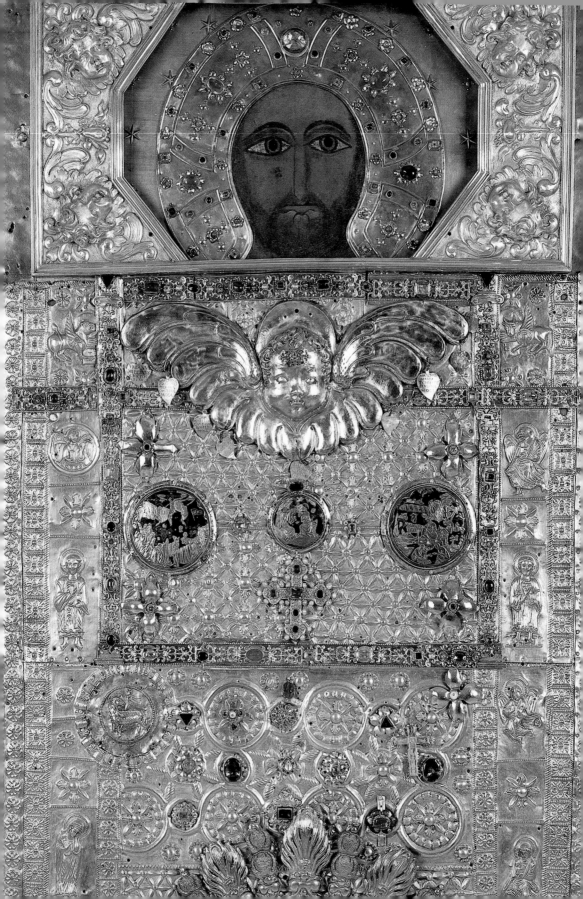

Holy Images

In 597, according to Bede's *Ecclesiastical History of the English People*, written before 731, Pope Gregory the Great sent a mission to England hoping to convert the pagan Anglo-Saxons to Christianity. When its leader Augustine and his fellow monks arrived in the territory of King Ethelbert of Kent, the king insisted upon meeting them on the isle of Thanet, in the open air, fearing the possible power of their magical arts. The monks came to him in a procession reminiscent of the ceremonial *adventus* of a Roman ruler, singing psalms, and carrying a silver cross 'and the likeness [Latin *imago*] of Our Saviour painted on a board'.[1] It was not the kind of magic Ethelbert expected.

Holy of Holies

Bede saw this event as an exciting new departure, in which the Church of Rome initiated conversions among non-Christian 'barbarians', beginning with his own English people. He took for granted, however, an important change that took place across the Christian world from the latter part of the sixth century, namely the treatment of images of Christ and other holy figures as holy objects in their own right, not merely representing but in some manner embodying the figure depicted therein. The 'cult of images', as it has been called, seems to have been most intense in the eastern parts of the Christian world, especially in the territories ruled by the Roman emperor from Constantinople, today commonly termed the Byzantine empire. The land where Jesus had lived and died and where the Christian Church began, known as the Holy Land, Palestine, always had a special importance, and pilgrims returned thence with image-decorated vials of holy oil [70]. From the sixth century these and other images came from the Holy Land in large numbers, sometimes associated with relics, as on a box of stones from holy sites whose lid carries images of the associated events [80]. Bede's text indicates, however, that by the end of the century holy images were not only venerated and used in Rome, whence Augustine's painting must surely have been carried, but were taken across western Europe.

The painted reliquary box just mentioned was kept, by the end of

Reliquary box with stones from sites in the Holy Land, and images of events related to those sites, probably made in Palestine, seventh century (241 × 184 mm), preserved in the Sancta Sanctorum at the Lateran Palace (Rome) since the late eighth century

Reading from the bottom are the Nativity, Baptism of Christ, Crucifixion, Three Marys at the Tomb (Resurrection), and Ascension.

the eighth century at the latest, in a small chapel at the pope's Lateran palace in Rome, a chapel known then and since as the Sancta Sanct-orum (literally Holy of Holies). The central object in that newly established chapel, still today on the altar, was not one among the imposing collection of relics, but a painted image of Christ, which may give some idea of the image with which Augustine began the conver-sion of the English [**81** and also on page 136]. The image functions on one level as a site of 'desire',[2] of absence, of longing for the divinity it represents, but also entails a new kind of presence effected by an image. The Lateran had long possessed images of the Saviour, to whom the cathedral basilica was dedicated, for example silver statues set up on the *fastigium* [see above, pages 50–1] including two representations of Christ. The *fastigium* figures were not regarded as in any manner miraculous, but offered decoration and honorific reference. Any status as holy things would have been because of their location in the cath-edral church and their association with the famous imperial donor.

NON·EST·IN·TOTO·SANCTIOR·ORBE·LOCVS

81

Rome, Lateran Palace, Sancta Sanctorum, view of private papal chapel with altar and icon of Christ the Saviour. The chapel was much restored in later Middle Ages and Renaissance

The image of Christ, object of veneration for at least 1200 years in this location, probably dates from the sixth–seventh century. The figure of Christ, repainted in the later Middle Ages, is almost entirely hidden by jewelled metal covers of later dates.

The Sancta Sanctorum Christ image is different, for it was regarded as a holy thing, kept with relics, offering protective power and not drawing holiness from but imparting holiness to the place where it was kept. The biography of Pope Stephen II (pope 752–7) in the *Liber Pontificalis* is the earliest unambiguous source referring to the image, introducing it at a moment of crisis. Under attack by the Lombard King Aistulf, and with appeals to the emperor in Constantinople, his traditional protector, seeming vain, Stephen was on the verge of taking the extraordinary step of travelling across the Alps to France to appeal for assistance from Pepin, king of the Franks. Before doing so, however, he appealed to the highest authority:

On a certain day with great humility he held a procession and litany in the usual way with the holy image of our Lord God and Saviour Jesus Christ

called the *acheiropoieta* [the panel now in the Sancta Sanctorum], and along with it he brought forth various other sacred religious objects. With the rest of the *sacerdotes* [clerics] the holy pope bore that holy image on his own shoulder, and both he and the entire people processed barefoot into God's holy mother's church called *ad praesepe* [Santa Maria Maggiore].[3]

The chapel in which this famous holy image was kept, the Sancta Sanctorum, obviously means to recall the innermost sanctuary of the Temple in Jerusalem. Attended by the high priest, that chamber contained the Ark of the Covenant, until the Temple was sacked and the Ark seized by the Romans in AD 70. Produced at the explicit command of God (Exodus 31: 1–11 and 37: 1–9) to hold the tablets containing the Law, the ten commandments, the Ark was the central cult object of the ancient Jewish tradition, and believed to radiate divine power (1 Samuel 5; 2 Samuel 6) [**109**]. The arrangement of the image of Christ at the Lateran's Sancta Sanctorum in fact recalls visually the image of the Temple above the Torah shrine in the Dura Synagogue, with its prominent doors [**16**]. In a deeper sense it claims to surpass the Temple, and does so by placing at the holiest place not the word of God, whether the tablets preserved in the Ark or the Torah preserved in the synagogue's niche, but the human and divine person of Christ, whose presence is conveyed by an image, as the presence of St Martin at Tours was conveyed by his body. The elevation of the image to status as a holy thing, and its connection to relics, could hardly be more striking.

Similar ideas were applied to other classes of objects bearing images, and in other areas of Europe. A rare small sarcophagus-shaped container bears images that together convey a powerful sense of spiritual presence and protective potency [**82**]. The half-length figures have

82

Chrismal, eighth century, probably Britain, gilt copper plates over a wooden core, Mortain (Normandy), Church of Saint-Evroult Treasury (140 × 105 × 51 mm)

The central figure of Christ, holding a book and blessing, is flanked by the archangels Michael and Gabriel, the 'guardian angels' who most commonly intervened to help people in trouble, while another angel with outstretched wings hovers above on the lid, the entire composition crowned by a cross.

no physical or spatial relationship to each other, but construct spiritual relationship with the viewer and provide a vision of a supernatural reality. Inscriptions identify figures whose generic quality might create the possibility of erroneous understanding, blocking the sought-after connection. This small object is usually termed a chrismal, and seems likely to be a rare survivor of a class of portable containers (note the rings at the two ends for the attachment of a chain) for carrying holy oil and the eucharistic bread to the sick or dying. It may have been used by a missionary. The imagery of blessing and protection is underscored and made directly personal by an inscription carved on the back (in runic characters): 'May god help Eada who made this.' The figures convey, and in some sense participate in the sanctity of the object contained, the box being like a new Ark of the Covenant. The hole pierced in the lid probably allowed a later medieval owner and user of the object to gain direct physical vision of the sacred contents, for which the early medieval audience was prepared to accept a representative holy image as a substitute.

The image of Christ is the key to the theological issues involving Christian pictorial art. However, holy images in some ways analogous to the Sancta Sanctorum panel or to that carried by Augustine to England, could portray any holy figure. Images of holy men and women had been produced from at least the fourth century, most commonly depicting them praying on behalf of those who invoked their aid [71–3]. No bright line separates such images, obviously used in, virtually used as, prayers, and what scholars today commonly designate with the special term 'icons'. However, there are some factors suggesting a change in tone and intensity after the middle of the sixth century. First is a tendency to increase the portability of holy images, which might be used not only in churches and tombs, but in believers' homes, and even while travelling. Second is a tendency to reduce or altogether remove action from the image, which conveys the holy figure as if present, perhaps awaiting the beholder's invocation to come alive. It is this frozen quality, often seen in images that we regard as 'portraits', which is usually meant by the term 'iconic' as applied to an image of any culture or date, whether a portrait of Napoleon enthroned [2] or images from early Chinese tombs. Although the category is cross-cultural, there is little doubt that the formal language of early Christian icons reflects the heritage of late Roman imagery, formulaic and abjuring naturalism in favour of conveying a higher truth [11].

Yet for all the formulaic character of Christian holy images apparent to us as modern beholders, they tended to be treated by those who made and used them as 'individuals'. One prayed to a specific saintly patron, by name, and if the name was not clear from the image's location, an inscription frequently performed this identifying function. Of particular significance is the notion of 'likeness'. Although there is no

83

Portrait icons of Sts Peter and Paul, leaves of a folding diptych from the Sancta Sanctorum, probably seventh century (each 86 × 57 mm)

The later mosaic images just visible above the shrine [81] are based upon these very icons preserved in the chapel.

historical basis for knowing the physical appearance of Christ, the Virgin, or the apostles, who are never described in the Gospels, by the sixth century authors are providing such descriptions in accord with what they regarded as tradition (conveyed by the crystallizing conventions of artistic representation) and appropriateness. Thus Ioannes Malalas describes St Peter as 'old, of medium height, with a receding hairline, white skin, pale complexion, eyes dark as wine, a thick beard, big nose, eyebrows that meet, an upright posture, intelligent, quick-tempered, changeable, cowardly, inspired by the Holy Spirit, a worker of miracles'.[4] The physical features are assumed to be a reflection of spiritual qualities, in accord with common ancient conceptions intensified in late antiquity, when biographies sought to capture the character of their subjects, taking physical appearance as both clue and evidence.[5] Images of St Peter almost always conform to Malalas' description. However derived, this image came to be taken as the 'true image', and other later images were all but obliged to conform to this tradition [83].

Christians came to recognize the objects of their devotion from their 'true likeness', whether in church or in visionary appearances. The *Miracles of Sts Cosmas and Damian* tells of a sick woman to whom the two saints appeared in a dream-vision 'in the form in which they are depicted', as she was able to confirm by subsequently comparing her vision to a painting.[6] The images themselves gained credibility

through newly invented stories tracing their histories to the lifetimes of the holy figures. According to the *Vita S. Pancratii*, St Peter ordered a painter named Joseph to 'make me the image of Our Lord Jesus Christ so that, on seeing the form of His face, the people may believe all the more', and then ordered Joseph also to paint his own image, 'so that those who use [it] for remembrance may say: "This was the apostle Peter who preached the word of God among us".'[7] Some other images, including the Sancta Sanctorum panel, were regarded as of miraculous origin, *acheiropoietai*, meaning 'not made by human hands'. The most famous example of such an image today is probably the so-called 'Shroud of Turin', but the class of objects to which it belongs originates in the sixth and seventh centuries.

Paradoxically, the conflict between an emphasis on generic types and an insistence upon individual images and histories provided ample space within which Christian artists and patrons could develop new imagery. For example, the city of Rome has not just one, but roughly half a dozen early paintings of the Virgin Mary, all datable to roughly the sixth–eighth centuries. The image from the Pantheon, commonly thought to date from the consecration of that abandoned pagan temple to the Virgin as Santa Maria ad Martyres in 609, presents the Virgin holding the Christ child in her left arm. Both figures stare directly out at the viewer, the Virgin's right hand bearing traces of gilding, which links it with pre-Christian healing cults.[8] The largest of the Roman panels presents the Virgin on a jewelled throne, holding the Christ child on her lap [84]. The theme of Majesty is underscored by the flanking angels, who turn towards her with gestures of awe, but obviously derive their pose from earlier Christian images [60] and ultimately from the Roman Majesty tradition. Its patron Pope John VII (705–7) was an important promoter of the Virgin's cult, who once showed himself before her (in a different image) with the inscription 'Servant of the Holy Mother of God'.[9] The image formerly in Santa Maria Antiqua and now in Santa Francesca Romana presents the Virgin and Child with their heads turned towards each other, although the Virgin still looks out at the beholder. This image, which for centuries played a major role in liturgical ceremonies, was already provided with a silver cover in 735, and already then referred to as an 'ancient image'.[10] These Marian images were preserved in different churches of Rome, and were only brought together for the first time in 1988, for an exhibition at Santa Maria Maggiore, where their stunning range of scale and iconography was apparent.[11]

Isolated images of the Virgin and Child, not forming part of any narrative scene but timeless objects of devotion, are so common from the later Middle Ages to the Renaissance, and indeed to the present day in Catholic and Orthodox tradition, that it is difficult to recover a sense of the novelty of such images in the early Middle Ages, at least in

Rome, Santa Maria in
Trastevere, Icon of the Virgin
and Child (sometimes called
La Madonna della Clemenza),
Rome, 705–7 (164 × 116 cm)
The figure of Pope John VII
kneels at the feet of the Virgin,
in the lower right corner, to
whom Christ seems to be
extending his hand. The
Virgin's costume, the
elaborately pearled crown and
robes of a contemporary
Byzantine empress, identify
her as Maria Regina, 'Queen
Mary', a type that has recurred
in the city of Rome for
centuries but almost never
elsewhere, a salient example
of the growing importance of
local traditions.

western Europe. Only one western book of the period contains such an image, the Book of Kells [85]. Although later sculptures in the British Isles associated with the same monastic tradition offer a number of parallels,[12] the only earlier example from the area is a simple engraving on the wooden coffin of St Cuthbert of Lindisfarne, probably made c.698 in connection with the installation (called a 'translation') of his bodily remains as a relic at the altar. The Kells and Cuthbert images share one striking feature: both show the two figures turned towards each other, as the Christ child sits across his mother's lap. The compositions recall the Roman icon from Santa Maria Antiqua, although the Cuthbert image has both figures facing the viewer, as on the Pantheon

icon. Yet both the Kells and Cuthbert images present the Virgin and Child alike in full-length poses, flanked by angels, as paralleled among the Roman icons only by that from Santa Maria in Trastevere [**84**].

Knowledge of Roman icons was transmitted to the British Isles during the course of the seventh century, in connection with the ongoing efforts to establish Christianity there. When founding during the 670s and 680s a double monastery at Monkwearmouth and Jarrow in northern England, then the independent Northumbrian kingdom, a wealthy noble named Benedict Biscop brought a large number of painted panels from Rome, including images of Christ and the Virgin. Although it would be possible to posit some lost model from Rome, from which the Cuthbert coffin carvings were likewise derived, one still would have to think that someone 'diverged' from the model. I would prefer to consider the possibility that the Kells miniature, and for that matter the Cuthbert coffin engraving, combine elements from various Roman icons that would have been seen by an Irish (or Northumbrian for that matter) pilgrim, the miniature reflecting an imperfect memory of those different Roman images, and combining some of their most salient features, or perhaps even deliberately evoking multiple holy images.

Although the specific form of the Book of Kells' 'icon' of the Virgin is rare, the notion of some spiritual potency being carried by images would by no means have been foreign to northern European peoples

85

The Book of Kells (Gospels manuscript), Virgin and Child miniature, Iona, probably second half of the eighth or early ninth century

This famous copy of the four Gospels takes its name from the Irish monastery where it was preserved through the later Middle Ages. Its origin is uncertain and controversial, most scholars now preferring to see it as having originated at Iona, or possibly another foundation associated with St Columba, as it was preserved in a shrine as a relic associated with him.

whether still pagan or recently converted to Christianity. Numerous bracteates carry imagery that can be seen as spiritually potent. In a number of cases the image has distinctively Roman origins, such as the theme of the mounted horseman derived from imperial coins and other images [**61**]. One bracteate has an image of Romulus and Remus suckling from the she-wolf, while a significant number of others carry images of Odin and other pagan divinities. Magical practices were of course condemned by Christian writers, with such frequency that the practices' wide distribution and persistence seem assured. Although some practices may have travelled from specifically pagan to specifically Christian contexts, or vice versa, the larger issue is surely that magical practices appealed to a wide swathe of both populations throughout the period.

Iconoclasm and the struggle over tradition

The moderately attentive reader may have wondered how such beliefs and practices could have been reconciled with the original position of Christians in regard to images, discussed in Chapter 2. A conflict was indeed felt by some Christians, especially during the period after the middle of the sixth century, when the pace of change in the use of and attitudes towards images seems to have quickened. During the second quarter of the eighth century a sharp reaction against holy images, with strong support from the emperor, culminated in iconoclasm (literally the breaking of images). A church council convened under the auspices of Emperor Constantine V in 754, known as the Council of Hieria, condemned the veneration of religious images and urged their destruction.

Already in the late sixth century, leaders of the Church began to develop and defend differing positions about the proper status of religious images in Christian life. The most famous and influential text in the early stages of the debate was written by Pope Gregory the Great. Bishop Serenus of Marseilles seems to have destroyed an image which he took to be idolatrous. Gregory responded:

Word has since reached us that you, gripped by blind fury, have broken the images of the saints with the excuse that they should not be adored. And indeed we heartily applaud you for keeping them from being adored, but for breaking them we reproach you. Tell us, brother, have you ever heard of any other bishop anywhere who did the like? This, if nothing else, should have given you pause. Do you despise your brothers and think that you alone are holy and wise? To adore images is one thing; to teach with their help what should be adored is another. What Scripture is to the educated, images are to the ignorant, who see through them what they must accept; they read in them what they cannot read in books.[13]

The idea of images as scripture for the unlettered is scarcely new to Gregory, and indeed I have argued here (especially Chapter 2) that the very origin of Christian art is connected with the desire to convey sometimes very elaborate messages and devotional ideas. Gregory was certainly familiar with the mosaic cycles of Roman churches such as Santa Maria Maggiore, although we do not know how he would have interpreted the images. It may be no coincidence that a fragmentary Gospel book [88], which may have been sent by Gregory with the mission to England, contains an extensive selection of narrative scenes, which could be interpreted as just the thing for the obviously illiterate and unlearned (to a Roman aristocrat) Anglo-Saxons to whom it was dispatched. Similar images, divorced from a reliquary context or a sacred text, may well have had something of that sacred character, and follow the same pictorial traditions. A private chapel in Rome offers precious evidence. It was made with the support of Theodotus, from 753 an important official called the *primicerius*, who had earlier been both consul and duke of Rome, and was the uncle of the later Pope Hadrian I (776–95). Theodotus appears at the entrance to the chapel, kneeling before the images of Sts Quiricus and Julitta, holding two lighted candles, and then again on the main eastern wall of the chapel standing and offering a model of the church to the enthroned Virgin. The accompanying inscription reads 'Theodotus first of the *defensores* and dispenser at God's holy mother the ever-virgin Mary's [church] called Antiqua' [86].[14]

The decoration's focus is not upon the enthroned Virgin, however, but upon the image of the Crucifixion, with Christ on the cross flanked by standing figures of the Virgin and of St John (the Evangelist). Between them and Christ are two active male figures, at Christ's right

Rome, Santa Maria Antiqua,
Chapel of Sts Quiricus and
Julitta, east wall, c.750

In the upper register is the
Crucifixion, and in the lower
MARIA REGINA sits between the
papal patrons Sts Peter and
Paul, with St Julitta at the left
and the tiny Quiricus at the
right, Pope Zacharias at the far
left, and the donor Theodotus
at the far right. All the figures
are identified by inscriptions.

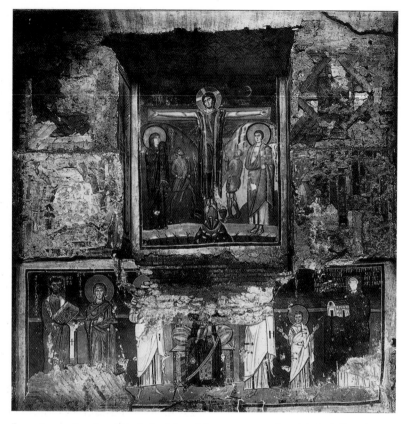

Longinus piercing Christ's side with a spear, and at his left Stephaton
holding to him a sponge soaked in vinegar. The figures, poses, costumes,
even the narrow front shelf of the landscape are all closely related to the
large Crucifixion image at the centre of the Sancta Sanctorum reliquary
box [**80**]. The scene finds most of its elements in the Gospel text (John
19: 25–34), but the strongly narrative appearance masks an important
equivocation, for the text is explicit that Jesus dies between the
presentation of the sponge and the piercing of his side. One explanation
is almost surely an artist's tendency to collapse different narrative
moments so as to convey more of the story in a single image, but here
there are other important issues involved. Representation of Christ dead
on the cross never occurred before the later eighth century, for obvious
theological reasons, as seeming to heighten the human as opposed to
divine nature of the god-man. At the same time, the imagery has
crystallized into a type hallowed by important icons, has become literally
traditional, and the Longinus/Stephaton Crucifixion type becomes the
standard form for other 'narrative' depictions, even in Insular
manuscripts of the period or Irish book covers,[15] while a closely related
Crucifixion icon from Mt. Sinai of similar date does indeed appear to
show Jesus already dead.[16]

The Theodotus chapel is remarkable on many levels, devotional,

polemical, and political. It is a relatively early example of the sort of private chapel set aside within a large church that would become so important a feature of later medieval and early modern art. The portraits of donors are no novelty, but follow a tradition going back through earlier Christian [60] to late Roman art, but here the choice and arrangement of subjects was also controlled by the private patron. Private chapels are a distinctive new characteristic of this period, among them the Sancta Sanctorum at the Lateran, the eighth-century funerary chapel known as the Tempietto del Clitunno near Spoleto in central Italy,[17] and examples in north-eastern Italy [99], and in western France [109].

The Theodotus chapel in Rome is also remarkable for its political context, having been dedicated in the years immediately following the iconoclastic council held in Byzantium in 754, whose conclusions were rejected by the pope. Setting himself as the defender of orthodox tradition against the heretical 'innovation' of iconoclasm, the Roman pope held to the position enunciated by Gregory the Great, that images could be useful for teaching, as well as for decoration, but should be neither adored nor destroyed. This position, whatever its theological merits, carried important political implications, cutting the Church of Rome off from the protection of the Roman emperor in Constantinople. The emperor responded by transferring ecclesiastical jurisdiction of southern Italy and of Dalmatia from the bishop of Rome to the bishop of Constantinople, an action whose effects ripple down to our own time in the former Yugoslavia. The emperor was no longer in the position to seize a difficult pope and bring him to Constantinople, as Justinian had done two centuries before, for the emperor had few troops and little practical power in Italy. Nonetheless, the pope needed a new political protector, for the Lombard king who controlled much of northern and central Italy from his capital at Pavia was threatening to take Rome by force, and would then be in a position to dictate to the pope.

In this difficult position a new alliance was formed, with long-lasting results. In 751, Pope Zacharias wrote to Pippin, the leader of the Franks from his position as Mayor of the Palace, that Pippin should rightly have the title as well as the power and responsibility of king. The last Frankish king from the family of Childeric and Clovis, the Merovingians, was then deposed, and Pippin anointed as king by the papal legate in the Frankish kingdom, St Boniface. Three years later, in 754, Zacharias's successor, Pope Stephen, continued the new policy, making the first papal transalpine journey, travelling north to the monastery of Saint-Denis, near Paris, where he crowned Pippin as king of the Franks. In the same year, the new Frankish–papal alliance was recognized, along with their joint opposition to Byzantine iconoclasm, in a remarkable work of art, a book of the Gospels

produced at a monastery in northern or central France by a scribe named Gundohinus. Not trained as a painter, or indeed as a writer of formal uncial book-scripts, in which the Gospel book is written, one can agree with Gundohinus's own assessment that he was 'inexpert' at the task he undertook. The five miniatures he painted are clumsy in execution, but ambitious in aim, apparently copied or perhaps one should say adapted from a manuscript written in Ravenna around the time that the churches of the city received their splendid mosaics. The four portraits of Evangelists, for example, are standing figures like ancient authors and some later Greek examples, of a type almost never otherwise seen in the medieval west before or after. Most interesting is the image standing before the text of the Gospels as a kind of frontispiece [87].

Christ sits in majesty on a bejewelled throne, flanked by angels. The large surrounding medallion also stems from ancient Roman tradition, for it is a laurel wreath, associated variously with triumph and divinity, and used as here to suggest ascension to heaven. Smaller medallions in the corners contain the symbols of the Evangelists, alluding both to the Old Testament contexts in which they bore the fiery chariot in which God appeared to several prophets, and to the dissemination of the divine word contained in the Gospels to the four corners of the world. This composition probably also stems from the sixth century, although

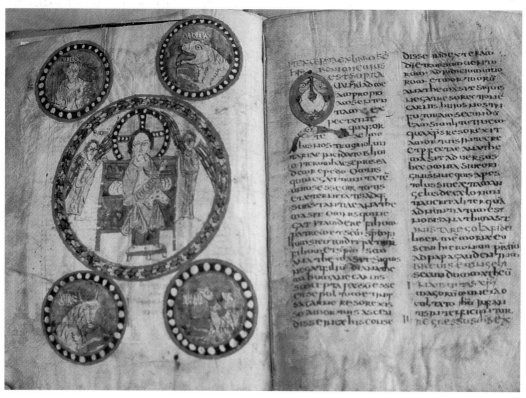

it seems to have been rare before Gundohinus's time, and only subsequently becomes a standard feature of Christian iconography whether in manuscript art or eventually in monumental Romanesque and Gothic sculpture.

The special significance of this image seems to be partially explained by the text on the facing page. This unique text, falsely attributed in the manuscript to St Jerome, probably stems from the fifth century. It contains a series of trenchant theological claims, hurling anathema at anyone who denies 'that the Father sees the Son and the Holy Spirit', or that Christ, the Son, 'was subject to suffering in human flesh', or that all will be resurrected in the flesh 'according to its similitude to that which Christ perfected'. All these sentiments recall the arguments advanced by the popes against the iconoclasts, and suggest that the Franks are making common cause in theological terms with their new political ally. The text closes with the claim that all these statements are the orthodox tradition of the Church's faith, and cannot be changed. The facing miniature, with its central depiction of the divinity of Christ in heaven, based upon an old model, is a visual analogue to the text, exploiting the antiquity of its pictorial model as a guarantee of some kind of authenticity. Indeed, the inscriptions stating that the two angels flanking Christ represent cherubim is a unique effort to link Christ with the Ark of the Covenant. As the Ark contained the Old Law, Christ represents the New Law, literally the Word of God made flesh. The novelty and originality of this use of imagery is startling. It is a harbinger of the many novel works of art of the next century in its complexity, inventiveness, and seemingly paradoxical explicit claim to the mantle of some ancient authority.

onginned godspeller

Incipit euangelii
genelogia matthei

cy
ne
un

cn
ni

iha
de
cn

Word and Image

9

When Augustine of Canterbury arrived in England to preach to the Anglo-Saxons, he must have brought with him not only the image of Christ and cross specifically mentioned by Bede, but also a Gospel book. The Gospel book, the record of Christ's deeds and words, was essential for missionary activity, and indeed the Irish missionaries developed a special type of 'pocket Gospels' for this purpose.[1] The Gospel book was also essential for the performance of the central Christian liturgy, the eucharistic sacrifice or Mass, whose performance varied significantly but always included Gospel readings, the particular passage to be read changing each day of the year. It is possible that Augustine's Gospel book still survives, preserved through the Middle Ages in his foundation at Canterbury. In its original form it probably contained eight large painted pages, of which two survive, preceding the Gospel of Luke. One of these pages presents 12 scenes arranged in a grid form, representing stories from Christ's Entry into Jerusalem to his carrying of the cross. The other miniature depicts the Evangelist Luke flanked by another 12 scenes from the Gospel story [**88**].

The small narrative scenes recall early Christian art, especially on sarcophagi and ivories [**56**], with a few small figures representing narrative events from the life of Jesus. The bottom scene on the right depicts Jesus's arrival in Jericho, with Zaccheus watching from a tree (Luke 19: 1–9), a motif commonly adapted from this passage to enrich the scene of the entry into Jerusalem, where a man in a tree is commonly represented [**32**] although not mentioned in the text. The small almost square framed images also recall those at the top and bottom of the roughly contemporary reliquary box from the Sancta Sanctorum [**80**]. The narrative scenes on that box are linked with the relics by inscriptions, almost like pictorial captions, and the narrative scenes in the Gospel book are linked with episodes of the Gospel text by inscriptions in the margins. In both works the pictorial signs decorate, potentially inform, and may even share something of the sanctity of the associated relics or text. Together they remind us that Christianity was a religion not only of holy people, but of a holy book.

The author of the sacred text sits on a large throne-like seat with pillow and footstool. Luke's left hand holds an open book in which we

Detail of 90

An enlargement of a section including both letters and ornament.

Gospels manuscript called
Gospels of St Augustine,
probably from Rome, late sixth
century

The page shows the Evangelist
St Luke seated on a throne, set
within an elaborate
architectural-form frame with
imitation marble columns and
inscription on the frieze, with
his symbolic creature, the ox,
in the lunette above him.
Flanking him are 12 narrative
scenes based upon texts in his
Gospel.

can read the first words of his Gospel, while his right hand is raised to his chin in a gesture often associated, in ancient art, with contemplation. In the arched lunette above him, carried by ornate paired columns painted to imitate coloured marble, a half-length figure of a winged bull or ox holds a book. This is the symbolic creature associated with Luke by Jerome, representing his heavenly inspiration. The seated figure with a book also appears in early Christian art [22], adapted from the pagan tradition of philosopher portraits, but now this figure is greatly magnified in scale and importance, displaying the holy book on his lap. The book itself is a codex, the form if not invented then greatly popularized by and associated with Christians. The framing of this author portrait, repeated in hundreds of later examples, also draws on ancient traditions. The gravestone of a third-century soldier from Rome [15] shows the roots of this compositional type, while an impressively decorated manuscript known as the Calendar of 354 (now lost but known to us indirectly through a copy of the Carolingian period) also used elaborate architectural frames for portraits.[2]

The decoration of luxurious codices with coloured paintings, showing narrative episodes from the associated texts, can be traced back to the early fifth century in both Christian and pagan books. In Chapter 5 two closely connected examples were presented, books containing large pictures (conventionally referred to by scholars as 'miniatures' when contained in books) [57–8]. Both manuscripts probably contained as many as several dozen such miniatures, and by the sixth century, at least in the Greek world, we know of both secular and Christian manuscripts that contained as many as several hundred. One of the most impressive Latin books of the sixth or seventh century is the Ashburnham Pentateuch (combining the name of a former owner with the Greek word for the first five books of the Old Testament). Its many large miniatures often occupied the full page, but sometimes space was left for some of the words, with the image interrupting the text column, as in a miniature from Genesis (24: 10–67) with the story of Isaac and Rebecca [89]. The strong desire to tell the stories in detail led to the inclusion of many distinct elements separated into registers, clarified in some examples by the use of strongly coloured backgrounds. These remain paintings in books, separated from the words rather than integrated with them.

The images in such late antique books, for all their impressiveness, contain also an ironic inversion of their intention of witnessing the centrality of the text. The picture of the author and the narrative scenes are richly designed and coloured, in visual terms little different from monumental paintings on walls. The words on the lintel above the Evangelist are written in large capital letters, like the inscription on a pagan temple or public building, but the words of the Gospel text itself are indistinguishable from any other text of the period, whether secular

89

Ashburnham Pentateuch
(manuscript containing the
first five books of the Old
Testament) Eliezer bringing
Rebecca from the house of her
father to be the wife of
Abraham's son Isaac,
unknown place of origin,
probably sixth–seventh
century

At the upper right are Eliezer
and his camels, meeting
Rebecca at the well. At the
upper left is the house of her
brother Laban, presented as
an elaborately palatial dwelling,
while at the lower right
Rebecca meets Isaac at the
house of Abraham.

or holy, being written in a script, known as uncial, used for all manner of books. The opening words of Luke's Gospel visible on the book he holds are almost carelessly written, and completely undecorated. During the succeeding centuries this anomalous situation will be changed, as the entire book, including the words of the text itself, becomes a field for rich decorative and figural embellishment.

The development of what I will term the illuminated book, with the text itself a locus of artistic decoration, depends upon and represents graphically the changing relationship between oral and written materials. In the late fourth century, Augustine (of Hippo, not Canterbury) describes coming to Bishop Ambrose of Milan, enthusiastically listening to him, taking with his ears the spoken word, and regretting that the crowds of other petitioners meant that Augustine 'was excluded from his ear and from his mouth'. Augustine then continues the passage by observing, with evident surprise shared by others about him, that Ambrose 'when he was reading, his eyes ran over the page and his heart perceived the sense, but his voice and tongue were silent'.[3] In the world of antiquity the written word was like an actor's script, a

guide to the memory of the speaker, whose audience would hear words, not see pages. In such a world the decoration of written words would have been absurd, and the 'ornaments' of a text, an important aspect of rhetorical training, were gesture and intonation and literally figures of speech, not figures drawn upon the page. The shift to silent reading, private reading, is a prerequisite for the development of the illuminated book, which presupposes a small and commonly solitary audience.

Muslim tradition identified Christians and Jews along with Muslims as 'peoples of the book', all sharing the idea of a single divinely inspired text as central to religious life. The Prophet Muhammad is in one sense very much within the ancient tradition, however, for his book, the Qur'an, is a spoken book, not a written book. Indeed, its title means 'recitation', and it only came to be preserved in written form in the period after his death in 632. Although we have no very early Qur'an manuscripts, from at least the ninth or tenth century the central Muslim text is written in a magnificently ornamental script, with decorative borders in gold, and enriched with ornament.[4] The ornament not only testifies to the holiness of the text, and to the wealth and piety of the person who ordered it to be so magnificently presented, it helps to articulate and clarify the text, introducing major units of the text, as *surahs* or chapters. None of these features are based upon early classical or Arabic or Iranian production, but are strikingly analogous to a new type of decorated book that begins to appear in Christian art from approximately the seventh century. In this new type of book, the 'illuminated' manuscript, the text pages may be articulated by decoration ranging from very simple ornament to elaborate compositions executed with gold and other precious materials.

The image of the word

Among the earliest well-preserved examples of an illuminated manuscript in the sense that I have defined the term is the famous Lindisfarne Gospels. According to a much later note preserved in the book, it was written for the monastery of Lindisfarne by its Bishop Eadfrith, who died in 721. The production of this extraordinarily luxurious Gospel book has often been associated by scholars with the translation of Cuthbert's relics to the main altar at Lindisfarne in 698, when his carved wooden coffin was also probably conceived. Anyone who looks at the book will realize that it is the product of many years of work, especially if, as is commonly believed, Eadfrith personally wrote and also 'painted' or 'illuminated' the book. The later colophon, whose reliability is not well established, only tells us that he wrote it, but examination of a number of literary sources from this period and region suggests that verbs for writing and painting could be used as synonyms.[5]

Examination of the book itself supports the hypothesis of a single artist. The same pigments are used throughout, and there are no obvious breaks between the writing itself and the extensive decoration, consisting of 15 (31 if the canon tables are considered) full-page compositions, none of which is devoted to narrative imagery. For example, the Gospel of Matthew opens with three full-page decorations. The first is a portrait of the Evangelist with his symbol, in a radically different style from but nonetheless manifestly in the tradition of the Gospels of St Augustine. The portrait, on the back or verso (left-hand page of the full opening) of a parchment leaf, faces a blank on the recto (right-hand page) opposite. Upon turning the page to the next opening, the reader and viewer finds an elaborate pair of compositions [90] quite unlike anything in the St Augustine Gospels or any other book from late antiquity. On the left is an ornate cross set within a complex frame, the cross itself and the background between it and the frame entirely covered with interlacing animal forms ultimately derived from the tradition of Style II animal ornament used in prestige metalwork [66]. Other pages in the book show abstract geometrical patterns closely related to even earlier chip-carved ornament [46] that might also have been found on floor mosaics or textiles as well as in Roman metalwork. Upon close inspection it is evident that the elements of the Lindisfarne miniature we are inclined to see as separate, here the cross and its frame, are merged together, sharing a common narrow red border. The aesthetics of simultaneous distinction and connection is seen in even more spectacular and novel fashion on the facing recto, with the opening words of the Gospel text itself, in Latin, *Liber generationis*. The first three letters are joined to make a single shape, and the letters themselves are filled with marvellous panels of ribbon and animal interlace. The next two letters are left hollow, but surrounded by interlace. The letters in the second line are solid black, but their feet turn into volutes and in some cases heads, all set against an open-work background. The words themselves are beautiful, and set within an elaborate frame that lends enhanced dignity while also responding to their shape (as along the left side), even allowing the text to escape onto the verso of the page, through a gap in the lower right corner. Words and decoration are partners in a new aesthetic system having no precedent in the art of antiquity.

The elaborate decorative arrangement of the Lindisfarne Gospels provides each of the four Gospels with three full-page prefatory decorations, Evangelist portrait, cross page (sometimes misleadingly termed 'carpet page'), and initial page. All are different from one another, and differ in ways that suggest systematic variations upon a theme. Thus only in the Matthew cross page are the borders of the cross connected with the frame. Colours change, types of ornament change: indeed it would require many pages simply to describe the five cross pages. Such a fascinating and wonderful way of decorating a book

cannot have sprung from nothing, but the earlier stages of the development are murky. The Lindisfarne Gospels is commonly seen as the successor of earlier and less elaborate illuminated books produced in several monasteries of the British Isles, including modern Ireland, Scotland, and England, whence the common jargon term 'Insular' for this new artistic tradition and type of illuminated manuscript. For example, the Book of Durrow has a similar system of Evangelist pages, cross pages, and initial pages for each of the Gospels. Somewhat smaller and simpler than the Lindisfarne Gospels, Durrow is commonly dated a few decades earlier (c.680?) than Lindisfarne and seen as its forerunner, but this dating is by no means certain. In any event even if true, this hypothesis simply moves the problem of the creation of this new type of book back a few decades, and makes the Book of Durrow seem to emerge as if by magic. Carl Nordenfalk showed that the roots of the style of lettering in the Book of Durrow lay in Irish books of the early seventh century, with features like split stems and spiralling serifs and a gradually decreasing scale of the letters from the largest initial into the text proper,[6] but this helps explain only one aspect of the new style. Books like Durrow and Lindisfarne have been seen as a kind of hybrid between this rather simple Insular book tradition and the remarkable Insular prestige metalwork tradition [66–8]. In my own view, an explanation should also involve the European mainland, albeit still within the orbit of the Insular missionary foundations.

While Columba was founding his monastery at Iona, from which Lindisfarne would be founded in the early seventh century, another Irish monk named Columbanus was founding monasteries in the territories of the Franks and Lombards. Bobbio in northern Italy was his last major foundation, in 612, and the place where he died and was buried in 615, while St Gall developed around the hermitage of one of his followers, Gallus [79 and 129]. The most important Columbanian foundation, however, was surely that at Luxeuil in Burgundy, founded perhaps initially with Frankish royal patronage c.593. During the mid-seventh century daughter houses of Luxeuil were founded that became some of the most important monasteries of medieval France, including Stablo-Malmedy, Chelles (a nunnery) [see 75], and then in the late 650s Corbie, one of the most important libraries and centres of book production in the eighth and ninth centuries.[7] From Bobbio's library comes the earliest dated example of a large initial page in what comes to be seen as the Insular manner, datable 615–22, and perhaps from nearly as early what is generally regarded as the earliest page given over entirely to ornament. From Luxeuil itself relatively few early manuscripts survive, due in part to the sack of the monastery by Muslim raiders in 732, but there can be little doubt of the monastery's importance for the written culture of the latter half of the seventh and early eighth centuries. A distinctive cursive minuscule script was developed

90 (overleaf)
Lindisfarne Gospels, probably produced in the first third of the eighth century, most likely at Lindisfarne in northern England

Ornamental cross page and beginning of the Gospel of Matthew (Latin text reading *Liber generationis ihu xpi filii david filii abraham*, and using some Greek letters). The tenth-century Anglo-Saxon gloss is visible in the right margin.

incipit euangelii
genelogia matheusei

LIBER

ENERATI
ONIS IHU
XPI FILII DAUID FILII ABRAHAM

there, allowing books to be copied more quickly and in smaller formats than the larger uncial and half-uncial scripts inherited from the Roman tradition, and it seems that Luxeuil exported books to other monasteries, which took up its distinctive decorative style.

None of the Luxeuil and Luxeuil-related manuscripts that survive are Gospel books, although Gospel books must certainly have been produced. We can only infer something of their possible appearance from the presumably less elaborate decoration of what might be termed 'library books', such as biblical commentaries. A commentary by Gregory the Great on Ezekiel, from the library at Corbie, perhaps written there although more likely produced at Luxeuil, is a small book, written in compact minuscule script. Yet it has surprisingly lavish decoration, including several full-page cross pages, framed initial pages, and framed and ornamented pages for *incipits* and *explicits* (notices identifying the beginning and end of a particular text section). Even the scribal marks identifying the gathering of parchment leaves into groups of eight, called quires, received sometimes elaborate illumination.

The manuscript begins with an imposing array of five fully ornamented pages. The first opening shows two contrasting cross pages [91], the second opening a cross page facing a framed *incipit* page, and the third a monumental initial page facing the continuation of the text proper, written in cursive minuscule. The decoration is executed in red,

91

Gregory the Great's *Homeliae in Ezechiel*, probably from the later seventh century from the monastery of Luxeuil

Two ornamental pages opening the manuscript, the cross at the left surrounded by the inscription CRUX ALMA FULGIT (the blessed cross shines). The inscription recalls the language of the famous hymn composed a century earlier by Venantius Fortunatus, a hymn still used in Christian liturgies today, *Vexilla regis prodeunt, fulget crucis mysterium* (The standards of the king appear, the mystery of the cross shines out in glory).

yellow, and green pigments as well as the brown ink with which the text is written. Extensive use is made of a compass for the decoration, which includes simple twist patterns, rosettes, birds, and fish. The first miniature has a tall thin cross, from whose arms are suspended the Greek letters *alpha* and *omega*, commonly used from early Christian times and referring to Christ's statement that 'I am *alpha* and *omega*, the beginning and the end' (Revelation 1: 8). At the centre of the cross is a rosette, and around it a large diamond-shaped frame, whose corners expand into linked pairs of circular segments, forming little fish where they intersect. The paired segments at the sides are set inside, and those at top and bottom outside the diamond. In the corners are four large birds. The facing page takes up these themes but varies them. At the centre is a large medallion containing a rosette, at whose centre is a tiny cross, while four larger medallions with crosses occupy the corners of the large rectangular frame. The diamond frame recurs, but is now doubled, the two diamonds intersecting at the central medallion (which 'covers' their merging), while the circular segments are single instead of double, and face out rather than in from the corners of the diamond. The four large birds recur, but are here brought to the centre of the page from the corners.

This sophisticated decoration is entirely derived from the themes and ornament and materials of late Roman tradition, having no trace of any insular theme, and no relationship to metalwork. The medallions and diamond lozenges occur in countless examples in all media, for example in the *opus sectile* (inlaid marble) frieze just below the mosaics in the apse of San Vitale in Ravenna [**60**]. It seems to me unlikely that such a decorative system was adapted from an imported Insular model like the Book of Durrow or Lindisfarne Gospels and translated back into late antique ornamental vocabulary. This decorative system seems more likely to represent a tradition developed in monasteries associated with the Columbanian mission, especially at Luxeuil, which in its turn may have formed an inspiration and point of departure for spectacular Insular books like the Lindisfarne Gospels. However we identify the chicken and the egg in this relationship, the novelty and inventiveness of the achievement is beyond question, as is the impact upon future manuscript decoration. A small Psalter, written *c.*795 at the command of Charlemagne as a gift for the pope shows the adoption of the same decorative schema, albeit with different script and ornamental forms [**92**]. The book is known as the Dagulf Psalter after its chief scribe, who proudly recorded his name in one of the two dedicatory poems with which the manuscript opens, poems written along with the entirety of the manuscript in golden letters. In this respect, as in the purple painting of the background for the initial page illustrated here, it draws upon late Roman traditions, for already in the late fourth century Jerome is criticizing such unnecessarily lavish and

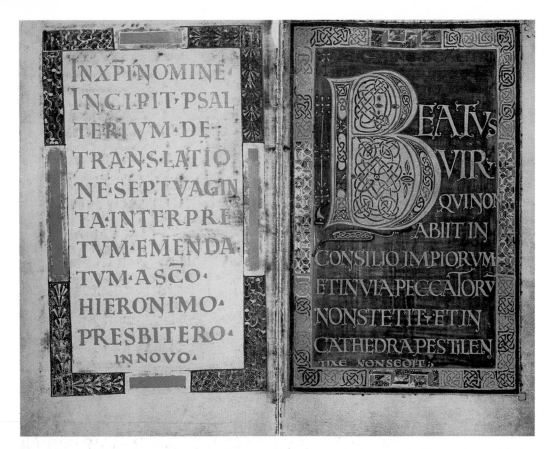

92

The Dagulf Psalter, probably written at Aachen or in any event at the orders of Charlemagne, c.795

This small volume, apparently intended as a personal gift for the pope, has a unique collection of prefatory texts. Although written in gold letters throughout, with many illuminated letters including three coloured and framed pages like this one, the manuscript never contained figural miniatures, although it was provided with a pair of ivory covers having remarkable scenes of David writing and Jerome translating the Psalms.

expensive books. Also Roman are the large capital letters in which the *incipit* page (the verso here, the page at the left) and most of the letters of the facing Psalm 1 are written, a distinctive script similar to inscriptions associated with the sponsor of Jerome's Bible translation, Pope Damasus. The ornament on some portions of the frames has an 'antique' character as well: perspective-meander patterns at the top and bottom centre of the initial page, fan-like patterns on the *incipit* page, or imitations of intaglio-cut gemstones in the corners of the *incipit* page. Yet the overall conception of an illuminated book is essentially like the Lindisfarne Gospels and St Petersburg Gregory [91], treating text as an artistic subject in its own right, creating a structured visual field that distinguishes among differing categories of text while emphasizing the most important.

Authority and inspiration

Author portraits, based in part upon portraits included in some late antique books, became the most common subject of early medieval figural book painting. Dating from a century later than the Gospels of St Augustine [88] is the portrait of Ezra in the Codex Amiatinus [93].[8]

This Bible itself is startling evidence for the transformation of a Roman frontier outpost area into a productive centre of Christian culture. Its makers were proud of their achievement, for its first page has a poetic inscription, written under an arch, in which Abbot Ceolfrith 'from the outermost reaches' offers the book to the shrine of St Peter, in hope that Peter will remember him in heaven. The book weighs 75 pounds (34 kg), and its 1,030 folios (2,060 pages) were written on the skins of 515 young calves, testifying to the wealth of the new aristocratic monasteries emerging in northern Europe (and an indication of the local diet). It is imposing not only in scale; it is the

93

Codex Amiatinus, the prophet Ezra, Monkwearmouth-Jarrow, early eighth century (before 716)

This miniature stands at the beginning of the huge Bible. The Northumbrian double monastery where it was written was founded in 674, and was the home of Bede. The inscription, probably composed by Bede himself, reads 'Codicibus sacris hostile clade perustis/Esdra D[e]o fervens hoc reparavit opus' ['When the sacred books were destroyed by fire, Ezra, inspired by God, restored this work'].

earliest surviving complete Bible in Latin, and also regarded as the most accurate surviving record of Jerome's Vulgate translation. It was written in a large uncial script very like that used for books produced in Rome at the time of Gregory the Great, written by nine carefully trained and highly disciplined scribes. Its magnificence is primarily testimony to its script and text and organization, for it was provided with only a small number of illustrations, only two of which had large figures. Standing before the New Testament was an image of Christ in Majesty, related in its composition and meaning to that in the Gundohinus Gospels [87], and standing before the Old Testament and the Bible as a whole is the Ezra miniature.

This miniature was for many years mistakenly thought to be a work of Italian art of the sixth century because of its heavily layered technique and illusionistic style of painting, creating a plausible space with naturalistic details like cast shadows [93]. The inscription above the miniature says that 'When the sacred books of the law were destroyed by fire, Ezra, inspired by God, made good the loss', apparently meaning that he wrote out the books from memory.[9] Ezra is indeed depicted in the act of writing the texts, an activity quite foreign to the Graeco-Roman conception of the author, in which the author dictated while a scribe recorded the words [30–1]. It is in fact in the Insular world where we first have substantial evidence for authors literally writing, as Columba of Iona, Abbot Eadfrith of Lindisfarne, and other important figures are said to have wielded their own pens. Suddenly the physical setting and actions of writing have become ennobled; we see behind Ezra a cupboard containing books, while on the floor before

94

Single leaf, possibly from a Gospel book, Ireland or St Gall or another Irish centre on the continent, eighth or ninth century

This leaf from an unknown text, possibly but not necessarily a Gospel book, was probably written in Ireland or at St Gall by a scribe-painter trained in the Irish tradition, but we cannot say with any certainty where he was trained or where he worked.

his feet is an inkwell. Another miniature of an author [94], shows not only the inkwell into which the writer is dipping his pen, but in his other hand the penknife used to keep the point sharp. Although commonly interpreted as the Evangelist Matthew, with his human-headed winged symbol in front of him, his purple mantle and cruciform halo suggest that the author here represented is Christ himself. In the eighth century an apocryphal text known as 'the Letter of Sunday Observance', purporting to be a letter in Christ's own hand that fell from heaven onto an altar, was circulating and gaining enough credibility that it was repeatedly condemned. One ninth-century manuscript illumination, in the Utrecht Psalter [116], shows Christ with pen in hand writing in a book, as suggested by the Psalm text (138:16).

The authoritative transmission of the text and the divine inspiration of its author are themes developed in a new way from the later eighth century, by showing the Evangelist as if inspired by his Symbol. The symbols stemmed from visions of the Old Testament, and convey the epiphany of the divine on the earth. In a Gospels manuscript probably produced in Reims [95], and certainly made for its Archbishop Ebbo, the writer sits as if transfixed, turning towards his eagle symbol, who appears above the hills as if in heaven, with an unfurled scroll from which it reads. The Evangelist has been recast in the role of the recording scribe familiar from late Roman art, but now with the 'author' projected into heaven. It is conventional to call attention to the agitated drapery style of this and related figures as in some sense a new

One miniature bespeaking high esteem for the artistic and spiritual significance of the writer of the sacred text is singularly original, and lacking in significant precedent, for it collapses the inspiring symbols of the four Evangelists into a single tetramorph [96]. Almost as if recognizing that the beholder might not know what to make of this strange figure, the artist has written the names of all four Evangelists around it, and proudly added below the frame THOMAS SCRIBSIT ('Thomas wrote [this]'). This is the signature of the scribe and painter, trained in an Insular tradition but working at least for this manuscript with a continental-trained colleague in the important missionary foundation of Echternach. Thomas also painted several other Evangelist portraits and other miniatures in this fascinating book, but chose this one, his most personal creation, for his signature.

96

Trier Gospels, miniature of a tetramorph, Echternach, c.720

The upper portion of the composite figure is the man of Matthew, while the lower portion shows not only the man's legs, but the legs of Luke's ox and of Mark's lion, and the wings of John's eagle. The artist's signature at the bottom of the page is placed where you would expect to find the artist's signature on a painting produced during recent centuries.

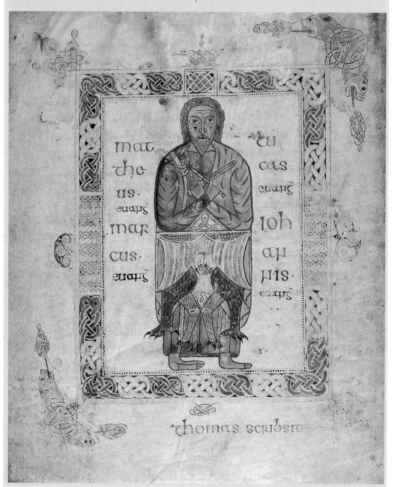

'northern' style, even though the composition and the details are thoroughly in the late Roman tradition. The contraction of the facial features is a device ultimately of Hellenistic heritage carried into late Roman art [**9**, note the head of the nearest barbarian], while its composition as a whole and especially the impossibly elegant arrangement

of its scroll depends upon knowledge of something like the Probianus ivory diptych [31]. That diptych is the exception that proves the rule that ancient authors are not physically engaged in writing, for the Roman official is really not writing but instead using the 'secretary mode' to represent words addressed to him by his once and future audience, PROBIANE FLOREAS ('Probianus, may you flourish'). Since the Probianus diptych was formerly in the important Carolingian abbey of Werden, it is entirely possible that this was the ancient model utilized by the Carolingian painter, although the transformation of style and conception and the entirely altered context show the enormous gulf that has opened between two different worlds.

Devotion

If icons as a special class of holy images are defined less by form than by context and function, it remains a question whether a miniature painting can truly be considered an icon, an image that could serve as the focus of prayer and personal devotion, at least in the early Middle Ages. There was at that time no developed class of private devotional book, analogous to the Books of Hours intended for an individual's prayers and spiritual contemplation that became so common from the thirteenth century. The Virgin and Child image of the Book of Kells [85] is related to Roman icon types, and surely demands some special explanation, for it has no parallel among Insular books, or for that matter among continental books of the early medieval period. It is not a narrative scene like the Adoration of the Magi, but an isolated image set at the very beginning of the manuscript, a powerfully personal statement by the painter. Was it a devotional image?

One type of early medieval book did contain prayers, within the context of the eucharistic liturgy, the sacramentary. An important Frankish example has no grand framed crosses or miniatures, its extensive and inventive decoration being restricted to the initial letters beginning new text sections. Largest and most important of these is the letter T for the words *Te igitur* ('You, therefore') that open the most sacred section of the Mass, the consecration of the liturgical bread and wine as the body and blood of Christ. The artist has used the shape of the letter to form a cross, and presents Christ crucified upon it [97]. Two angels fly down from above, as if singing the words of their hymn, 'Holy, Holy, Holy', written beside them in Greek letters (although in the Latin language) as read in the liturgy. The words here literally come to life, but Christ is presented at the moment of passage from life to death, for although his eyes are still open, the blood pouring from his side through the wound opened by Longinus signifies his death. His staring eyes make direct contact with the viewer, in the manner of an icon. Indeed the composition recalls the Theodotus chapel [86], but

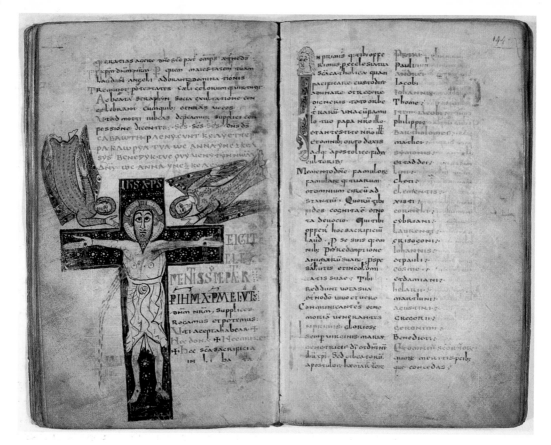

97

Gellone Sacramentary, the opening words of the central portion of the Mass, *Te igitur*, probably written at the monastery of the Holy Cross at Meaux (near Paris), *c.*790s

On the facing recto the Mass text continues, showing especially the list of saints to be specifically mentioned at each performance. On the left-hand page, two angels fly down from heaven chanting the seraphic hymn *SANCTUS SANCTUS SANCTUS* (Holy, Holy, Holy), which is written in Greek letters just above them, and which is part of the performance of the Mass.

here instead of representing the saints through their images in the sacred space of the chapel, the saints to be especially remembered are represented through their names, written on the facing page. The head crowning the initial at the top of the left column on that page seems to regard the image of the crucified Christ, and may represent either the officiating priest or the personification of the Church itself, both of which are named in the text.

Another initial letter in the Gellone Sacramentary, for the prayers said on the Saturday before Easter, and commemorating the death of Christ, may be the earliest surviving image in Christian art that unambiguously shows Christ dead on the cross. The text calls for such an interpretation, but it is difficult to assess the miniature, for almost alone among the many dozens of miniatures in the book it has been seriously damaged, apparently by rubbing.[10] Is this an example of devotional use? Although the Gellone Sacramentary's decoration seems rough, almost crude, in style, it is inventive and engaging, and seems to have been highly regarded in its own time. The manuscript is the earliest source for prayers used in connection with royal corona-tions, and contains an early text of a special prayer for the blessing of the Frankish army before going off to battle (introduced with the

image of an armoured soldier on horseback). Someone named David signed two of the initials, and his prestige is also indicated by the fact that he served as the corrector for a book written at a nearby convent, also signed by the nun who wrote it.[11] Moreover, in devoting special attention to the theme of the cross, and Christ's sacrificial death on the cross, the illuminator of the Gellone Sacramentary was starting down an increasingly prominent new path.

A small manuscript made for the personal use of King Charles the Bald [98] introduces the 'Prayer for the Adoration of the Cross' with a double miniature. On the recto is Christ on the cross, his weight stretching his body, which sways to one side, evidently either already dead or at the point of death. Facing him is a portrait of the king, on his knees, humbling himself before and possibly crawling towards the image, which seems almost to come to life before him as if a vision granted in response to his prayers. The inscription above Charles is presented as if spoken by Charles in his own words, 'O Christ, you who on the cross have absolved the sins of the world, absolve, I pray, all [my] wounds for me.' The plea for personal salvation could hardly be more clear, and the choice of the word 'wounds' (*vulnera*) where one might have expected 'sins' connects Charles's suffering with that of Christ. Such identification can be traced in earlier monastic figures such as Columbanus, whose biographer several times refers to the saint 'taking the cross upon himself and following Christ',[12] yet there is also something more here. In a royal context the image proclaims a new theme for the ideology of rulership that was entirely foreign to ancient Roman conceptions, namely that the ruler should imitate Christ not only in his majesty but in his humility and sacrifice for his people.

98

Prayer book of King Charles the Bald, probably *c*.860s

Written by a scribe and with paintings by an artist associated with Charles's court on several projects, but with no certain place of production. These are the only miniatures in the manuscript, a strong indication of the growing centrality of the image of the crucified Christ in Christian art from the ninth century.

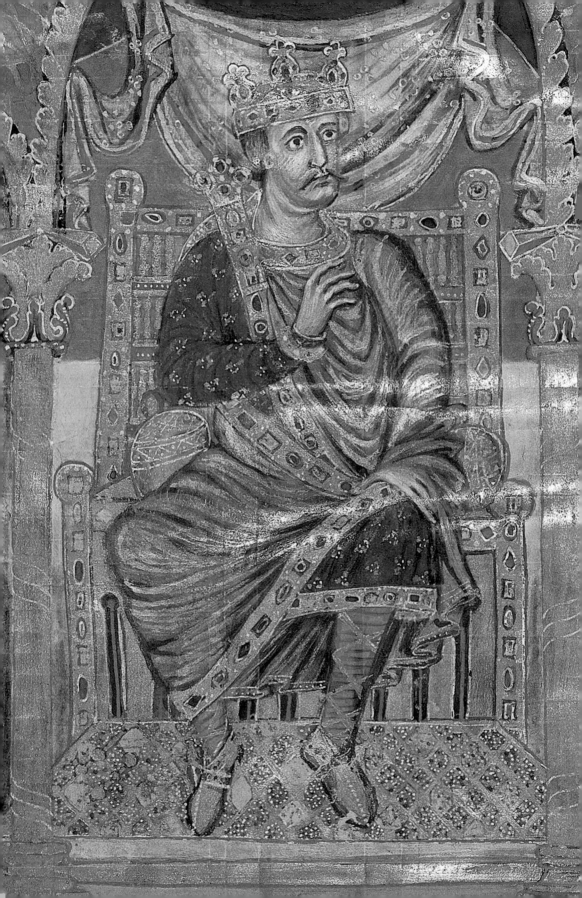

Art at Court

10

Although ecclesiastical institutions had far greater success in preserving their treasures, early medieval courts were also important artistic centres, the focus not only of political and military affairs but of large areas of cultural life. An important section of *Beowulf* is set in a king's drinking hall, and is one salient example of the heroic literature produced for and performed in that setting. Einhard's *Life of Charlemagne*, written by a man with long experience of both secular and ecclesiastical life, although mainly seeking to present an idealized picture of the wise and just king, also gives glimpses of an occasionally raucous court life. Young men ride out to hunts, and one hundred people bathe together in the hot springs around which Charlemagne constructed his palace at Aachen. Poems in Latin by Alcuin of York and Theodulf of Orleans convey a vivid impression of life at Charlemagne's court. The latter describes a feast, where the royal children surround their father while his chief officials and penurious scholarly petitioners gather round; the poet reads his verses while a drunken 'brawny hero' darts him black looks and an Irishman who has become his rival and enemy shudders and groans.[1]

Following in the pattern of militarized late Roman society, rulers of early medieval western Europe spent much of their time travelling with their armies, especially during the summer campaigning season [**Map 6**]. At other times, they spent much time at country places, usually referred to as villas in late antiquity but more commonly as palaces in the early medieval period. They also wanted to continue the tradition of having something approximating a capital, if not truly a fixed seat of administration, then at least a site whose imposing buildings represented to all who saw them the rulers' power. Already in the fifth and sixth centuries new ruling groups embellished their capitals with public buildings and especially with grand churches, as in Euric the Visigoth's Toulouse or Theoderic the Ostrogoth's Ravenna [**49**]. Eighth-century Islamic rulers of the Umayyad dynasty constructed rural villa-fortress-palaces, while embellishing their major cities and especially their capital, Damascus, with monumental architecture, richly decorated. Some centres embodied aspects of both villa and capital, such as Yeavering in seventh-century Northumbria. One ninth-century royal

hall survives in the Asturian kingdom in northern Spain, near the capital city of Oviedo, in and around which several churches were built. Among these, San Julian de los Prados preserves extensive non-figural wall-paintings, chiefly images of the cross and architectural complexes that have been linked with the Heavenly Jerusalem.[2] In Italy the Lombards erected impressive buildings at the royal court at Pavia and the ducal court in Benevento, while the local court on the north-eastern frontier at Cividale has extensive remains from the mid-eighth century, including a chapel decorated with frescos and large almost free-standing sculptures of saints executed in stucco [99]. The packed density of decoration in many different colours and materials conveys a richness and luxury as important in secular as in contemporary ecclesiastical interiors.

Most impressive of early medieval court sites is Charlemagne's Aachen. In the years before and after 800, on the site of hot springs

99

Cividale, Santa Maria in Valle ('Tempietto'), view of entrance wall with stuccoes and wall-paintings, probably early eighth century

On the walls are figures of standing saints. The six monumental stucco figures of women are not identified by inscription. The four outer figures, standing frontally, all wear crowns and hold both crowns and crosses. They may be either saints or royal patrons or both; the innermost pair lack attributes and wear simpler garments often seen on biblical figures; they turn towards the centre, and probably are meant to address the lost figure seated under the central niche, most probably Christ.

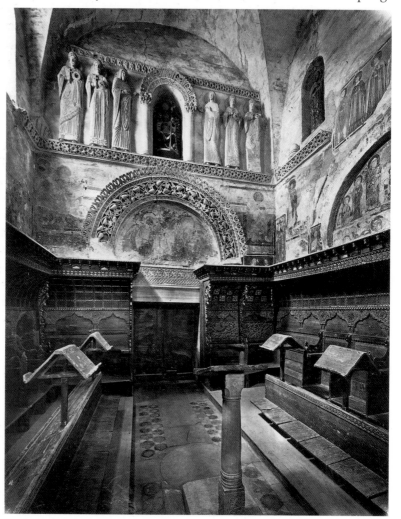

Map 6 Charlemagne's travels during his reign, 768–814

and a royal hunting lodge, a complex of buildings was constructed
including a church [**100**], a gate-house, a basilican hall used as throne
and reception room, a bath-house, and no doubt many domestic struc-
tures. This complex served for at least two decades as the 'capital' of
the Frankish kingdom, which by this time had become virtually co-
terminous with Christendom in western Europe, including all but the
small kingdoms in the British Isles and in northernmost Spain.
Between roughly the middle of the eighth and middle of the ninth
century, and especially during the long reign of Charlemagne from 768
to 814, the Frankish court was an immensely creative centre of
European politics and culture, both ecclesiastical and secular. The
church at Aachen, which alone of the many structures established by
Charlemagne survives in large part, served as palace chapel, with a
private entrance on the upper storey leading to the royal seat, and also
as the church for the court and larger community. Its opulent decora-
tion includes panels of coloured marbles on walls and piers in the lower
parts, as in Justinian's Hagia Sophia, San Vitale in Ravenna, and the
Dome of the Rock in Jerusalem, while the vaulted spaces were covered
with gleaming mosaics [**100**], as in those buildings. Even the utilitar-
ian railings are lavish works of art, cast in bronze, each panel having a
different design and decorated with a range of ornamental patterns
recalling contemporary book illumination.

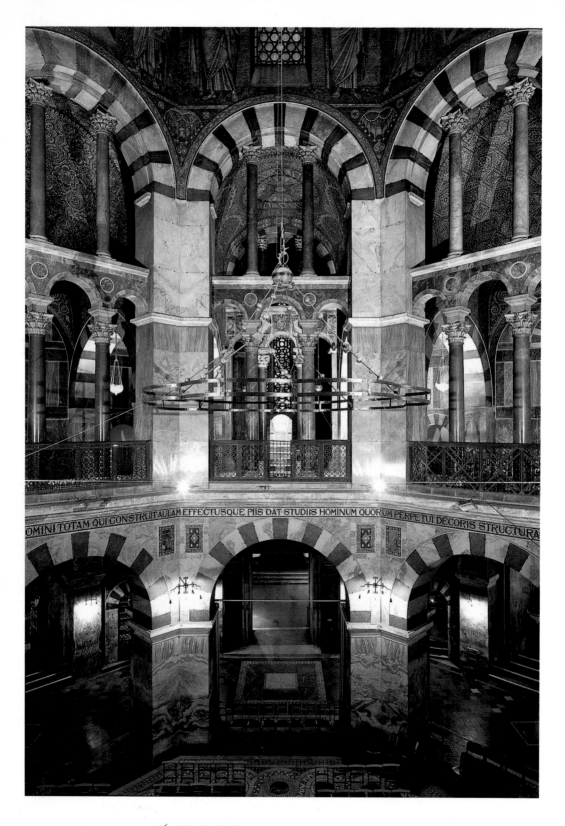

...OMINI TOTAM QVI CONSTRVIT AVLAM EFFECTVSQVE PIIS DAT STVDIIS HOMINVM QVORVM PERPETVI DECORIS STRVCTVRA...

Aachen, Palace Chapel, interior view, towards the royal throne on the gallery level. End of the eighth and early ninth century

The throne itself is probably a later addition on the spot where Charlemagne would have sat while observing services in the chapel. Behind his seat was a door leading to a portico overlooking the large courtyard in front of the church, from which he could have appeared to his followers and people, a feature drawing upon some Roman precedents (for example the arch over his head), but possibly based upon the biblical description of the palace of Solomon.

Luxury arts of the court

Unfortunately, little of the visual art of the early medieval courts survives. Buildings were largely destroyed and rebuilt, and it is no accident that at Aachen only the church survives largely intact, while the early modern city hall stands directly upon the foundations of the rebuilt royal hall. With the royal hall disappeared its elaborate decoration. A poem by Ermoldus Nigellus describes the royal hall in the Carolingian palace at Ingelheim, which contained, he claimed, a series of paintings showing famous rulers, including Cyrus the Persian, Romulus and Remus, Hannibal, Alexander the Great, Constantine and Theodosius.[3] Courtly imagery surely took the form of textiles as well as paintings. According to a later source, the widow of Ealdorman Byrhtnoth, whose heroic death in the battle at Maldon of 991 is celebrated in one of the finest Anglo-Saxon poems, gave to Ely Cathedral in his memory 'a hanging embroidered with the deeds of her husband'. The ninth-century ship burial at Oseberg in Norway provides a rare fragment of a secular textile hanging, and perhaps hints at the background for the famous Bayeux Tapestry.[4]

Textiles, used both as wall-hangings and as clothing, have almost entirely disappeared, but literary sources convey something of their high value and prestige. As in the early Islamic world, from which we have at least one surviving silk garment covered with medallions inhabited by fantastic winged creatures, courtiers certainly wore elaborate costumes, as Einhard and other Carolingian authors describe, usually critically.[5] The 'body language' of personal appearance could send political messages. When Charlemagne allowed Grimoald of Benevento to return to his Lombard principality in 787, he required Grimoald to put Charlemagne's name on all coins and official documents, and to be barbered in the Frankish rather than the Lombard manner. Whatever that distinction meant, contemporaries were alive to it, for when Grimoald appeared with hair and beard cut like a Lombard, Pope Hadrian wrote to Charlemagne with the news that he had been betrayed.[6]

Although they cannot be taken as literally accurate, miniature paintings in manuscripts may convey something of the rich court costumes. The clerics parading before King Charles the Bald in the great Bible made for him at Tours suggest, with their gorgeous variety of brilliantly coloured and patterned stuffs, fashion models on a catwalk. These are of course ecclesiastical vestments, but evidently shared a courtly luxury and style with secular garments. A miniature showing the same king enthroned among members of his court [101 and page 172], with its golden columns and lamps and rich costumes, gives an unforgettable impression of the splendid effect that the court cultivated. Imitation

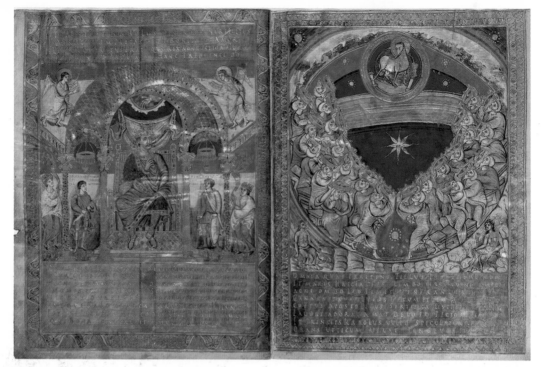

textile patterns were sometimes painted onto parchment in luxurious books, the most startling example being the 'contract' stating what gifts would be made to Princess Theophanu when she arrived from Constantinople to marry Emperor Otto II in 972. The document is written in golden letters on a long vertical scroll, with a background of paired medallions, each painted with images of animal combats [**102**], evoking the courtly theme of hunting. With few earlier precedents, such imitation textile patterns became a prominent fashion in the most luxurious court-supported books of the next decades.

Works in precious metals were easy prey to recycling, unless or until preserved in church treasuries and adapted for ecclesiastical use. The silver dishes which King Oswald of Northumbria was to use for his Easter feast were, according to Bede, broken up for distribution to the poor.[7] According to local tradition, the ewer now in the treasury of Saint-Maurice d'Agaune [**103**] was presented to the monastery by Charlemagne, who in turn had received it from Caliph Harun al-Rashid of Baghdad. The story is probably untrue, even though plausible, for the Caliph certainly sent an ambassador who brought an elephant along with other gifts, according to Einhard 'robes, spices and other riches of the east'.[8] Exchange of gifts among rulers was an important aspect of politics with obvious potential impact upon the arts. In this case, the style of the object argues against an Islamic origin, although an Islamic transmittal to the west is not excluded, and the origin of the enamels remains uncertain. The unknown object on which

the enamels were originally mounted was perhaps acquired by Charlemagne, conceivably when he seized the Avars' treasury in 796, and the enamels remounted with acanthus ornament similar to that used on ivories associated with Charlemagne's court. It is impossible to say for certain whether this vessel for the pouring of wine was intended for secular use at a feast or ecclesiastical use at an altar; as the Church was becoming increasingly aristocratic, secular courts became suffused with religious themes and practices. Whichever origin story fits this particular object, diplomatic gift, plunder, or refashioning of spoils, each variety of story would fit substantial numbers of objects for court use.

Elaborate court costumes must have been held together with impressive fibulae and buckles, and enriched with other jewellery. Rulers continued to derive much of their power from the distribution

Saint-Maurice d'Agaune,
enamelled ewer, eighth
century and later (30.3 cm H).
The enamels probably date
from the eighth century and
may be of Byzantine origin, but
were reset on this object
probably during the ninth
century by a Carolingian
goldsmith

The motif of affronted griffins is
a common royal emblem,
almost certainly not religious
iconography. The object was
used as a reliquary from the
twelfth century.

of booty, but with the ending of the custom of furnished burial in the
seventh century secular jewellery has mostly disappeared from our
view, for unburied objects were probably remelted to make more fash-
ionable creations, or converted to ecclesiastical purposes. Only from
northern areas such as modern Ireland and Scotland and Scandinavia
have many examples of secular prestige metalwork survived. The
Hunterston Brooch [104] is based upon the large class of penannular
brooches commonly used in Ireland and other Celtic areas from the
pre-Christian period, in which a large ring with an opening at one
point could be turned around over the long pin to whose head it was
attached, in order to lock the garment into place. Oddly, this brooch is
pseudo-penannular, for the opening in the ring has been closed with an
elaborate cross-pattern reminiscent of the cross pages in Insular books
of the same period, like the Lindisfarne Gospels. This great brooch
represents a new class of jewellery, which included pins larger in scale
and richer in decoration than anything previously known, the ultimate

in display if no doubt awkward and heavy to wear. Rather like the items
made for the Sutton Hoo burial, this and related pseudo-penannular
brooches such as the famous Tara Brooch used multiple techniques,
casting, filigree, glass, and amber studs, so that the artistic originality
and distinction lends prestige to the wearer. The type was taken over,
one might say appropriated, by the Vikings who raided and eventually
occupied portions of the British Isles from the early ninth century, and
interlaced-animal and other motifs of Scandinavian origin were then
applied to their decoration [105].

Although the significance of the objects just considered lay primar-
ily with their precious materials and workmanship, with the social
status they represented and conveyed, and in some cases with their
exoticism, court art could also convey particular ideas and messages.
Charlemagne's reform of Frankish coinage, substituting silver for the
Roman and Byzantine gold standard, possibly reflecting Islamic prece-
dent and an influx of contemporary Islamic coins, created a stable
currency under at least some measure of royal control throughout the
realm. Coins were issued in larger numbers from a smaller number of
mints, bearing the royal monogram. Only from *c.*804 or even later did

105

Bossed penannular brooch from Ballespellan (Co. Kilkenny), hammered silver, late ninth century (115 mm diameter)

The motifs of biting heads recall Style II metalwork of two centuries earlier, but here the gripping paws and wandering serpents in the field connect it to contemporary metalwork from Scandinavia, while other details connect them to contemporary Pictish work from northern Scotland.

106

Silver denarius of Charlemagne, minted c.806, at Frankfurt, c.20 mm

The obverse has a profile portrait and inscription KAROLUS IMP[erator] AUG[ustus] ('Charles Emperor Augustus'), and the reverse a temple front and inscription XPICTIANA RELIGIO ('Christian Religion' (using three Greek letters).

the Carolingians begin to issue coins with the royal portrait, thereby returning to the Roman and Byzantine tradition followed also by the preceding Merovingian dynasty. The resultant coins provide our only contemporary 'portraits' of Charlemagne [**106**], and are justly famous. Initially struck in small numbers, more like commemorative medallions than coins for large circulation, under his son and successors coins with the profile portrait of the reigning sovereign became the fundamental type. The reverse shows what looks like a Roman temple, as employed on Roman coins especially from the period just before Constantine, with the cult image of the temple's deity visible at the centre. Here however the cross has been substituted for the pagan statue, and another cross mounted upon the top of the pediment, the imagery working with the emphatic inscription invented for this type to insist upon the transformation of the ancient tradition by the triumph of Christianity. An earlier tradition has been appropriated by the new rulers, borrowing some features but endowing them with new meaning.

Religious life was an essential feature of early medieval politics and court life, as the ubiquity of some sort of church or chapel at court attests. According to Einhard, Charlemagne attended services daily, and the luxury of the liturgical fittings must have at least matched the luxury of secular decorations. We still have the illuminated manuscript made for the readings of the Gospels in Charlemagne's chapel. In his colophon, its scribe and painter Godescalc tells us that he wrote the book for the king, and describes himself as a *famulus* of the king, a member of the royal household. This remarkable book is the earliest surviving example demonstrably made for a royal patron, conceivably in a court 'school' or workshop, and the earliest example of the revived antique figural style that would become a hallmark of many works of art from this time forward. Godescalc adopted the new style of book illumination, in which the entire book becomes a work of aesthetic design. The text columns on every page are given frames with

Carolingian minuscule

Although the main text of the Gospels in Godescalc's Lectionary was written in stately large uncial letters derived from Roman precedents, letters of silver and gold, this book also contains the earliest example of an important new script, invented at this time. Caroline or Carolingian minuscule script is used for the long colophon, the name used for material added at the end of a manuscript by its scribe, which may be as simple as a name and date, but may be an extensive discussion of the circumstances of writing. Caroline minuscule is far more compact and far quicker to write than any ancient book hand, yet far more clear and legible than ancient cursive scripts used for administrative documents like charters, and quickly spread from the royal court with such long-lasting success that the printing of this book is directly in the tradition thence established.

elaborately patterned and coloured ornament, almost never exactly repeating, while the opening page of the text [107] has large ornamented initial letters like the Lindisfarne Gospels [90]. The facing verso draws upon that tradition, seen also in earlier Frankish books [91] in featuring a large cross and a variety of animals, here treated in a more naturalistic manner. The central motif is quite different, however, and represents an important personal and political reference.

This manuscript was written no earlier than 781, because Godescalc's colophon refers to the baptism of Charlemagne's sons and heirs by Pope Hadrian in that year (the closing date of 783 is provided by the death of Queen Hildegard, mentioned in the colophon as still alive). The baptism took place in Rome, in the Lateran Baptistery, and represents Charlemagne's acknowledgement of the supremacy of the bishop of Rome, the pope, in ecclesiastical affairs. Moreover, the baptism

107

Godescalc Gospel Lectionary, unknown place of origin, for the court of Charlemagne, 781–3

The text gives the first reading of the liturgical year, for the Vigil of the Nativity of Christ. The image shows a building or structure, with a peaked covering carried upon eight columns, and beneath it a railing of some sort. On one level it probably symbolizes the fountain of life, but probably also alludes to the octagonal baptistery at the Lateran used for the ceremony of 781.

emphasized the special relationship between the Frankish royal house and the pope, who a generation earlier had authorized the elevation of Charlemagne's father to the kingship, and whom the Frankish kings now promised to support and protect.

Appropriation and politics

The new Carolingian dynasty from its inception sought to validate its initially precarious claims to legitimacy through the invocation of tradition. Charlemagne, following his father's lead, reissued the oldest Frankish law code, the Lex Salica, with a new preface including a series of bold claims:

The famous race of Franks, whose Founder is God, strong in arms, true to its alliances, deep in counsel, noble in body . . . free from heresy . . . by God's favor, Clovis King of the Franks, powerful, glorious and famous, first received Catholic Baptism. Long live Christ who loves the Franks! May he guard their kingdom, fill their leaders with the light of his Grace, protect their army, accord them the defense of the Faith.[9]

The linked themes of military strength and the defence of Christian orthodoxy were disseminated through the radiating impact of people trained at or associated with the royal court, and expressed by works of art produced there. Images of the archangel Michael or mounted saints spearing demons express the militancy of Church and court, as do images depicting Christ trampling upon beasts, based upon Psalm 91: 13: 'Thou shalt walk upon the asp and the basilisk: and thou shalt trample under foot the lion and the dragon.' Although known in late antiquity, the image was never given great prominence, but in works associated with Charlemagne's court it appears frequently, both in painting and ivory carving.

One ivory [108] surrounds Christ trampling beasts with narrative images of the infancy of Christ and the miracles he performed. The latter make excellent illustrations for the triumphant power over evil exemplified by the symbolic central image. Such manipulation of the narrative probably also accounts for the enlarged scale of the central figure at the top, the Virgin Mary receiving Gabriel's Annunciation of the birth of Christ, while beside her in the upper corner stands Isaiah with his prophecy (7: 14): 'Behold a Virgin shall conceive.' The prophetic figure was most likely introduced here to emphasize the full divinity of the Virgin's son from conception, against the so-called Adoptionist heretics of eighth-century Spain, whom the Carolingians (mistakenly) thought denied this doctrine. Both Alcuin and Paulinus of Aquileia, important figures at Charlemagne's court, wrote treatises against the Adoptionists, and the former was also a correspondent of Charlemagne's sister Gisela, abbess of the monastery of Chelles where

108

Ivory cover of a Gospel
Lectionary, produced probably
by an artist associated with the
court of Charlemagne, *c.*800
Around the central image of
Christ are, reading clockwise
from the top left, the prophet
Isaiah, the Annunciation,
Nativity, Adoration of the Magi,
Massacre of the Innocents,
Baptism of Christ, miracle at
Cana, storm on the Sea of
Galilee, raising of Jairus'
daughter, and healings of the
possessed man, paralytic, and
woman with an issue of blood.

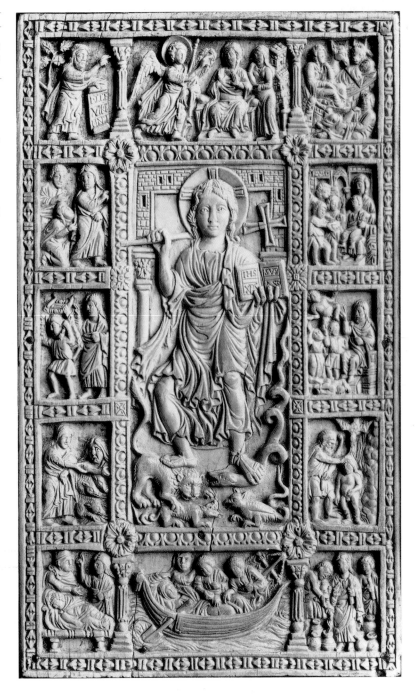

the book was written on whose cover the ivory is still found. The imagery addresses contemporary political controversies and reflects the strong personal ties among the remarkably small group of men and women leading the political and cultural and also artistic reforms around Charlemagne.

Another aspect of this ivory demands consideration, indeed has often been the sole focus of discussion in reference to this and related objects, namely its relationship to earlier works of art from the late Roman period. In this case, the relationship is direct, as we still have the fifth-century ivories upon which the Carolingian work is partially based, and whose compositions it follows closely for six of the miracle scenes. In that sense, it represents the notion of a 'Renaissance' of the classical world sponsored at the Carolingian court, and thus a fore-shadowing of the 'Renaissance' commonly associated with fifteenth-century Italy. There is nothing wrong with the term except its common implications of dependence and a sense of inferiority, entirely inconsistent with the Carolingian court's proud insistence upon its superiority to the Roman tradition, seen in the preface to the Salic Law quoted above and in many other sources. The new coin type adopted by Charlemagne after his assumption of the Roman imperial title [**106**] obviously depends upon Roman precedents, but also seems to 'correct' or improve that tradition, especially where it seemed to undervalue the centrality of the Christian religion. For this reason one scholar suggested that we should speak not of the Carolingian Renaissance but of the Carolingian 'correction', a term used by contemporaries that captures this special flavour.

No single term can hope to capture the complexity of one culture's relationship to another, but the concept of appropriation, already brought forward in connection with Scandinavian bossed penannular brooches and Carolingian coins, is very helpful. Carolingian artists, and Carolingian culture more broadly, claimed the Roman tradition as their own, adopting some and rejecting other specific features. In their great basilicas they frequently included a large continuous transept in front of the altar, a feature occurring in the early Christian period only in the great apostolic and papal basilicas of Peter and Paul in Rome. Adopting the form, first at Saint-Denis for the burial church of the new dynasty's founder, Charlemagne's father Pippin, almost certainly was meant to convey meaning, attachment to the Christian Church's greatest apostolic saints, and alliance with their successor, the pope. Although earlier churches built by kings and destined for royal burials had been dedicated to Peter (the burial church of Clovis in Paris)[10] or Peter and Paul (the monastery built by Ethelbert at Canterbury),[11] there is no evidence that in architectural form these structures evoked their Roman model, as did Saint-Denis. Later buildings need not have been nearly so concerned to indicate a special meaning, for the transept

became a standard feature of Carolingian building practice, forming a new tradition. Indeed, in the Plan of St Gall [79] the basilica with transept is intimately associated with a dramatically novel development, the cloister courtyard and its surrounding structures, in such a way that it seems most unlikely that contemporaries would have perceived the church plan or the entire complex as 'Roman'.

Ivory carvings constituted a distinctive class of Roman visual art in the fourth into the early sixth centuries [30, 31, 42, 44, 59], but production of carved ivories then ceased for well over two centuries. When artists associated with Charlemagne's court began to carve ivories, they manifestly 'revived' a late Roman type and tradition, and the reference to that tradition is obvious even in the material itself. Carolingian artists needed, at least in the earliest examples, to study Roman ivories in order to learn how to produce their own, for there was no living craft tradition whatsoever, and the correspondence in many stylistic and iconographic features is thus scarcely surprising. Indeed the relationship was at least in the area of ivory carving almost literally parasitic. Active trade in elephant tusks had ended with the economic crisis of the sixth century, and a further separation from African and Asian markets was entailed by the Muslim conquests of the seventh century. There being no ready supply of new ivory panels, Carolingian artists frequently planed down the surface of late Roman consular diptychs and other secular carvings (never, to my knowledge, a work with Christian subject-matter) and carved their new works on the other side. Sometimes they divided a rectangular Roman ivory in two, making two small, nearly square panels from it.[12] This is appropriation, indeed consumption, with a vengeance. Latent is a political message, that the Carolingian ruler now occupies the traditional role of the Roman emperors and senators with whom ivory carving had been so closely associated.

A striking example of court propaganda and its dissemination is provided by a mosaic in the apse of the little chapel of Germigny-des-Prés [109] not far from Orléans, where its patron Theodulf was bishop. Theodulf was not only one of the chief court poets, but also a theologian given the leading role in drafting the official Frankish response to the restoration of the cult of images by the Seventh Ecumenical Council, called by the Byzantine Emperor Irene in 787. Offended at not being invited to a supposedly universal council of the Church, and informed of the council's actions only through a defective Latin translation of its Acts, Charlemagne and his advisers felt compelled to respond to what they regarded as an endorsement of idolatry. They maintained that images should be neither destroyed nor venerated as holy things, but should be used for the decoration of Christian sanctuaries and for the instruction of the faithful. In taking this line, they clearly thought that they were in accord with the ancient tradition of

109

Germigny-des-Prés, oratory of Theodulf, mosaic in apse, early ninth century

At the bottom is the Ark of the Covenant, in the form of a rectangular box. Upon its corners stand two small images of cherubim, with their wings touching. At the sides stand two large images of cherubim, also with wings touching. Note that the image does not represent heavenly beings themselves, but represents the images of heavenly beings made at the express order of God for the Ark and for the Temple. If they fail to make a life-like impression, the patron would be pleased.

the Church, expressed by Gregory the Great among others, and compiled a lengthy treatise of 121 chapters in which their views were presented and those of the Byzantine council rebutted. Theodulf drafted these so-called *Libri Carolini* or 'Caroline Books', probably in the winter of 792–3, with the intention that they should be presented to the pope for his anticipated endorsement. Unfortunately, Pope Hadrian accepted the Seventh Council's Acts, and rejected the Carolingian formulation. After all, Rome was full of holy icons whose orthodoxy his predecessors had not long before vigorously defended against the Byzantine iconoclasts [**80–1, 83–4, 86**].

Theodulf's mosaic takes up a theme prominent in the *Libri Carolini*, the Ark of the Covenant and its decoration with golden figures of cherubim. One pair were made in the time of Moses when the Ark was first created (Exodus 25: 10–21), and the other larger pair were added in the time of Solomon when the Ark was put in the Sancta Sanctorum in the Jerusalem Temple (1 Kings 6: 19–28). Authorized by God's specific command, these images of angelic spiritual beings were manifestly orthodox. Their visual presentation, as in the image of Christ in Majesty as the new Ark from the Gundohinus Gospels [**87**], served to rebuke the iconoclasts. However, in the *Libri Carolini* the cherubim are contrasted with holy images that were not authorized by God, such as Byzantine icons (in Theodulf's view). This unique monumental apse mosaic, with neither precedents nor followers, substitutes for images of Christ or saints then current in most churches the 'purified' focus upon the written word, not the image, of God,

contained in the Ark, to which the angels turn in petition along with the beholder. Rejecting the sacred character of all 'novel' iconic images, Theodulf accepts as truly sacred and the means to salvation not images but only the cross, relics, the eucharistic bread and wine consecrated in the Mass, and biblical scripture. All of these sacred things are strongly associated with the altar, and will become increasingly important in the ninth and tenth centuries.

Rome is closely entwined with contemporary Carolingian court art, both giving and receiving influences on many levels. We do not know where Godescalc learned to paint, but some of the best parallels for his style may be found in Italian art, especially in northern Italy. For example, the figures of saints added to the Boethius diptych [43] show something of the effort to model forms in a three-dimensional manner with tones of light and dark employed by Godescalc, while a collection of sermons by the leading Fathers of the Church made for Bishop Egino of Verona between 796 and 799 provide a comparison so close that one may be tempted to see them as the work of the same artist. Godescalc may well have come from Italy, and may have returned there. He seems not to have been involved in the production of any later manuscripts associated with Charlemagne, and may have worked for the bishop of Liège in the earlier 790s before going to Italy with Egino, who was himself a Frank rather than an Italian. Such prominent Italian scholars as Paulinus of Aquileia and Paul the Deacon (from a Lombard noble family) played an important role in the earlier stages of the explosion of cultural activity at Charlemagne's court from the 780s, and contacts continued with increasing intensity up to Charlemagne's journey to Rome in 800 (his fourth visit). That journey was motivated by Charlemagne's desire to re-establish Leo III on the papal throne, from which he had been driven by his opponents in the city in the previous year. The most famous result of the visit was Charlemagne's acclamation as emperor of the Romans on Christmas Day, 800, in St Peter's Basilica at the Vatican.

Any reader of his official biography will see that Leo III was keenly interested in visibly displaying his power and generosity. He repaired many churches of Rome, sometimes enlarging them, and constructed hospices for pilgrims, to which he transferred relics. It was his name inscribed on the great shrine of the Sancta Sanctorum. He donated countless vestments, altar cloths, and implements, including at least one golden Gospel book studded with jewels (weighing 17 lbs (8 kg)). He constructed two large halls at the Lateran that would for centuries be important parts of the papal palace there. The larger, known as the Hall of the Council, had a marble floor and couches for dining, arranged around a central porphyry fountain carved in the form of a shell. The walls were punctuated by ten niches with images of the apostles preaching, while the decoration focused upon an apse mosaic

with Christ preaching, surely in a manner evoking the art of the fourth and fifth centuries [29]. The other hall, or *aula*, was a tri-apsed triclinium, very much like the tri-apsed throne hall of Charlemagne's Aachen, its walls sheathed with coloured marbles like those surviving in Aachen's chapel. Leo's *aula* had figural floor mosaics, and an apse mosaic again showing Christ preaching. On the triumphal arch, Peter sat on a throne between the kneeling figures of the pope and Charlemagne, bestowing a spear upon Charlemagne and the *stola* of metropolitan ecclesiastical authority upon Leo. The political message could hardly be more clear, proclaiming the alliance of Roman papacy and Frankish king now elevated to the Roman imperial title.[13]

The major works of Leo III do not survive intact, but it is clear that the manner in which they vividly drew upon the tradition of early Christian art in Rome not only corresponds to the evocation of older traditions practised at Charlemagne's court, but also solidified a Roman preference for artistic projects that presented themselves as conservative and traditional even when in fact exploring new directions. We might look at Roman art in the ninth century, with its evident revival of forms not used for several centuries, and see a revival or even Renaissance, but it seems to me wrong to imagine that contemporaries would have agreed. The notion of revival demands a notion of a break, a separation, but Rome's monumental works of art and architecture proclaim precisely the opposite, the unchanging and unbroken tradition of the Church. They seem imitative to us because they appropriate the past into the present. The construction and decoration of the basilica of Santa Prassede under Pope Paschal I is an outstanding example of these attitudes and trends. The *Liber Pontificalis* devotes three chapters in Paschal's biography to this project, admitting that the old building was abandoned altogether, but nonetheless presenting this entirely new structure on a different site as the 'restoration' of the old church whose collapse the pope had been able to anticipate.[14] The plan of the church was unusual, having a large continuous transept like those being erected for several decades in major Carolingian churches, but here representing a revival of the Roman type hitherto used only for the great fourth-century apostolic basilicas. The surviving mosaics present a fascinating mix of traditional and novel [110]. The apse shows Christ floating upon clouds, flanked by Peter and Paul, by Santa Prassede to whom the church is dedicated, and by the papal donor, a composition based directly upon the sixth-century mosaic still visible a mile away at SS Cosma e Damiano. The inner triumphal arch around the apse presents the 24 Elders of the Apocalypse offering crowns to the Lamb of God, again based directly upon SS. Cosma e Damiano, and before that the basilica of St Paul (and also the theme of the mosaics in the Aachen chapel). Instead of following such important local examples, however, the triumphal arch

at the entrance to the transept is unprecedented. Here the mid-point of the arch depicts the celestial city of heaven, full of the blessed, with Christ standing at the centre, on axis with his figure in the apse and with the altar below. Angels guard the gates to the city, to which crowds of martyrs, bishops, and others are approaching, representing along with the crowds of offering saints lower on the walls those whose relics are gathered in the church and who can serve as intermediaries for transmitting the prayers of the faithful, gathered in the church in hopes of gaining heaven themselves.

The political utility of pictorial imagery is a hallmark of the ninth and tenth centuries in Byzantium as well as in the west, where such imagery was by no means limited to the Carolingian and papal courts. A remarkable charter from the year 966 survives from Winchester [111], to whose New Minster it was presented by King Edgar. Although not a book but a charter confirming the reorganization of the monastery according to the Benedictine rule, it is presented in the form of a luxury Gospel codex. It opens with a full-page miniature of Christ in Majesty facing a monumental caption, then on the next opening are framed *incipit* and initial pages written in gold letters. The miniature presents the king on the central axis, between the Virgin

110
Santa Prassede, Rome. View of the mosaics of the apse and the two triumphal arches. Decorated under Pope Paschal I, 817–24

Although the form of the building, with large transept, and the mosaic decoration both recall buildings of the early Christian period in Rome, the church was from its foundation intended to be in the care of a community of Greek monks, designed as in effect a huge reliquary for the bodies of 2,300 saints (according to the inscription) collected from the Roman catacombs and now gathered together for their protection and veneration.

111

Charter of King Edgar for New Minster, Winchester, AD 966

Christ appears in the sky borne by four angels, above the figure of King Edgar, whose outstretched arms suggest both prayer, as if Christ appears in a vision to the king, and humble supplication. The charter is the earliest datable example of what scholars have termed the 'Winchester Style' of decoration, whose luxuriant acanthus ornament is its most obvious feature.

and St Peter, offering the charter itself to Christ, presented as if descending from heaven to receive it. The composition is unparalleled, as is the document itself, although some precedents can be sought in royal Carolingian manuscripts like the Prayer Book of Charles the Bald [**98**]. Even the Pictish kingdom in eastern Scotland presents a series of important works of monumental sculpture with evidently royal iconographic themes. On the so-called St Andrews Sarcophagus [**112**] vigorously carved panels of interlace ornament frame a large panel in high relief. Occupying most of the surface are animals, scattered over the surface in a manner reminiscent of mosaics, glass, and silver from the fourth century. At the top centre is a combat between a lion and a mounted figure, while the surface as a whole is dominated by the huge figure at the right side who stands and rends with his hands the jaws of a lion. Recalling the iconography of Hercules seen

112

The St Andrews Sarcophagus, sandstone, date uncertain, probably second half of the eighth century

This enormous sarcophagus has often been associated with King Oengus, son of Fergus (d. 761), probably the most powerful of the Pictish kings. Although that seems a far from conclusive identification, it does seem likely to have been intended as a royal tomb, although its form might also be connected with altars.

on many Roman stone sarcophagi [27], the imagery much more likely represents David, who had become increasingly important as the pre-eminent biblical prototype for the powerful, just, and pious Christian king.

Expressive and Didactic Images

11

Early medieval images could play many roles, as decoration, representation of social status and political power, sites for spiritual devotion, and sometimes all of these together. From the beginning of Christian art images could also be used to convey specific messages, as when Clement of Alexandria says that Christians can use the image of an anchor, because it signified hope, or of a fisherman because it might recall the apostle as a fisher of men [see above, Chapter 2]. Meaningful images such as these might be static and symbolic, as in the numerous images of majesty, or episodes from a narrative. During the ninth and tenth centuries both modes of conveying meaning were highly developed in novel ways. Although it is not possible to demonstrate any direct causal relationship, it seems likely that the problematic nature of Christian imagery, brought again to the fore because of the iconoclastic controversy, played some role in intensifying the communication of meaning through visual signs, through art. New images were developed that could carry elaborate and tightly programmed meanings, comprehensible to a select audience, given the proper setting and direction. At the same time, the form of images sought not merely to convey a story or message, but to convey it in a way that appealed to the beholder's emotions. The colophon to a manuscript of Beatus' commentary on the Apocalypse written by its scribe and painter Maius states: 'I have painted a series of pictures for the wonderful words of its stories so that the wise may fear the coming of the future judgment of the world's end.'[1] Learn, and fear.

Images and commentaries

Central to Christian art of the ninth century is the image of the cross, and of Christ crucified upon it. The cross had been a prominent feature of earlier art, as in the cross pages in illuminated manuscripts [**90** and **91**], or crosses serving as a focus of monumental decorations [**73**]. However, the crucified body of Christ on the cross was rarely presented in images before the eighth century, when this became an important theme attempting to counter the arguments of the iconoclasts [**86** and **97**].[2] An extraordinary meditation upon the cross was composed in the

Hrabanus Maurus, *De laudibus sanctae crucis*, Christ crucified within acrostic poem, probably Fulda, second quarter of the ninth century

early ninth century by Hrabanus Maurus, a Carolingian monk from Fulda in central Germany, commonly referred to as his *De laudibus sanctae crucis* (On the praises of the holy cross) [113]. In its original form this work comprised 28 acrostic poems, written in a regular grid-block rather like a crossword puzzle, and constructed so that isolating certain letters pictorially would give an additional reading. The pictures literally form words. The system was derived from a practice known in the fourth century at the court of Constantine that had been revived by Alcuin and Theodulf among others at the court of Charlemagne, where these convoluted rebuses were an expression of rivalry in learning, and also of humour. Hrabanus is, however, deadly serious, and attempts to employ this strange genre as a means of expressing Christian spiritual devotion while teaching allegorical interpretation.

The opening poem shows Christ with arms outstretched as if upon the cross. Behind him are the 47 lines of the poem, written in the universal language of Latin, of course. Important areas of his body constitute separate verses: reading clockwise around his halo REX REGUM ET DOMINUS DOMINORUM (King of Kings and Lord of Lords), reading anti-clockwise around his right foot and up his leg AETERNUS DOMINUS DEDUXIT AD ASTRA BEATOS (The Eternal Lord leads the blessed to the stars). The next 27 poems operate in the same way, with images of angels, the Ark of the Covenant, divine names and attributes, and many varieties of crosses, spelled out by the visual signs that they form. Obviously reading these multiple poems is difficult and slow work (to say nothing of composing them, the thought of which

makes one shudder), and it would be easy to miss something of potential spiritual value. For this reason Hrabanus provided his own commentary for each picture-poem, arranged always on the facing recto, so that the reader/beholder could refer from one to the other without needing to turn the page, almost like footnotes in a scholarly text. Surprisingly, this rigid and apparently cumbersome system proved popular, as did the text itself. Several extant manuscripts were made during Hrabanus' long life (he died in 856, having been elevated to the position of Archbishop of Mainz), apparently as gifts to the king and important churchmen, probably under Hrabanus's own supervision, and copies continued to be made for several centuries, long after his death. The learned men of the great Carolingian monasteries evidently had a taste for such work, or at least wished to express a taste for such work by making and distributing copies.

Hrabanus wrote many other works, including a popular encyclopaedic manual and commentaries on various books of the Bible, commentaries that eventually formed part of the famous *glossa ordinaria*, the marginal commentaries found in many Bibles from the later Middle Ages. The gloss, which began to be compiled in the Carolingian period, functioned rather like Hrabanus' commentary on his picture-poems, being written always on the same page as the text whose meaning it was clarifying and expanding. Carolingian biblical manuscripts containing both text and marginal gloss commentary are rare, and none contains accompanying illustrations, but there is a ninth-century manuscript equipped with both. This is a copy of the book of Job, one of the most difficult biblical texts, subject of a commentary by Gregory the Great, his *Moralia in Job*, that became one of the most commonly read texts in western monasteries. Despite its importance for monastic contemplation, the Job text does not immediately seem to lend itself to illustration, chiefly comprising long discussions about the nature of God's justice carried on among Job and his friends while the former sits upon a dung-hill after all his family and possessions have been destroyed.

The Job manuscript to which I refer was written in Greek rather than Latin, although probably written in or near Rome rather than the eastern Mediterranean.[3] The text is written in large letters, sometimes only six lines of text on a page [114], while the much more extensive commentary is written in smaller letters beside it. Illustrations occupy varying locations on the page, sometimes as framed miniatures, and sometimes with unframed figures above or below or, as in this case, virtually surrounding the text. This page shows the opening of the action (Job 2: 1), when the angels and Satan come before God, and Satan proposes to show that Job's uprightness is simply the result of divine favour. The hand of God reaches down from the vault of heaven in a manner stemming from early Christian sources [54], but here instead

114

Book of Job with commentary, Satan and angels before the Hand of God. Probably from a Greek monastery in Italy, most likely in Rome, ninth century

Satan is enclosed in the dark mandorla at the lower left. At the upper right the hand of God reaches out of the concentric circles of Heaven, with rays descending around it. The biblical text is immediately beneath this image, written in large letters, while the other smaller letters at the left are the commentary on these lines by Olympiodorus.

of conveying action it is conveying speech, directed to Satan. The image of Satan constitutes something novel, for only from the later eighth and ninth centuries do we have him or other demons presented in visual form. In the Book of Kells, for example, he appears in one of the two narrative images, the temptation of Christ. In the Vatican Job, he is contained in an oval which is a sort of parody of the mandorla or glory often used for Christ, and is given dark skin and a short tunic, seeking to distinguish him from the 'good' angels clumped together making gestures of listening, and managing only to look bewildered. The gulf between good and evil, and for that matter between other heavenly figures and the divinity is given effective visual expression, Satan and the nearest angel turning backs to one another, both far beneath the majestic divine hand.

The best-known early medieval illustrated commentaries are the Beatus manuscripts. Beatus was probably a monk and most likely a priest at the northern Spanish (Asturian) monastery of Liebana [**Map 5**], until his death in or around 798. In 776 or shortly thereafter Beatus completed the first version of his *Commentary on the Apocalypse*, a compilation of and selection from earlier Christian commentaries upon the last book in the Christian Bible. Twenty-six manuscripts of Beatus' commentary survive, ranging in date from the late ninth to the thirteenth centuries, all of them illustrated, and it has generally been thought that Beatus planned for illustrations from the start. The manuscripts with what came to be a standard system of illustration

contained 118 images, of which 68 were based directly upon the relevant Apocalypse text, and immediately followed that text as reproduced in the Beatus manuscripts, preceding the commentary upon it. Some illustrations accompanied various prefaces, with among other things author portraits and genealogical tables, while seven were based directly upon the words of Beatus' commentary. These included an allegorical palm tree with martyrs, and a map of the world, intended as an aid to understanding the apostles' mission to convert the entire world to Christianity [**115**]. The format of the map is 'scientific', based upon world maps of the Greek and Roman geographers transmitted through earlier Christian writers, but its significance is 'apocalyptic' in today's generic sense, looking forward to the impending cataclysmic end of the world. Spread out over a full opening, with a border of the surrounding ocean filled with fish, and with the Mediterranean Sea arranged vertically in the 'gutter' where the leaves are bound, it locates not only continents but countries and mountains. Although versions of the map in some later Beatus manuscripts show portraits of the 12 apostles at the places where they died and were buried, this earliest surviving version has only one small figural illustration. At the top, Adam and Even are in the Garden of Eden, at the moment when through the temptation offered by the serpent they fell from paradise, beginning the history that would culminate in the second coming of Christ.

115

World Map, from the Morgan Beatus, possibly from the monastery of Tábara, datable 940–5 (each page 387 × 285 mm)

Painted by Maius, who wrote a long and very personal commentary, in which his own name appears as an acrostic as well as in direct speech. The map is arranged with north at the left side, so Europe is in the lower left quadrant.

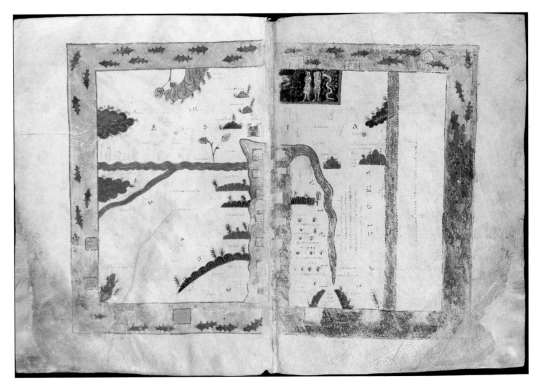

Images as commentaries

These three examples, Hrabanus Maurus, the Vatican Job, and the Beatus manuscripts, show images physically joined with both a text and a commentary upon the text, each in a different manner. This is a novel procedure, and somewhat unusual, but from the ninth century substantial numbers of manuscripts have illustrations that are themselves a kind of commentary upon a text. In the Utrecht Psalter each of the 150 Psalms is preceded by a miniature, full of small figures drawn in ink without added colour [**116**]. The Psalm texts are written in three columns in a script of all capitals, sometimes misleadingly termed rustic capitals, that was only rarely used for books, a few of the prominent exceptions including the Vatican Virgil manuscript [**58**], known to have been in the Carolingian monastery of Tours in the mid-ninth century and known to have inspired some artists there. The Utrecht Psalter makes an unusual impression, and some scholars have seen it as a careful copy of a manuscript from the fifth or sixth centuries, although I think it more likely that it wished to evoke such a book as the Carolingian audience (and some modern scholars) believe might have once existed. The date and place of origin of the Utrecht Psalter are unknown, as are the names of its patron, recipient, and artist(s), but it is related to a group of manuscripts associated with Reims, especially to the luxurious Gospel book made for Archbishop Ebbo [**95**]. These two manuscripts share the

116

Utrecht Psalter, illustrations to Psalms 1 and 2, region of Reims, probably second quarter of the ninth century

Although the main text script surely, and the illustrations possibly, suggest the art of late antiquity, the large golden initial B for the first Psalm, with its interlaced top, is pure Carolingian book illumination. The illustration for Psalm 1 occupies the entire page at the left, the 'blessed man' under the canopy at the upper left, and the two conversing figures just to his right. The illustration for Psalm 2, on the right-hand page, follows the format for all subsequent miniatures, occupying only a portion of the page and set within the columns of text.

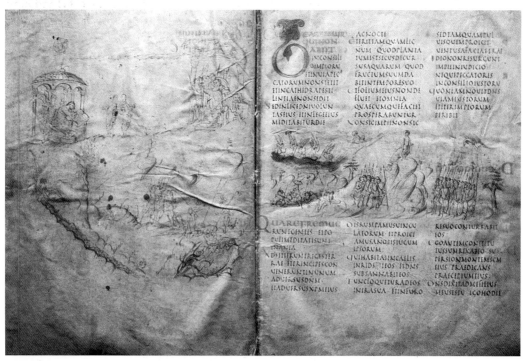

same extraordinarily lively manner of drawing, with exaggerated and highly expressive facial features and gesticulating hands.

The illustrations often draw upon the words of the Psalm text in a literal way, but also expand upon it in what amounts to a pictorial commentary. It is worth looking at one example, the miniature to Psalm 1, in some detail. The text reads:

Blessed is the man who hath not walked in the counsel of the ungodly, nor stood in the way of sinners, nor sat in the chair of pestilence. But his will is in the law of the Lord, and on his law he shall meditate day and night. And he shall be like a tree which is planted near the running waters, which shall bring forth its fruit, in due season, and his leaf shall not fall off: and all whatsoever he shall do shall prosper. Not so the wicked, not so: but like the dust, which the wind driveth from the face of the earth. Therefore the wicked shall not rise again in judgment: nor sinners in the council of the just. For the Lord knoweth the way of the just; and the way of the wicked shall perish.

The contrast between good and evil, blessed and wicked, essential to the text, is also built into the visual structure of the image, the 'good' at the viewer's left and the 'evil' at the right. In part the order may be explained by the order of reading, from left to right, for the good is discussed first, but it also evokes the arrangement in Last Judgement scenes beginning to appear at just this time, where the saved are at the right hand of the central image of the enthroned Christ, also at the viewer's left. The 'good man', who also represents the Psalmist, King David, is shown bending over a large book, with an angel behind him; the evil man is represented by a king, holding an unsheathed sword, with armed men at his right and a devil (covered with serpents) lurking behind his throne. Neither these figures nor their architectural settings nor their companions are called for by the text, of which they are interpretations rather than literal illustrations. In the middle of the page are two standing men, not mentioned or even alluded to in the Psalm text, pointing towards the two seated exemplary figures while turning their heads together as if in conversation. Do they represent the ideal reader noticing, or even the artist pointing out, the two paths open to man? The contrast between reading and fighting, the church (with its dome) and the secular world (with its gabled pediment) expands the rich pictorial language presented here. Whether or not its unknown patron ever accorded it such attention, the imagery seems to expect, demand, and reward intimate and prolonged consideration from its beholder.

The emphasis on speaking figures seen in both the Vatican Job and the Utrecht Psalter recalls Roman *adlocutio* images [6, 8], although the differences are greater than the continuity. The gestures themselves are different, and the Carolingian images relate to a specific text, so that one could almost regard them as cartoon figures with 'balloons' over

Combat between Anger (*Ira*) and Patience, from Prudentius' *Psychomachia*, probably from Christ Church, Canterbury, late tenth century

The flaming-haired personification of Anger argues with the modestly dressed Patience in a series of closely linked scenes. In the third scene she threatens Patience with spears while vaunting 'Receive the death-stroke in thy calm breast'. Immediately below we are shown the futility of Anger's violence, for its spears and sword lie broken, snapped off by Patience's spiritual armour.

their heads containing their words. The taste for allegory and commentary conveyed through images may be seen in the many copies of Prudentius' allegorical poem *Psychomachia* [**117**].[4] Much more challenging to the modern scholar as a puzzle whose meaning needs to be deciphered, and presumably also to the original early medieval audience, are complex allegorical images not physically linked to a text, whose interpretation must be supplied from conjecture or memory. For example, in a Carolingian carved rock crystal depicting the baptism of Christ [**118**] the material itself carried a hidden allegorical meaning. Ancient authors such as Pliny had defined crystal as water 'hardened by excessively intense freezing', and the Carolingian author Haimo of Auxerre compared 'the purity of faith received at baptism' to a 'gleaming crystal', suggesting that the spiritual transformation of baptismal water is paralleled by the physical transformation of water into crystal.[5] A sophisticated and learned audience might have received an enriched understanding through such commentary, but even for the well-educated such a meaning might easily be missed.

Complex allegorical meanings even occur on secular jewellery [**119**]. The first impression is of a cross-shape within a medallion, its centre expanded to exhibit a large half-length frontal figure, surrounded by four full-length smaller figures in the almond-shaped frames. The pictorial structure evokes Christ in Majesty surrounded by the four Evangelists and/or their Symbols, but the odd gestures of the surrounding figures stretch the presumed iconographic pattern beyond the breaking point. It must signify something else, but what? One figure has his hand in his mouth, one raises his right hand behind his

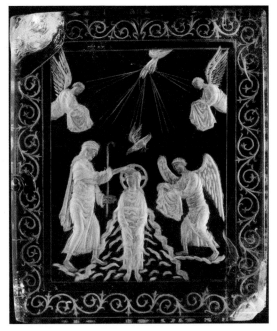

118

Baptism of Christ, rock crystal, mid-ninth century (?855–69), probably northern Rhineland area (Aachen?) (82.5 × 69 mm)

Christ stands in the water-pyramid at the centre, surrounded by many fishes, perhaps alluding to the fish symbolism so prominent in early Christian art. The beautiful acanthus vine border also recalls early Christian imagery of paradise. The dove of the Holy Spirit and the hand of God above him make a central axis of the Trinity. The arrangement is closely analogous to the most common Byzantine iconography for the scene.

ear, one touches one hand with the other, and the last has his hands hidden behind him while his face, in profile, is pressed against a spade-shaped leaf. These figures represent the five senses, with taste at upper left, then reading clockwise smell, touch, and hearing. At the centre, with frontal eyes staring at the beholder, is sight.

The primacy of sight is a theme important in contemporary theological writing, and also related to the early development of vision literature, especially at the Carolingian court in the mid-ninth century. The theme is also related to the iconoclastic controversy, which turned upon such issues as whether or not divinity could be seen, and/or represented,

119

Fuller brooch, silver inlaid with niello, Anglo-Saxon England, late ninth century (114 mm diameter)

The personification of Sight at the centre is surrounded by the personifications of the other senses.

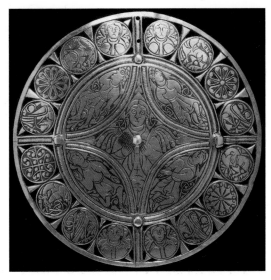

after the incarnation of Christ. Indeed, the unique text facing the Gundohinus Gospels Majesty image [87] addresses precisely these issues, directly linking vision and incarnation: 'anathema upon all who deny that the Son sees the Father and the Holy Spirit, or that the Father sees the Son and the Holy Spirit, or that the Son of God took on human flesh'. The contrast between this emphasis upon the visible and hence representable nature of divinity and the views of the earliest Christian writers is striking, indeed suggesting a virtual reversal of understanding. Minucius Felix wrote in the late second century that 'the God we [Christians] worship we neither show nor see . . . [How] do you expect to see God with the eyes of the flesh, when you can neither see nor lay hold of your own soul, the organ of life and speech?'[6] Clement of Alexandria, Augustine, and other early Christian writers uniformly assumed, with the Greek philosophical tradition, that any use of the construction 'seeing God' can only be metaphorical, not literal.[7]

Immediately after the Last Supper, Jesus is presented as discussing heaven with the Apostles, when Philip asks to be shown God the Father (John 14: 8–10). Jesus rebukes Philip, but answers: 'Philip, he that seeth me seeth the Father also.' Early Christian writers rejected any corporeal vision of the Father, but by the ninth century the corporeal vision of the Father in Christ has become of central importance. The shift in views on the nature and possibility of seeing as an avenue to truth is important, constituting a recognition of visuality as a semiotic system with independent and equal or even superior claims as a means of representing knowledge and communicating ideas. In works of art such as those just considered, artists of the ninth century exploit the possibilities of this rich language, recognizing both its potential and the risks that the audience may need verbal correlates or clues in order to grasp the iconography's complex significance.

Expressive imagery

Although the examples provided to this point were intended for select audiences who might hope to understand their layers of meaning, complex works of art were also produced with the aim of appealing to a larger audience. A new altar made for San Ambrogio in Milan bore on its sides elaborate images reminiscent of Hrabanus Maurus' acrostic poems [120]. Diamond lozenges are set on squares, with crosses at the centre surrounded first by eight important saints specially venerated in Milan and then by eight angels; all 16 figures are depicted in various complex bending, prostrating, gesticulating postures as if adoring the cross. On the altar's back are 12 scenes from the life of St Ambrose, the great fourth-century archbishop of Milan whose body rests under this altar. At the centre, on the doors giving access to the relic, are portraits of Ambrose's successor Angilbert (archbishop of Milan 824–59), who

120

Altar in San Ambrogio, Milan, front view (84 cm H × 218 cm W × 122 cm D)

The altar has magnificent glass enamel work, studded with jewels, the figures raised in relief from a gilded ground in the front, and silver-gilt on sides and back. Portraits on the back show the donor Archbishop Angilbert and the artist Wolvinius flanked by twelve scenes from the life of St Ambrose. Some scholars believe that a different master was responsible for the reliefs on the front, with Christ in Majesty and scenes from Christ's life, but this is most uncertain, as is the artistic background of Wolvinius.

ordered the altar to be made, and given equal prominence is Wolvinius, who made it; both are shown bending to receive a blessing from their patron Ambrose [page 194]. On the front of the altar are again 12 narrative scenes, a cycle from the life of Christ flanking the large image of him enthroned in Majesty, set within a cross in whose arms appear the four Evangelists and in whose corners are the 12 apostles. This complex programme uses repeated number patterns (12 scenes from the life of Christ, 12 of Ambrose, 12 apostles; eight patron saints and eight angels), linking Christ's life with that of Ambrose by selecting scenes that could be made to appear in like form.[8] The gleaming large figured reliefs are executed with a bold simplicity that allows them to be 'read' at some distance, and one must imagine that in this sacred place there would have been someone available to explain their many meanings. We cannot be certain of the appearance of this area or the setting of the altar in the ninth century, for the church was rebuilt in the twelfth. However, it is clear from many sources that the arrangement of reliquary altars so as to be visible and accessible to crowds of pilgrims and other visitors was a major issue in the ninth century, with many innovative means of display.[9]

The theme of the cross, increasingly important from the ninth century, was combined with extensive narrative cycles and complex iconographic and devotional programmes in the remarkable monumental crosses of Ireland and other sites in northern and western Britain. The cross at Iona [**77**] has already been mentioned as a means of marking the sacred character of the monastic site, and that underlying significance was accompanied by many other functions. Such monuments appear perhaps as early as the eighth century, and are especially characteristic of the ninth and into the first half of the tenth. Early examples like the Ruthwell cross from south-west Scotland already have intricate image programmes designed primarily for a learned monastic audience. Some later crosses feature less recondite

121

Monasterboice (Co. Louth, Ireland), south cross, probably before 924 (3.1 m H including the base)

The inscription on the base asks for prayers for Muiredach, probably the abbot of Monasterboice who died in 924. This side of the cross, facing east, has the Last Judgement at the centre, with David playing his harp at Christ's left and Archangel Michael weighing souls at the feet of Christ. Below this are Adam and Eve's sin and Cain killing Abel; David and Goliath before the enthroned Saul; perhaps Moses striking the rock; and the Adoration of the Magi.

122 [pages 208–9]

The Woman Clothed in the Sun (Apoc. 12: 1–18), from the Morgan Beatus, possibly from the monastery of Tábara, datable 940–5

The miniature seeks literally to depict the phantasmagoric imagery of the text. At the centre is an enormous red seven-headed dragon, whose tail cast stars down from heaven towards the earth and the abyss of hell along with the fallen angels. Satan lies at the bottom right of the image, portrayed in black, but with his face apparently deliberately erased. At the upper left is the woman 'clothed in the sun' attacked by the dragon. At the upper right, literally above the stars, the woman's miraculous son is presented at the throne of God (here flanked by two angels with raised wings, like the cherubim over the Ark of the Covenant [cf. **87** and **111**]).

imagery, representing mainly well-known events drawn from the Old and New Testaments; the sobriquet 'Cross of the Scriptures' commonly applied to an example from Clonmacnoise is a later but apt description. There, as on the south cross from the monastery of Monasterboice [**121**], the focal images are the Crucifixion and Last Judgement. These images represent fundamental items of belief for all Christians, enshrined in the Creed recited at every mass:

I believe in God the Omnipotent Father . . . and in his son Jesus Christ who . . . was crucified, died and was buried . . . and rose from death, ascended to Heaven, whence he will come to judge the living and the dead . . . I believe in the remission of sins and the resurrection of the body to eternal life, Amen.

Without excluding the possibility of additional meanings accessible only to the learned, the appeal of this imagery is universal within a thoroughly Christian world, reminding the viewers of their beliefs and of their own personal responsibilities and hopes. Details of the imagery such as the figure of Michael weighing a soul at the feet of Christ, while a lively little devil tries to cheat by grabbing the scale, serve to engage the beholder's attention in a direct emotional manner. The text of the apostolic Creed in the Utrecht Psalter (from which the preceding phrases were translated) was accompanied by an illustration in which the scenes of Resurrection and Second Coming play a central role, as on the Monasterboice Cross, but in the latter the audience is vastly larger. Such crosses were probably used for the organization of processions, and as both sites and subjects for sermons. At Monasterboice it is also a memorial for Muiredach, for whose welfare the beholder is requested to pray, according to the prominent inscription on the base, below the Last Judgement.

Many aspects of style were utilized in the drive to create appealing emotional effects. Energetic drawing and emphatic gestures appear in many works [**111, 116–18**]. In comparison, even magnificent fourth–sixth century images may inspire deep feeling, but the figures themselves, although arguably more naturalistic in proportions and actions, are distant, restrained, lacking sharply characterized expressions. Artists and patrons of the ninth and tenth centuries were prepared to forgo heightened naturalism for heightened affective appeal. The Evangelist John of the Ebbo Gospels [**95**] has his brows knit together and his eyebrows raised in a pattern ultimately derived from Hellenistic/Roman art, but here even the toes seem to grip, almost to flutter as if keeping time with some unheard heavenly music, conveying visually the excitement of divine inspiration. The Morgan Beatus, whose world map [**115**] drew upon ancient geographical conceptions, for its narrative images [**122**] uses brilliant colours to make the illustrations unearthly but powerful, creating an effect still shockingly arresting, almost transporting.

super capud eius stellas duodecim

mulier
amicta
sole

et luna
subpe
dibus
eius

data resunt
mulieri ale
aquile du
lares in
heremum

ubi serpens
misit ex ore
suo aquam
post
mulie
rem

michael
angeli
eius
pugna

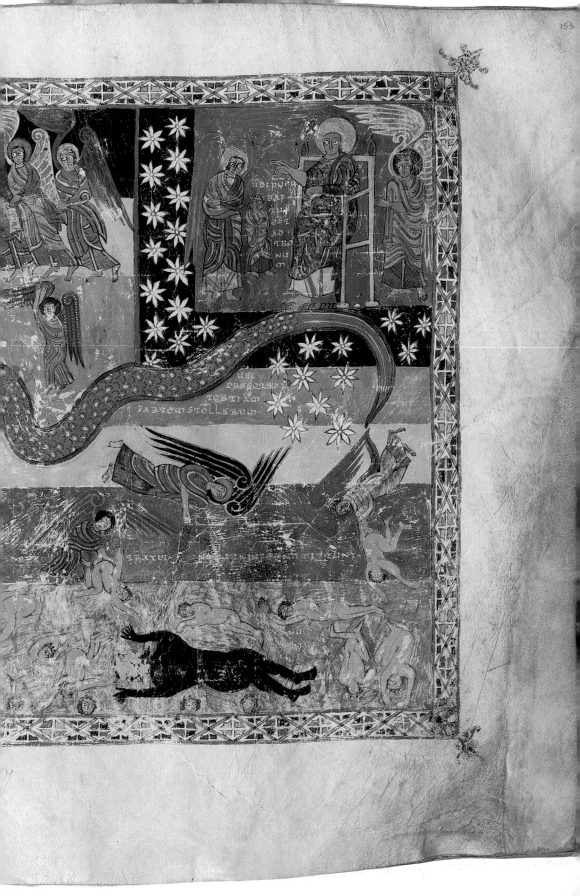

The rapid drawing style deployed by some Carolingian artists could convey astonishing immediacy, as if the artist had a scene before his or her eyes and rendered it as a quick sketch drawn from life. A manuscript in Bern containing works by Prudentius, whose allegorical *Psychomachia* was such a favourite for illustrations [**117**] and was copied many times, possibly following an early Christian manuscript, also includes illustrations for several of his other poems. The story of the martyred St Cassian of Imola has three miniatures, the only extant illustrations of the text, probably invented for this manuscript.[10] In the first Prudentius kneels before the martyr's shrine, illustrating the text literally, which recounts this moment. The other two miniatures, facing each other on a single opening [**123**], tell Cassian's story. In the first, the schoolmaster Cassian is shown teaching his six young pupils, two of whom are writing, two of whom pretend to write, and two of whom argue with their teacher, as he reads from a book before him on a lectern. Prudentius tells us that Cassian was strict, not a popular teacher. In the scene below, he is shown bound and led before a crowned judge, who condemns Cassian to death for refusing, as a devout Christian, to offer sacrifice at pagan altars. The judge condemns Cassian to a literal death by a thousand cuts, stabbed to death by his own angry students, who revenge themselves for the floggings they had received by inscribing wounds all over his body with their pens as they had previously formed words in their notebooks. This scene is shown on the opposite page, with the gleeful students hopping

about the martyr, whose soul is carried to heaven by an angel in the upper right.

Strangely, the martyrdom scene was said by Prudentius to have been depicted in 'an image painted with colours' that he had seen in the shrine, while the teaching and trial scenes were merely recounted to him in answer to his questions. The teaching scene conveys the disorderly noise of a classroom, perhaps reflecting the experience of boys in a monastic or cathedral school, where the scribes, artists, and readers of this manuscript themselves learned their letters. Contrast the rigid frontality and formality of the dictation scenes on early Christian ivories [31], of which this is a sort of travesty, and one sees why it is almost surely a mistake to take Prudentius at his word; the detailed and graphic verbal description he provides is exactly what cannot be paralleled in early Christian images, but what Carolingian artists had mastered. The drawings vividly evoke a teacher's nightmare, or perhaps a student's dream. It is surely no accident that Hucbald of Saint-Amand, a Carolingian teacher from northern Francia contemporary with the illustrations of the Bern Prudentius, composed an extended prose version of the life of this obscure saint, patron of teachers maintaining high standards.[11] The illustrations are on one level a kind of 'in joke' among the learned audience, the forerunner of ineffective faculty members at other times lamenting the ignorance and laziness of 'students today'. The joke carried a menacing undertone of threat: the monastery of St Gall (where the book may have been written) was destroyed on 26 April 937 in a fire 'stirred up by school lads'.[12] What is most striking in this context is the highly personal and strongly affective style in which these images are presented to the beholder.

Towards a New Age

12

The later ninth and early tenth centuries were difficult times. The sea-borne raiders known as Vikings first appeared in the late eighth century, and in 792 sacked the monastery of Lindisfarne. Coming especially from Denmark and Norway, they returned to eastern England in subsequent years, attacking targets of wealth and opportunity there, in Ireland, and in the Frankish kingdom. By the mid-ninth century they were operating as large armies, sailing up the Seine, Loire, Rhine, and other rivers to sack important cities like Orléans, Paris, and Cologne. They destroyed many churches and monasteries, including such centres of artistic production as Tours, sacked in 853, although a contemporary chronicle tells us that the monks were able to save 'the body of Saint Martin . . . and the treasures of his church'.[1] After 865 the 'Great Army' destroyed the Northumbrian, Mercian, and East Anglian kingdoms, killing the king soon venerated as St Edmund, especially honoured around his tomb at Bury St Edmunds. Southern and central Italy were attacked by Muslims, who conquered Sicily after 827, and from that base attacked Rome in 846, looting the extramural apostolic basilicas of St Peter and St Paul. In 881 they sacked the monastery of San Vincenzo al Volturno. In central Europe the Magyars, operating not from ships but on horseback, took cities such as Pavia, and monasteries such as St Gall, sacked in 926.

The external frontier

Perhaps surprisingly, even paradoxically, the European Christian states survived the crisis, emerging stronger and more confident [**Map 7**]. By the mid-tenth century the surviving English kingdom of Wessex had become a compact and well-organized state, to emerge as the kingdom of England by the end of the century. In Italy, the struggle against the Muslims strengthened the maritime city-states such as Lucca, Pisa, Amalfi, and Venice, which played such an important role in the succeeding centuries. In central Europe, the decisive defeat of the Magyars in 955 strengthened the Saxon king Otto I's claim to dominance within Germany, and his claim to supplant the

Detail of 129
St Gall, dressed in monk's cowled robes, receiving firewood from a bear

Map 7 The Christian world, *c.*1000

ICELAND

GREENLAND

Western
settlement

Eastern
settlement

Atlantic
Ocean

KINGDOM O
ORKNEY

SCOTLAND

IRISH
KINGDOMS ○Armagh
Tuam○
○ Dublin
Cashel○

WELSH
STATES

Lindisfa
Jarrow
Wearmo

York

Malmesbury
London
Canter
St Ama
St Bertin
St Vaast d'Arras
St Riquier
St Wandrille
Jumièges Rouen
Landevennec Brittany St Denis
Redon St Germain-des-Prés Paris R
Orléans, Ferr
Noirmoutier Tours Lar
Fleury Bourges Lux
Poitiers Autun
WEST Cluny
FRANKISH
Bordeaux○ KINGDOM
Santiago NAVARRE (FRANCE)
LEÓN Auch BU
Oporto ○Braga Burgos Toulouse
Liebana
CASTILE Narbonne
Urgel SMAL
Gerona COUNT
Barcelona

EMIRATE OF CÓRDOBA

Córdoba Balearic Is

Cartagena

▢ Extent of Catholicism
○ Archbishoprics
+ Some of the important literary and cultural centres

0 500 miles
├─────────────────────────────────┤
0 500 1000 km

Kaupang

• Birka

rth
ea

ST
KISH
OOM
ANY)

DENMARK

• Ripen

Hamburg
Bremen

abrück
Saxony
Münster
Essen
Werden
Cologne
Corvey

Gandersheim

Magdeburg Gniezno

POLAND

Vistula

ternach
Mainz
Hersfeld
Fulda
er
Würzburg
Lorsch
Weissenburg Regensburg

Augsburg Freising

Tegernsee Salzburg Gran

Gall
Benedictbeuern

HUNGARY

Danube

Milan Cividale Aquileia
Verona Grado
Pavia
bio
Nonantola Venice
Genoa
Ravenna
Pisa
Florence
Sienna

CROATIA

Black Sea

Ragusa

Nish

BULGARIA

ARMENIA

Rome Trivento
Monte Cassino Sant' Angelo
Trani
Naples Conza Bari
Sorento Brindisi
Amalfi Taranto Otranto
Salerno

BYZANTINE EMPIRE

dinia

Monreale Messina
Palermo Sicily Reggio
• Catania

SYRIA

Mediterranean Sea

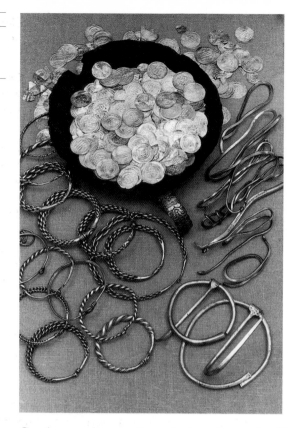

Hoard of Islamic coins, bracelets, penannular brooches, and hack-silver, from Birka, *c.*975

On the island of Gotland (off the east coast of Sweden) some 40,000 Arabic, 38,000 German, and 21,000 Anglo-Saxon silver coins had been found by *c.*1980.

Carolingian dynasty through elevation to the title of Roman emperor in 962. During the later tenth and eleventh centuries the Magyars themselves became Christian and settled in the Danube basin as the Hungarian kingdom, while the Polish and other Slavic kingdoms, including Kievan Rus, the forerunner of Russia, took the borders of Christendom from the Elbe–Danube line nearly to the Volga. The Viking invasions, which lasted into the eleventh century, already by the later ninth century were ending in permanent settlement. Large portions of the 'Great Army' of 865 settled in Yorkshire by 876, and a different group occupied northern France around the mouth of the Seine, Normandy, granted to them by the Frankish king in 911. One Viking hoard [124] displays a tiny portion of the loot available, ranging from coins minted in Baghdad to penannular brooches probably from Ireland, testifying to the society's capacity for creating wealth. Vikings were not indiscriminate destroyers; even while still themselves pagan, we know of at least one luxuriously illuminated Gospel book taken by the Danes in England and ransomed from them for return to Canterbury.[2] Sometimes they were blamed for outrages such as the sacking of monasteries of which they were not guilty, or which they committed together with local rulers, as modern historians have recently come to recognize. Vikings also served as the vanguard

of the expansion that marked the next millennium of European history, reaching out to Iceland, Greenland, even briefly North America. Vikings served as Varangian Guards protecting the emperor in Constantinople, and some made contact with cultures further to the east; one settlement site in central Sweden included a statue of Buddha seated on a lotus flower, probably produced in north-western India![3]

Christendom expanded in part by absorbing the Viking and Magyar invaders, whose conversion to Christianity during the course of the ninth and tenth centuries marked, save only Ireland, the first movement of Christianity beyond the borders of the Roman empire since Constantine and his successors had linked Church with State. That link lasted for many further centuries, albeit often with a different state, and eventually a different Church. The great stone erected by King Harald Bluetooth beside the church he built [125], near a group of royal burial mounds carries the following inscription: 'King Harald had this monument made in memory of his father Gorm and his mother Thyri. This was the Harald who won for himself all Denmark and Norway, and made the Danes Christians.'[4] Linking Christianity with a royal and national dynasty foreshadows the sixteenth-century formula of Augsburg, *cuius regio eius religio* ('Let the religion be that of the ruler'). In Iceland, differences between the largely pagan Viking settlers and some turbulent Christian missionaries threatened an outbreak of violence, but in 1000 the national assembly decided that all would agree to follow the same religion, and the Lawspeaker announced that all would be Christian.

125

The Jelling stone, carved in the churchyard at Jelling (Jutland, Denmark) at some point around 965–85

The stone is roughly a three-sided pyramid, with the crucified Christ on one side, a large crested and clawed quadruped (a lion?) on another, and the large dedicatory inscription on the third. The smaller stone beside it bears an inscription in memory of Queen Thyri 'glory of Denmark' from her husband King Gorm.

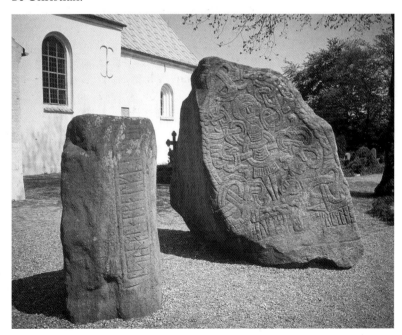

The Christianity and Christian art adopted by Icelanders and Magyars were not, of course, the religion and art of the early Christian but of the Carolingian world. Harald's Jelling stone bears what had become the central Christian emblem, Christ with arms outstretched as if upon the cross, although here the cross is replaced by interlacing ribbon patterns. The monumentality of this low-relief sculpture reflects not Roman triumphal monuments, but the traditions of stone carving in northern European countries, especially in the British Isles. The complex interaction between Vikings and indigenous traditions are exemplified by the bossed penannular brooches [**105**] produced either in Ireland for Norse patrons, or possibly in Scandinavia under the influence of Irish objects. Indeed, even before the conversion to Christianity, Scandinavia produced a series of carved and inscribed stones with votive and commemorative inscriptions, some illustrating pagan mythological subjects.[5]

In tenth-century Spain the process of self-definition through struggle against an Other across the frontier, Islam, was complex and dramatic, and expressed through works of art. The small northern Spanish Christian states of Asturias, Leon, Navarre, and Catalonia were beginning the process of *Reconquista*, retaking Spain from the Islamic rulers who had destroyed the Visigothic kingdom and occupied most of the peninsula from 711. The reconquest would only be completed with the taking of Granada in 1492, but by the tenth century the initiative had passed to the Christians, who recaptured the Roman and Visigothic capital of Toledo in 1085. Political relationships are expressed in early medieval Spanish church architecture, the adoption of a transepted basilica analogous to the contemporary Carolingian buildings for the court chapel near Oviedo apparently representing an aggressive statement of Christian solidarity, while buildings constructed further south may have deliberately revived Visigothic features as a different way of making the same claim.

An extraordinary image in a Beatus manuscript from the Leonese monastery of Tábara depicts a mounted horseman spearing a serpent [**126**], a figure not accounted for by the Apocalypse text or Beatus's commentary, and occurring in no other manuscript. Its evidently Islamic style of dress has previously been seen as an index of 'Convivencia' (literally living together) between the different religious communities, but it may be that the image encodes a hostile attack on the Muslims. Rather than presenting the Islamic 'knight' attacking evil, as Roman emperors and Christian saints had long done, the rider recalls King Herod seeking to destroy Christ in another illustration.[6] The serpent could allude to the Christian soul, for Christ tells his followers to suffer persecution by being 'as cunning as serpents and as harmless as doves' (Matthew 10: 6). When I cited the same Gospel passage in Chapter 2, it was to contrast the adoption of the dove as a

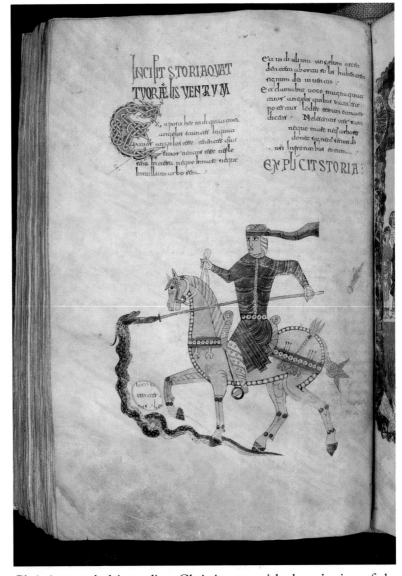

The colophon dated 6 July 975
is by the scribe Senior. The
illuminators were Ende and
Emeterius, the former
apparently a woman and
probably a nun, and the latter a
priest. Their names are
inscribed on the last leaf along
with the abbot Dominicus, who
ordered the book to be made
(for the inscription see
Williams, *Illustrated Beatus*, II.
51 and fig. 397).

Christian symbol in earliest Christian art with the rejection of the
serpent, whose rich traditions of meaning in the ancient world seem to
have made it indigestible, or untransmutable. That it could be adopted
in the tenth century is one index of the distance established from
antiquity. Fresh mining of the text, and a new context, serve nearly a
millennium later to release the latent symbolism; one sees here the
power of a text-based religious tradition to generate new iconographic
motifs. The theme of agonistic conflict between good and evil so
clearly in evidence here is a leading feature of art at the end of the first
millennium.

The internal frontier

The outer frontier with those outside Christendom was accompanied by an 'inner border' of social and cultural stratification. Insufficient Christianization of the mass of the populace beneath the royal house and associated aristocratic families, and the great churchmen drawn from the same small circle of families, seemed a chronically intractable problem. Bernard of Angers, writing to Bishop Fulbert of Chartres about his travels in southern Francia, describes witnessing as 'an established usage, an ancient custom . . . that people erect a statue for their own saint', observing that 'To learned people [such as himself] this may seem to be full of superstition, if not unlawful, for it seems as if the rites of the gods of ancient cultures, or rather the rites of demons, are being observed'.[7] The Church turned with increasing attention to this broader social world, engaging in political and social affairs by preaching the Peace of God, and reaching out to the people by encouraging pilgrimages and the cult of relics with a new intensity. Monumental art became increasingly important, whether sculptural crosses in Ireland, or wall-paintings in cathedral, monastery, and even parish churches.

Few early medieval wall-paintings are well preserved, although there are painted crypts in several ninth-century churches [78]. The monastic church of St Georg at Oberzell, Reichenau [127] is extensively restored, but gives some sense of an artistic genre that expanded tremendously in the succeeding Romanesque period. Surviving paintings on the nave walls portray eight of Christ's miracles culminating in the Raising of Lazarus, recalling the miracle scenes in early Christian art [33, 43, 56]. Early Christian cycles evidently addressed a wide

127

St Georg, at Oberzell, Reichenau (Germany), interior view of the nave. The paintings on the nave walls date probably from the late tenth century

Visible on the north wall are the Healing of the dropsical man (Luke 14: 1–5), the storm on the Sea of Galilee (Matthew 8: 23–27), and the Healing of the man born blind (John 9: 1–38). The smaller standing figures above the windows, holding scrolls, recall the figures at San Apollinare Nuovo. The paintings in the church were extensively restored and in some cases repainted during several campaigns of recent centuries.

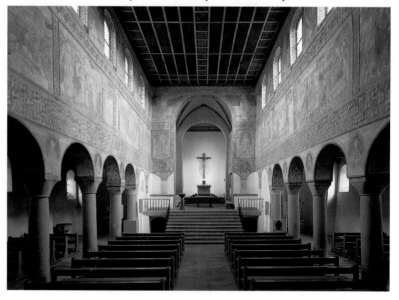

A book for the public

Another indication of the new concern to make even book illustrations, normally the preserve of the literate clergy and aristocracy, visible to a larger public is the production from the end of the tenth century in southern Italy of a new type of manuscript, the Exultet roll. This was in one sense a return to an ancient book form, but in Exultet rolls the text of a hymn for the Easter vigil was written not in short text columns like ancient rolls, but in a long continuous strip, rather as a Carolingian artist mistakenly imagined such books [97]. The most extraordinary feature of the Exultet roll is the placement of the pictures upside-down in relationship to the text. Set upon a lectern or pulpit during the liturgical service, as the text was sung by the deacon the scroll was unrolled so that it would hang over the end of the lectern and the picture would then appear right-side up to the audience.

segment of the populace, for they were located in large public buildings, not in monastic churches like Reichenau, ostensibly designed for the spiritual athletes dedicated to lives of prayer and devotion. However, as the monks would have spent most of their time in the monastic choir near the altar, rather than in the nave where these narrative paintings were to be found, the paintings' purpose and audience may be in some measure 'popular'. Indeed, the choice of scenes corresponds to readings from the Gospel performed during the liturgy, so that to the written captions beneath each scene would have been added an oral text more readily understandable to a larger segment of society. Such close linkage of images with both written and oral biblical texts seems a realization of Gregory the Great's justification of images as books for the illiterate, a monumental public expansion of the idea embodied in the Gospels of St Augustine manuscript [88].

Of course, even oral readings during the liturgy would have been in Latin rather than in the local vernacular language, and hence less accessible. It is noteworthy, then, and revealing, that the ninth and tenth centuries saw sporadic attempts to use the vernacular. The Lindisfarne Gospels, written in Latin in the early eighth century, received an interlinear Anglo-Saxon gloss in the tenth [90]. During the late ninth century King Alfred of Wessex translated Pope Gregory the Great's *Pastoral Care* and Boethius' *Consolation of Philosophy* into the Anglo-Saxon language, while the story of Christ's life was transmuted into heroic Saxon in the *Heliand*. From the third quarter of the ninth century stems a manuscript of the Gospels rendered into German, which was provided with two full-page miniatures illustrating the Crucifixion and the Entry into Jerusalem [128]. The iconography of the latter scene follows the earliest Christian scheme [32] in certain respects, and the mounted Christ still parallels the imperial *adventus* formula [12], but great prominence is now given to the cross-crowned domed building at the top right, which represents the future tomb of Christ, later the Church of the Holy Sepulchre. The anonymous common people become far more important than in late antique

Entry into Jerusalem, from the Gospels of Otfried of Weissenburg, in German, *c.*868

The manuscript may be the autograph of its author (it too is an exceptionally free 'translation'), Otfried, a monk at Weissenburg in Alsace, written in his own hand. The heads of the apostles above Christ were added by a later hand, probably in the eleventh century, indicating that the book was still being looked at, and that the presence of the representatives of the institutional Church was then thought necessary.

129

One of a pair of ivory book covers, with the Ascension of the Virgin, and St Gall's encounter with the bear, carved at St Gall, late ninth century

According to a monastic writer at St Gall, the ivories with the Virgin and St Gall were carved by the monk Tuotilo, whose artistic interests apparently included book illumination and music. The beautifully carved vines, with a lion attacking a bull, almost exactly reproduce another ivory in the St Gall collection, and a recent book suggests that both ivories came to St Gall from the court of Charlemagne, but with one pair remaining blank until carved by Tuotilo.

representations. At the top right they carry the palm branches associated in the ninth century also with martyrdom.[8] At the bottom they throw their mantles before Christ so that the mantles, rather than Christ, occupy the centre of the pictorial space, simultaneously destroying any illusion of natural space.

Some new monastic imagery seems well suited to appeal to a wider viewing public, bespeaking popular and local interest even when it is difficult to imagine how they would have been able to see it. At St Gall a richly illuminated Gospel book was provided with bejewelled metal covers having splendid ivory carvings [**129**]. The high altar where it would have been displayed on holy days was jointly dedicated to the Virgin Mary and St Gall. On the back cover appears a remarkably early version of the Virgin's ascension to heaven, a subject commonly referred to as her Assumption in later art which corresponds in its iconography to a hymn written by Notker of St Gall, fellow monk and apparently close friend of the ivory carver Tuotilo who made these panels. Even more remarkable is the lowest register, showing the founder of the abbey, Columbanus's follower Gallus, when he first came to the site where the monastery would be built. As his disciple was asleep, Gallus asked a bear to throw a log on the fire, and when the bear did so, gave it bread to eat. The story is much older than the image, but had never, so far as we know, been illustrated previously. As well as recounting what amounts to local folklore, it provides a neat

ASCENSIO SCE MARIE

SGALLL PANE PORRIGITVRSO

metaphor for the exchange of services between monk and laity, the former providing spiritual (and often also material) food in exchange for loyal labour. The imagery of the saints, with extensive cycles of scenes from their lives, as so often in later medieval and early modern Christian art often linked with local and indeed personal interests, emerges in a new way in the ninth and tenth centuries. The illustrated life of Cassian [123] is one of the earliest examples, but contained within a comprehensive collection of all Prudentius' poems, the whole having a very learned bookish character. The earliest *libelli*, illustrated saints' lives as discrete manuscripts, appear in the late tenth century, for example at Fulda, laying out the many episodes in detail, not just the scenes of the saint's martyrdom and especially of his intercessory prayers most characteristic of earlier hagiographic images [71–3].

Monasteries were dominant economic, social, and even political institutions. Founded in the tenth century specifically so as to be free of secular or even episcopal oversight, Cluny grew rapidly in power and prestige as a proponent of ecclesiastical reform. The reformed monasteries drew upon Carolingian achievements, endowing monasteries with the resources that allowed such men as Gerbert of Aurillac to learn about Greek and Arabic sciences, and to rise to be head of the school at Reims, tutor to the future Emperor Otto III, and eventually at the turn of the millennium Pope Sylvester II. One index of the role of the monasteries is the number of surviving Latin manuscripts produced in the writing centres scattered across the Carolingian world, the largest number being located in monasteries [**Map 7**]. There was a huge upsurge in production, something of the order of 8,000 surviving manuscripts having been written in the Carolingian kingdom during the ninth century alone, roughly six times as many as surviving from the entire Latin writing world prior to the year 800. Far fewer books, especially richly decorated manuscripts, were produced during the tenth century, but there was a notable upsurge towards the end of the century. In the eastern part of the former Frankish kingdom luxurious manuscript illumination was associated with the revived imperial tradition of Saxony, what art historians often call Ottonian Germany. Illuminated manuscripts also emerge in various centres of the west Frankish kingdom, now beginning the earliest stages of its reorganization as the kingdom of France, and also in northern and central Italy, although these almost never seek to pick up the courtly luxury of the Carolingian tradition.

Monasticism represented an ideal of perfection, which increasingly came to, indeed sought to, influence secular life. The humility before God so graphically and powerfully expressed in the Prayer Book of Charles the Bald [**98**] reflects monastic ideals which had been to a remarkable degree accepted as normative during the time of Charles's father, Charlemagne's son, Emperor Louis the Pious (814–40). In

The *Regularis Concordia*
(Harmony of the Rule), King
Edgar between Archbishop St
Dunstan of Canterbury and
Bishop Aethelwold of
Winchester. Second half of the
eleventh century, very possibly
after an original of the later
tenth. The monk in the lower
register is acting out a
metaphor, wrapping the Rule
around him like a belt.

England a century later, King Edgar sponsored a meeting of representatives of the kingdom's different monasteries so that they might all agree on one version of the Benedictine Rule to be followed. The resulting document, known as the *Regularis Concordia*, was furnished with two miniatures. One shows St Benedict, the author of the Rule, enthroned in Majesty like a late Roman emperor or figure of Christ. The other [**130**] shows King Edgar enthroned in the same manner, but now joined by two equally large and important figures, the leaders of the ecclesiastical reform movement in England, the three figures linked by the unfurled scroll that represents the newly agreed Rule. The image seeks to bridge the gap between secular and ecclesiastical authority, making Edgar the 'father of his country' in a manner analogous to Benedict and other abbots as 'fathers' to their monks. Its similarity to the image of Emperor Otto III in Majesty [**1**] is striking, both images representing a longing for stability and homogeneity in a world becoming increasingly fluid and diverse.

Relics and reliquaries

The church at Reichenau whose paintings were discussed above [**127**] was built to house the relic of the head of St George, given by the pope on the occasion of Abbot Haito's visit to Rome in 896. Relics of many different kinds, physical links with sacred persons and places, had long

been treasured by Christians [80]. The decision by the Frankish Church in 806, in part reacting to the controversy over holy images in the eastern Church, that all altars must be provided with a relic, reflects but also surely promoted a new insistence upon relics and their cult, and a search to find them. In 827, as the story is later told, two merchants of Venice 'saved' the body of St Mark the apostle and evangelist by removing it from Alexandria to the new and highly ambitious city at the head of the Adriatic. There the relic eventually came to be housed in the famous Basilica of San Marco, where his presence both reflected and supported the ecclesiastical rank of the city as a patriarchal see like Rome and Constantinople that its citizens believed should correspond with their growing economic and political status.[9]

Monastic communities also found or if necessary seized relics that would enhance their status, spiritual life, and perhaps also income, in exchange for which they would give enhanced honour to the saint's memory and relics through liturgies, texts, and works of art and architecture. Bernard of Angers, who remarked on the superstitions he encountered in southern France that seemed to him redolent of ancient paganism, even demonic [page 220], experienced a conversion when he came to the isolated monastery of Conques. He made it his task to compile two books recounting the genuine miracles worked by the relics of Ste Foy, which he found there. She was believed to have been a young woman martyred under the great Diocletianic persecution c.300, at Agen. Her relics remained at Agen until they were taken, in effect stolen, by the poor little monastery of Conques some miles away, at a date before 883. The effect of Ste Foy's arrival emerges from Bernard's narrative, composed in the early eleventh century:

The monastery of Conques was [originally] dedicated in honor of the Holy Savior. Long ago the holy martyr's [Ste Foy's] body was secretly carried away from the city of Agen and brought to Conques by two monks. After that Sainte Foy's name prevailed there [i.e. the church became known, as it still is today, as Ste-Foy] because of her more numerous miracles. Finally, in our own time, after the renown of the great miracle worked for Guibert (called 'the Illuminated') flew across the whole of Europe, many of the faithful made over their own manors and many other pious gifts to Sainte Foy by the authority of their wills. And though the abbey had long ago been poor, by these donations it began to grow rich and to be raised up in esteem. In the time before Guibert's era the place was not adorned with so many golden or silver reliquary boxes . . . The most outstanding of the ornaments then was the splendid image [of the saint, **131**], which was made long ago. Today it would be considered one of the poorer ornaments if it had not been reshaped anew and renovated into a better figure.[10]

Bernard proceeds to tell of the golden altar frontal, monumental silver crucifix and many other precious objects found in his day in the church, some of which still survive in the church's wonderful treasury. His

131
Reliquary statue of Ste-Foy, gilt and silver-gilt over wooden core, with added jewels and cameos, comprising portions of various dates around a core probably of the later ninth century (850 mm).

main focus remains, however, upon Ste Foy and the miracles worked for those devoted to her, for it is she who, already residing in heaven, can open its gates for those on earth. The miraculous connection between earth and heaven effected by holy relics appears in an image [132] showing a pious couple making a donation to a monastery church. On the facing page, literally the quid pro quo, they humble themselves before the monastery's patron saint, who passes on their prayer to Christ, appearing in an oval mandorla above.

Bernard mentions a large silver crucifix among the major works of art at Conques. A leather-clad wooden crucifix of the sixteenth century may be a replica of a monumental silver statue given to the pope by a

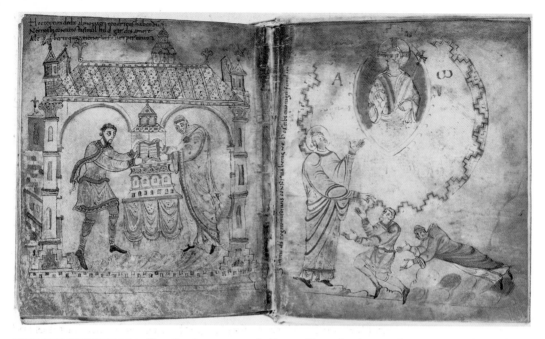

132

Miniatures added to the slightly earlier Egmond Gospels, Flanders, c.950

Donors Count Theoderic II of West Frisia and his wife Hildegard presenting the book to the monastery of Egmond, and then being presented to Christ by its patron St Adalbert. The inscription records Adalbert's words: 'Almighty God I humbly beg you to hold these people in your good will, as they continually labour to serve you in a worthy manner.'

Carolingian monarch,[11] recalling the large silver statues from Constantine's *fastigium* at the Lateran [see above, page 50]. Here again one touches, as so often, upon the issue of the relationship with the art of antiquity and/or the early Christian centuries. The silver crucifix from Rome is now lost, but by the late tenth century at the latest, and very possibly earlier, monumental crucifixes were appearing in churches of Italy and elsewhere in western Europe. The life-size wooden statue in Lucca, known as the Volto Santo or 'Holy Face', is probably later in date, but might possibly reproduce an earlier image said to have arrived miraculously in the eighth century. A similar large wooden crucifix at San Sepolcro has recently been dated to the ninth century, and there is an over-life-size crucifix from Pavia in northern Italy, dating to the later tenth century.[12] All represent an important artistic departure, being virtually free-standing sculpture. The crucified Christ is here taken out of narrative context and displayed in three-dimensional form as an object for contemplation and devotion [**133**].

Appropriating antiquity

Bernard's *Book of Sainte Foy* mainly consists of a collection of miracle stories, miracles wrought, of course, not by the golden statue [**131**] but by the holy martyr whose remains it contained. Bernard's book is but one example of a prominent literary genre, books which served as historical records 'verifying' saintly miracles, but also probably used for readings to pilgrims. The Ste Foy miraclebook survives today in multiple manuscripts from different times and places, copies distributed to

other churches where they might serve as propaganda, each adding new miracles as they become known or otherwise shaping the text to the needs of its audience. The saint's fame, and the wealth of her church, rested squarely upon belief in her miracles. Yet this belief was supported through witnesses and history, and works of art came to play a part in the construction of this sense of reliable authority. Bernard tells us that the statue 'was made long ago', and it must have been helpful that it looked, and in some parts was in fact, ancient. The head may have been made in late antiquity and added to the wooden core produced in the ninth century to contain the saint's bones. The jewels studding the surface were added at many different times, recording important donations, and trace centuries of piety. They would impress pilgrims not only by their monetary value and gleaming brilliance, but also by their rarity and suggestions of antiquity.

Some other late tenth-century works of art pick up the theme of antiquity constructed through the incorporation of ancient objects in a calculated way that we now recover and hope to understand. Egbert of Trier (bishop 978–93), the aristocratic son of Theodoric II and Hildegard of West Frisia [132], inherited their taste for relics and art, but operated on an altogether larger scale. Close to the new Saxon-Ottonian imperial house and archbishop in the old Roman imperial capital where Constantine's father had ruled, he commissioned among many other works two important reliquaries for apostolic relics, the

133

Crucifix given by Archbishop Gero to Cologne Cathedral, painted oak, Cologne, c.970s (1.9 m H, body only)

The sway of body and sunken head unambiguously present Christ as dead on the cross.

Reliquary of the sandal of the
apostle Andrew, gold, ivory,
cloisonné enamel, pearls and
jewels, inscription in niello,
made for Archbishop Egbert of
Trier, c.980s (310 × 447 ×
220 mm)

The heel of an image of
Andrew's foot is visible sitting
atop the box-like reliquary
container.

staff of St Peter and the sandal of Peter's brother Andrew [**134**]. Both visibly buttressed Trier's claim to have been founded by St Eucherius, who had been sent there by Peter, and thus its claim to pre-eminence among all the churches of Germany.

The reliquary of Peter's staff has images of Peter and the later archbishops of Trier, culminating in Egbert himself, and also a long inscription telling how the relic had come to Trier. However, no evidence whatsoever supports these claims, the story first appearing with the reliquary itself in 980. It is difficult to think, at least on historical grounds, anything other than that the relic was 'invented' by Egbert not in the Latin sense of 'found' but in the modern English usage of 'made up, created', in this case one might even say 'forged'. The relic of Andrew's sandal has similarly insubstantial historical claims to authenticity, but the reliquary itself is in a different and visible way authentically ancient. It incorporates a large Frankish garnet cloisonné disk brooch of the sixth century, a brooch that in turn incorporates its own 'appropriated' object, a gold coin of Justinian. The imperial reference seems to have been part of the elaborate programme that Egbert was pursuing, seeking to make Trier an imperial capital by giving it relics associated with the apostles most strongly connected with the traditional imperial capitals of Rome and Constantinople (where Andrew was the patron).

The coin and brooch reset in Egbert's reliquary are interesting examples of *spolia*, 'spoils' taken out of one context and inserted into another. The most obvious examples are architectural, notably large columns and capitals, splendid large-scale works that could be found in decaying ancient buildings and taken therefrom to be reused, as columns from the Baths of Caracalla were used for the construction of the twelfth-century church of Santa Maria in Trastevere in Rome,[13] or, in the words of Einhard's biography: 'When he [Charlemagne] could not obtain the columns and marble for this building [the Aachen chapel, **100**] anywhere else, he took the trouble to have them brought from Rome and Ravenna.'[14] Although there was a long tradition of such reuse of building materials and especially of columns, the fifth- and sixth-century examples chiefly reflected practical concerns, and very likely represented the wealth and taste of the aristocratic bishops and their circle of friends who donated the material.[15] By the time of Egbert, however, the incorporation of ancient works may have had programmatic as well as practical motivations and results, representing claims that the new building either is or at least is like those of an earlier age. Each specific instance of the use of *spolia* can only be assessed through careful consideration of its context, especially its patronage. In something like the Egbert shrine, quite unlike a sixth-century church, the *spolia* are so obviously incongruous, intrusive in visual terms, that they call attention to themselves and suggest a deliberate attempt to

make a point of the appropriation of antiquity. Already at the end of the eighth century Theodulf of Orléans wrote a poem purportedly describing an ancient silver vase, but in fact the details of the descriptions were stitched together from purely literary sources. Theodulf was both playing with his ability to describe and his readers' ability to recognize such descriptions of works of art, a staple of ancient rhetorical education (the *ekphrasis*), and using the game as a serious commentary upon an important issue of his day, namely the propriety of adopting elements of pagan culture and civilization.

The incorporation, appropriation, imitation, and evocation of ancient forms and subjects has been a constant theme of this book, reflecting the importance of antiquity in the development of Christian art. The relationship had always been a site of contention, in which antiquity often represented a means of addressing other issues. The terms of engagement and tone had shifted from the time of the early Christians, for whom ancient forms could be effectively neutral, nothing more than the comprehensible or one might say vernacular pictorial language available for visual communication. In the last centuries of the first millennium, however, ancient art had become a foreign language. Quotations might often be used to convey an impression of sophistication, but needed first to be recognized as in fact 'foreign'. The tone may well be affectionate, as in the late antique *cento* poems, of which 16 survive. These works are total pastiches, in which the author has written nothing new whatsoever, but simply taken whole or half-lines from Virgil's poems and recombined them to make something entirely different. Proba wrote a *cento* with Christian meaning, whereas Ausonius' version, a nuptial epithalamium, is notoriously lewd.[16] Change of context is part of the fun. The feasting birds in the tree between Gallus and the bear in their first encounter, on the ivory book cover from late ninth-century St Gall [**129** and on page 212] strikingly echo those in the early Christian Resurrection ivory now in Munich [**55**], which we know to have been familiar to Carolingian artists, who used several aspects of its iconography as the basis for book illuminations produced for Archbishop Drogo of Metz *c*.850. Tuotilo's quotation of the bird-in-tree motif may be nothing more than another 'in-joke', or evocation of the ancient work as a means of setting a scene, or merely for the pleasure of seeking to rival a great work of an earlier age.

Another and in the long run far more important role of antiquity, beyond incorporation or possible evocation, is the inspiration offered by its forms and expressive possibilities, as in the pseudo-antique styles in the Utrecht Psalter [**116**]. In the later tenth century one great artist went much further. We no longer know his name, although he must have been famous in his own time, but his style is sufficiently distinctive that modern scholarship has given him an œuvre and a name, the

Master of the Registrum Gregorii, or Gregory Master. He had an exceptionally varied relationship with older works of art, for example painting miniatures to be inserted into Carolingian and pre-Carolingian Gospel books. He seems to have studied such late antique illustrated manuscripts as the Vatican Virgil, from which he borrowed many features, including figure-drawing and the construction of atmospheric settings. He also looked at works in other media, such as an early Christian ivory [31] preserved near his primary working location at Trier, whose imperial image he adapted for a grand portrait of Emperor Otto II. He seems to have adapted ancient spoliated capitals, long before inserted into the Cathedral of Trier, for the design of ornamental leaf-masks that appear in some of his manuscripts. He not only 'renovated' Carolingian books but based some of his compositions upon Carolingian images, and also drew upon contemporary Byzantine art.

To have seen these and other works of art, and drawn inspiration from them, it is likely that the Gregory Master travelled, visiting such sites as Tours as well as Trier. He seems to have been a professional artist, who could travel not only to see works of art but to produce them,[17] for his work appears not consistently within a 'scriptorium' but in books produced at differing times and places. Trier, still today full of impressive and well-preserved Roman buildings, was the seat of his major patron, Archbishop Egbert [134]. For Egbert he painted the facing-page portraits of the Emperor Otto and Pope Gregory the Great, for presentation to Trier's Cathedral as a pictorial statement of the city's role in imperial–ecclesiastical alliance. Also for Egbert he played a leading role in providing the most extensive narrative cycle of paintings of the life of Christ yet produced in Christian art, in a liturgical book of Pericopes (readings from the Gospels), the so-called Codex Egberti. Comprising 51 narrative miniatures in all, they are arranged in strict chronological order according not to the ecclesiastical calendar of feasts and readings, but according to the biography of Jesus, so that they unroll through the book almost like a proto-film documentary. Some are obviously intended to appeal to the audience, for example the miniature of the Massacre of the Innocents [135]. In details like its thin red- and gold-spindle-decorated border, its atmospheric sky, and the posture of the figure of King Herod at the left, it probably directly draws upon miniatures in the Vatican Virgil [58] or a very similar book. The figures of the mourning women are very similar to some of the women mourning at the death of Dido in that manuscript. The Gregory Master may also have drawn directly upon ancient Roman imagery visible only in the monuments of Rome, which he might have visited on the occasion of his patron Egbert's two trips there. The striking motif of the executioners' swords and spear arranged in parallel lines, with their dismembered victims lying on the

moritur Et nondixit cibi nonmoritur. sedsicev
uolomanere doneeueniam. quidadte Hic est disci
pulus quitestimonium perhibet dehis. et scripsithxc
Et scimus quia uerum est. testimonium eius

INNATAL INNOCENTŪ. SECUNDŪ MATHEŪ
N ILLOTEMPRE Angelus dni apparuit in
somnisioseph dicens Surge et accipe puerum et ma
trem eius. et fuge in aegyptum. etesto ibi usq, dum
dicam tibi futurum est enim. ut herodes querat

Master of the Registrum
Gregorii, Massacre of the
Innocents, from the Codex
Egberti (Archbishop Egbert's
liturgical Gospel book), Trier or
Reichenau, before 993

ground beneath, closely echoes a relief from the Column of Marcus Aurelius [9]. I know of no intermediary source from which this image could have been derived that would match not only its composition and narrative content but also its emotional expression. The costumes and grouping around King Herod recall the mosaic on the triumphal arch in Santa Maria Maggiore [53]. The miniature can be analytically teased apart as if a pastiche of sources, and it is even possible that the pictorial allusions would have been recognized by, and were meant to be recognized by, the learned patron and beholder Egbert. Yet the image is an effective and coherent new creation, antiquity appropriated, made one's own.

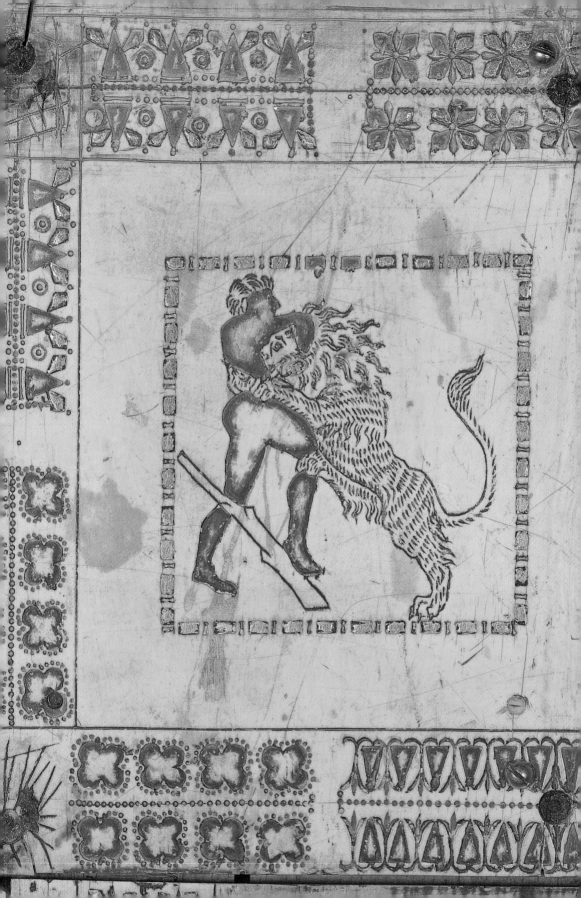

Conclusion

The early medieval artistic tradition stretches over nearly one thousand years, and a vast territory. No simple conclusion about the nature or significance of the period as a whole could be satisfying, but several general remarks may be in order. First, the importance of the period for the development of western art and culture can scarcely be overstated. Far from being a long pause between the ancient and modern worlds, many of the fundamental conditions of the next millennium were determined. Second, highlighting the period's preservation and emulation of Greek and Roman antiquity is a venerable art-historical commonplace, and like so many clichés this one holds a good deal of truth. Yet it may also be fair to say that the continuing significance of the Graeco-Roman artistic tradition was never in great danger during the early Middle Ages. Virtually every period and sub-period, every region and sub-region, including the non-figural metalwork of the so-called barbarians that is so often considered its very antithesis, relied upon antiquity in some manner for its artistic language and material. Third, in my own view the decisive phenomena of the period here under review are the rise of first Christianity and then Islam to be world religions. From the standpoint of the believer, this religious phenomenon may be seen as providential, the working of a divine will in the events of the world, but from the standpoint of the historian both religions seem at least in their earliest days unlikely candidates for their respective triumphs, linked as they both were to small and marginalized populations. Yet by the year 1000 they dominated nearly all of Europe, north Africa, and southern Asia, and both had developed artistic traditions easily recognizable, and readily distinguished from each other and from the art of the ancient world.

The stylistic revolution of early medieval tradition in western Europe is obvious enough, although in my own view attempts to define a single 'evolution' or 'development' through the period according to neat categories such as naturalistic or abstract, three- or two-dimensional are doomed to failure. Such evolutionary theories, a core structure of earlier twentieth-century thinking, not only in art history,[1] have now become deeply unfashionable because they manifestly rely upon arbitrary choices that reflect the historian's presuppositions and

Detail of 138
Hercules and the Lion

prejudices, and can succeed only by arbitrarily defining some works as important or progressive, and ruling irrelevant the many others. Medievalists have been relatively less encumbered by distinctions between fine art and popular art, between important and peripheral centres than many art historians. Vast as it is, the artistic material surviving from the early medieval period is tiny in comparison to later periods, so that what does survive tends to be treasured for its rarity, and is more difficult to ignore than the huge areas of recent art that have until very recently been dismissed as 'not important to the development' or even literally 'not modern'. Moreover, in early medieval art the creation of unnatural styles to serve alongside more naturalistic, 'classical' styles that they never altogether replaced, goes back to the late Roman period. Within a single period and region, often within a single work of art, one can identify divergent and sometimes contradictory stylistic features. Although the balance evidently shifted in different locations and times, early medieval artists could choose among different stylistic modes in order to find the means of expressing their ideas in visual terms. Styles reflect a complex blend of factors, including the training and skill of available artists, the wealth and ambitions of patrons, the demands of the subject, and the materials chosen. The period is not, however, one of complete chaos. Although some examples resist attribution with heroic resolution, most of the artworks of this period can, by comparing them to other better-documented works with which they share specific stylistic features, be assigned to a reasonably narrow geographic and chronological area with as high a degree of certainty as in later periods of European, or for that matter non-European, art. Unresolved debates about individual works often involve issues of deliberate archaism of style, or the possibility of artists travelling to different areas; thus a work in identifiably Irish or Italian style need not have been made by an Irishman or an Italian (whatever such anachronistic terms might be thought to signify), in Ireland or Italy, but was definitely made by an artist working in a strongly determined tradition.

In both Christian and Islamic traditions the role of visual art, so essential in the ancient world upon which both so heavily depended, was highly problematic, and it would be relatively easy to imagine either or both never developing such distinctive and remarkable artistic expressions. Both largely abandoned important categories of ancient art such as monumental stone sculpture, while inventing others such as book illumination. Both raised the value of other categories that had been regarded (as they have commonly been in recent centuries) as minor, such as textiles and ceramics. The highly problematic character of the artistic enterprise in these new world religions has long-term implications for later western developments. Art has already become during the early medieval period a subject of controversy, in part

136

Susanna (or Lothair) Crystal,
made for King Lothair II, before
869, probably north-eastern
France or central Rhineland
(114 mm diameter, stone
alone)

It is a small object, although
remarkably large for a gem,
whose original place and
manner of display is unknown.

precisely because it becomes so closely identified with the representa-
tion of religious and political power. It also became a vehicle for the
expression of controversy, an artistic tradition richly laden with
meaning, a site where differing views of society were contested. In the
absence of explicit commentaries upon images and texts, only occa-
sionally provided, both contemporaries and subsequent beholders are
forced to generate their own interpretations, which may vary widely.

One outstanding example of the contesting and contested image is
a reverse-carved Carolingian rock crystal [136], densely covered with
highly active figures telling in eight episodes the story of Susanna
(Daniel 13). Two Elders of high social standing come upon young
Susanna bathing and solicit sexual favours. When rejected, they
unjustly accuse her of seeking to seduce them, causing her arrest and
trial, and her ultimate vindication through the wisdom of her judge,
the prophet Daniel. The imagery ends with the execution of the two
apparently pious but corrupt Elders. The story has obvious appeal as a
mildly ripping yarn, with its reversal of fortune and implicit social crit-
icism of the powerful, but its meaning on this particular object is
difficult to assess, and has long been a subject of controversy among
modern scholars.[2]

The central image represents Daniel's wise judgement, Susanna's
prayers to heaven for justice, expressed by her raised arms, being

answered through the divinely inspired prophet. Immediately above the scene is the inscription 'Lothair King of the Franks ordered me to be made'. The most likely candidate for this ruler and patron is Charlemagne's great-grandson Lothair II, king of the region stretching along the Rhine river from 855 until his death in 869. In style the crystal seems likely to stem from this general region and period, but with this ruler's involvement the task of interpretation becomes especially difficult, and intriguing. The obvious interpretation is that the crystal shows the ruler's responsibility to provide justice in the contemporary world, as the just figures of the Old Testament had done. Many Carolingian writers preached just such a message to their kings, who were at least expected to listen and respond. Charlemagne and his successors repeatedly demanded (at least in texts) that widows and orphans and the weak must be protected from the depredations of the powerful, and in general it seems easy to imagine the Susanna crystal as a moral exhortation to the king, a flattering elevation of his own deeds through a biblical parallel. No doubt some contemporary beholders would have understood such a message. Many, being clerics or educated by clerics, would also have known the common scriptural interpretation that linked Susanna the innocent virgin with the Church itself, seeing her as a symbol of Ecclesia, or even of the Virgin Mary. Another and sharply divergent interpretation is also available, however.

The most notorious event associated with King Lothair II was his lengthy but ultimately unsuccessful attempt to divorce his wife Teutberga, who was childless, so that he could marry his mistress, with whom he had illegitimate offspring, who could then be made his heirs. Divorce was no more available to him than it would later be to King Henry VIII of England, save by a judgement of the Church that there had never been a proper marriage. Like Henry, Lothair applied for this sort of ecclesiastical relief, in 857, and was granted his divorce by the bishops of his kingdom, led by the archbishops of Cologne and Trier. The archbishops had 'encouraged' the queen to confess to an incestuous relationship with her brother, sufficient grounds to invalidate the royal marriage. However, Teutberga subsequently won the support of bishops in other kingdoms, notably Hincmar of Reims, and appealed to the pope, who in 865 ordered Lothair to take back his legitimate wife, and deposed the two archbishops who had granted the divorce. Lothair was forced to accept the decision. It is not hard to see parallels between the stories of Teutberga and Susanna, the two archbishops and the two elders. Indeed, in his treatise upon the issue of the divorce, Hincmar specifically links the case to the Old Testament story.[3] I cannot imagine that a Carolingian viewer would have been able to look at the lively story on this wonderful gem without thinking of the contemporary parallel. Probably one must reckon with as wide a gulf of

interpretations as among modern scholars; the archbishops of Reims and of Cologne, for example, could hardly be expected to react in the same manner as Teutberga (one theory would have the gem be a peace-offering from Lothair to his wife)! The essential point in this context, however, is precisely the richness of the implications of this work of art, bearing upon politics and Church–State relations, involving knowledge of earlier artistic traditions as well as of biblical and legal texts.

At the centre of the Susanna Crystal is the just ruler, seated, while all the other figures in all the scenes stand. Sitting is here literally central. A naïvely positivist survey of late antique and early medieval art, in contrast to earlier Graeco-Roman and post-medieval art, would reveal a strong disposition to sitting. Rather than reflecting a sedentary life-style, this distinction reflects seated posture while others stand as an indication of social distinction,[4] and preference for a particular mode of representation. Significant (and novel) classes of late antique art such as consular diptychs commonly show seated figures, while important state formulae feature the One Seated, first the emperor and later Christ. Certain genres or classes of representation appear to shift in form, for example author portraits which before late antiquity were likely standing figures or *imagines clipeatae* become seated portrayals, as in numerous Evangelist portraits. Indeed, the seat itself becomes the focal element of many ensembles, whether as an actual object such as the episcopal *cathedra* which gives its name to the greatest Christian churches [**59**], or the royal and imperial thrones whose elaborate settings can to some degree be reconstructed from visual [**100** and **101**] or literary sources. The famous throne room or Chrysotriklinos of Theophilus in the early ninth-century imperial palace in Constantinople had lavish decoration including wine-spouting fountains filled with pistachios and almonds, while organs played, choirs sang, and dancers performed before the emperor on his golden throne.[5] In the mid-tenth century, Liutprand of Cremona, serving as ambassador, describes the emperor seated on a huge golden throne that rose into the air while the golden lions on it roared, and mechanical golden birds sang in a golden tree.[6] Indeed, late antique art even prominently featured the image of an empty throne, as in the *hetoimasia* that appeared as a focal element of mosaic decorations, as at Santa Maria Maggiore in Rome [**53**]. At San Vitale in Ravenna [**60**] Christ sits in the apse mosaic, enthroned in majesty, flanked by his angels and saints, and directly beneath him the city's bishop sat in his marble throne surrounded by his clergy, making a living tableau arranged for the viewing of the congregation.

The theme constructed by such images is the representation of authority, which may be judicial, expository, or apocalyptic, and may be conveyed by a particular situation, for example in an apse, or particular material, especially ivory and/or gold. Drawing upon both ancient and biblical traditions, the iconography of the throne might

include features like lion supports or lions on its steps, which reflect both Roman practices and biblical texts (1 Kings 10: 18–20):

King Solomon also made a great throne of ivory: and overlaid it with the finest gold. It had six steps . . . and two lions stood, one at each hand. And twelve little lions stood upon the six steps on the one side and on the other: there was no such work made in any kingdom.

Such works were made in the early medieval kingdoms, however, linking them with this rich tradition. In closing, I would like to consider two thrones, with very different yet oddly linked forms and histories.

In relating to fellow monks and posterity his stewardship of the abbey of Saint-Denis, near Paris, the mid-twelfth-century Abbot Suger described new administrative, financial, and artistic achievements of which he was proud. He also told of some older things, including a bronze throne that still survives [**137**]: 'Further, we saw to it, both on account of its so exalted function and of the value of the work itself, that the famous throne of the glorious King Dagobert, worn with age and dilapidated, was restored.'[7] Both its apparent age and its association with the seventh-century Merovingian king were evidently important to Suger, and exploited by him in his campaign to establish Saint-Denis as the pre-eminent royal church in France. The throne plays its part well. Skilfully cast in bronze, its lower portions comprise a folding mechanism, making it like a Roman consul's seat

137

Throne of Dagobert, bronze throne, probably northern Francia, fifth–twelfth century (104 cm maximum height)

The age of this throne has been controversial, apparently since the twelfth century. Some serious scholars believe it to have been cast in the fourth–fifth century, some in the seventh (associated indeed with Dagobert), and some in the ninth (associated with Charlemagne or one of his successors), while manufacture for Suger himself is conceivable to some. Most credit Suger at least with the addition of the gable- or pediment-shaped triangular back, which prevents the seat from being folded.

for military campaigns, the *sella curulis*. The legs are in the form of lions' legs, and crowned by lion's heads, motifs both occurring on extant late Roman thrones and also visible in the images on many ivory consular diptychs. Whatever its date of origin, the throne is in fact unique.[8]

The other chair survives in Rome, in the apse of St Peter's basilica in the Vatican, inside the great bronze sculpture made by Bernini in the seventeenth century to house it. Known as the *Cathedra Petri*, the throne of St Peter [**138**], it was long regarded as the chair upon which Peter himself sat, the embodiment of his and his successors' claim to rule the Church of Rome and the world. It is a wooden chair, framed with open arcades on all four sides. The arcades on the back rise to a pediment on columns, visually a kind of temple façade still visible today in many parts of the former Roman empire (and imitated widely

138

Cathedra Petri (Throne of St Peter) general view, in original as-found condition prior to restoration, with the surrounding frame for carrying in procession removed. Wooden frame with ivory carvings, third quarter of ninth century, probably near Reims or Metz (in the kingdom of Charles the Bald, for whom it was made).

elsewhere and later), and represented on Roman and medieval coins [106] and in miniatures [58]. The posts were inlaid with strips of ivory, and the lower front was composed of ivory panels depicting the Labours of Hercules and some weird beasts. Long after manufacture it was enclosed within a wooden frame and fitted with rings so that it could be carried in processions. Again a work unique in many ways, controversy raged among scholars and the faithful concerning its date and place of origin. Only when it was removed from the Bernini shrine for the first scientific and historical study, in and after 1968, were some of the mysteries settled. At the centre of the back, at the base of the pediment, is a portrait of Charlemagne's grandson Charles the Bald. Abundant evidence of many kinds shows that the throne as a whole is certainly Carolingian, made in north-eastern Francia, perhaps somewhere near or using artists associated with Reims or Metz, dating from the third quarter of the ninth century. Probably taken to Rome by Charles the Bald for his imperial coronation in 875, it stayed there,[9] and eventually came to be associated with St Peter.

The design of the throne, and especially the addition to it of the Labours of Hercules represented on a series of Carolingian ivories deliberately made to look ancient, in consonance with their ancient, pagan, subject-matter, required a high level of craftsmanship, skill, learning, and probably a certain level of daring. This throne and its imagery must always have been controversial, very likely were meant to be controversial, presenting ideas about the proper relationship between the new Christian Roman empire of Charlemagne and his successors and the pagan and imperial tradition represented by Hercules that would be opposed by some viewers. So it has remained, a site of controversy, an enigma even, and a direct and indirect influence lasting centuries.[10] The ill-fitting pediment added to the 'Dagobert Throne' probably was inspired by this seat, and royal wooden chairs in England like St Stephen's Throne in Hereford and St Edward's Throne at Westminster reflect its materials and form. Indeed, the seat of authority of the Speaker in the early eighteenth-century House of Burgesses in Williamsburg, Virginia, shows the migration to a 'new world' unknown to antiquity of the seat of authority with pedimented top and curving legs transmitted from the Roman world through the early medieval period.[11]

Notes

Except as noted, all biblical quotations are taken from the Douay–Rheims version.

Introduction

1. *Mercure de France* 26 (1806), 77, quoted and trans. in Robert Rosenblum, *Jean-Auguste-Dominique Ingres* (rev. edn, New York, 1990), 60.
2. Rosenblum, *Ingres*, 60.
3. Patrick Geary, *Before France and Germany: The Creation and Transformation of the Merovingian World* (Oxford, 1988), vi.

Chapter 1. The Roman Language of Art

1. Sabine MacCormack, 'Loca Sancta: The Organization of Sacred Topography in Late Antiquity', in Robert Ousterhout (ed.), *The Blessings of Pilgrimage* (Urbana, Ill., and Chicago, 1990), 7–40, esp. 12–15, figs. 5–7.

Chapter 2. Earliest Christian Art

1. Clement of Alexandria, *Logos Paidagogos*, III. 59. 211; Jeffrey Spier, 'Early Christian Gems and their Rediscovery', in Clifford Malcolm Brown (ed.), *Engraved Gems: Survival and Revivals*, Studies in the History of Art 54 (Washington, 1997), 34.
2. But see Figure 126 and discussion.
3. 'Alexander the Quack Prophet', in *Selected Satires of Lucian*, ed. and trans. Lionel Casson (Garden City, NY, 1962), 267–300.
4. 'Lucius, the Ass', in *Selected Satires of Lucian*, 58–84.
5. André Grabar, *Early Christian Art*, (New York, 1968), pls. 64–5. Jerome praises one who destroyed 'the grotto of Mithas and all the dreadful images therein' (Letter 107, ch. 2). See W. H. Fremantle (ed. and trans.), *St. Jerome: Letters and Select Works*, A Select Library of Nicene and Post-Nicene Fathers (2nd ser., New York, 1893; repr. 1975), 6. 190.
6. Alice Christ, 'Consuming Bodies in Early Imperial Rome', *Bulletin of Ancient History* 10 (1997), 93–109.

Chapter 3. Conversion

1. Raymond Davis (ed. and trans.), *The Book of Pontiffs (Liber pontificalis)* (Liverpool, 1989), 16–25, a portion reproduced in Caecilia Davis-Weyer, *Early Medieval Art 300–1150* (Englewood Cliffs, NJ, 1971), 11–13.
2. Sible de Blaauw, *Cultus et decor: Liturgia e archittura nella Roma tardoantica e medievale*, Studi e Testi 355–6 (Vatican City, 1994), I. 117–27, figs. 2–3.
3. The term is borrowed from Peter Brown, *The World of Late*

Antiquity, AD 150–750 (London, 1971), 82–94.
4. Thomas F. Mathews, *The Clash of Gods: A Reinterpretation of Early Christian Art* (Princeton, 1993; rev. edn 1999), 92–114 on the Majesty image, and 3–22 for a highly critical review of what he terms 'the emperor mystique'.
5. 'Rescript on Christian Teachers', in Wilmer Cave Wright (ed. and trans.), *The Works of the Emperor Julian* (New York, 1923), III. xix. 116–23, quotation at 121.
6. William Tronzo, *The Via Latina Catacomb. Imitation and Discontinuity in Fourth-Century Roman Painting* (University Park, Pa., and London, 1986), figs. 4–5 and 34–5.

Chapter 4. Art for Aristocrats

1. Peter Brown, *The World of Late Antiquity, AD 150–750* (London, 1971), 34.
2. W. B. Anderson, *Sidonius: Letters and Poems* (Cambridge, Mass., 1936), I. 451–61; Hugh G. Evelyn-White, *Ausonius* (London, 1961), 12–31 and 32–39, respectively.
3. Peter Godman, 'The Poetic Hunt, from St. Martin to Charlemagne's Heir', in Peter Godman and Roger Collins (eds), *Charlemagne's Heir: New Perspectives on the Reign of Louis the Pious* (Oxford, 1990), 565–89.
4. Kurt Weitzmann (ed.), *Age of Spirituality* (New York, 1979), no. 79, pp. 89–90.
5. Evelyn White, *Ausonius*, 370–93; see also Anderson, *Sidonius*, 200–41.
6. Kathleen Shelton, *The Esquiline Treasure* (London, 1981), 36–40.
7. Augustine, *De civitate Dei*, VII. 4, cited in Shelton, *Esquiline Treasure*, 51.
8. Painter, 'Roman Silver Hoards: Ownership and Status', in Noel Duval and François Baratte (eds), *Argenterie romaine et byzantine* (Paris, 1988), 97–111, esp. 104–5 and 108–9, transcribing and translating fourth-century texts.
9. J. P. C. Kent and K. S. Painter, *Wealth of the Roman World AD 300–700* (London, 1977), 123–4, nos. 193–9.
10. Ibid. 140–57, nos. 304–30. Oleg Grabar (ed.), *Sasanian Silver: Late Antique and Early Mediaeval Arts of Luxury from Iran* (Ann Arbor, 1967).
11. For a similar brooch with a cross among vines, see Leslie Webster and Michelle Brown (eds), *The Transformation of the Roman World AD 400–900* (London, 1997), pl. 2.
12. Alan Cameron, *Claudian* (Oxford, 1970).
13. Guy Halsall, 'Towns, Societies and Ideas: The Not-so-Strange Case of Late Roman and Early Merovingian Metz', in

N. Christie and S. T. Loseby (eds), *Towns in Transition: Urban Evolution in Late Antiquity and the Early Middle Ages* (Aldershot, 1996), 235–61, at 244.

14. Charles Thomas, 'The Artist and the People: A Foray into Uncertain Semiotics', in Cormac Bourke (ed.), *From the Isles of the North: Early Medieval Art in Ireland and Britain* (Belfast, 1995), 1–7.

15. C. King, 'Roman, Local and Barbarian Coinages in Fifth-Century Gaul', in J. Drinkwater and H. Elton (eds), *Fifth-Century Gaul: A Crisis of Identity?* (Cambridge, 1992), 184–95.

16. Morten Axboe and Anne Kromann, 'DN ODINN P F AUC? Germanic "Imperial Portraits" on Scandinavian Gold Bracteates', *Acta Hyperborea* 4 (1992), 271–305, esp. p. 290 and fig. 22.

Chapter 5. Endings and Beginnings

1. James J. O'Donnell, *Cassiodorus* (Berkeley, 1979), esp. 43–54.

2. J[ohn] B. Ward Perkins, 'A Carved Marble Fragment at Riom (Puy-de-Dome) and the Chronology of the Aquitanian Sarcophagi', *The Antiquaries Journal* 40 (1960), 25–34.

3. Cassiodorus, *Variae* III. 31; IV. 51; trans. in Caecilia Davis-Weyer, *Early Medieval Art 300–1150* (Englewood Cliffs, NJ, 1971), 51–3.

4. Walter Ensslin, *Theoderich der Grosse* (Munich, 1947), 111–17 and pl. 5.

5. Cassiodorus, *Variae*, I. 6, in Davis-Weyer, *Early Medieval Art*, 50.

6. Ibid. 59–66.

7. Wilfried Menghin, *Hunnen Germannen Awaren* (Nuremberg, 1988), 194, no. IV, 6g, and 618–29, no. XV, 32d, respectively.

8. Ian Wood, 'The Audience of Architecture in Post-Roman Gaul', in L. A. S. Butler and R. K. Morris (eds), *The Anglo-Saxon Church: Papers on History, Architecture and Archaeology in Honour of Dr. H. M. Taylor* (London, 1986), 74–9.

9. Werner Jacobsen, 'Saints' Tombs in Frankish Church Architecture', *Speculum* 72 (1997), 1107–143, at 1108.

10. W. B. Anderson (ed. and trans.), *Sidonius: Poems and Letters* (London, 1936), I. 461–9, at 465. Davis-Weyer, *Early Medieval Art*, 54–5.

11. Peter Brown, 'Dalla "Plebs Romana" alla "Plebs Dei": Aspetti della Cristianizzazione di Roma', in *Governanti e intellettuali popolo di Roma e popolo di Dio* (Turin, 1992), 123–45.

12. Sible de Blaauw, *Cultus et decor: Liturgia e architettura nella Roma tardoantica e medievale* (Vatican City, 1994), I. 335–447.

13. Suzanne Spain, '"The Promised Blessing": the Iconography of the Mosaics of S. Maria Maggiore', *Art Bulletin* 61 (1979), 518–40.

14. Davis-Weyer, *Early Medieval Art*, 25–33.

15. Compare two famous panels inscribed NICOMACHORUM and SYMMACHORUM; Dale Kinney, 'A Late Antique Ivory and Modern Response', *American Journal of Archaeology* 98 (1994), 457–80.

16. Davis-Weyer, *Early Medieval Art*, 8–23.

17. Jerome, *Praefatio in librum Job* (Migne, PL 28: 1142); W. H. Fremantle (ed. and trans.), *St. Jerome: Letters and Select Works*, A Select Library of Nicene and Post-Nicene Fathers (2nd ser., New York, 1893, repr. 1975), 6. 491–2

18. Davis-Weyer, *Early Medieval Art*, 23–4.

19 John Lowden, 'The Beginnings of Bible Illustration', in John Williams (ed.), *Imaging the Early Medieval Bible* (University Park, Pa., 1999), 9–59.

20. H. L. Pinner, *The World of Books in Classical Antiquity* (Leiden, 1948), 21.

Chapter 6. Craftsmanship and Artistry

1. Procopius, *The Buildings*, I. i, as trans. Cyril Mango, *The Art of the Byzantine Empire 312–1453* (Englewood Cliffs, NJ, 1972), 75.

2. Dafydd Kidd, 'Some New Observations on the Domagnano Treasure', *Anzeiger des germanischen Nationalmuseums* (1987), 129–40.

3. *Die Alamannen* (Stuttgart, 1997), 491–8.

4. Andrew Wallace-Hadrill, *Houses and Society in Pompeii and Herculaneum* (Princeton, 1994), esp. 143–74.

5. Martin Carver, *The Age of Sutton Hoo* (Woodbridge, 1992), 365.

6. Bk. II, ch. 15, here quoted from Leo Sherley-Price, rev. R. E. Latham (Harmondsworth, 1979), 130.

7. Susan A. Boyd and Marlia Mundell Mango (eds), *Ecclesiastical Silver Plate in Sixth-Century Byzantium* (Washington, 1992).

8. Ian Wood, 'The Franks and Sutton Hoo', in I[an] N. Wood and N. Lund (eds), *People and Places in Northern Europe, 500–1600: Essays in Honour of Peter Sawyer* (Woodbridge, 1991), 1–14.

9. Susan Youngs, 'Recent Finds of Insular Enamelled Brooches', in Catherine E. Karkov, Robert T. Farrell, and Michael Ryan (eds), *The Insular Tradition* (Albany, NY, 1997), 189–210.

10. See Günther Haseloff, *Email im frühen Mittelalter* (Marburg, 1990), 20–4. There are only two surviving enamelled metalwork pieces thought to date from late antiquity, and one has been convincingly shown to be a forgery; see Terry Drayman-Weisser and Catherine Herbert, 'An Early Byzantine-Style Gold Medallion Re-considered', *Journal of the Walters Art Gallery* 49/50 (1991/2), 13–25.

11. Wilmer Filmer-Sankey, 'The "Roman Emperor" in the Sutton Hoo Ship Burial', *Journal of the British Archaeological Association* 149 (1996), 1–9.

12. Birgit Arrhenius, *Merovingian Garnet Jewellery: Emergence and Social Implications* (Stockholm, 1985), 195–6.

13. Jerome Baschet, 'Inventivité et sérialité des images médiévales. Pour une approche iconographique élargie', *Annales, Histoire, Sciences sociales* 51 (1996), 93–133.

Chapter 7. Saints and Holy Places

1. Peter Brown, *The Cult of the Saints: Its Rise and Function in Latin Christianity* (Chicago, 1981), 4.

2. Olympia 1, in Richmond Lattimore (trans.), *The Odes of Pindar* (Chicago, 1947), 1–4.

3. Brown, *Cult of the Saints*, 72

4. Robert C. Gregg, *Athanasius: The Life of Antony and the Letter to Marcellinus* (New York, 1980). For a pagan analogue or source see Patricia Cox, *Biography in Late Antiquity: A Quest for the Holy Man* (Berkeley, 1983).

5. F. R. Hoare (ed. and trans.), 'The Dialogues', *in Sulpicius Severus et al.: The Western Fathers* (New York, 1954), 101–3.

6. *Life of St. Martin*, chs. XVI and XII, in Hoare, *Sulpicius Severus*, 29 and 20–1, respectively.

7. Gregory of Tours, *De virtutibus sancti Martini*, 2. 60, discussed by Peter Brown, 'Vers la naissance du Purgatoire: Amnistie et pénitence dans le christianisme occidental de l'Antiquité tardive au Haut Moyen Age', *Annales. Histoire, Sciences sociales* (1997), 1247–61, at 1253.

8. Amanda Claridge, 'Hadrian's Column of Trajan', *Journal of Roman Archaeology* 6 (1993), 5–22

9. George E. Gingras (ed. and trans.), *Egeria: Diary of a Pilgrimage*, Ancient Christian Writers 38 (New York and Paramus, 1970); and John Wilkinson, *Jerusalem Travellers before the Crusades* (Warminster, 1977).

10. Cynthia Hahn, 'Loca Sancta Souvenirs: Sealing the Pilgrims' Experience', and Gary Vikan, 'Pilgrims in Magi's Clothing: The Impact of Mimesis on Early Byzantine Pilgrimage Art', in Robert Ousterhout (ed.), *The Blessings of Pilgrimage* (Urbana, Ill., and Chicago, 1990), 85–96 and 97–107, respectively, figs. 14–17 and 19–21.

11. Letter 107, ch. 1. For the full text, and a less literal translation, see W. H. Fremantle (ed. and trans.), *St. Jerome. Letters and Select Works*, A Select Library of Nicene and Post-Nicene Fathers (2nd ser., New York, 1893; repr. 1975), 6. 189–95.

12. Cynthia Hahn, 'Seeing and Believing: The Construction of Sanctity in Early-Medieval Saints' Shrines', *Speculum* 72 (1997), 1079–106, esp. 1093–4, figs. 3 and 12.

13. Otto von Simson, *Sacred Fortress. Byzantine Art and Statecraft in Ravenna* (Princeton, 1957), 40–68.

14. Werner Jacobsen, 'Saints' Tombs in Frankish Church Architecture', *Speculum* 72 (1997), 1107–43, esp. 1108–9 fig. 1.

15. Ibid. 1127 and 1134–7, figs. 3 and 19–27.

16. Compare Abbess Etheldreda of Ely's spurning of the jewellery she had worn as a child, in Bede, *Historia Ecclesiastica* Bk. IV, ch. 19, and *Bede: A History of the English Church and People*, trans. Leo Sherley-Price (Harmondsworth, 1955), 240.

17. See descriptions of gifts from Pope Leo III; Raymond Davis (trans.), *The Lives of the Eighth-Century Popes (Liber Pontificalis)* (Liverpool, 1992), e.g. ch. 51, p. 203, ch. 82, p. 218.

18. Mildred Budny and Dominic Tweddle, 'The Early Medieval Textiles at Maaseik, Belgium', *The Antiquaries Journal* 65 (1985), 353–9, at 354–5.

19. Davis, *Lives of the Eighth-Century Popes*, ch. 92, p. 223.

20. Bertram Colgrave (ed. and trans.), *Two Lives of Saint Cuthbert* (Cambridge, 1940).

21. C. F. Battiscombe (ed.), *The Relics of Saint Cuthbert* (Oxford, 1956).

22. Ernst Kitzinger, 'The Coffin-Reliquary', in Battiscombe, *Relics of Saint Cuthbert*, 202–304, and Lawrence Nees, 'The Iconographic Program of Decorated Chancel Barriers in the pre-Iconoclastic Period', *Zeitschrift für Kunstgeschichte* 46 (1983), 15–26.

23. Gingras, *Egeria*, 54–6.

24. Frederick S. Paxton, 'Power and the Power to Heal: The Cult of St. Sigismund of Burgundy', *Early Medieval Europe* 2 (1993), 95–110.

25. Hahn, 'Seeing and Believing', 1101–94, figs. 14–18.

26. Jacobsen, 'Saints' Tombs', 1139, figs. 36–7.

27. Translations from Walter Horn and Ernest Born, *Plan of St. Gall* (Berkeley, 1979), I. xx.

Chapter 8. Holy Images

1. Bede, *Historia Ecclesiastica*, Bk. I, ch. 25; see *Bede: A History of the English Church and People*, trans. Leo Sherley-Price (Harmondsworth, 1955), 69.

2. Charles Barber, 'From Transformation to Desire: Art and Worship after Byzantine Iconoclasm', *Art Bulletin* 75 (1993), 7–16.

3. Raymond Davis (trans.), *The Lives of the Eighth-Century Popes (Liber Pontificalis)* (Liverpool, 1992), 57. During a recent cleaning, the cover was removed and the image beneath the later cover and repainted head photographed for the first time. See Herbert L. Kessler and Johanna Zacharias, *Rome 1300: On the Path of the Pilgrim* (New Haven and London, 2000), fig. 57.

4. Malalas, *Chronographia*, 256; quoted from Gilbert Dagron, 'Holy Images and Likeness', *Dumbarton Oaks Papers* 45 (1991), 23–33, at 26.

5. Patricia Cox, *Biography in Late Antiquity: A Quest for the Holy Man* (Berkeley, Los Angeles, and London, 1983).

6. See Cyril Mango (ed. and trans.), *The Art of the Byzantine Empire 312–1453* (Englewood Cliffs, NJ, 1972), 139.

7. Ibid. 137.

8. Hans Belting, *Likeness and Presence: A History of the Image before the Era of Art* (Chicago and London, 1994), 38–40, fig. 8 and colour pl. opp. p. 264.

9. Hans Belting, 'Eine Privatkapelle im frühmittelalterlichen Rom', *Dumbarton Oaks Papers* 41 (1987), 57 n. 12.

10. Belting, *Likeness and Presence*, 72 and 124, pl. I

11. Ibid. 73 and fig. 23 for photographs of the installation.

12. Jane Hawkes, 'Columban Virgins: Iconic Images of the Virgin and Child in Insular Sculpture', in Cormac Bourke (ed.), *Studies in the Cult of Saint Columba* (Dublin, 1997), 107–35.

13. Caecilia Davis-Weyer, *Early Medieval Art 300–1150* (Englewood Cliffs, NJ, 1971), 47–9.

14. *Liber pontificalis*, Hadrian I, ch. 2; see Raymond Davis (trans.), *The Lives of the Eighth-Century Popes (Liber pontificalis)* (Liverpool, 1992), 123.

15. George Henderson, *From Durrow to Kells: The Insular Gospel-books 650–800* (London, 1987), figs. 114, 116, and 118.

16. Kathleen Corrigan, 'Text and Image on an Icon of the Crucifixion at Mount Sinai', in Robert Ousterhout and Leslie Brubaker (eds), *The Sacred Image East and West* (Urbana, Ill., and Chicago, 1995), 45–62, fig. 11.

17. Judson Emerick, *The Tempietto del Clitunno near Spoleto* (University Park, Pa., 1998).

Chapter 9. Word and Image

1. Patrick McGurk, 'The Irish Pocket Gospel Book', *Sacris Erudiri* 8 (1956), 249–70.

2. Henri Stern, *Le calendrier de 354. Etude sur son texte et sur ses illustrations* (Paris, 1953).

3. Augustine, *Confessions*, trans. Henry Chadwick (Oxford, 1991), V. 23–4 and VI. 3, pp. 88 and 92–3.

4. Richard Ettinghausen and Oleg Grabar, *The Art and*

Architecture of Islam 650–1250) (New Haven and London, 1987), 119–24.

5. Lawrence Nees, 'Ultán the Scribe', *Anglo-Saxon England* 22 (1993), 127–46. On the dating and localization of the Lindisfarne Gospels see David Dumville, *A Palaeographer's Review: The Insular System of Scripts* (Osaka, 1999).

6. Carl Nordenfalk, 'Before the Book of Durrow', *Acta archaeologica* 18 (1947), 151–9.

7. David Ganz, *Corbie in the Carolingian Renaissance* (Sigmaringen, 1990).

8. See R[upert] L. S. Bruce-Mitford, *The Art of the Codex Amiatinus*, Jarrow Lecture 1967 (Jarrow, 1967), and Lawrence Nees, 'Problems of Form and Function in Early Medieval Illustrated Bibles from Northwest Europe', in John Williams (ed.), *Imaging the Early Medieval Bible* (University Park, Pa., 1999), 122–77.

9. The translation is by Bruce-Mitford, *Art of the Codex Amiatinus*, 11, as is the wording of the inferential clause.

10. Folio 152v. For the manuscript in general see A. Dumas (ed.), *Liber sacramentorum Gellonensis*, Corpus Christianorum, series Latina CLIX A (Turnholt, 1981), this initial as fig. 102.

11. Bernhard Bischoff, *Manuscripts and Libraries in the Age of Charlemagne*, trans. Michael Gorman (Cambridge, 1994), 25.

12. For Jonas's *Life of Columbanus* see Edward Peters (ed.), and D. C. Munro (trans.), *Monks, Bishops and Pagans: Christian Culture in Gaul and Italy, 500–700* (Philadelphia, 1975), 75–113, esp. ch. 9, pp. 78–9.

Chapter 10. Art at Court

1. Peter Godman, *Poetry of the Carolingian Renaissance* (Norman, Okla., 1985), 4–22 and 150–63, the passage alluded to on p. 161.

2. Xavier Barral i Altet, *The Early Middle Ages: From Late Antiquity to A.D. 1000* (Cologne, 1997), 194–204.

3. Godman, *Poetry*, 252–5.

4. Mildred Budny, 'The Byrhtnoth Tapestry or Embroidery', in Donald Scragg (ed.), *The Battle of Maldon AD 991* (Oxford, 1991), 263–78.

5. Paul Edward Dutton (ed. and trans.), *Charlemagne's Courtier: The Complete Einhard* (Peterborough, Ont., 1998), 31; C. R. Dodwell, *Anglo-Saxon Art: A New Perspective* (Ithaca, NY, 1982), 129–87.

6. Barbara M. Kreutz, *Before the Normans: Southern Italy in the Ninth and Tenth Centuries* (Philadelphia, 1991), 6–8.

7. Bede, *Historia Ecclesiastica*, Bk. III, ch. 7, and *Bede: A History of the English Church and People*, trans. Leo Sherley-Price (Harmondsworth, 1955), 150.

8. Dutton, *Charlemagne's Courtier*, 26.

9. J[ocelyn] N. Hillgarth, *The Conversion of Western Europe, 350–750* (Englewood Cliffs, NJ, 1969), 93.

10. Gregory of Tours, *The History of the Franks*, trans. Lewis Thorpe (Harmondsworth, 1974), Bk. II, ch. 43; Bk. IV, ch. 1, pp. 158, 197.

11. Bede, *Historia Ecclesiastica*, Bk. I, ch. 33; *Bede: A History*, 91–2.

12. Kurt Weitzmann, 'The Heracles Plaques of St. Peter's Cathedra', *The Art Bulletin* 55 (1973), 1–37, esp. 25–9.

13. Raymond Davis, trans., *The Lives of the Eighth-Century*

Popes (Liber Pontificalis) (Liverpool, 1992), respectively ch. 91, p. 222, ch. 57, p. 204, ch. 39, p. 198, and ch. 9, p. 183; Hans Belting, 'Die beiden Palastaulen Leos III. im Lateran und die Entstehung einer päpstlichen Programmkunst', *Frühmittelalterliche Studien* 12 (1978), 55–83.

14. Davis (trans.), *The Lives of the Ninth-Century Popes (Liber Pontificalis)*, chs. 8–10, pp. 9–13.

Chapter 11. Expressive and Didactic Images

1. Quoted in *The Art of Medieval Spain AD 500–1200* (New York, 1993), no. 78, p. 153.

2. Charles Barber, 'The Body within the Frame: A Use of Word and Image in Iconoclasm', *Word and Image* 9 (1993), 140–53. Essential now is Celia Chazelle, *The Crucified God in the Carlingian Era: Theology and Art of Christ's Passion* (Cambridge, 2001).

3. Kathleen Corrigan, *Visual Polemics in the Ninth-Century Byzantine Psalters* (Cambridge, 1992), 107–11; here also discussion of Byzantine manuscripts with marginal 'commentary' illustrations.

4. H. J. Thomson (ed. and trans.), *Prudentius* (London, 1949), I. 286–7.

5. Geneva Kornbluth, *Engraved Gems of the Carolingian Empire* (University Park, Pa., 1995), 17, fig. 2–1.

6. Quoted from Minucius Felix, *Octvavius* (London, 1953), Ch. 32, 1–6, pp. 413–15, in Caecilia Davis-Weyer, *Early Medieval Art* (Englewood Cliffs, NJ, 1971), 6–7.

7. Paul Corby Finney, *The Invisible God: The Earliest Christians on Art* (Oxford, 1994), esp. 42–5 and 275–9.

8. Cynthia Hahn, 'Narrative on the Golden Altar of Sant' Ambrogio in Milan: Presentation and Reception', *Dumbarton Oaks Papers* 53 (1999), 167–87.

9. Werner Jacobsen, 'Saints' Tombs in Frankish Church Architecture', *Speculum* 72 (1997), 1107–43.

10. Thomson (trans.), *Prudentius*, II. 220–9.

11. Francois Dolbeau, 'Passion de S. Cassien d'Imola composée d'après Prudence par Hucbald de Saint-Amand', *Revue bénédictine* 87 (1977), 238–56.

12. Werner Vogler, 'Historical Sketch of the Abbey of St. Gall', in James C. King and Werner Vogler (eds), *The Culture of the Abbey of St. Gall* (Stuttgart and Zurich, 1991), 16.

Chapter 12. Towards a New Age

1. Janet L. Nelson (trans.), *The Annals of St-Bertin* (Manchester, 1991), 77.

2. Carl Nordenfalk, *Celtic and Anglo-Saxon Painting* (New York, 1977), 96–107 and pls. 33–8, esp. p. 106 and pl. 38.

3. Richard Hodges and David Whitehouse, *Mohammed, Charlemagne and the Origins of Europe* (Ithaca, NY, 1983), 118, fig. 49.

4. James Graham-Campbell, *The Viking World* (London, 1980), 200–1.

5. Ibid. 199.

6. O[tto]-K[arl] Werckmeister, 'The Islamic Rider in the Beatus of Girona', *Gesta* 36 (1997), 101–6.

7. Pamela Sheingorn (trans.), *The Book of Sainte Foy* (Philadelphia, 1995), 77.

8. In his sermon for Palm Sunday Hrabanus Maurus links the

viewers with martyrs, and makes them an example of the proper devotion of Christians in adversity; see J.-P. Migne, *Patrologia latina*, vol. 110, col. 29d, a reference I owe to Celia Chazelle.

9. Thomas Dale, 'Inventing a Sacred Past: Pictorial Narratives of St. Mark the Evangelist in Aquileia and Venice, ca. 1000–1300', *Dumbarton Oaks Papers* 48 (1994), 53–104.

10. Sheingorn, *Book of Sainte Foy*, 82.

11. Peter Lasko, *Ars Sacra, 800–1200* (Harmondsworth, 1972), pl. 18.

12. Michele Camillo Ferrari, 'Imago Visibilis Christi. Le *Volto Santo* de Lucques et les images authentiques au Moyen Age', in *La visione e lo sguardo nel Medio Evo*, Micrologus VI (Sismel, 1998), 29–43.

13. Dale Kinney, 'Spolia from the Baths of Caracalla in Sta. Maria in Trastevere', *Art Bulletin* 68 (1986), 379–97.

14. Paul Edward Dutton (ed. and trans.), *Charlemagne's Courtier: The Complete Einhard* (Petersborough, Ont., 1998), 32.

15. Ian Wood, 'The Audience of Architecture in Post-Roman Gaul', in L. A. S. Butler and R. K. Morris (eds), *The Anglo-Saxon Church: Papers on History, Architecture and Archaeology in Honour of Dr. H. M. Taylor* (London, 1986), 74–9.

16. P. Ermini, *Il centone de Proba* (Rome, 1909), and for Ausonius' epithalamium R. H. P. Green (ed. and trans.), *The Works of Ausonius* (Oxford, 1991), 132–9 and 518–26.

17. On professional and/or travelling artists see Lawrence Nees, 'On Carolingian Book Painters: the Ottoboni Gospels and Its Transfiguration Master', *Art Bulletin* 83 (2001), 209–39.

Conclusion

1. Stephen Jay Gould, *Wonderful Life: The Burgess Shale and the Nature of History* (New York, 1989).

2. Genevra Kornbluth, *Engraved Gems of the Carolingian Empire* (University Park, Pa., 1995), 31–48.

3. Hincmar, *De divortio Hlotharii*, the passage quoted in English translation by Kornbluth, *Engraved Gems*, 38.

4. Bede, *Historia Ecclesiastica*, Bk. II, ch. 2; *Bede: A History of the English Church and People*, trans. Leo Sherley-Price (Harmondsworth, 1955), 102.

5. Theophanes Continuatus, quoted at length in Cyril Mango, *The Art of the Byzantine Empire 312–1453* (New York, 1972), 161–5.

6. Quoted in Thomas F. Mathews, *Byzantium: From Antiquity to the Renaissance* (London, 1998), 74.

7. *De administratione*, ch. xxxiv, see Erwin Panofsky (ed. and trans.), *Abbot Suger on the Abbey Church of St.-Denis and its Art Treasures* (2nd edn, rev. Gerda Panofsky-Soergel; Princeton, 1979), 73.

8. *Le trésor de Saint-Denis* (Paris, 1991), 63–8.

9. Lawrence Nees, *A Tainted Mantle: Hercules and the Classical Tradition at the Carolingian Court* (Philadelphia, 1991).

10. See Lawrence Nees, 'Audiences and Reception of the *Cathedra Petri*', *Gazette des Beaux-Arts* 122 (1993), 57–72.3

11. Dell Upton, *Holy Things and Profane: Anglican Parish Churches in Colonial Virginia* (New Haven and London, 1986), p. 135 and fig. 162.

Further Reading

This is a starting place for readers who wish to explore various topics in greater detail, compiled by the publisher. The author has compiled an extended bibliographical essay, which can be found on the *Oxford History of Art* website (www.oup.co.uk).

General

G. W. Bowersock, Peter Brown, and Oleg Grabar (eds), *Late Antiquity: A Guide to the Postclassical World* (Cambridge, Mass., 1999).

Peter Brown, *The Rise of Western Christendom: Triumph and Diversity AD 200–1000* (Oxford, 1996).

—— *The World of Late Antiquity, AD 150–750* (London, 1971).

Roger Collins, *Early Medieval Europe, 300–1000* (New York, 1991).

Patrick J. Geary, *Before France and Germany: The Creation and Transformation of the Merovingian World* (Oxford, 1988).

Judith Herrin, *The Formation of Christendom* (Princeton, 1987).

Rosamond McKitterick (ed.), *The New Cambridge Medieval History*, vol. II: *c.700–c.900* (Cambridge, 1991).

Klaus Randsborg, *The First Millennium AD in Europe and the Mediterranean* (Cambridge, 1991).

Leslie Webster and Michelle Brown (eds), *The Transformation of the Roman World AD 400–900* (London, 1997).

Early Medieval Art: General

Robin Cormack, *Byzantine Art* (Oxford, 2000).

C. R. Dodwell, *The Pictorial Arts of the West, 800–1200* (New Haven and London, 1993).

George Henderson, *Early Medieval* (Harmondsworth, 1972).

Ernst Kitzinger, *Early Medieval Art* (London, 1940; rev. edn, Bloomington, Ind., 1983).

John Lowden, *Early Christian and Byzantine Art* (London, 1997).

Lawrence Nees, *From Justinian to Charlemagne: European Art, 565–787* (Boston, 1985).

Roger Stalley, *Early Medieval Architecture* (Oxford, 1999).

Chapter 1. The Roman Language of Art

Richard Brilliant, *Visual Narratives: Storytelling in Etruscan and Roman Art* (Ithaca, NY, and London, 1984).

Jaś Elsner, *Imperial Rome and Christian Triumph* (Oxford, 1998).

—— *Art and the Roman Viewer* (Cambridge, 1995).

Steven Fine (ed.), *Sacred Realm: The Emergence of the Synagogue in the Ancient World* (New York and Oxford, 1996).

Diana K. E. Kleiner, *Roman Sculpture* (New Haven and London, 1992).

Chapter 2. Earliest Christian Art
General

Ramsay MacMullen, *Christianizing the Roman Empire AD 100–400* (New Haven, 1984).

Robert L. Wilken, *The Christians as the Romans Saw Them* (New Haven and London, 1984).

Early Christian art

Paul Corbie Finney, *The Invisible God: The Earliest Christians on Art* (New York and Oxford, 1994).

André Grabar, *Early Christian Art* (New York, 1968).

Roger Ling, *Roman Painting* (Cambridge, 1991), 183–92.

[Sister] Charles Murray, *Rebirth and Afterlife: A Study of the Transmutation of some Pagan Imagery in Early Christian Funerary Art*, B.A.R. International Series 100 (Oxford, 1981).

Chapter 3. Conversion
General

T. D. Barnes, *Constantine and Eusebius* (Cambridge, Mass., 1981).

Averil Cameron, *The Later Roman Empire* (Cambridge, Mass., 1983).

Ramsay McMullen, *Christianity and Paganism in the Fourth to Eighth Centuries* (New Haven and London, 1997).

Art and architecture

Richard Krautheimer, *Early Christian and Byzantine Architecture* (Harmondsworth, 1965; rev. edn 1975, rev. with Slobodan Curcic, 1986).

Sabine G. MacCormack, *Art and Ceremony in Late Antiquity* (Berkeley, 1981).

Thomas F. Mathews, *The Clash of Gods: A Reinterpretation of Early Christian Art* (Princeton, 1993; rev. edn 1999).

Chapter 4. Art for Aristocrats
General

Averil Cameron, *The Mediterranean World in Late Antiquity* (London, 1993).

J. Drinkwater and H. Elton (eds), *Fifth-century Gaul: A Crisis of Identity?* (Cambridge, 1992).

Walter Goffart, *The Narrators of Barbarian History* (Princeton, 1988).

Walter Pohl (ed.), *Kingdoms of the Empire: The Integration of Barbarians in Late Antiquity* (Leiden, 1997).

Silver hoards
J. P. C. Kent and K. S. Painter, *Wealth of the Roman World AD 300–700* (London, 1977).
Kathleen Shelton, *The Esquiline Treasure* (London, 1981).

Chapter 5. Endings and Beginnings
General
Patrick Wormald (ed.), *Ideal and Reality in Frankish and Anglo-Saxon Society: Studies Presented to J. M. Wallace-Hadrill* (Oxford, 1983), 177–201.

Luxury and craftsmanship
Birgit Arrhenius, *Merovingian Garnet Jewellery: Emergence and Social Implications* (Stockholm, 1985).
Dominic Janes, *God and Gold in Late Antiquity* (Cambridge, 1998).

Texts and early book illumination
Kurt Weitzmann, including *Late Classical and Early Christian Book Illumination* (New York, 1977).
—— *Illustrations in Roll and Codex: A Study of the Origin and Method of Text Illustration* (Princeton, 1947, rev. edn 1970).
David H. Wright, *The Vatican Vergil* (Berkeley and London, 1993).
Cemetery archaeology
Donald Bullough, 'Burial, Community and Belief in the Early Medieval West', in Patrick Wormald (ed.), *Ideal and Reality in Frankish and Anglo-Saxon Society: Studies Presented to J. M. Wallace Hadrill* (Oxford, 1983).
Guy Halsall, *Early Medieval Cemeteries: An Introduction to Burial Archaeology in the Post-Roman West* (Glasgow, 1995).

Chapter 6. Craftsmanship and Artistry
General
C. R. Dodwell (ed.), *Theophilus: The Various Arts [De diversis artibus]* (Oxford, 1961).
Richard Hodges and David Whitehouse, *Mohammed, Charlemagne and the Origins of Europe* (Ithaca, NY, 1983).
B. Ward-Perkins, *From Classical Antiquity to the Middle Ages: Urban Public Building in Northern and Central Italy, A.D. 300–850* (Oxford, 1984).

Art and decorative arts
Paul T. Craddock, 'Metalworking Techniques', in Susan Youngs (ed.), *The Work of Angels: Masterpieces of Celtic Metalwork, 6th–9th centuries AD* (London, 1989), 170–213.
Anthony Cutler, *The Hand of the Master: Craftsmanship, Ivory, and Society in Byzantium (9th–11th centuries)* (Princeton, 1994).
André Grabar, *The Golden Age of Justinian* (New York, 1967).
Lawrence Nees, 'The Originality of Early Medieval Artists', in Celia Chazelle (ed.), *Literacy, Politics, and Artistic Innovation in the Early Medieval West* (Lanham, Md., 1992), 77–109.

Sutton Hoo ship-burial
Rupert Bruce-Mitford, *The Sutton Hoo Ship-Burial*, 3 vols.

(London, 1975, 1978, and 1983).
M[artin] O. H. Carver (ed.), *The Age of Sutton Hoo: The Seventh-Century in North-Western Europe* (Woodbridge 1992).
—— *Sutton Hoo: Burial Ground of Kings?* (Philadelphia, 1998).

Chapter 7. Saints and Holy Places
Lisa M. Bitel, *Isle of the Saints: Monastic Settlement and Christian Community in Early Ireland* (Ithaca, NY, and London, 1990).
Gerald Bonner, David Rollason, and Clare Stancliffe (eds), *St Cuthbert, His Cult and His Community to AD 1200* (Woodbridge, 1989).
Peter Brown, *The Cult of the Saints: Its Rise and Function in Latin Christianity* (Chicago, 1981).
Paul Fouracre and Richard A. Gerberding, *Late Merovingian France: History and Hagiography 640–720* (Manchester and New York, 1996).
Jo Ann McNamara and John E. Halborg, with E. Gordon Whatley (eds and trans.), *Sainted Women of the Dark Ages* (Durham and London, 1992).
Thomas F. X. Noble and Thomas Head (eds), *Soldiers of Christ. Saints and Saints' Lives from Late Antiquity and the Early Middle Ages* (University Park, Pa., 1995).
David Rollason, *Saints and Relics in Anglo-Saxon England* (Oxford, 1989).
Raymond Van Dam, *Saints and Their Miracles in Late Antique Gaul* (Princeton, 1993).

Pilgrimage and associated artistic works
Herbert L. Kessler, 'Pictorial Narrative and Church Mission in Sixth-Century Gaul', in Herbert L. Kessler and Marianna Shreve Simpson (eds), *Pictorial Narrative in Antiquity and the Middle Ages*, Studies in the History of Art (Washington, 1985), 75–91.
Anna Muthesius, *Studies on Byzantine and Islamic Silk Weaving* (London, 1995).
Robert Ousterhout (ed.), *The Blessings of Pilgrimage* (Urbana, Ill., and Chicago, 1990).
Gary Vikan, *Byzantine Pilgrimage Art* (Washington, 1982).

Monasteries
Richard Hodges, *Light in the Dark Ages: The Rise and Fall of San Vincenzo al Volturno* (Ithaca, NY, 1997).
Walter Horn and Ernest Born, *The Plan of St Gall* (Berkeley, 1979).

Chapter 8. Holy Images
Hans Belting, *Likeness and Presence: A History of the Image before the Era of Art* (Chicago and London, 1994).
Anthony Bryer and Judith Herrin (eds), *Iconoclasm* (Birmingham, 1977).
Robin Cormack, *Painting the Soul: Icons, Death Masks and Shrouds* (London, 1997).
Valerie I. J. Flint, *The Rise of Magic in Early Medieval Europe* (Oxford, 1991).
Anna Kartsonis, *Anastasis: The Making of an Image* (Princeton, 1986).

Lawrence Nees, *The Gundohinus Gospels* (Cambridge, Mass., 1987).

Robert Ousterhout and Leslie Brubaker (eds), *The Sacred Image East and West* (Urbana, Ill., and Chicago, 1995).

Kurt Weitzmann, *The Icons*, I: *From the Sixth to the Tenth Century* (The Monastery of Saint Catherine at Mount Sinai, Princeton, 1976).

Bracteates and protective images

Bente Magnus, 'The Firebed and the Serpent: Myth and Religion in the Migration Period Mirrored through some Golden Objects', in Leslie Webster and Michelle Brown (eds), *The Transformation of the Roman World AD 400–900* (London, 1997), 194–207.

Chapter 9. Word and Image
General

Paul Saenger, *Space between Words: The Origins of Silent Reading* (Stanford, Calif., 1997).

Barbara A. Shailor, *The Medieval Book* (New Haven and London 1988; repr. Toronto, 1991).

Book illumination

J. J. G. Alexander, *Medieval Illuminators and Their Methods of Work* (New Haven and London, 1992).

Christopher De Hamel, *Scribes and Illuminators* (London, 1992).

Henry Mayr-Harting, *Ottonian Book Illumination*, 2 vols (London, 1991).

Mireille Mentré, *Illuminated Manuscripts of Medieval Spain* (London, 1996).

Florentine Mütherich and Joachim Gaehde, *Carolingian Painting* (New York, 1976).

Columbanus

H. B. Clarke and Mary Brennan (eds), *Columbanus and Merovingian Monasticism*, B.A.R. International series 113 (Oxford, 1981).

Michael Lapidge (ed.), *Columbanus: Studies on the Latin Writings* (Woodbridge, 1997).

Insular books

J. J. G. Alexander, *Insular Manuscripts 6th to the 9th Century* (London, 1978).

George Henderson, *From Durrow to Kells: The Insular Gospel-books 650–800* (London, 1987).

Continental insular-style illumination

Lawrence Nees, 'The Irish Manuscripts at St. Gall and Their Continental Affiliations', in James C. King (ed.), *Sangallensia in Washington* (New York, 1993), 95–132, on the St. Gall 1395 miniature at 112–20.

Nancy Netzer, *Cultural Interplay in the Eighth Century: The Trier Gospels and the Making of a Scriptorium at Echternach* (Cambridge, 1994).

Chapter 10. Art at Court
General

P. S. Barnwell, *Kings, Courtiers and Imperium: The Barbarian West, 565–725* (London, 1997).

Donald Bullough, '"*Imagines regum*" and Their Significance in the Early Medieval West', in Giles Robertson and George Henderson (eds), *Studies in Memory of David Talbot Rice* (Edinburgh, 1975).

Dhuoda, *Handbook for William: A Carolingian Woman's Counsel for Her Son*, trans. Carol Neel (Lincoln, Nebr., and London, 1991).

Paul Edward Dutton (ed. and trans.), *Charlemagne's Courtier: The Complete Einhard* (Peterborough, Ont., 1998).

Peter Godman, *Poets and Emperors: Frankish Politics and Carolingian Poetry* (Oxford, 1987).

Byzantium

Henry Maguire (ed.), *Byzantine Court Culture from 829 to 1204* (Washington, 1997).

Michael McCormick, *Eternal Victory: Triumphal Rulership in Late Antiquity, Byzantium and the Early Medieval West* (Cambridge, 1986).

Carolingian art

George Henderson, 'Emulation and Innovation in Carolingian Art', in Rosamond McKitterick, *Carolingian Culture: Emulation and Innovation* (Cambridge, 1994).

Jean Hubert, Jean Porcher, and Wolgang Fritz Volbach, *The Carolingian Renaissance* (New York, 1970).

Perette Michelli, 'Migrating Ideas or Migrating Craftsmen? The Case of the Bossed Penannular Brooches', in R. Michael Spearman and John Higgitt (eds), *The Age of Migrating Ideas: Early Medieval Art in Northern Britain and Ireland* (Edinburgh, 1993).

Lawrence Nees, 'Carolingian Art and Politics', in Richard E. Sullivan (ed.), *'The Gentle Voices of Teachers': Aspects of Learning in the Carolingian Age* (Columbus, Oh., 1995).

The Muslim world

Oleg Grabar, *The Formation of Islamic Art* (New Haven and London, 1973), 139–78.

Chapter 11. Expressive and Didactic Images

Paul Edward Dutton, *The Politics of Dreaming in the Carolingian Empire* (Lincoln, 1994).

Paul Edward Dutton and Herbert L. Kessler, *The Poetry and Paintings of the First Bible of Charles the Bald* (Ann Arbor, 1997).

Oleg Grabar, *The Mediation of Ornament* (Princeton, 1992).

Peter Harbison, *The High Crosses of Ireland: An Iconographic and Photographic Survey*, 3 vols (Bonn, 1992).

Herbert L. Kessler and Marianna Shreve Simpson (eds), *Pictorial Narrative in Antiquity and the Middle Ages*, Studies in the History of Art (Washington, 1985).

Elizabeth Sears, 'Louis the Pious as *Miles Christi*. The Dedicatory Image in Hrabanus Maurus' *De laudibus sanctae crucis*', in Peter Godman and Roger Collins (eds), *Charlemagne's Heir: New Perspectives on the Reign of Louis the Pious (814–840)* (Oxford, 1990).

Robert Stevick, *The Earliest Irish and English Bookarts: Visual and Poetic Forms before A.D. 1000* (Philadelphia, 1994).

John Williams, *The Illustrated Beatus* (London, 1994).

Chapter 12. Towards a New Age

General

Robert Bartlett, *The Making of Europe: Conquest, Colonization and Cultural Change, 950–1350* (Princeton, 1993).
Heinrich Fichtenau, *Living in the Tenth Century: Mentalities and Social Orders*, trans. Patrick Geary (Chicago, 1991).
Thomas Head and Richard Landes (eds), *The Peace of God. Social Violence and Religious Response in France around the year 1000* (Ithaca, NY, and London, 1992).
Timothy Reuter, *Germany in the Early Middle Ages 800–1056* (London, 1991).

Monastic reform

Barbara H. Rosenwein, *Rhinoceros Bound: Cluny in the Tenth Century* (Philadelphia, 1982).

The cult of saints and relics

Barbara Abou-el-Haj, *The Medieval Cult of Saints: Formations and Transformations* (Cambridge, 1997).
Patrick J. Geary, *Furta Sacra: Thefts of Relics in the Central Middle Ages* (rev. edn; Princeton, 1990).

Art

Janet Backhouse, D. H. Turner, and Leslie Webster (eds), *The Golden Age of Anglo-Saxon Art 966–1066* (London, 1984).
Otto Demus, *Romanesque Mural Painting* (New York, 1968).
The Art of Medieval Spain: A.D. 500–1200 (New York, 1993).

Events	People	Works of art
		Works listed here are limited to those mentioned or illustrated in the text which can be approximately dated to a relatively narrow span on the basis of external criteria such as inscriptions or historical context

200

c.200
Earliest examples of Christian art

230s–256
Decoration of the Synagogue and Christian building at Dura (Europos)

250s
Ludovisi Battle sarcophagus

251
First great persecution of Christians under Emperor Decius

284
Accession of Emperor Diocletian

284–305
Reign of Emperor Diocletian

300

c.270–356
St Anthony hermit in Egypt, *Life* 356

303
Beginning of the great persecution of Christians under Emperor Diocletian

c.300
Porphyry Four Tetrarchs statue, Venice

306–37
Reign of Emperor Constantine

312
Battle of the Milvian Bridge; Constantine becomes sole emperor in the west

313
Edict of Milan announcing tolerance for Christians

c.315
Arch of Constantine

324
Constantine defeats Licinius, becoming sole emperor; founds Constantinople as new capital

325
First Ecumenical Council called in Nicaea (Nicene Creed established)

335–97
Life of St Martin of Tours

c.340s
Santa Costanza, Rome

359
Sarcophagus of Junius Bassus

361–3
Pagan revival under Emperor Julian 'the Apostate'

378
Battle of Adrianople; barbarian army defeats Roman force under Emperor Valens, who is killed

379–95
Reign of Emperor Theodosius

Events

391
Closing of pagan temples by Emperor Theodosius

400

406
Great invasion across the Rhine

410
Sack of Rome by Alaric the Visigoth; Roman army abandons Britain

431
Third Ecumenical Council held at Ephesus

439
Vandal army captures Carthage, establishes Vandal kingdom

451
Fourth Ecumenical Council held at Chalcedon.
Battle of Catalaunian Fields, Attila's Hunnic army defeated by allied Visigoths and Romans

455
Sack of Rome by Vandal army

476
Deposition of western Roman emperor by Odovacer

493
Ostrogothic kingdom established in Italy by Theoderic

c.496
Baptism of Clovis, king of the Franks

500

c.507
Battle of Vouillé in which Clovis and Franks defeat the Visigoths, control most of modern France

People

363–425
Life of Sulpicius Severus

395–430
St Augustine bishop of Hippo

470–80
Sidonius Apollinaris bishop of Clermont

c.481–511
Reign of Clovis, king of the Franks

c.490
Death of St Patrick in Ireland

493–526
Reign of Theoderic the Ostrogoth as king of Italy

c.480–547
Life of St Benedict of Nursia, founds Monte Cassino 529

490–583
Life of Cassiodorus Senator

527–65
Reign of Emperor Justinian

Works of art

c.400
Ivory diptych of Stilicho and Serena.
Ivory diptych of Consul Rufus Probianus.
Vatical Vergil and Quedlinburg Itala manuscripts

c.440
Rome, Santa Maria Maggiore

c.480
Burial of Childeric, king of the Franks

487
Ivory diptych of Boethius

c.500
Burial of Ostrogothic jewellery at Domagnano

Events	People	Works of art
533 Justinian's Roman army reconquers Carthage and North Africa		
535–53 Justinian's armies reconquer Italy from the Ostrogoths		**546–8** Mosaic decoration of San Vitale in Ravenna
*c.*563 Foundation of Iona by St Columba (Colum Cille)	**563–97** St Columba (Colum Cille) abbot at Iona	
568 Invasion of Italy under Alboin the Lombard		
*c.*570 Queen Radegund founds Convent of the Holy Cross at Poitiers	**573–94** Gregory bishop of Tours	
580 Lombards sack Monte Cassino		
*c.*590 Foundation of Luxeuil by St Columbanus	**590–604** St Gregory the Great as pope	
597 Arrival of St Augustine in Kent, establishment of Canterbury as centre of Roman mission in Britain	*c.*590–615 St Columbanus on the continent	*c.*597 Gospels of St Augustine
600		*c.*600 Book covers given by Queen Theodelinda to Monza
622 *Hijra*—Muhammad establishes an Islamic community at Medina	**623–38** Reign of Dagobert as sole king of the Franks	
632 Death of Muhammad	**628–33** Reign of Edwin, first Christian king of Northumbria	*c.*630s Sutton Hoo ship-burial
635 Foundation of Lindisfarne monastery by St Aidan of Iona		
636 Battle of Yarmuk, Roman armies defeated by Islamic Arab army, Jerusalem taken by Arabs shortly after	**641–60** St Eligius (Eloi) bishop of Noyon	
664 Synod of Whitby establishes primacy of the Roman Church in Northumbrian kingdom	*c.*664–80 Queen St Balthilde founding abbess at Chelles	
669 Theodore of Tarsus becomes archbishop of Canterbury	*c.*635–87 St Cuthbert, hermit, then from 685 bishop at Lindisfarne	

Events

674–7
First Arab siege of
Constantinople

711
Arab army invades Spain,
quickly destroys Visigothic
kingdom

724
St Pirmin founds Reichenau
monastery

*c.***726**
Iconoclasm begins in
Constantinople

733
Battle of Poitiers; Charles (father
of later King Pippin) defeats
Arab army invading Francia

739–41
Lombard King Liutprand
besieges Rome

750
End of Umayyad dynasty based in
Damascus; beginning of Abbasid
dynasty based in Baghdad

751
Ravenna, Byzantine capital in
Italy, captured by Lombards.
Pippin anointed as king of the
Franks at Soissons by the papal
legate St Boniface, with papal
authorization

754
Iconoclastic Council held at
Hieria.
Coronation of King Pippin at
Saint-Denis by Pope Stephen.
Boniface martyred while
preaching in Frisia

770s–790s
Franks conquer the Saxons

People

672–735
Life of Bede at Jarrow,
Ecclesiastical History 731

690–739
St Willibrord abbot at
Echternach

716–54
St Boniface active in Francia

741–68
Pippin ruler of the Franks, king
from 751

768–814
Reign of Charlemagne, king of
the Franks, Roman emperor from
800

772–95
Pope Hadrian

Works of art

691–2
Caliph Abd al-Malik constructs
Dome of the Rock

*c.***698**
Coffin reliquary of St Cuthbert.
Earliest date for the Lindisfarne
Gospels, likely written in
following decades

705–7
Icon of Santa Maria in
Trastevere, Rome

716
Abbot Ceolfrith takes the Codex
Amiatinus with him from
Northumbria to Italy

*c.***720s**
Trier Gospels (cod. 61) by
Thomas

750
Theodotus Chapel at Santa
Maria Antiqua, Rome

754
Gundohinus Gospels

700

Events

774
Charlemagne and the Franks conquer the Lombard kingdom in Italy

787
Seventh Ecumenical Council held at Nicaea (Nicaea II)

790s
Franks conquer the Avar kingdom

793
First Viking raid sacks Lindisfarne monastery

798
Pope Leo III driven from Rome, travels to meet Charlemagne at Paderborn in Saxony

800

800
Charlemagne acclaimed as emperor of the Romans by Pope Leo III at St Peter's in the Vatican

822
Emperor Louis publicly does penance, at Attigny

843
End of Iconoclasm in Byzantine empire.
Treaty of Verdun produces truce among the sons of Louis the Pious, results in lasting division of the Frankish kingdom, separation of France and Germany

People

782–804
Alcuin of York associated with court of Charlemagne, abbot of Tours from 796

*c.*781–856
Life of Hrabanus Maurus, monk at Fulda from *c.*790, abbot there from 822, archbishop of Mainz from 847

814–40
Reign of Emperor Louis I ('the Pious') in Francia

838–77
Reign of Charles the Bald in western Francia, Roman emperor from 875

Works of art

775
Dedication of new basilica at Saint-Denis

781–3
Godescalc Gospel Lectionary

790s
Construction of Aachen palace complex
Gellone Sacramentary

795
Dagulf Psalter made for Charlemagne as gift for pope

*c.*800
Germigny-des-Prés oratory made for Bishop Theodulf of Orléans

*c.*806
Profile portrait coin of Charlemagne introduced

816–40
Gospels made for Archbishop Ebbo of Reims

817–24
Construction of Santa Prassede, Rome

*c.*820s
Plan of St Gall.
Vatican manuscript of Hrabanus Maurus *De laudibus*

824–42
Abbot Epiphanius of San Vincenzo al Volturno decorated crypt with paintings

824–59
Golden altar of San Ambrogio in Milan

Events

853
Sack of monastery of St Martin at Tours

855
Danish Great Army invades Britain

881
Sack of San Vincenzo al Volturno

885
Viking siege of Paris

900

911
Norman duchy created by grant of French king

955
Battle of the Lechfeld, Otto I defeats Magyars

962
Coronation of Otto I as emperor of the Romans

972
Otto II marries Byzantine princess Theophanu.
Coronation of Edgar as king of the English

People

844–82
Hincmar archbishop of Reims

871–99
Alfred the Great king of Wessex

959–75
Edgar king of Wessex, from 973 king of the English

c.945–1003
Life of Gerbert of Aurillac, at cathedral school of Reims after 972, variously tutor of Otto III, abbot at Bobbio, archbishop of Reims, Archbishop of Ravenna, from 999 Pope Sylvester II

983–1002
Reign of Emperor Otto III

Works of art

c.860s
Prayerbook made for King Charles the Bald
Susanna crystal made for King Lothair II

c.868
Gospels of Otfried of Weissenburg

c.870
Codex Aureus of St Emmeram, Gospels made for King Charles the Bald

c.875
Cathedra Petri made for King Charles the Bald

before 924
South High Cross at Monasterboice erected for Abbot Muiredach

940–5
Morgan Beatus manuscript

966
Charter of King Edgar for Winchester New Minster

c.970
Crucifix of Archbishop Gero of Cologne

972
Marriage agreement of Otto II and Theophanu

975
Girona Beatus manuscript

c.980s
Archbishop Egbert of Trier commisions Reliquary of St Andrew and Codex Egberti

Events

987
Hugh Capet crowned king of France; end of Carolingian dynasty

987
Prince Vladimir of Kiev accepts Christianity

1000

1000
Iceland accepts Christianity

People

995–1000
Olaf Tryggveson first Christian king in Norway

Works of art

after 986
Jelling stone erected by King Harald of Denmark

c. **1000**
Liuthar Gospels of Otto III in Aachen

Gallery/Museum	Website

	Gallery/Museum	Website
France	**Bibliothèque Nationale de France** **Paris** Perhaps the richest collection of illuminated manuscripts from the early medieval period.	*www.bnf.fr/web-bnf/connaitr/manu.htm*
United Kingdom	**The British Library** **London** Rich collection of illuminated manuscripts, including the Lindisfarne Gospels among others. Usually has extensive exhibition of manuscripts on view.	*www.bl.uk/index.html*
	The British Museum **Department of Medieval and Modern Europe** **London** Great collection of medieval objects, featuring material from the Sutton Hoo ship burial among much else.	*www.thebritishmuseum.ac.uk/medieval/index.html*
United States	**Dumbarton Oaks** **Washington, DC** Great collection of early Christian and Byzantine art, especially metalwork and silver. Operated with an important research centre and library also accessible through the website.	*www.doaks.org/Byzantine.html*
	The Metropolitan Museum of Art **New York** Rich comprehensive collection, most of the material from the early medieval period at the main site on Fifth Avenue, but some (much later) medieval art at The Cloisters. Especially important for silver and ivories and metalwork.	*www.metmuseum.org/collections/department.asp?dep=17* [medieval department] *www.metmuseum.org/collections/department.asp?dep=7* [The Cloisters]
Italy	**Musei Vaticani / Biblioteca Apostolica Vaticana** **Vatican City** **Rome** Includes links to the many different collections among which the extraordinarily rich collections are divided, especially notable for early Christian sarcophagi and other sculpture.	*www.christusrex.org/www1/vaticano/0-Musei.html*

www.chass.utoronto.ca/~hsonne/MedartL
A site for discussion of topics related to
medieval art.

www.princeton.edu/~ica/icaintro.html
The Index of Christian Art, Princeton University
A huge database founded in 1917 for medieval
iconography, with branches at Dumbarton Oaks
and the Vatican Library. Site gives introduction
and instructions for gaining some online access.

www.medievalart.org
International Center of Medieval Art, New York
Operated by a major scholarly organization, with
newsletter, information about conferences, and
a selection of links for medieval art.

www.fordham.edu/halshall/sbook.html
Internet Medieval Sourcebook
Maintained by Paul Halshall at Fordham
University. Especially strong for medieval texts
and for religious topics.

labyrinth.georgetown.edu
The Labyrinth: Resources for Medieval Studies
sponsored by Georgetown University
Excellent general site for all areas of medieval
studies, with many links, now including a key
word search feature.

grid.let.rug.nl/~martens/links.htm
Links in Medieval and Northern Renaissance Art
History
Operated by Maximilian P. J. Martens, a Dutch
art historian. A valuable collection of links to
sites especially in northern Europe.

netserf.cua.edu/art/default.cfm
NetSERF: Medieval Art
Operated by Beau Hardin at the Catholic
University of America. Many links to medieval
images and databases.

List of Illustrations

The publisher and author would like to thank the following individuals and institutions who have kindly given permission to reproduce the illustrations listed below.

Introduction, frontispiece (detail of 1). The figure of Otto III enthroned in majesty.

1. Gospels of Otto III, Otto III enthroned in majesty, datable c.996, produced at the monastery of Reichenau on Lake Constance, on the border between Germany and Switzerland (298 × 215 mm each page). Domkapitel Aachen (Liuthar or Aachen Gospels, ff. 15v–16r)/photo Ann Münchow.

2. Jean-Auguste Dominique Ingres, *Napoleon Enthroned in Majesty*, 1806. Oil on canvas (265.4 × 160 cm). Musée de l'Armée, Paris/photo Réunion des Musées Nationaux.

3. The Gemma Augustea, onyx cameo, c.10 BC? (190 × 230 mm). Kunsthistorisches Museum (Antikensammlung, inv. IX. a.79), Vienna.

4. Liuthar or Aachen Gospels of Otto III, Crucifixion, probably from Reichenau, late tenth century (298 × 215 mm each page). Domkapitel Aachen(Liuthar or Aachen Gospels, f. 232r)/photo Ann Münchow.

Chapter 1, frontispiece (detail of 16). Dura (Europos) Synagogue: portion of the western wall to the left of the Torah shrine, with Abraham above, King Ahasuerus and Esther below. National Museum, Damascus/AKG London/photo Erich Lessing.

5. Reconstruction of the Column of Trajan rising in the centre of Trajan's Forum, with the Basilica Ulpia the huge building behind it. From H. L. Pinner, *The World of Books in Classical Antiquity* (Leiden, 1948), after p. 54.

6. Trajan's Column, AD c.120, Rome. Detail showing *adlocutio* scene. Photo Alinari, Florence.

7. Trajan's Column, AD c.120, Rome. Detail showing *adventus* scene. Photo Ancient Art and Architecture Collection, Pinner.

8. Marcus Aurelius Column, AD 180–192, Rome. Detail showing *adlocutio* scene. Photo Deutsches Archäologisches Institut, Rome.

9. Marcus Aurelius Column, AD 180–192, Rome. Detail showing execution scene. Photo Alinari, Florence.

10. Commonly known as the Ludovisi Battle Sarcophagus, the work is often associated with Trajan Decius' son Hostilian and dated to c.251, but it may have been made for another member of an imperial family, and could date a decade or more later. Marble (1.52 m H). Museo Nazionale delle Terme, Rome/photo © G. Dagli Orti, Paris. Lid: Römisch-Germanisches Zentralmuseum, Mainz.

11. Four Tetrarchs, from Constantinople although perhaps carved in Egypt, porphyry, c.300 (1.3 m H). Venice, San Marco, south-west corner pier. Photo Michael Holford, Loughton.

12. Medallion of Constantius Chlorus, gold, from the mint at Trier, c.296 (42 mm diameter). Musée Municipal, Arras/photo Gérard Poteau.

13. Coin of Emperor Licinius, issued at Nicomedia in c.320, a multiple aureus, gold (34 mm diameter). Bibliothèque Nationale (Cabinet des Médailles), Paris.

14. Floor mosaic, from the House of Dominus Iulius in Carthage, probably from the middle or second half of the fourth century (5.9 × 5.0 m). Bardo Museum, Tunis/photo AKG London.

15. Funerary stele of a centurion in the pretorian guard in Rome, third century. Marble (1.25 m H). Galleria Lapidaria, Vatican City/photo Monumenti Musei e Gallerie Pontificie, Rome.

16. Dura (Europos), Synagogue, view of paintings on the west wall, before AD 256. National Museum, Damascus/photo Percueron/copyright Artephot, Paris.

Chapter 2, frontispiece (detail of 27, other long side). Velletri Sarcophagus, with Hercules leading Alcestis through the portals of the underworld. Museo Civico, Velletri/photo Editions Gallimard, Paris.

17. Silver denarius of Domitian, AD 81, silver (18 mm diameter). © The British Museum (BMC.3 C.194.55), London.

18. Early Christian seal impression, with anchor, fish and IXΘYC inscription, pressed from a red jasper seal ring, probably third century. Ägyptisches Museum, Staatliche Museen Preussischer Kulturbesitz, Berlin.

19. Seal carved from a carnelian gem, probably fourth century. © The British Museum, London.

20. Tomb closure slab with anchor and two fish, Rome, third century, from the Domitilla catacomb. Pontificie Commissione per l'Archeologia Sacra/Benedettine di Priscilla, Rome.

21. Sarcophagus for Livia Primitiva, detail of central section, with good shepherd, fish, and anchor. Marble, third century. Musée du Louvre, Paris/photo Réunion des Musées Nationaux/Hervé Lewandowski.

22. Sarcophagus from Santa Maria Antiqua, Rome, marble, mid-third century. Photo Alinari, Florence.

23. Ceiling painting in a large chamber from the catacomb of SS Pietro e Marcellino, Rome, late third or early fourth century. Pontificie Commissione di Archeologia Sacra/Benedettine di Priscilla, Rome.

24. Baptistery of the Christian meeting-house (*domus ecclesiae*) at Dura, a Roman frontier city on the Euphrates River in Syria,

from the first half of the third century (before AD 256). Yale University Art Gallery (Dura-Europos Archive), New Haven, CT.

25. Glycon, cult statue of a 'deity' in the form of a serpent, marble, probably third century. Muzeul de Istorie Naţionalăşi Arheologie Constanţa.

26. Mithras slaying the cosmic bull, on a small (7 cm) bronze medallion found in Ostia, near Rome, third century. Ashmolean Museum (inv. 1927.187), Oxford.

27. Sarcophagus from Velletri, near Rome, second century (1.45 m H). Museo Civico, Velletri/photo Deutsches Archäologisches Institut, Rome.

Chapter 3, frontispiece (see also 36). Reconstruction of the restored ceiling of a chamber from the Constantinian imperial palace in Trier, early fourth century. Bischöfliches Dom- und Diözesanmuseum, Trier.

Map 1, The Roman Empire at the death of Emperor Constantine, c.337. After Jaś Elsner, *Imperial Rome and Christian Triumph* (Oxford, 1998).

28. Arch of Constantine, Rome, reliefs above the western arch. Hurriedly erected after Constantine's victory in 312. Photo Alinari, Florence.

29. Mosaic in the apse of the Chapel of San Aquillino, at San Lorenzo in Milan, from the second half of the fourth century. Photo Scala, Florence.

30. Ivory pyxis, early fifth century, of uncertain origin (Italy? Syria? Trier?) (120 mm H, 146 mm diameter). Museum für Spätantike und Byzantinische Kunst (inv. 536)/Staatliche Museen zu Berlin/photo A. Voigt.

31. Ivory diptych of Rufius Probianus, probably made in Rome, c.400 (316 × 129 mm left panel, 300 × 129 right). Staatsbibliothek zu Berlin Preussischer Kulturbesitz (Handschriftabteilung, MS. theol. lat. fol. 323).

32. Junius Bassus sarcophagus, AD 359 (1.18 × 44 m). Museo Storico del Tesoro della Basilica di San Pietro, Vatican City/photo Fabbrica di San Pietro in Vaticana.

33. Via Latina catacomb, Cubiculum O, mid-fourth century. Pontificie Commissione de Archeologia Sacra/Benedettini di Priscilla, Rome.

34. Via Latina catacomb, Cubiculum N, mid-fourth century. Pontificie Commissione de Archeologia Sacra/Benedettini di Priscilla, Rome.

35. Ambulatory vault of Santa Costanza, Rome, mid-fourth century. Copyright Artephot, Paris/photo Nimatallah.

36. Reconstructed panel from the restored ceiling of a chamber from the Constantinian imperial palace in Trier, early fourth century (see Chapter 3 frontispiece).

Chapter 4, frontispiece (detail of 40). Silver plate from the so-called Sevso Treasure, detail of the inner medallion. Property of the Trustee of the Marquess of Northampton, 1987 Settlement/photo courtesy Sotheby's London.

Map 2, Aristocratic wealth in the late Roman Empire.

37. Gold-glass plate (the 'Alexander Plate'), mid-third century (257 mm diameter). © The Cleveland Museum of Art, Leonard C. Hanna Jr. Fund (acc. 69.68), OH.

38. Projecta casket, oblique overall view of the front, second half of fourth century, Rome (549 × 431 × 279 mm H). © The British Museum (inv. 1866, 12–29.1), London.

39. Projecta casket, from the Esquiline Treasure, overall view top, second half of fourth century, Rome (549 × 431 × 279 mm H). © The British Museum (inv. 1866, 12–29.1), London.

40. Silver vessels from the so-called Sevso Treasure, probably dating from the fourth century. Property of the Trustee of the Marquess of Northampton, 1987 Settlement/photo courtesy Sotheby's London.

41. Horse trappings, silver with gilding, from the Esquiline Treasure, probably Rome, second half of fourth century (each 635 mm L). © The British Museum (inv. 1866, 12–29.26), London.

42. Ivory diptych of Consul Boethius, front, 487, probably Rome (each panel 350 × 126 mm). Museo Civico, Brescia/Archivio Fotografico Bresciano/Fotostudio Rapuzzi.

43. Ivory diptych of Consul Boethius, back, 487, probably from Rome (source, see 42).

44. Ivory diptych of Stilicho and Serena, c.400, from Rome or northern Italy (each panel 322 × 162 mm). Museo del Tesoro del Duomo, Monza/photo Alinari, Florence.

45. Pair of bow-fibulae, early fifth century, found at Untersiebenbrunn (Austria) (each 159 mm L). Kunsthistorisches Museum (inv. U.1+2), Vienna.

46. Belt buckle, found in Herbergen (Lower Saxony), bronze, circa fourth century (113 mm W). Landesmuseum fur Kunst und Kulturgeschichte (inv. LMO.2.858), Oldenburg.

47. Gold bracteate found in Gotland (Sweden), fifth century (93 mm diameter). Statens Historiska Museum (inv. 18375), Stockholm.

Chapter 5, Frontispiece (detail of 53). Rome, Santa Maria Maggiore, 432–40: detail showing Christ child enthroned between angels and beneath the star of Bethlehem.

48. Sword and scabbard mounts from the tomb of King Childeric, before c.482. Silver-gilt cloisonné garnets. Bibliothèque Nationale (Cabinet des Médailles), Paris.

49. Ravenna, San Apollinare Nuovo, detail of mosaics on the south wall, first half of sixth century. Photo Scala, Florence.

50. Eagle fibula, cloisonné garnets and gold on bronze, c.500 (121 mm L). Found at Domagnano (San Marino), near Ravenna, its place of manufacture is uncertain, and may have been at or for the Ostrogothic court at Ravenna. Germanisches Nationalmuseum (inv. FR.1608), Nuremberg.

51. Eagle pendant, gold foil, and granulation with jewels, found in Sweden, probably sixth century (23 mm H, 21 mm W). Byzantine (or at least eastern Europe or Mediterranean). Statens Historiska Museum (inv. 7004), Stockholm.

52. Rome, Santa Maria Maggiore, 432–40, interior of the nave looking towards the apse. Photo Scala, Florence.

53. Rome, Santa Maria Maggiore, 432–40, mosaic on the so-called triumphal arch above the altar. Photo Scala, Florence.

54. Santa Maria Maggiore, 432–40, mosaic in the nave, Abraham and Melchisedek. Photo Scala, Florence.

55. Ivory panel with Three Women at the Tomb and the Resurrection of Christ, probably Rome, first half of fifth century (187 × 116 mm). Bayerische Nationalmuseum (inv. MA.157), Munich.

56. Pair of five-part ivory diptychs, Rome or northern Italy,

mid-fifth century (each panel 375 × 281 mm). Museo del Tesoro del Duomo, Milan/Alinari, Florence/photo George Tatge.

57. The Quedlinburg Itala, probably Rome, first half of fifth century (each page 303 × 205 mm). Staatsbibliothek zu Berlin Preussischer Kulturbesitz (Handschriftabteilung MS theol. lat. fol. 485, f. 2r).

58. The Vatican Virgil, Rome, early fifth century (each page 219 × 196 mm). Biblioteca Apostolica Vaticana (cod. lat. 3225, f. 45v), Vatican City, Rome.

59. Ivory throne of Archbishop Maximian of Ravenna, mid-sixth century (1.50 m H, 605 mm W). Museo Arciviscovale, Ravenna/photo © G. Dagli Orti, Paris.

Map 3, The world of late antiquity, c.600.

Map 4, The British Isles, c.700. From Susan Youngs (ed.), *The Work of Angels* (London, 1989), and Rosamond McKitterick (ed.), *The New Cambridge Medieval History*, vol. 2 (Cambridge, 1995), pp. 22, 44.

60. Ravenna, San Vitale, interior of chancel looking over the altar into the apse, constructed in the 520s and decorated c.546–8. Photo Scala, Florence.

61. Gold bracteate from Akershus (Norway), c.600. University of Oslo (Oldsaksamling), Oslo/photo Erik Irgens Johnsen.

62. Bow-fibula from a wealthy female grave at Wittislingen (south-west Germany), late sixth or early seventh century (160 mm L). Cloisonné setting of garnets with green glass, gold filigree, silver, and niello (silver oxidized to black). Archäologische Staatssamlung (Museum für Vor- und Frühgeschichte, inv. IV.1891), Munich/photo Manfred Eberlein.

63. The Mass of St Gilles, a fifteenth-century painting by the Master of St Gilles. Oil and egg on wood (61.6 × 45.7 cm). The National Gallery (NG.4681), London.

64. Book covers of Theodelinda, late sixth or early seventh century. Gold, gemstones, pearls, antique cameos, and cloisonné (each 267 × 172 mm). Museo del Duomo, Monza/photo Scala, Florence.

65. Sutton Hoo ship-burial, escutcheon from the hanging-bowl, fifth or sixth century. Bronze with millefiori enamel. © The British Museum (inv. 1939, 10–10.110), London.

66. Gold buckle from Sutton Hoo, first half of seventh century, gold, probably south-eastern England (or Sweden?) (132 mm L). © The British Museum (inv. 1939, 10–10.1), London.

67. Hinged clasps from Sutton Hoo, first half of seventh century, probably south-eastern England. Gold (each 127 mm L.). © The British Museum (inv. 1939, 10–10.4), London.

68. Derrynaflan (Co. Tipperary) Hoard, view of strainer, chalice, paten stand, and paten with covering bronze basin under which they were buried, Ireland, eighth–ninth century (paten diameter c.360 mm, chalice height 192 mm). Copyright National Museum of Ireland, Dublin.

Chapter 7, frontispiece (detail of 76). Fragment of silk textile with David enthroned. Archeological Museum, Maaseik/photo Institut Royal du Patrimoine Artistique, Brussels/copyright IRPA-KIK.

69. Pilgrim token, St Symeon the Younger, clay, Syria, sixth or seventh century (38 mm diameter). The Menil Collection (inv. 79–24.198.DJ), Houston/photo Janet Woodard.

70. Ampulla from Jerusalem, silver repoussé, c.sixth–seventh century (approximately 5 cm diameter). Museo della Basilica di San Colombano, Bobbio.

71. SS Giovanni e Paolo, Rome, view of *confessio*, probably later fourth century. Pontificie Commissione di Archeologia Sacra/Benedettine di Priscilla, Rome.

72. Chapel of San Vittore in Ciel d'Oro, at San Ambrogio, Milan, view into dome, fifth century. Photo Scala, Milan.

73. San Apollinare in Classe, Ravenna, apse and mosaic decoration, c.550. Photo Scala, Florence.

74. Jouarre, underground burial chamber, seventh century. Photo © G. Dagli Orti, Paris.

75. Chemise of Ste Balthilde, silk embroidery on linen, seventh century, produced at the monastery at Chelles for the founding abbess, and still preserved there. Photo Musée Alfred Bonno, Chelles/E. Mittard and N. Georgieff.

76. Detail showing one of several narrow strips, from the *Casula* of Sts Harlindis and Relindis, silk and linen, probably England, early ninth century. Archeological Museum, Maaseik/photo Institut Royal du Patrimoine Artistique, Brussels/© IRPA-KIK.

77. Iona (Scotland), monastery of St Columba. Cross of St Martin, probably eighth century. Photo Lawrence Nees.

Map 5, Some major monasteries in western Europe, c.550–800. From Judith Herrin, *The Formation of Christendom* (Princeton, NJ, 1987), p. 293, and Pierre Riché, *Education and Culture in the Barbarian West* (Columbia, SC, 1976), pp. 111, 278, 332, 370, 400.

78. San Vincenzo al Volturno, crypt of Epiphanius, 824–42. Photo James Barclay-Brown/© University of East Anglia, Norwich.

79. The Plan of St Gall, parchment, probably Reichenau c.820 (110 × 75 cm). Stiftsbibliothek (Cod. Sang. 1092), St Gall.

Chapter 8, frontispiece (detail of 81). Icon of Christ the Saviour, deposited in Sancta Sanctorum when that was constructed by Leo III, silver mounting added mainly in twelfth century. Monumenti Musei e Gallerie Pontificie, Vatican City, Rome.

80. Reliquary box with stones from sites in the Holy Land, and images of events related to those sites, probably made in Palestine, seventh century (241 × 184 mm), preserved in the Sancta Sanctorum at the Lateran (Rome) since the late eighth century. Photo Leonard von Matt.

81. Rome, Lateran Palace, Sancta Sanctorum, view of private papal chapel with altar and icon of Christ the Saviour. Photo Leonard von Matt.

82. Chrismal, eighth century, probably Britain, gilt copper plates over a wooden core, Mortain (Normandy), Church of Saint-Evroult Treasury (140 × 105 × 51 mm). Photo Lawrence Nees.

83. Portrait icons of Sts Peter and Paul, leaves of a folding diptych from the Sancta Sanctorum, probably seventh century (each 86 × 57 mm). Photo Leonard von Matt.

84. Rome, Santa Maria in Trastevere, Icon of the Virgin and Child (sometimes called La Madonna della Clemenza), Rome, 705–7 (164 × 116 cm). Photo Scala, Florence.

85. The Book of Kells (Gospels manuscript), Virgin and Child miniature, Iona? probably second half of the eighth or early ninth century. The Board of Trinity College (MS 58, ff. 7v–8r) Dublin.

86. Rome, Santa Maria Antiqua, Chapel of Sts Quiricus and

Julitta, east wall, c.750. Photo Istituto Centrale per il Catalogo e la Documentazione, Rome.

87. Gospels manuscript known after its scribe and painter as the Gundohinus Gospels. Produced at an otherwise unknown monastery, Vosevio, probably located in Burgundy, dated to the third year of King Pippin, so probably AD 754. Bibliothèque Municipale, Autun.
Chapter 9, frontispiece (detail of 90). An enlargement of a section including both letters and ornament.

88. Gospels manuscript called Gospels of St Augustine, probably from Rome, late sixth century (each page 251 × 196 mm). Master and Fellows of Corpus Christi College (MS 286, f. 129v), Cambridge.

89. Ashburnham Pentateuch (manuscript containing the first five books of the Old Testament) Eliezer bringing Rebecca from the house of her father to be the wife of Abraham's son Isaac, unknown place of origin, probably sixth–seventh century (each page 371 × 321 mm). Bibliothèque Nationale (cod. nouv. acq. lat. 2334, f. 21r), Paris.

90. Lindisfarne Gospels, probably produced in the first third of the eighth century, most likely at Lindisfarne in northern England (each page 340 × 240 mm). The British Library (Cotton Nero D.IV, ff. 26v–27r), London.

91. Gregory the Great's *Homeliae in Ezechiel*, probably from the later seventh century from the monastery of Luxeuil (each page 259 × 183 mm). National Library of Russia (cod. Q.v.i.14, ff. 1v–2r), St Petersburg. From E. H. Zimmermann, *Vorkarolingische Miniaturen* (Berlin, 1916), pl. 64.

92. The Dagulf Psalter, probably written at Aachen or in any event at the orders of Charlemagne, c.795 (each page 192 × 120 mm). Österreichische Nationalbibliothek (cod. 1861, ff. 24v–25r), Vienna.

93. Codex Amiatinus, the prophet Ezra, Monkwearmouth-Jarrow, early eighth century (before 716) (each page 505 × 340 mm). Biblioteca Medicea Laurenziana (MS Amiatino 1, f. Vr), Florence/Ministero per i Beni e le Attività Culturali.

94. Single leaf, possibly from a Gospel book, Ireland or St Gall or another Irish centre on the continent, eighth or ninth century (219 × 178 mm). Stiftsbibliothek (Cod. Sang. 1395, p. 418), St Gall.

95. Ebbo Gospels, Evangelist John and initial to John, probably Reims, second quarter of ninth century (each page 260 × 149 mm). Bibliothèque Municipale (cod. 1, ff. 134v–135r), Epernay.

96. Trier Gospels, miniature of a tetramorph, Echternach, c.720 (each page 300 × 245 mm). Domschatz (cod. 134/61, f. 5v)/Bistum Trier/Amt für kirchliche Denkmalpflege/photo Rita Heyen.

97. Gellone Sacramentary, the opening words of the central portion of the Mass, *Te igitur*, probably written at the monastery of the Holy Cross at Meaux (near Paris), c.800 (each page 292 × 176 mm). Bibliothèque Nationale (cod. lat. 12048, ff. 143v–144r), Paris.

98. Prayer book of King Charles the Bald, probably c.860s (135 × 102 mm). Schatzkammer der Residenz (s.n., ff. 38v–39r), Munich/Bayerische Staatsbibliothek.
Chapter 10, frontispiece (detail of 101). The figure of the king seated on his throne, in elaborate court costume.

99. Cividale, Santa Maria in Valle ('Tempietto'), view of entrance wall with stuccoes and wall-paintings, probably early eighth century. Centrale per il Catalogo e la Documentazione, Rome.
Map 6, Charlemagne's travels during his reign, 768–814. From Donald Bullough, *The Age of Charlemagne* (London, 1965), p. 50.

100. Aachen, Palace Chapel, interior view, towards the royal throne on the gallery level. End of the eighth and early ninth century. © Könemann GmbH/photo Achim Bednorz, Cologne.

101. Codex Aureus, or 'golden Gospels' of St Emmeram, was produced for King Charles the Bald probably c.870 (each page 420 × 330 mm). Bayerische Staatsbibliothek (Clm. 14000, ff. 5v–6r), Munich.

102. Marriage agreement of Emperor Otto II and Empress Theophanu, parchment, possibly painted at Trier or Reichenau or other centre, possibly by the Master of the Registrum Gregorii, c.972 (145 cm L × 35 cm w). Niedersächsische Staatsarchiv (6.Urk. 11, Hieratsurkunde 14 April 972), Wolfenbüttel.

103. Saint-Maurice d'Agaune, enamelled ewer, eighth century and later (30.3 cm H). Augustiner-Chorherrenstift Treasury (Kanton Wallis)/Colorphoto Hans Hinz, Allschwil.

104. Hunterston Brooch, front, cast silver with gold filigree and amber (122 mm diameter). National Museum of Antiquities of Scotland, Edinburgh.

105. Bossed penannular brooch from Ballespellan (Co. Kilkenny), hammered silver, late ninth century (115 mm diameter). National Museum of Ireland, Dublin.

106. Silver denarius of Charlemagne, minted c.806, at Frankfurt (c.20 mm diameter). Staatliche Museen zu Berlin (Munzkabinett).

107. Godescalc Gospel Lectionary, unknown place of origin, for the court of Charlemagne, 781–3 (each leaf 310 × 210 mm). Bibliothèque Nationale (cod. nouv. acq. lat. 1203, ff. 3v–4r), Paris.

108. Ivory cover of a Gospel Lectionary, produced probably by an artist associated with the court of Charlemagne, c.800 (211 × 125 mm). Bodleian Library (MS Douce 176, front cover), University of Oxford.

109. Germigny-des-Prés, oratory of Theodulf, mosaic in apse, early ninth century. Photo Bridgeman Art Library, London.

110. Rome, Santa Prassede. View of the mosaics of the apse and the two triumphal arches. Decorated under Pope Paschal I, 817–24. Photo Scala, Florence.

111. Charter of King Edgar for New Minster, Winchester, AD 966 (each page 288 × 162 mm). British Library (MS Cotton Vespasian A.VIII, f. 2v), London.

112. The St Andrews Sarcophagus, sandstone, date uncertain, probably second half of the eighth century. Cathedral Museum, St Andrews, Fife/Photo Crown ©: Royal Commission on the Ancient and Historical Monuments of Scotland, Edinburgh.
Chapter 11, frontispiece (detail of 120). Wolvinius Altar, S. Ambrogio, Milan. Back view (central portion): above, Archangels Michael (left) and Gabriel; below, Bishop Angilbertus (left) and Master Wolvinius before Ambrose. Photo Scala, Florence.

113. Hrabanus Maurus, *De laudibus sanctae crucis*, Christ crucified, within acrostic poem, probably Fulda, second quarter of the ninth century (each page 365 × 295 mm). Biblioteca Apostolica Vaticana (cod. reg. lat. 124, f. 8v), Rome.

114. Book of Job with commentary, Satan and angels before the Hand of God. Probably from a Greek monastery in Italy, most likely in Rome, ninth century (*c*.368 × 266 mm). Biblioteca Apostolica Vaticana (cod. gr. 749, f. 12v), Rome.

115. World Map, from the Morgan Beatus, possibly from the monastery of Tábara, datable 940–5 (each page 387 × 285 mm). Pierpont Morgan Library (cod. M.644, ff. 33v–34r), New York/photo Art Resource.

116. Utrecht Psalter, illustrations to Psalms 1 and 2, region of Reims, probably second quarter of the ninth century (each page 330 × 258 mm). Universiteitsbibliothek (MS 32, ff. 1v–2r), Utrecht.

117. Combat between Anger (*Ira*) and Patience, from Prudentius' *Psychomachia*, probably from Christ Church, Canterbury, late tenth century (each page 215 × 135 mm). British Library (MS Cotton Cleopatra C.VIII, ff. 10v–11r), London.

118. Baptism of Christ, rock crystal, mid-ninth century (?855–69), probably northern Rhineland area (Aachen?) (82.5 × 69 mm). Musée des Antiquités, Rouen/photo François Degué.

119. Fuller brooch, silver inlaid with niello, Anglo-Saxon England, late ninth century (114 mm diameter). © The British Museum (inv. 1952, 4–4.1), London.

120. Altar in San Ambrogio, Milan, front view (84 cm H × 218 cm W × 122 cm D). Photo Scala, Florence.

121. Monasterboice (Co. Louth, Ireland), south cross, probably before 924 (3.1 m H including the base). The Irish Picture Library, Dublin.

122. The Woman Clothed in the Sun (Apoc. 12: 1–18), from the Morgan Beatus, possibly from the monastery of Tábara, datable 940–5 (each page 387 × 285 mm). Pierpont Morgan Library (MS M.644, ff. 152v–153r), New York/photo Art Resource.

123. St Cassian of Imola teaching, led before a pagan judge, and martyred at the hands of his pen-wielding students. From a manuscript of the poems of Prudentius, probably stemming from St Gall or Reichenau, late ninth century (each page 275 × 218 mm). Burgerbibliothek (cod. 284, pp. 120–1), Bern. Chapter 12, frontispiece (detail of 129). St Gall, dressed in monk's cowled robes, receiving firewood from a bear. Stifsbibliothek (Cod. Sang. 53), St Gall.

Map 7, The western Christian world, *c*.1000. From John Man, *Atlas of the Year 1000* (Cambridge, MA, 1999), p. 36, and John Contreni, 'The Carolingian renaissance in education and literary culture', in Rosamond McKitterick, ed., *The New Cambridge Medieval History*, vol. 2 (Cambridge, 1995), pp. 722–3.

124. Hoard of Islamic coins, bracelets, penannular brooches, and hack-silver, from Birka, *c*.975. Statens Historiska Museum, Stockholm.

125. The Jelling stone, carved in the churchyard at Jelling (Jutland, Denmark) at some point roughly 965–85. Photo Nationalmuseet, Copenhagen.

126. Beatus manuscript from Girona, 'Islamic Rider' spearing a serpent, probably from Tábara, 975 (each page 400 × 260 mm). Museo Tesoro de la Catedral de Girona/rights reserved © Cabildo de la Catedral de Girona/photo Josep Maria Oliveras.

127. St Georg, at Oberzell, Reichenau (Germany), interior view of the nave. The paintings on the nave walls date probably from the late tenth century. Photo Achim Bednorz, Cologne.

128. Entry into Jerusalem, from the Gospels of Otfried of Weissenburg, in German, *c*.868 (each page 261 × 212 mm). Österreichisches Nationalbibliothek (cod. 2687, f. 153v), Vienna.

129. One of a pair of ivory book covers, with the Ascension of the Virgin, and St Gall's encounter with the bear, carved at St Gall, late ninth century (320 × 155 mm). Stifsbibliothek (Cod. Sang. 53), St Gall.

130. The Regularis Concordia (Harmony of the Rule), of King Edgar between Archbishop St Dunstan of Canterbury and Bishop Aethelwold of Winchester. Second half of the later tenth century, very possibly after an original of the later tenth (each page 240 × 177 mm). © The British Library (Cotton Tiberius a.III, f. 2v), London.

131. Reliquary statue of Sainte Foy, gilt and silver-gilt over wooden core, with added jewels and cameos, comprising portions of various dates around a core probably of the later ninth century (850 mm H). Photo © G. Dagli Orti, Paris.

132. Miniatures added to the slightly earlier Egmond Gospels, Flanders, *c*.950 (each page 232 × 207 mm). Koninklijke Bibliotheek (cod. 76 Fl, ff. 214v–215r), The Hague.

133. Crucifix given by Archbishop Gero to Cologne Cathedral, painted oak, Cologne, *c*.970s (1.9 m H, body only). AKG London/photo Henning Bock.

134. Reliquary of the sandal of the apostle Andrew, gold, ivory, cloisonné enamel, pearls and jewels, inscription in niello, made for Archbishop Egbert of Trier, *c*.980s (310 × 447 × 220 mm). Photo Bildarchiv Foto Marburg.

135. Master of the Registrum Gregorii, Massacre of the Innocents, from the Codex Egberti (Archbishop Egbert's liturgical Gospel book), Trier or Reichenau? before 993 (133 × 102 mm) Stadtbibliothek (cod. 24, f. 15v), Trier. Conclusion, frontispiece (detail of 138): Hercules and the Lion.

136. Susanna (or Lothair) Crystal, made for King Lothair II, before 869, probably north-eastern France or central Rhineland (114 mm diameter, stone alone). © The British Museum (inv. 1855, 1201.5), London.

137. 'Throne of Dagobert', bronze throne, probably northern Francia, fifth–twelfth century (104 cm maximum height). Bibliothèque Nationale (Cabinet des Médailles), Paris.

138. *Cathedra Petri* (Throne of St Peter) general view, in original as-found condition prior to restoration, with the surrounding frame for carrying in procession removed. Wooden frame with ivory carvings, third quarter of ninth century, probably near Reims or Metz (in the kingdom of Charles the Bald, for whom it was made). Museo Storico della Basilica di San Pietro, Vatican City, Rome/Photo Fabbrica di San Pietro in Vaticana.

The publisher and author apologize for any errors and omissions in the above list. If contacted they will be pleased to rectify these at the earliest opportunity.

Index

Page numbers in italics refer to illustrations. Saints are arranged by their personal names while churches and places are under Saint, San, etc.

Aachen
 and Charlemagne 174–5
 Palace chapel *176*
Aachen Gospels *8*, 9–12, *10*, 15, 29
 crucifixion *13*
Abraham
 mosaic *90*
 sacrificing Isaac 55, *56*
 Torah shrine at Dura 27–9
St Adalbert *228*
Adoptionists 184
Aethelwold, Bishop *225*
St Aidan 128
Aistulf of the Lombards 139
Alaric the Visigoth 81
Alcestis 43
Alcuin of York 173, 184
Aldenik monastery 126
Alexander plate *65*
Alfred of Wessex
 translates into Anglo-Saxon 221
Amalasuntha 86
St Ambrose *121*
 altar in Milan 204–5, *205*
anchors *35*, 35–6, *36*
St Andrew
 reliquaries *230*, 231
 Sarcophagus *192*, 192
Angilbert, Archbishop of Milan 204–5
Anglo-Saxon language 221
animals
 boars 113
 doves 34
 eagles 85–6, *86*, *87*, 111
 fish 31–2, *32*, *33*, 34–5, *35*, *36*

griffins *180*
serpents *104*, 111, *182*
St Luke's ox *154*, 155
St Antony 117
St Apollinare *122*, 122–3
Apollinaris, Sidonius 64
apostles
 discuss heaven 204
 mixed portrayal *168*
 Santa Maria Maggiore mosaics 91
 sarcophagus of Junius Bassus 55, 56
Arcadius 81
architecture
 Islamic 173
 see also Christian places of worship
Arianism 83, 85
aristocracy
 hunting 64–5, *65*
 ivory carvings *72*, 72–4, *73*, *75*
 late Roman 63–5
 map of estates *64*
 metalwork 75–9
 'new men' 71–2
 silver 65–7, *66*, *67*, 68–9, *70*, 70–2
Ark of the Covenant 151
 evocation of 140–1
 at Germigny-des-Prés *188*, 188–9
 Hrabanus 196
asceticism of saints 117–18
Ashburnham Pentateuch 155, *156*
St Athanasius, Bishop of Alexandria
 Life of St Antony 117
Attila the Hun 88
St Augustine of Canterbury
 Gospel book of 153, *154*, 155
 magic icon 137
St Augustine of Hippo *73*, 204

City of God 70–1
 witnesses silent reading 156–7
Aurelius, Marcus 19–21, *20*, *21*
Ausonius of Bordeaux 232
 background and career 63, 64

'barbarian art'
 glass 74
 metalwork 75–9, *77*, *78*
Bassus, Junius
 career 63
 sarcophagus 55–6, *56*
St Bathilde *125*, 125
Beatus 195
 Commentary on the Apocalypse 198–9, *199*
 Tábara manuscript 218–19, *219*
 The Woman Clothed in the Sun 208–9
Bede, Venerable 178
 Ecclesiastical History of the English Church and People 109, 137
Belasarius, General 99
Benedictines
 Regularis Concordia 225, *225*
Beowulf 173
Bernard of Angers 220
 Book of Sainte Foy 225–6, 228
The Bible
 Old Testament narratives 91
 story-telling 36–9
 see also books and manuscripts; New Testament
Biscop, Bishop 145
Bobbio 159
St Boethius
 Consolations of Philosophy 221

diptych 189
ivory carvings *72*, 73, *73*
Book of Kells 144–5, *145*
Job 198
Book of Sainte Foy (Bernard of Angers) 225–6, 228
books and manuscripts
 authority and inspiration 164–9
 Beatus 198–9, *199*, 218–19, *219*
 Book of Kells 144–5, *145*
 Carolingian minuscule 183
 Christian influences 12–13
 court luxuries 177–8, *178*, *179*
 Dagult Psalter 163–4, *164*
 development of illumination 153–7
 Egmond Gospels *228*
 the Exultet rolls 221
 Godescalc Gospels 182–4, *183*
 Gospels of Otfried 222
 Hrabanus' picture-poem 195–7, *196*
 Insular 159, 163, 166
 Ireland *166*
 Islam's 'People of the Book' 157
 Jewish literacy 29
 Lindisfarne Gospels 157–9, *160–1*
 Luxeuil manuscripts 159, *162*, 162–3
 metalwork covers *107*
 monasteries 224–5
 narrative images 13–14, 93–7
 origins of decoration 163–4
 painters' signatures 168
 for prayer and devotion 169–71
 silent reading 156–7
 switch to codex from

papyrus 94
vernacular languages 221
Vikings ransom Gospels 216
'Winchester style' 191, *192*
Books of Kells 169
bracteates *104*
spiritual imagery 145–6
Britain
defeat of Constantine III 81
map *108*
monasteries 132
see also England; Scotland
brooches
Hunterston 180–1, *181*
Ireland *182*
Islamic *216*
penannular 218
Bruce-Mitford, Rupert 114
Buddhism 217
Byzantine Empire
'cult of images' 137

Calendar of 354 155
calligraphy, Carolingian 183
Canterbury
Peter and Paul monastery 186
Vikings ransom Gospels 216
Caracalla, Baths of 231
Carolingian minuscule 183
Carthage
Roman floor mosaic *25*
Vandal kingdom 81
St Cassian of Imola *210*, 210–11, 224
Cassiodorus 82, 83
catacombs
Domitillia 35, *35*
Pietro de Marcellino *37*
Cathedra Petri 243, 243–4
Ceolfrith, Abbot 165
ceramics
pilgrim tokens 118–19
Charlemagne 163
appropriation of Roman model 186–7
Christian politics 187–91, 193
coins 181–2, *182*
court luxuries 178–9
Einhard's *Life* of 173
Godescalc Gospels at court 182–4, *183*
Lex Salica 184, 186
map of travels *175*
Charles I (the Bald) of France

177, *178*, 192
Cathedra Petri 243, 244
manuscript 171, *171*, *172*
prayer book 224
Childeric 82–3, *83*, 85
Chlotiar II 106
chrismals 140, *140–1*
Christian art
Ark image 140–1
divine majesty 52–6
early meetings places 47
expressive imagery 204–6, 210–11
Hellenistic influences 56–8, 60–1
iconoclasm 147–51
image of Christ 141–3
imagery 195
imperial portraits 9–12
narrative *36*, 36–9, *37*, 89–96, 148
pictorial commentaries 200, 200–4, 202
problem of visual art 238–9
quotation and adaptation 232
roots and influences 12–14, 31–2
signs and symbols 32–6, *33*, *34*, *35*, *36*
stylistic revolution 237–8
Christian places of worship 47, 50
cathedra to cathedrals 241–4
destroyed by Vikings 213
Dura meeting house 39–40, *40*
see also individual churches and cathedrals
Christianity
bishops' role 87–8
conversion from classical world 47, 50–2
effect of Vikings and Magyars 216–18
maps of *48–9*, *214–15*
martyrs 117–18
persecution 50
sanctuaries 39–40
Chrysotriklinos of Theophilus 241
Cicero, Marcus Tullius 63
City of God (Augustine of Hippo) 70–1
Cividale *174*, *174*
St Clement, Bishop of Alexandria
Christian symbols 32–6

St Clement of Alexandria 204
anchor image 195
Codex Amiatinus 164–6, *165*
Codex Aureus 178
Codex Egberti 233
coins
Carolingian 181–2, *182*
Islamic *216*
Roman 22, *24*, 24–7, *31*, 244
St Columba
monastery at Iona 128, *128*
St Columbanus 128, 159, 171
Commentary on the Apocalypse (Beatus) 198–9, *199*
Consolations of Philosophy (Boethius) 221
Constantine III 81
Constantine the Great
closed martyrdom 117
conversion of empire 47, 50–2
map of empire *48–9*
silver gifts to Lateran Basilica 71
Constantinian Basilica 50–2, *51*
Constantinople 137
Constantius Chlorus *24*
crosses 205–6
crucifixion
Aachen Gospels *13*
Cologne Cathedral 229
growth of cross imagery 205–6
Hrabanus' picture-poems 195–7, *196*
pilgrim's ampulla 119, *119*
prayer and devotional books 169–71, *170*
Theodotus chapel 147–8, *148*
St Cuthbert 128–9, 157
coffin engraving 144–5
St Cyprian, Bishop of Carthage 50, 120

Dagobert
throne of 242, *242*, 244
Dagult Psalter 163–4, *164*
Damascus 173
Damasus, Pope 70, 164
Danes 216–17, *217*
David, King 28, 29
silk fragment *116*
Utrecht Psalter 201
De laudibus sanctae crucis (Hrabanus) 195–7, *196*
St Denis cross *106*, 106–7

Derrynaflan 115
Diocletian 50
Tetrarchy 21–2, *23*
Domitian coin *31*
Domitilla catacomb 35, *35*
Drogo, Archbishop of Metz 232
St Dunstan 225
Dura
Christian meeting-house 39–40, *40*, 47
Mithraeum 41–2
Dura Synagogue 27–9, *28*
Ark of the Covenant 140
Torah shrine *16*
Durrow, Book of 159, 163

Eadfrith, Bishop
Lindisfarne Gospels 157–8
Ealdorman Byrhtnoth 177
Ebbo, Archbishop 200
Ebbo Gospels *167*
John the Evangelist 206
Ecclesiastical History of the English Church and People (Bede) 109, 137
Ecclesius, Bishop 104
Edgar of England 191, *192*
Regularis Concordia 225, *225*
Egbert, Archbishop of Trier 229–31, 233
Egino, Bishop 189
Egmond Gospels 228
Einhard 177
Life of Charlemagne 173, 231
Eliezer *156*
St Eligius (St Eloi) of Noyon 106–7, 125
life and career 109
St Emmeram Gospels 178
England
Viking invasions 216
Epiphanius, Abbot 133
escutcheons
Sutton Hoo *111*
Esquiline Treasure
commercial impression 71–2
horse trappings 70, *70*
Projecta casket 66, 66–7, *67*, 70–1
Ethelbert of Kent 137, 186
ethnicity
ethnogenesis 14
Euphronius of Autun 88
Euric the Visigoth 173
Europe
map of *c*.1000 AD *214–15*

map of Constantine's
empire 48–9
Eusebius of Caesara 47
Exultet rolls 221
Ezra
Codex Amiatinus 164–6,
165

St Felix 121
Fortunatus, Venantius 125
Four Tetrarchs 21–2, 23
St Foy
relics 225–6, 226
Franks 14
map 100–1
Viking invasions 213
Fuller brooch 203

St Gall 159, 211, 212, 222
Galla Placidia 81
Gallus 222, 232
Gellone Sacramentary
169–71, 170
The Gemma Augustea 12
Genesis, Book of
Adam and Eve 39
Isaac and Rebecca 155, 156
St George
relic head of 225
Gerbert of Aurillac 224
Germanic states
language 221
metalwork 77, 77
Germigny-des-Prés 187, 188
Gero, Archbishop 229
St Gervasius 121
St Gilles see Master of St
Gilles
St Giovanni 120
Gisela, Abbess 184
glass
the Alexander plate 65
Glycon 41, 41
Godescalc Gospels 182–4, 183,
189
Gospels see New Testament
Gospels of St Augustine 153,
154, 155
Goths 14
Greek art 237
Gregory Master 233, 234, 235
Gregory of Tours 118
Gregory the Great, Pope 73,
137, 221, 233
Homeliae in Ezechiel 162,
162
iconoclasm 147
Moralia in Job 197–8

Pastoral Care 221
Grimoald of Benevento 177
Gundohinus Gospels 150,
150–1, 166, 188

Hadrian, Pope 177, 183
Hagia Sophia 99, 102, 175
Haimo of Auxerre 202
Haito, Abbot 133, 135, 225
Harald Bluetooth of the
Danes 217, 217
St Harlindis
textiles 116, 126, 127
Harun al-Rashid, Caliph of
Baghdad 178
Hebrews, Epistle to 35
Hegel, Georg F. W.
classical versus barbarian 15
Hellenism
influence on Christian art
56–8, 60–1
Hercules
and Alcestis 58, 58
Cathedra Petri 244
and the Lion 236
Mithraism 43, 44–5
Hieria, Council of 146
Hildegard 183
Hildegard of West Frisia 229
Hincmar 240
Homeliae in Ezechiel (Gregory
the Great) 162, 162
Homer 96
Honorius 81
Hrabanus Maurus 204
De laudibus sanctae crucis
195–7, 196
other works 197
Hucbald of Saint-Amand 211
Hunterston Brooch 180–1, 181
hunting
late Roman aristocracy
64–5, 65

Iceland
Vikings and Christians
216–18
iconoclasm
views and meaning of
images 146–51
icons
Christ in Lateran Palace
136, 139
'cult of images' 137
miniatures 169
San Apollinare Nuovo 84,
84
Ingelheim 177

Ingres, Jean Auguste
Dominique
Napoleon Enthroned in
Majesty 10–11, 11
Iona
cross 205
monastery 128, 128
Ireland 217
brooch 182
Derrynaflan 115
Gospel book 166
map 108
monasteries 132
Irene, Emperor 187
Islam and Muslims 118
advance into Europe 213
architecture 173
Italy struggles against 213
'knight' in Beatus' Tábara
manuscript 218–19, 219
'People of the Book' 157
problem of visual art 238–9
in Spain 218
trade of courtly luxuries 178
Italian states 213, 216
Iulius, Dominus 63
ivory carvings
for aristocracy 72, 72–4, 73,
75
Carolingian 187
Cathedra Petri 244
Charlemagne's court 184,
185, 186
Maximian's throne 98
Probanius diptych 169
Santa Maria Maggiore
92–3, 93
St Gall and the bear 223

Jarrow monastery see
Monkwearmouth-
Jarrow
Jelling Stone 217, 217
St Jerome 73
criticizes lavish books
163–4
criticizes manuscripts 94
Gundohinus Gospel 151
on tombs of the martyrs
119–20
wealthy patrons 67
Jesus Christ
Aachen Gospels 12–14, 13
baptism 203
on Caesar's coins 31
images of 141–5
majesty 53, 53
transfiguration 122–3

jewellery
belt buckle 77
bow-fibula 105
bracteates 78, 78–9, 104,
145–6
brooches 180–1, 181, 182, 203
cloisonné 85–6, 86
fibulae 76, 76, 85–6, 86
Islamic 216
metalwork 75–9
royal courts 179–81, 181, 182
Sutton Hoo 110–14, 111, 112
Job
manuscripts of 197–8, 198
John, Gospel of 148
St John the Baptist basilica,
Rome 50
St John the Evangelist 167,
167–8, 206
John VII, Pope
Virgin Mary cult 143
Jonah
carnelian seal 34
Christian story-telling 36,
36–8
Joshua, Abbot 132, 133
Jouarre holy tombs 123, 124,
125
Judaism and Jews
Ark of the Covenant 140
centrality of the book 12
roots of Christianity 31, 32
Torah shrine at Dura 16,
27–9, 28
Julian the Apostate 56–7
St Julitta 147–8, 148
Justinian 99, 104

kingship
divinity 27
imperial representation
9–12
Roman 17–19, 21–2, 22–7,
23, 24
see also royal courts
Klimova treasure 74

Lateran Basilica 52
Sancta Sanctorum 138,
138–40, 139, 142
silk veil 127–8
silver 71
law
Charlemagne's Lex Salica
184, 186
St Lawrence 132
Lazarus 57, 57, 220
Leo I, Pope 88

Leo III, Pope
 Christian politics 189–90
 silk veil 127–8
Lex Salica 184
Liber Pontificalis 190
Licinius *24*
Life of Charlemagne (Einhard)
 173, 231
Lindisfarne 128
Lindisfarne Gospels *152,*
 157–9, *160*–*1*, *163*–4, 221
Liuthar 10
Liutprand of Cremona 241
Lothair II of the Franks *239,*
 240
Louis the Pious, Emperor 224
Lowden, John 95–6
Ludovisi Battle Sarcophagus
 22
St Luke
 St Augustine Gospel *154,*
 155
Luke, Gospel of 156
Luxeuil manuscripts 159, *162,*
 162–3

Magyars 213, 216, 217
Maius 195, *199*
Malalas, Ioannes 142
manuscripts *see* books
Marcus Aurelius Column
 19–21, *20, 21*
St Mark
 relics of 225
St Martin of Tours 117–18,
 129
 relics 140
 tomb 123
Mary, Virgin
 images of 143–5, *144*
 narrative art 90
The Mass of St Gilles (Master
 of St Gilles) *106*
Massacre of the Innocents
 233, *234*
Master of St Gilles
 The Mass of St Gilles 106
Mathews, Thomas 52
Matthew, Gospel of 34
 good shepherd 39
 on Jonah's three days 38
 Lindisfarne 158
 symbolic fish 33
Maximian, Archbishop 104,
 123
 throne of *98*
medieval art
 cathedrae and thrones 241–4

stylistic revolution 237–8
 see also Christian art
Melchisedek 90, 91, 102, 103
metalwork
 Childeric's sword *83*
 chrismals 140, *140*–*1*
 cloisonné 104, *105*, 114, 231
 pilgrim's ampulla 119, *119*
 reliquary of St Andrew *230*
 Roman and barbarian 75–9,
 76, 77, 78
 royal court luxuries 178–82,
 180, 181, 182
 Style II *104, 104*–7, *105, 107*
 Sutton Hoo 110, *111, 112, 115*
Michael, Archangel 184
Milan imperial palace 63
Minucius Felix 204
*Miracles of Sts Cosmas and
 Damian* 142–3
Mithraism 41–3, *42, 44*–5
monarch *see* kingship; royal
 courts
Monasterboice cross 205, *206*
monasteries 128–9, 132–3
 dominant institutions
 224–5
 map of major sites *130*–*1*
 sacked by Vikings 213
 St Georg, Reichenau *220,*
 220–1
Monkwearmouth-Jarrow
 monastery 145, 165
Mont-Saint-Michel 129
Monte Cassino 129
monuments
 Harald's Jelling Stone 217,
 217
Morgan Beatus *see* Beatus
mosaics
 Roman Carthage *25*
 San Vitale 241
 Santa Maria Maggiore 80,
 89, 89–91, *90*, 241
 Santa Prassede 190, *191*
Mount Sinai monastery 129
Muhammad the Prophet 118,
 157

St Nabor *121*
*Napoleon Enthroned in
 Majesty* (Ingres) 10–11, *11*
New Testament 12
 signs and symbols 33
Nigellus, Ermoldus 177
Nordenfalk, Carl 159
Norway *104*
 ship burial 177

Odovacer 82
Oengus of the Picts *192*
Orthodox Church
 Ravenna churches 83–7
Ostrogoths 99
Oswald of Northumbria 178
Otfried, Gospels of 222
Otto I, Emperor 213
Otto II, Emperor 178, *179*, 233
Otto III, Emperor 224, 225
 Aachen Gospels 8, 9–12,
 10, 29

pagan religion
 Roman imagery 40–4, *41,*
 42, 44–5
Painter, Kenneth 71
Palestine 137
St Paolo 120
Parthenon frieze 19
Paschal I, Pope 190
Pastoral Care (Gregory the
 Great) 221
St Paul
 anchors 35
 icon from Sancta
 Sanctorum *142*
Paul the Deacon 189
Paula, follower of Jerome 67
Paulinus of Aquileia 184, 189
Paulinus of Nola 94
Pepin of the Franks 139
Perpetuus of Tours, Bishop
 88, 123
Persia 74
St Peter 165
 description 142
 icon from Sancta
 Sanctorum *142*
 image of Christ 143
 reliquaries 231
pilgrim tokens 118–19
 St Symeon *118*
Pindar 117
Pippin of the Franks 149, 186
Pliny the Elder 202
Pliny the Younger 50
Primitiva, Livia, sarcophagus
 36
Proba, Marcus Valerius 232
Probianus, Rufius
 career 63
 diptych 53–5, *54*, 169
Procopius 102
Projecta casket, Esquiline
 Treasure 66, 66–7, *67, 70,*
 71
St Protasius *121*

Prudentius
 Psychomachia 202, *202*, 210
Psalms, Book of 184
 Utrecht Psalter 200, 200–1
Psychomachia (Prudentius)
 202, *202*, 210
pyxides *53, 55*

Quedlinburg Itala
 manuscript 94–5, *96*
St Quiricus 147–8, *148*
Qur'an
 early texts of 157

Radegonde of Poitiers 123, 125
Ravenna
 imperial palace 64
 Theodoric's churches 83–7
 see also San Apollinare
 Nuovo; San Vitale
Redwald
 possible Sutton Hoo burial
 109–10
Regularis Concordia 225, *225*
Reichenau monastic church
 220, 220–1, 225
relics and reliquaries 137–41,
 138, 225–8, *227*
religious art *see* Christianity;
 Islam and Muslims;
 Judaism and Jews
St Relindis
 textiles *116*, 126, *127*
resurrection
 Santa Maria Maggiore
 91–2, *92*
rock crystal *203*
Rome
 adaption to Christian art
 231, 232
 coins 22, *24*, 24–7
 conversion to Christianity
 47, 50–2
 early Christians 50
 fall of 81–2
 floor mosaic 25, 25–6
 imperial columns 17–22, *18,*
 19, 20, 21, 22
 influence on Carolingian
 culture 186–7, 190
 influence on Christian art
 237
 map of Constantine's
 empire *48*–*9*
 map of late antiquity *100*–*1*
 metalwork 75–8
 partial influence 12
 praetorian guard *26*

religious imagery 40–4, *41, 42, 44–5*
Trajan's Column 26, *27*
Romulus and Remus 146
Rosenblum, Robert
on Ingres's Napoleon 10
royal courts
Christian politics 187–91, 193
creative centres 173–5
luxury of 177–84
religious books 182–4, *183*
Russia 216
Ruthwell cross 205

Saint-Denis, near Paris 242
Saint Gall monastery 187, 222, *223*
plan of 133, *134*, 135
Saint Georg, Oberzell 220, 220–1
Saint-Maurice d'Agaune 129, 178
enameled ewer *180*
Saint Paul's Basilica, Rome 186
Saint Peter's Basilica, Rome 186, 189
saints
holy tombs 119–23, *120*, *121*, *122*, *124*, 125–8
lives of 222, 224
relics and reliquaries 225–8, *227*
Samuel, Book of
Saul 94–5
San Ambrogio
altar *194*, 204–5, *205*
San Apollinare Nuovo 84, *84*, *122*
San Aquillino chapel
mosaic *52*, 53
San Crisogono 47
San Julian de los Prados 174
San Marco Basilica 225
San Sebastiano
catacombs 47
San Vincenzo al Volturno 213
monastery 132–3
San Vitale 102–4, *103*, 175
mosaics 241
San Vittore Chapel *121*

San Cosma e San Damiano 190
Santa Costanza
vault of *59*
Santa Maria, Cividale 174, *174*
Santa Maria, Trastevere *144*, 231
Santa Maria Antiqua chapel 147–9, *148*
Santa Maria Maggiore 50, 143, 235
built for Sixtus III 88–9
mosaics *80*, 89, 89–91, *90*, 241
narrative 94, 95
nave *80*, *88*
Santa Prassede 190–1, *191*
Saul
Quedlinburg Itala
manuscript 94–5, *95*
Saxon language 221
Scotland
monasteries 132
Secundus, Turcius 66, 70, 74, 75
Serena 75
Serenus, Bishop of Marseilles 147
serpents 34
Sevso Treasure
silver vessels 62, 68–9
Shelton, Kathleen 71
shepherd image *36*, 39
Shroud of Turin 143
Sidonius Apollinaris 88, 102
signs and symbols
Christian 32–6, *33*, *34*, *35*, *36*
silver
Klimova Treasure 74
late Roman aristocrats 65–7, 66, *67*, 68–9, 70, 70–2
workshops 70–1
Sixtus III, Pope 88, 91
Skellig Michael 129
Spain
Islamic 218
statues
fastigium figures 138
St Stephen *132*
Stephen II, Pope 139, 149
Stilicho 74, 75, *75*, 81

Suger, Abbot 242
Sulpicius Severus 117–18
Susanna and the Elders
Crystal *239*, 239–40
and Queen Teutberga 240–1
Sutton Hoo burials 107
map *108*
metalwork and jewellery 110–15, *111*, *112*, *115*
possibly Redwald's grave 109–10
Sweden 217
gold bracteate *78*
Sylvester II, Pope 224
St Symeon the Stylite the
Elder 118
St Symeon the Stylite the
Younger 118

Tara Brooch 181
Tempietto del Clitunno 149
Teutberga, Queen
and Susanna 240–1
textiles
court dress 177–8
from holy tombs *116*, 125, 125–8, *127*
manufacture 126
Oseberg tapestry 177
Theodechilde, Abbess 123
Theoderic II of West Frisia *228*, 229
Theoderic of the Ostrogoths 81–2, *83*, 86
and Ravenna 83–7, 173
Theodora 104
Theodosius I 74, 81
Theodotus
Roman chapel 147–9, *148*
Theodulf of Orléans 173, 187–9, *188*, 232
Theophanu, Princess 178, *179*
Theophilius
Chrysotriklinos of 241
thrones 241–4
of Dagobert 242, *242*
tombs
of saints 119–23, *120*, *121*, *122*, *124*, 125–8
Toulouse
La Daurade church 85

Trajan Decius
persecution of Christians 50
Trajan's Column *18*, *19*, 26, 27
burial place 118
narrative 96–7
Trier Gospels *168*
Trier imperial palace 63
ceiling *46*
female portrait *60*
Tuotilo 232

Utrecht Psalter 167, *200*, 200–1, 206, 232

Valentinian III 81
Vandals 99
Velletri Sarcophagus *44–5*, 55
Hercules and Alcestis
detail *30*
Venus
Projecta casket *66*, 66–7, *67*
Via Latina catacomb *57*, 57–8, *58*
Vikings
effect on Europe 213, 216–18
jewellery 181
sack churches and
monasteries 213, 216
St Vincent of Saragossa 133
Virgil 232, 233
manuscript painting *96*, 96–7
Visigoths
map *100–1*
Vosevio monastery 150

Weitzmann, Kurt 95
Williamsburg, Virginia
House of Burgess seat 244
Winchester
'Winchester style' of
decoration 191, *192*, *193*
wood
St Cuthbert's coffin 129, 144–5

Yeavering 173

Zacharias, Pope *148*, 149